Art Has No History!

Art Has No History!

The Making and Unmaking of Modern Art

Edited by
JOHN ROBERTS

VERSO

London · New York

First published by Verso 1994

Verso
UK: 6 Meard Street, London W1V 3HR
USA: 29 West 35th Street, New York, NY 10001–2291

Verso is the imprint of New Left Books

ISBN 0-86091-627-8
ISBN 0-86091-457-7 (pbk)

British Library Cataloguing in Publication Data
A catalogue record for this book is available from the British Library

Library of Congress Cataloging-in-Publication Data
A catalogue record for this book is available from the Library of Congress

Typeset by Servis Filmsetting Ltd, Manchester
Printed and bound in Great Britain by
Biddles Ltd, Guildford and King's Lynn

Contents

Acknowledgements

Thanks to Waddington Galleries, London; Leo Castelli Gallery, New York; The Andy Warhol Foundation for the Visual Arts, Inc., New York; Anthony d'Offay Gallery, London; John Weber Gallery, New York; Metro Pictures, New York; Mary Kelly; and the ICA, London.

Thanks to Steve Edwards and Esther Leslie for comments and suggestions, and to Malcolm Imrie for his faith in the project.

Notes on Contributors

Terry Atkinson is an artist and writer. He has exhibited widely in Europe. In 1983 he had a one-person show at the Whitechapel Gallery, London.

Michael Corris is a writer, lecturer and curator. In the early seventies he worked with Art & Language and was a founding editor of *Fox* magazine. He is a regular contributor to *Artforum* and *Art & Text*.

Sean Cubitt has written on photography, film and video for various magazines and journals, including *Screen* and *Third Text*. He is the author of *Timeshift: On Video Culture* (1991).

Gen Doy teaches art history at De Montfort University.

Jessica Evans teaches photographic studies at the University of Westminster. She has contributed to *Ten:8*.

Inter Alia (Dave Beech and Mark Hutchinson) are artists and writers. They have exhibited in Britain and the USA.

Catherine Lupton teaches art history at various institutions.

Fred Orton teaches art history at Leeds University. He has contributed to many publications including *Block* and the *Oxford Art Journal*. He is co-author, with Griselda Pollock, of *Vincent Van Gogh* (1978) and, with Charles Harrison, of *A Provisional History of Art and Language*, and is co-editor with Charles Harrison of *Modernism, Criticism, Realism: Alternative Contexts for Art* (1984).

Jeffrey Steele is an artist and writer. He has exhibited extensively in Europe and the USA since the sixties.

Paul Wood teaches art history at various institutions. He has written for numerous magazines and journals, including *Artscribe* and the *Oxford Art Journal*. He is the co-editor with Charles Harrison of *Art in Theory* (1992).

John Roberts is a writer and curator. He is the author of *Postmodernism, Politics and Art* (1990) and *Selected Errors* (1992), and recently curated the travelling exhibitions 'Approaches to Realism' (1990) and 'Renegotiations: Class, Modernity and Photography' (1993).

INTRODUCTION

Art Has No History!

Reflections on Art History and

Historical Materialism

John Roberts

The title of this anthology is not meant to be misleading, even if its tone is meant to be slightly mischievous. Art, of course, has a lot of history, in fact it has recently been drowning in it. The paraphrasing of Althusser is therefore somewhat disingenuous. When Althusser talked about ideology having no history, he was expressing what he perceived as its unchanging basic structures. Ideology was indistinguishable from all forms of lived experience, whatever mode of production, and therefore unavailable to rational dissuasion and control. My emphasis is more prosaic, reflecting on the ambiguities of current radical Anglophone art history.

Thus we might say the title is the polemical conflation of three opposing, though not necessarily contradictory, critical art historical positions. Without sounding too obtuse, we can describe them as those views which hold that there is no such thing as *art* history, *Art History* and art *history*. The first position is commonly associated with older forms of the sociology of art and Marxist art history in their respective detachment from formalist models; the second with the New Art History, with its radical disdain for notions of a unitary field of art historical investigation; and the third, at least since the sixties, with modernist accounts of the superfluity of historical analysis in the face of the challenge of individual aesthetic experience. This anthology charts the dialectical tensions of these positions as they have come to be played out and transmogrified in recent ideological struggles within Anglophone writing on art.

However, the anthology is not a survey of 'critical positions', even though there are sharp divergences in opinion. On the contrary, the authors recognize that there is a debate to be had across these positions *within* the bounds of historical materialism. That is, there is no *logical* contradiction between, say, espousing a defence of class struggle, the causal theory of representation and the inviolability of the aesthetic experience.

1

Contradictions arise when the quality of one sort of aesthetic experience is hierarchized in the light of other sorts of aesthetic experience. For example, are the experiences obtainable from certain kinds of paintings to be valued more than other kinds of visual experience, particularly when the intellectual range of popular visual experience in our culture is so proscribed? This, of course, is a familiar dispute, and has been waged since the thirties at least by the defenders of historical materialism under the banner of the respective claims of high culture and popular culture. The contributors to this anthology make no apologies about continuing the debate on this terrain. The antithetic voices of Adorno and Benjamin still locate the wider terms of the discussion, whatever sanguine voices may argue to the contrary.

Specifically, the anthology draws together work by professional art historians and artists in Britain whose continuing commitment to historical materialism has made art historical studies on the left in this country still something of a fertile area of engagement with the dominant culture. Since the late sixties a steady stream of rigorous and ambitious work has found an expanding professional and non-professional readership. Much of this work, however, owes as much to the intellectual output of art schools as it does to art history departments. The importance of British art schools in the development of British popular culture has been extensively commented on; its importance in the development of the radical theorizing of visual culture less so. It was very much the internal critique of modernism in the late sixties by artist-writers such as Art & Language and Victor Burgin, amongst others, that provided the ideological lead in the critique of traditional art history. The sophisticated appraisal of art critical method in this writing, which drew together Marxism, Anglo-American analytical philosophy and various strands of situationist theory, was far in advance of anything being done in art history departments at the time. Victor Burgin may have moved a long way ideologically since the sixties, but nevertheless the sense of the artist *as* writer and intellectual and the art school as a place of combative intellectual work has been a continuing characteristic of British cultural life since that period. Consequently, it is no surprise that a considerable number of art students have passed through art school to become art historians or cultural theorists. Despite repeated political attacks on 'theory' from within and outside of their walls, art schools have been relatively successful intellectual training grounds.

There is a discernible sense, then, that in the radical study of visual culture in Britain strong lines of connection have developed between theory and the vicissitudes of practice, just as there have developed strong lines of connection in the opposite direction, in the name of the artist-as-intellectual, between practice and theory. The result of this is not only a wider class composition within the profession of 'art history' but also a more complex division of intellectual labour within the culture as a whole, as the roles of

critic, historian and artist have become more fluid. This breakdown in the division of intellectual labour is reflected in this anthology. Most of the historians have passed through art school at some time or other, and the artists see themselves not so much as artists writing history as artists intervening in the historical debate in order to extend their own visual practice.[1] This breakdown in the division of labour has contributed, I believe, to a stronger commitment to critical realism in the study of art, that is, to a greater sensitivity to the causal production of artworks. Adherence to a causal theory of representation has been in vogue for some while in traditional art history. In this area, however, particularly in Michael Baxandall's writing,[2] there is a tendency to use the discussion of causality to endow the artwork with a kind of purposive intention. Artworks become successful or unsuccessful resolutions to pre-given sets of problems. There is much in the idea of artworks as 'solutions' to problems, but the result is a kind of comforting closure around the making of meaning. For the writers in this anthology, intention and agency are crucial components of the art historical analysis, but there is a more forceful attention to the dissimulations involved in authors' self-representations. This I believe is the product of stronger lines of connection between the writers and the uncertainties of artistic production itself.

This is why the anthology was commissioned as a series of essays on individual artists, not in order to fetishize authorship, but to bring work and author back into complex intentional view. The 'trying-on' of much post-structuralist theory in art history recently has produced writing that is textually sensitive but indifferent to matters of intention, reproducing the worst kinds of simple-minded pattern recognition in the name of 'critical difference' as in old-style formalism. Consequently, there is a sense, at least tentatively, in which the essays in this anthology mark out a 'new complexity' in Marxist writing on art, a clearer view that the making of meaning for the historian or critic is the social remaking of authorship. This, of course, is not new. The school of Voloshinov, Bakhtin and Medvedev in the twenties sought to extract literary studies from the twin pitfalls of formalist ahistoricism and Marxist sociologism by emphasizing that artworks were complexly authored. The psychic and the social were brought together as a means of showing how the making of the artwork was an intentional ideological act inscribed in both determinate and indeterminate relations to the dominant culture. The description of such a programme as realist then could be said to turn on a critique of the use of undifferentiated and highly abstracted categories in analysing the relations between author, artwork and the social world, whether they are Hegelian, structuralist or hermeneutic in provenance.

A central case in point is the history of modernism. A good deal of recent historical materialist writing on art indebted to this realist model has been

concerned to critique the self-image of modernism in both traditional art history and the leftist New Art History.[3] In both histories modernism is given a certain historicist 'tidying up'. In the former it is bound up with the construction of a continuing tradition of Western artistic achievement, in the latter with the homogenization of the opposition, the more easily for it to be disposed of. Realist writing, by contrast, has brought its critique of meaning and value in modernism under a framework that is more attuned to the internal diversities and conflicts of modernism, introducing, as a result, a stronger sense of the discontinuous into the historical account. This kind of approach finds its extended voice in the first half of the book, where leading modernist figures and modernist 'transitional' figures such as Andy Warhol and Gerhard Richter are made to speak in ways that brush against the grain of both their conservative and radical interpreters. In the second half, which deals loosely with leading artists who have made their reputations in the wake of the crisis of modernism since the late sixties, the same scepticism about history as retroactive *rationalizing* process applies. However, in this case, the histories being unpacked are generally of the left, and in particular the feminist left.

The Search for Complexity

The call for a new complexity in art history is, of course, the history of the discipline itself this century, and at least from the twenties it has been internal to the pursuit of new conditions of complexity within historical materialism. By the late twenties and early thirties, the developing crisis in Hegelianized forms of Marxism produced a widespread critique of 'objectivist' Marxism in philosophy and cultural criticism. The anti-objectivism of Benjamin, Adorno, Bloch, Trotsky, Max Raphael and Meyer Schapiro and others, all contributed in their various ways to an attack on Second International historicism and Stalinist economism in the name of a greater specificity of relations between base and superstructure. Generally this can be drawn under two headings: against idealism and against 'undialectical materialism'. Soviet Diamat and Hegelianized materialism were both accused of collapsing science into philosophical abstraction (when the scientific status of Marxism was not being attacked itself, as in Adorno). The result was the pursuit of a non-reductive dialectics (whether partial or systematic) as a means of opening out Marxism to a more differentiated account of causal relations.

Writing in the thirties, Max Raphael was perhaps the only figure at the time concerned specifically with the problems of dialectics and art history, though of course Benjamin's work can be recognized as an implicit engagement with such problems.[4] In Raphael's essay 'The Marxist Theory

4

of Art',[5] published in German in 1932 and in French in 1933, he condemns both bourgeois and historicist Marxist accounts of art history for their lack of dialectical sophistication. At the beginning of the essay he quotes from a letter from Engels to Paul Ernst (5 June 1890): 'the materialist method turns into its opposite if it is not taken as one's guiding principle in historical investigation but as a ready pattern according to which one shapes the facts of history to suit oneself.'[6] Or, in other words, vulgar Marxism is unable to move beyond the most inert of dialectical methods, in which art simply passively 'reflects' class interests or ideologies. Raphael calls for a new art history that will take sharper account of the relative independence of art. A materialist dialectics that not only 'grasps all of social life in terms of a single method, but also ... leaves relatively autonomous the specificity of each domain'.[7] As such he demands a new art history which can command a wide range of specialist knowledges, insisting that dialectical thought 'has not been able to undertake more than fitful, fragmentary investigation into specific artistic problems'.[8]

As with a later generation of anti-Stalinist Marxists, Raphael's reading in the twenties of Marx's 'Introduction to a Critique of Political Economy' (1857) allowed a respectfully 'orthodox' path to be opened up through the economistic and historicist misinterpretations of Marx. The 'Introduction', which expanded the preface to *A Contribution to the Critique of Political Economy* first published in 1859, was first published by Karl Kautsky in his journal *Neue Zeit* in March 1903 and then in an English translation by N.I. Stone in Chicago in 1904. The *Grundrisse*, however, of which it was the opening section, was not published in full until 1939–41 in Moscow.[9]

These details are important because no one else in Paris and Berlin at the time, on the strength of available textual evidence, was addressing its implications for art. This places Raphael's essay in something of a privileged theoretical position, insofar as it allows Raphael to use direct textual evidence from Marx's writing to break open the 'objectivist' treatment of art dominant during the period. What the discussion of methodology in the 'Introduction' makes clear is how the notion of the dialectic for Marx is not a unitary philosophical method (as in Hegel and in fact Engels's Hegelian/naturalistic emphases), but a number of different, if related, topics.[10]

In Marx, the dialectic is a methodological commitment to the empirically controlled investigation of causal relations, and not – *pace* Hegel and Hegelian Marxism – a naturalized process in which history is 'objectively' interpreted in terms of the categories of a universal teleological system. This essentially is what Raphael attacks in his call for 'the joint collaboration of several special sciences'.[11] For Raphael, therefore, what Marx's discussion of ancient Greek culture in the 'Introduction' allows into the cultural debate is a conditional relational dialectics. That is, Marx's recognition of the discrepancy between the level of the forces of production in ancient Greek

culture and the continuing pleasure Greek art gives invites a critical acknowledgement of aysmmetry into the debate on aesthetic value, in a Marxist art historical discipline that invariably talked in reified terms about 'bourgeois' art and 'socialist' art.

Marx's recognition of the aesthetic value of work, irrespective of the exploitative conditions under which the work was produced, made it easier for historians such as Raphael to distance themselves from the crude politicization of art under Stalinist models. 'Spiritual expression does not develop in direct ratio to the means of material production.'[12] The coded anti-Stalinism of this is also reflected in a sensitivity on Raphael's part to the ideologically differentiated and conflictual character of art in a given social formation, a theme that was to preoccupy Benjamin in particular, and of course was to dominate the reception of Gramsci and Althusser in Anglophone cultural criticism in the late sixties and seventies.

In the forties and fifties the critique of Stalinized forms of cultural history continued to loom large in the development of new forms of complexity in Anglophone art history. As with the post-war solidification of modernism, this was a culture of exile and emigration. The anti-fascist diaspora of the thirties led Max Raphael and other writers and intellectuals to New York, participating in what was a largely anti-Stalinist, pro-Trotsky cultural formation. Similarly Fredrick Antal, the Hungarian art historian, left Germany for Britain, contributing to an emergent Communist Party-dominated art critical milieu that included the talents of Anthony Blunt, Francis Klingender and Herbert Read. The theoretical climate, however, was very different to that of New York and Paris. Strongly pro-Stalinist and anti-Trotskyist, there was little sympathy for any thorough-going discussion of historical method, with the exception of Read's work, whose proletarian anarchism and support of European geometric art was always critical of the cultural dead hand of Stalinism.[13] Thus it is revealing that in the same period Raphael was writing 'The Marxist Theory of Art' and Benjamin his equally anti-historicist 'The Author as Producer',[14] Klingender was writing in his essay 'Revolutionary Art Criticism' in *Left Review* about the need for a 'truly revolutionary style'[15] of art.

This populist idealism, along with its theoretical props of economism and historicism, was to continue to underpin much Marxist writing on art in Britain in the late thirties and forties, doing a great deal, as many commentators have pointed out, to fog the political reception of modernism. Antal, however, although a close collaborator with Klingender, was always too respectful of the older neo-formalist criticism (Dvořák, Riegl and Warburg) to speak openly of 'bourgeois aesthetic theory'.[16] The reduction of art to 'class ideologies' simply created a sociological mirror-image of the isolationist art history of Heinrich Wölfflin.[17] Nevertheless, if Antal was instrumental in weakening some of the historicist and populist inflections of

vulgar Marxist art history (like Benjamin and Warburg he had a strong sympathy for the aesthetically marginal and remaindered products of artistic history), his work remained under-theorized. It is striking how theoretically bland his 1949 'Remarks on the Method of Art-History' actually are.[18] In the thirties and forties nothing was written in Britain in the area of art historical methodology that matched the sophistication of Raphael's 'The Marxist Theory of Art', not to mention, of course, the work of more well-known European names within the cultural debate.

This was to be amended, however, in the fifties. With the emergence of Arnold Hauser's reputation in this period (Hauser, like Antal, was a Hungarian émigré to Britain), the disparate criticisms of vulgar Marxist art history in Britain find a coherent voice from the left. Hauser's massive two-volume history of the Western tradition, *The Social History of Art* (1951),[19] was an attempt to bring art history in line in a systemic fashion with the wider material forces of history: a *non*-isolationist history of art. However, it was widely criticized, by Ernst Gombrich amongst others, for its class reductionism. In response to his critics, and as an extensive act of self-criticism, Hauser published his greatest work, *The Philosophy of Art History*, in 1959.[20] This impressive and largely overlooked collection of lengthy essays presents an erudite defence of the sociology of art history from a position that is sympathetic to Marxism and emphatically anti-Hegelian and anti-historicist. What is most vivid about the work is its unprecedentedly wide reading in German and French Marxism and sociology and in Western philosophy generally. Hauser's reference in German to Benjamin's 'Artwork' essay must be one of the first to appear in English. The result is the first major work of methodology to be written in English on art history.

Clearly deeply swayed, as Raphael was, by Marx's 1857 'Introduction', *The Philosophy of Art History* is largely an excursus on the 'relative autonomy' question and an attack on the idea of art history as a unitary process.[21] In this regard, the work can be seen as the summation of the disparate anti-objectivist trends in European Marxist art history and the sociology of art from the twenties onwards. In providing a summation, however, Hauser also provides a qualitative transformation in the level of the debate *within* art history, introducing or emphasizing themes that were later to be given more theoretically acute treatment after Althusser. The work takes in questions of ideology, of psychoanalysis and social psychology, it critiques expressivist theories of art, challenges the idea of a unitary audience for art (Hauser sees the consumption of art in terms of publics), defends the dialectical interchange between popular culture and high culture, and, borrowing from Freud as Althusser was to, talks about the 'overdetermined' meanings of art. This is a perspicacious list of 'structuralist' topics and themes, pointing not so much to how prescient he was, as to how parasitic developments in art history are on developments in the social sciences and philosophy. It has to be

said that Hauser's book was at the end of one tradition, and not at the beginning of another, for all its prefigurations.

Crucially, *The Philosophy of Art History* puts the artist and his or her social agency on the cultural map for historical materialism, and as a consequence directs its attentions to the complexities involved in the representation of artistic intention. Wölfflin's 'art history without names' and vulgar Marxist art history's symmetrical relations between ideology, expression and meaning are thoroughly disposed of, providing a stepping stone to a causal theory of representation. 'Art is not only a form of exposure, but also one of disguise.'[22] 'The ambiguity of artistic form is not merely the result of the artist's divided consciousness, but also a product of continuous reinterpretation.'[23]

In essence, Hauser's book was a systematic attempt to rid art history of those idealist abstractions inherited from the Hegelian dialectic, resulting in a tentative realist critique of the dissolution of Marxism into philosophical method. Thus, for Hauser, there is no 'consciousness in general',[24] no art history in general, only specific artistic individuals operating under specific historical conditions and pressures with specific audiences. Consequently, we might argue that Hauser's bid for a 'new methodology' was driven by the need for a new sense of differentiality in representing the production and consumption of art, what he called art's complex relationship to the 'manifold nature of historical reality'.[25] In this the too 'radical differentiation between external influence and inner logic'[26] that affected Wölfflin's history and historicist Marxism's conflation of meaning with class content could only be resolved by breaking with an essentially passive model of authorship in which the artist was merely the reflector of inherited ideological materials. This is probably the most insightful aspect of Hauser's attack on idealism and undialectical materialism. Taking on board (the non-reductionist) Engels's dictum that the power of historical materialism lies in its capacity to analyse how social forces 'go through the *heads*' of individuals, Hauser sees artistic agency in terms of choices taken ideologically at the level of specific materials and 'modes of representation'. This is not to say that the available stock of aesthetic and cognitive resources and 'modes of representation' aren't culturally pre-given, but the making of art is not a supraindividual process separate from what Hauser calls individual 'necessities'.[27] 'Modes of representation' and cognitive and aesthetic resources are therefore never applied or appropriated inertly.

Hauser's pursuit of a new complexity for art history rests on bending the stick back to a materialist encounter with the individual artist, after a long period of what he perceived as grey sociologism in Marxism. His foregrounding of agency and ideology, the differential nature of historical time and the 'overdetermination' of meaning in art asserted the need for a greater empirical verification and conceptual scrutiny. The reception of

Hauser's work in Britain, however, was scant. The cultural reaction of the Cold War period, and the dominant class solidity of the institutions of art history, combined to prevent any ideological mobility occurring in the construction of a new radical visual culture. By the time Hauser left Britain for the United States in the late fifties,[28] even the prestige of the pre-war Communist historians had waned, leaving a revivified Courtauld Institute to reassert its formalist hegemony.

It wasn't until the shifts in higher education in the sixties in favour of working-class and lower-middle-class entrants, and the emergence of a local Marxist culture indebted to the theoretical advances of French theory, that Hauser's expectations gained ground. The meeting between a general lack of class deference for the precedents of high culture amongst many students and the anti-humanist iconoclasm of the new theory generated the necessary institutional space for new radical work.

The crucial intellectual figure for this conjuncture was, of course, Althusser. Althusser's complete detachment of Marx from Hegel, his prioritization of complex totalities over expressive ones and emphasis on ideology as 'lived experience' rather than false consciousness created a steely theoretical armature with which to attack bourgeois and Marxist humanist culture. As John Tagg was to say in the late eighties: 'Althusser's theory made a cultural politics possible.'[29] That is, it made a systematic anti-historicist cultural politics possible. In contrast to the Hegelian dialectic, in which forms of consciousness arise out of each other generating ever more inclusive totalities, the Althusserian dialectic stood for the non-sublated complexity of wholes, in which the structural determination of multiply determined phenomena could be investigated by a number of disciplines.

However, if Althusserianism had a widespread influence on cultural theory in the seventies in Britain and the USA, its effects on *art history* were far more diffuse. Although by the mid-seventies there was a discernible sensitivity on the left about the need for a theoretically responsible art history, it is difficult to point to a single work of Althusserian art history in English.[30] This may have had something to do with the impact of Nicos Hadjinicolaou's *Art History and Class Struggle*, published in French in 1973 and in 1978 in English,[31] which to a large extent mediated many of the substantive themes of Althusserianism to the English-speaking art community. Fairly crude in its application of Althusser's (and Pierre Macherey's) 'structuralism', it actually pushed Marxist art history back into a deterministic and sociological mode, feeding all kinds of rightist fantasies about the *essential* determinism of historical materialism.

Rejecting art history as a history of artists and individual works of art, Hadjinicolaou invokes the history of art as the history of conflicting 'visual ideologies'. Transcending the individual as the expression of a social group, visual ideologies are a 'specific combination of the formal and thematic

9

elements of a picture through which people express the way they relate their lives to the conditions of their existence, a combination which constitutes a particular overall ideology of a social class'.[32] For example, according to Hadjinicolaou, David's *The Death of Marat* (1793) belongs to the 'visual ideology of the revolutionary bourgeoisie',[33] which corresponds to this class's struggle for power between 1789 and 1795. Each work of art, therefore, alludes to a particular view of reality which the consciousness of a class has of itself and the world. The 'allusion to reality goes together with an allusion about the objective place a class occupies within class relations in a society'.[34] However, the visual ideology of one class or class fraction can permeate another: for instance, the permeation of the 'visual ideologies' of the working class by the 'visual ideologies' of the ruling class. Thus although 'visual ideologies' express fixed class relations, they are not fixed in class content.

Antal's view that the ideology of a social class is simply 'translated' into art through the themes of the artist is the primary target here. Hadjinicolaou breaks with an intentionalist model of ideology in which the ideological position of the work is ascribed to the manifest content of the work. In this, Hadjinicolaou adopts the textualism of Macherey. To know a work of art is not to discover or rediscover its hidden content, but to produce a new interpretation and therefore in a sense a 'new' object. Thus the process of rewriting is structured by the work's unconscious meanings, those ideological anomalies and discrepancies which mark the contradictory construction of its identity. In accord with Althusser's own anti-epistemological reading of Marx's 'Introduction to the Critique of Political Economy',[35] Hadjinicolaou distinguishes between the critical knowledge that artworks might give us and a critical understanding of the knowledge that went into the production of the work. For the historical materialist the two are not synonymous. Too often, Hadjinicolaou argues, Marxist art history does not take account of this distinction, analysing and adjudicating in favour of the former. This is the 'epistemological illusion' of vulgar Marxism, in short those forms of idealism espoused by Klingender and others, in which the critique of bourgeois art history gets rewritten through the construction of a counter-tradition of works of overt political character. 'Art history becomes the history of visual images with political subjects considered "Progressive".'[36] Without complication, this has been a Realist tradition: Hogarth, Daumier, Millet, Delacroix, Géricault, Courbet. The failure of vulgar Marxist art history to distinguish between the political and ideological is the result, therefore, of a weak sense of the mediated nature of a work's content. Thus the critical ideological effects of works cannot out of necessity be reduced to overt messages or to a compendium of 'radical styles'.

Although these points are now commonplaces under the widespread account of art history as a politics of *representation*, Hadjinicolaou's framework is none the less highly problematic. The suppression of intentionality

produces an artist-less history in the manner of Althusser's history without a subject. Although Hadjinicolaou addresses this problem by referring to artworks' 'own unique features'[37] in relation to their 'visual ideology', there is little sense of how and why the work takes the form that it does. Artists simply inherit and appropriate ideological materials as the bearers of class ideologies. The complexities of identity (gender being the most obvious and glaring omission in *Art History and Class Struggle*) are mere kinds of subjectivist residue, incidental to the objective ideological interpellation of the subject. This functionalism is also reflected in Hadjinicolaou's one-dimensional account of spectatorship, in which a symmetry between aesthetic pleasure and ideology is defended which would do justice to the most correspondence-obsessed vulgar Marxist. 'I deny the existence of an aesthetic effect which can be dissociated from the visual ideology of a work'.[38] 'The "values" of a work are nothing but its visual ideology.'[39] These infamous quotations, which set the tone of Hadjinicolaou's reception in Britain and the USA in the late seventies and early eighties, in many respects indicate how Janus-faced Althusser's influence was on art history. The overheated attack on Art History may have disclosed how complicit the older Marxist art history was with bourgeois art history in its lack of ideological specificity, but if art history was to be no more than ideology-critique, then was it, as Charles Harrison put it in the mid-eighties, to be no more than a branch of social anthropology?[40]

The effect of Althusserianism on cultural theory and art history was largely to *secularize* ideology, that is, actually to embody it in practices and institutions. Ideology was seen less as a coercive system of pre-given doctrines than as a set of images and symbols which are lived out both consciously and unconsciously. This had a profound effect on art historical work, whether Althusser's theory of ideology was defended in its specificities or not. The society/artwork dualism that Hauser was still locked into was opened out to a relational model of signifying practices and codes. The artwork was no longer a template of social forces, the artist in these terms 'mediating' the world, but discursively engaged in, and on, antecedent representations of social reality. As a result a more complex sense of contestation and negotiation entered the debate on art and ideology. Of course, Hauser in part acknowledges this in his anti-Romanticist commitment to 'modes of representation', and his stratified understanding of cultural production, but it will take the specific development and application of concepts such as 'social formation', 'ideological state apparatus' and 'signifying practice' to turn intuition into a practical model.

This was very much the theoretical terrain that T.J. Clark entered into in 1973 with the publication of his *Image of the People* and *The Absolute Bourgeois*.[41] Like Hadjinicolaou, Clark talks about a deep crisis in the discipline of art history, calling on the new sciences of structuralism and semiotics to question

the artist-centred account of art history. Both authors bring art history's recovery of meaning in line with the analysis of the ideological production and reception of the work: the insertion of works into a textual account of how meanings are made, consumed and reproduced. Unlike Hadjinicolaou, however, Clark's new social history refuses to endorse the anti-aesthetic bellicosity of early Althusserianism. What was at stake for radical art history was not the destruction of Art, as that which was irredeemably complicit with bourgeois culture, but a *political* reading of art history. His work on Courbet in *Image of the People* is expressly an attempt to reconstitute the Western tradition in the name of a politicized defence of value; and as such owes a debt to the older Marxist art history. Courbet's art is rewritten into a complex political formation, in which his ideological commitments become *inseparable* from the attributes of value and his 'greatness'. Adjusting the canon, getting it into decent ideological shape so that artworks might 'speak back' from the past in all their ideological specificity, is the pressing political priority for Clark. This is certainly a secularized art history, in which the particularities of how ideology is 'lived out' through art are dealt with in class-specific ways, but it is not a history without individual artistic agency. That Courbet stood for certain things, that he intended certain things rather than others, is important to the historical record, to recognizing the fact that the artwork is caused and *believed*. For Hadjinicolaou this would seem like mere mystique: 'Art history never asks why an artist painted in one way rather than another, why a particular person became a person, and so on'.[42]

In 1985, Clark discusses his methodology in some detail in his introduction to *The Painting of Modern Life*.[43] His target, as before, are those forms of bourgeois and vulgar Marxist history that do not pay sufficient attention to the 'hierarchy of representations'[44] in a given social formation. However, this is no longer a provisional research programme that needs to be teased into view, but a coherent model with a viable history that needs to be defended openly and suasively. To see society as a 'battlefield of representations',[45] Clark says emphatically, is not to weaken the historical materialist account of art. Innocuous words in one way, but the expression of fulfilled promise in another. Here was Hauser's and Raphael's anti-historicism and the new cultural politics writ large in a work of undoubted sophistication; post-'68 Anglophone Marxist art history had come of age.[46]

For Clark the critique of the vulgar Marxist 'bloc' analysis of the ideological content of works is resolved in the Adornoesque direction of the 'formal' as the 'social'; 'foreground' and 'background' meet under the causal examination of the production of pictures. As such Clark spends some time in the introduction to *The Painting of Modern Life* discussing the modernist concept of 'flatness' in late-nineteenth-century Paris as an index of egalitarian social values. 'Flatness was imagined to be some kind of analogue of the "Popular".... It was therefore made as plain, workmanlike, and

emphatic as the painter could manage.'[47] In effect the 'flatness' of the picture was 'construed as a barrier put up against the viewer's normal wish to enter a picture and dream'.[48] To treat 'background' as social 'foreground' in this case is, for Clark, to render the *why* of a work of art through an analysis of the *how* of its making. Content, therefore, is inscribed in how aesthetic decisions as ideological decisions are *put to work*. This involves, on the one hand, the detailed reconstruction of the conditions of reception of the work under view – a Hauserian sociology of publics, which Clark's followers are now widely noted for[49] – and, on the other, a strong emphasis on the artist as the manipulator, rather than simply the bearer, of 'signifying practices'. The result is that with Clark's writing a far more pronounced sense of the uncertainty involved in the making of the meanings of art enters Marxist art history, bringing an older critical semiotics into alignment with a Paul de Manian 'ethics of reading'. Conventional and vulgar Marxist history invariably smooths out aesthetic anomalies and discrepancies in a historicist account of the artist's rationally unfolding concerns. The artist is always 'in control'; or what appears to be untoward is easily fitted retroactively into a theory of 'happy accidents'. *Incompetence* never makes the critical agenda. This is something that Art & Language were concerned to rectify in their writings on the causal theory of representation in the early eighties.[50] Art historians are far too fond, they declared, in imputing rational and coherent reasons for the aesthetic moves and strategies of artists. As a consequence art history, in the mirror-image of Hegel's universal history, becomes a succession of necessary evolutions.

To bring uncertainty into view, to acknowledge the aleatory and ad hoc, is to formulate a clearer sense of how the production of meaning for the artist is also a post hoc affair. Clark discusses what he sees as the fudging and confusion going on in Pissarro's *Coin de village, effet d'hiver* (1877). Pissarro, he argues, 'would have had no very well-informed notion of what the paint could stand for and how effectively. While it was being made the likeness was barely one at all and at best the justice of it was provisional.'[51] To say that the artist is not in total control, is naturally not to say he or she is out of control. The relationship between intention and belief then becomes crucial in the examination of the artistic claims of artists. To hold that artists are not responsible for their works is as specious as saying they are wholly responsible for them.

Clark's emphasis on agency and intention, his concern with the conditions of art's reception, and as such his explicit recognition of art's complex ideological negotiation with the culture, upped the stakes considerably for a historical materialist art history. Yet, whatever advance this represented over conventional art history and the last vestiges of vulgar Marxist art history, Clark's project as a whole was largely scandalized from birth by the impact of the women's movement and the new cultural criticism – aspects of

which eventually mutated into the New Art History and its post-Althusserian critique of high culture. Thus Clark's historical materialism was accused of remaining within a traditional problematic – the Western fine art tradition – reproducing forms of ideological subordination around art and its relations of production that were characteristic of both conventional art history and the older Marxist art history. In short, the new concern with the ideological positioning of art did nothing to weaken the essential masculinist logic of the history under review: the fact the bourgeois tradition and the radical counter-tradition were almost interchangeable through their subordination of women.

Marxist art history had been under attack by feminism from at least the early seventies; and the *Painting of Modern Life* in certain respects incorporates this critique, but even so there is a sense that the 'new complexity' on offer is the old Great Tradition social history in refurbished garb. In an ironic twist, Clark's new history is discharged for its crudity and abstraction. As Adrian Rifkin says, in a swingeingly critical review of the *Painting of Modern Life*:

> the material conditions of artistic production and distribution, and of the consequent formation of movement and style, nowhere inform the analysis of historically possible meaning. Rather, C's tactic in differentiating his text from traditional art history, is to shift the focus of attention from meaning to reading.[52]

The result is a collection of 'imprecise generalizations',[53] in which sensitivity to struggles over representation and the conditions of art's reception is gained at the expense of a 'precise material base'.[54] Rifkin's attack is unrelenting. Clark's 'method proceeds by repeated synecdoche'[55] (Adorno's oft-voiced criticism of Benjamin's Paris project); he produces an 'eclectic and pragmatic use of evidence',[56] he creates an 'aestheticizing vision',[57] he 'collapses the marxist idea of class struggle as a "motor force" of history into class as the context of historical situations and signs'[58] ('vulgar marxism'[59]); and in his discussion of Manet's *Olympia* 'does not consider what it was that the middle- or upper-class *women* would see at the Salon'.[60] In short, Clark is condemned to 'speculative generality'.[61]

Four years before this hit list was drawn up, Art & Language also criticized Clark for his insufficient materialism. Echoing Rifkin, if not his misplaced vituperation, Art & Language accuse Clark of placing too much emphasis upon the interpretation of *Olympia* in the late 1860s and 1870s.[62] Clark's interpretation of the picture as 'failing to signify' in some sense at the time (and thereby offering a critical judgement on its manipulation of its ideological materials of race, gender and class) produces what they see as a moral anxiety about how things are consumed, and not an analysis about how they were produced. The result, they declare, is a kind of 'wishing otherwise' in the reclamation of meaning. What Clark seems to long for is

'first order objects which [he] can enjoy without any sense of compromise with [his] political commitments'.[63] 'What's wrong with *Olympia*'s failing to signify?',[64] they argue.

If this seems a bit rich given Clark's insistence on the asymmetrical relations between art and its wider history, nevertheless it points to one of the recurrent problems of writing art history freighted with counter-hegemonic expectations. Without adequate work on the conditions of production, the meanings of artworks become hermeneutically unhooked from their actual conditions of *possibility*. Post-structuralism, of course, has turned this into something of a virtue. Thus there is a sense in both Rifkin's and Art & Language's criticisms that the claims for a 'new complexity' in Clarkian textualist art history are paper thin when interpretation rides roughshod over what could and could not be spoken of at a particular time; when, that is, *readings* of art come to make the picture of society that produced the art.

Clark's critics have also been unforgiving about his treatment of gender. Although a large part of *The Painting of Modern Life* is taken up with the representation of femininity and female sexuality, Clark does not, as Griselda Pollock says, 'pause in his discussion of *Olympia* to ask why modernism is installed upon the territory of a commodified female body'.[65] Clark's claim to be producing a history sensitive to society as a 'battlefield of representations' stands in sharp contrast to the masculinist assumptions of his critique of art historical orthodoxy. Women may be positioned as objects of critical analysis in his history, and gender and class may be brought under some kind of sociological scrutiny, but the wider context of the social definitions of masculinity and femininity as they affect the production of art and the ideological reproduction of bourgeois culture are left relatively unexamined. This not only reinforces the boundaries of the traditional canon, but diminishes the ideological complexity of the social formation under analysis. Thus, for Pollock, Clark's argument that Manet's break with prevailing representational codes of the female nude in *Olympia* establishes a greater 'realism' in French history painting misses the altogether more fundamental issue that it was women's bodies which were the territory across which male artists established their modernity. As Pollock points out in *Avant-Garde Gambits, 1888–1893*,[66] in which she looks at Gauguin's racial appropriation of *Olympia* in *Mano Tupapau* (1892), Olympia is *a naked woman in bed*; moreover, she is a naked woman in bed being attended to by another working-class woman, a black woman recently displaced from her African home. The 'first' candid representation of the contradictions of modernity then comes fully inscribed with the signs of sexual difference: women's sexual visibility and 'social invisibility'.

Clark's argument that Olympia is *naked* rather than nude (a view which he inherits from John Berger) is therefore highly problematic as a means of distinguishing the image's greater 'realism'. By using the concept as a form of

positive distinction from all those other images of unclothed women in bed in the Western tradition, the representation of the female as a continuous site of social control in capitalist culture is weakened. Representation of the female body is not one subject amongst many, but the very ground upon which the subordinations of sexual difference are played out. As Lynda Nead says in *The Female Nude: Art, Obscenity and Sexuality*,[67] the female nude is at both the centre (pornography) and margins (art) of the culture.

> Art and pornography cannot be seen as isolated regimes of representation, but should be recognized as elements within a cultural continuum that distinguishes good and bad representations of the female body, allowable and forbidden forms of cultural consumption and that defines what can or cannot be seen.[68]

Clark, Pollock argues, doesn't take account of the magnitude of this cultural continuum.

Since the early eighties, with the publication with Roszika Parker of *Old Mistresses: Women, Art and Ideology*,[69] Pollock has effectively had three targets: traditional art history, vulgar Marxist art history of the old school and the new Marxist art history. All three, she argues, are gender-blind in their respective ways, even if Clark's social history can be seen as being produced in alliance with feminism. Thus, for Pollock, the idea of rewriting art history has only limited value. Writing women back into history is necessary, but it does not expose the 'mechanisms of male power'[70] that continue to produce and reproduce the hierarchies of sexual difference. Yet at all times she has defined her project as a historical materialist one. In *Vision and Difference* she outlines her position. Feminist historical materialism does not substitute gender *for* class, but searches out the complex interdependence of gender, class and race.

> What we have to deal with is the interplay of multiple histories – of the codes of art, of ideologies of the artworld, the institutions of art, of forms of production, of social classes, of the family, or forms of sexual domination whose mutual determinations and independence have to be mapped together in precise and heterogeneous configurations.[71]

This all sounds perfectly reasonable, a kind of dialectical upgrading of Clark's new social history. But is it historical materialism? If historical materialism is not a mono-causal system of historical explanation, neither is it an 'open' one in which all social relations are reciprocally related. On the contrary, historical materialism is committed to finding causal *asymmetries* between causally reciprocal things.[72] This is why it places such an emphasis upon class relations and class exploitation. Not because the working class is the most oppressed social group, but because its structural relationship to the means of production expresses the fundamental asymmetrical relations of power locked into the capitalist system. Pollock's 'open dialectics', with its

reciprocal relations between class, gender and race, fails to register this, flattening out the asymmetric causal relations between base and super-structure. Now this is not to say that class relations explain all social relations (the common complaint against Marxism), but that, by ascribing causal priority to class we are in a better position to understand why gender relations and race relations take the form that they do under capitalism. It is difficult, however, to imagine it the other way round, that is, racism and women's oppression explaining the realities of class.[73] Thus Pollock is absolutely right in criticizing Clark's 'classist' treatment of gender in his analysis of *Olympia*, but on far more shaky ground when this leads to the inflation of gender difference as the fundamental historical division. Modernism may have been made on the naked backs of women, but these were the backs largely of working-class women.

Pollock's simultaneous attack on Marxism and defence of historical materialism is the result in many respects of her Althusserian formation as a writer. Althusser's attack on historicism and economism may have made a new cultural politics possible, but it also induced a fear of ascribing primacy to certain things, as evidence of reductionism.

As has been mapped out in this Introduction, the critique of reductionism is the very motor of art history's intertwined relationship with historical materialism this century. By the late seventies, however, with the advent of the New Art History, this critique had transmuted into something quite different from the procedures of historical materialism. To assign a Marxist-type priority within the interdependence of things was held to be reductive in and of itself. Period. This, naturally, has always been part of the anti-Marxist tradition. But now it was being argued from within the Marxist tradition, and its fringes. From a position where Marxism was acknowledged as being able to explain a few things reasonably well, it was now characterized as not being able to explain *everything*, as if Marxism was some insatiable knowledge-machine that had lost control. Thus when the followers of Paul Hirst and Barry Hindness were not criticizing Althusser for not being 'overdetermined' enough, or the followers of Foucault dismissing Marxism as a 'nineteenth-century problematic', sections of the left were denouncing Marxism's claims to systematicity for its authoritarianism.

With the rise of the women's movement – as much an influence on Hirst and Hindness as Hirst and Hindness were on its socialist wing – this kind of thinking had a profound effect on art history as it was going through its Clarkian revolution – or crisis of confidence. Marxism seemed more and more to be 'in the way', a nuisance that could only be got rid of by dumping systematic notions of complexity in favour of plural ones. Thus, it was argued, the representation of gender, race, ethnicity and sexuality had their own logics of identity and interrelation and therefore could only be diminished by historical materialism's talk of explanatory priorities.

This new pluralism, of course, is not an isolated phenomenon but represents a considerable change in political emphasis in radical Western culture in the eighties, and needs little introduction. The remnants of post-Althusserianism have dovetailed with an intellectually dominant post-structuralism and supportive Derridean deconstructionism to create, as I write, a widely anti-Marxist climate in the humanities, not seen since the fifties, though Derrida's own debt to Althusser and his insistence on his work as a *dialogue* with Marxism complicates matters.[74] In most hands, however, these forms of epistemological scepticism have extracted an almost adaman-tine provisionalism from writing history. As *subjected* subject, the writer of histories is never more than the writer of fables. Although Clark was warning about this perspectival approach in the early seventies,[75] it has come to have a profound influence on the newer art history, as the Althusserian critique of the idea of a unitary history has emerged through post-structuralism into the methodologies of micro-history. The result of this is a downgrading of dialectical knowledge as such, to the point in fact where it is seen as actually antithetical to the business of doing art history. Consequently, complexity is now understood in terms of interrelations of difference, rather than in terms of relations of hierarchy *and* difference. The rise of theories of difference in recent art history, therefore, can be seen as part of that wider derogation of 'totalizing' forms of knowledge that now dominate the horizon of Western culture. However, what largely goes unremarked by the left is how this derogation has always marked the parameters of bourgeois thought, which is quite happy singing paeans to difference. What all this installs, in fact, is a quite extraordinary collapse of 'common sense' on matters of explanation and determination. As Norman Geras says, the idea that there can't be a 'middle way' between an all-explanatory concept of the economy or class and a pluralism of elements or factors because economic or class determi-nation in 'the last instance' is no less reductive is just 'inane'[76] when exposed to explanatory reason. In effect what it does is forbid 'the possibility that one thing might just be more important than others'.[77]

If Griselda Pollock commits herself to a weak dialectics, this is not to say that she hoists her political colours to *anti*-Marxism or to the worst aspects of the new postmodernist pluralism. However, her work does represent a misreading of historical materialism if she believes it can get by without causal asymmetries and explanatory hierarchies. This tendentiousness is reflected particularly in her Hadjinicolaou-like subsumption of value under ideology. There is a strong element of functionalism in her counter-hegemonic rewriting of the canon; things get slotted in for their 'good endeavours'. In one sense, this can be seen to have its origins in the culturalism of early Althusserianism, the idea that art is a continuation *of* ideological struggle. But in another sense, it can be seen as a tactical political response to the predominant association of value within the canon with art

produced by men; moreover, with certain *kinds* of art by men: painting and sculpture. Therefore, the attack on the canon by Pollock and the New Art History is as much an attack on high culture as it is on male hierarchies. How is it possible to speak of universal aesthetic values when the Western traditions of painting and sculpture, through which such values were held to be inscribed in their highest form, excluded the actual, or equal, participation of women? Such forms have to be de-hierarchized in writing, and critiqued in practice.

Hence for Pollock and the New Art History what has been of equal stake in their criticism of traditional art history and of Clark is a contest over the object of knowledge. As in conceptualism's earlier critique of the canon, Pollock and the New Art History have sought to expand art history's objects of knowledge into the area of mechanized and electronic media, providing not histories of reconstruction (or an appropriation of photographic history) but histories of possibility. This has been the most fruitful area of criticism of Clark's 'traditionalism', linking up the new history, ironically, with one of the dominant themes of the old Marxist history: the breakdown between the publics of mass culture and the publics of high culture.[78] On this score, women's participation in art, Pollock argues, is worthless if it doesn't unsettle prevailing relations of cultural production. Sophisticated counter-hegemonic readings of traditional forms may be important, but, none the less, as sources of cultural capital they remain bound to their restrictive male high cultural origins. Consequently, painting can only be appropriated by women at the cost of their autonomy.[79]

The widespread use of photography since the mid-seventies by women artists, therefore, is not simply an attack on official categories of taste, or a desire for a 'popular' audience, but a means of exercising a greater control over meaning and self-image. Photography's characteristics of portability, reproducibility and indexicality allowed an early generation of feminist artists to critique in ideologically specific forms what was done to women's bodies in the name of the dominant culture, and to find new and active publics for art outside of the dominant modernist institutions. As a result, with the extensive production of photographic-based practices, new interdisciplinary forms of study have been able, as Adrian Rifkin has put it, 'to move out into a radical dismantling of social relations without having to bring these discoveries back as nothing more than meanings for the hallowed series'.[80]

From the mid-seventies to the mid-eighties, Britain experienced a large expansion of counter-public forms into public life, mainly through feminist cultural work. But is this the case today? For Pollock and the New Art History, the dismantling of art history as a history of domination has not stretched, at least recently, to questions of class. Although the implications of Rifkin's words are class-based and although early feminist art culture linked

itself to a class analysis of the relations of cultural production, the story currently is quite different. As the new objects of New Art Historical study have become incorporated into general feminist and anti-Eurocentric histories of art, and as the women's movement becomes more and more confined to academic life, the publics for counter-hegemonic practice have shrunk back into the art world. This is not to moralize or to collapse the discussion into a resistance/recuperation model, or even to deny that on the whole the art world was where those publics have always been, but to recognize the price paid in art historical studies when cultural analysis escapes the wider analysis of the balance of class forces.

Intention, Meaning, Value

The essays in this book owe their focus of identification or dissension to the history above. In the case of some of the writers, this is the result of an active participation in these debates as they have unfolded; in the case of others, it has meant, either through age or inclination, a more retrospective appraisal. Nevertheless, all the writers inherit a sense of abiding crisis about the discipline of art history. However, this isn't merely the old complaint that the masterpieces are still in place, but that the new art histories have in themselves created new kinds of problems and confusions as well as new possibilities. The problems could be said to rest within three main areas: the increasing subsumption of art under cultural studies; the conferring of value through counter-hegemonic content; and the failure to deal adequately with the representation of artistic intentions.

In classic terms all three complaints centre on the insufficiently differentiated character of the histories under discussion. As Inter Alia say in their essay on Francis Picabia, a critique of his postmodernist interlocutors, art history's endemic prioritization of historical coherence over the 'contradictions of practical actions' denies how 'quarrelsome, contested and fractured' the making of meaning in art actually is (see pp. 39 and 41 below). Crude periodizations and ideological congealment are the constant enemy. For historical materialists, this of necessity means that the relations between artistic intention and social agency, between meaning and the failure to control meaning, need to be brought under close scrutiny, that is, brought under the demands of a realist version of the causal theory of representation. Art must be seen to be caused within some open system of causal relations, allowing dialectical inquiry to secure conditions of emancipation from the hermeneutic circles of interpretation of artists and critics alike. The invocation of difference theory as dialectics – in this instance the recourse to *artistic* reasons as explanations – simply closes off the hermeneutic circle to further inquiry. In terms of Marx's realist understanding of dialectics, this

can be summed up as follows: the examination of causal relations necessarily remains prior in the production of meaning, insofar as locating the contradictions in thought and the crises of socio-economic life which generate such relations goes towards explaining the character of the forms of intention and agency under discussion.[81]

In essence, knowing an agent's intentions does not necessarily explain the reasons behind such intentions. If this is a standard proposition in Marxist and non-Marxist philosophy, and psychoanalysis, it does not seem to have breached the intellectual boundaries of much art history. Artists' intentions are forever being described as causes. In this collection, however, the gap between intentions and reasons is very much in the foreground of analysis. Terry Atkinson, Inter Alia, Gen Doy, Michael Corris and Catherine Lupton all offer sceptical accounts of the artists' claims for their work. Moreover, they also offer powerful critiques of those interpreters who disregard the intentions of authors. If intentions are inscrutable, this does not mean that they cannot be placed in a plausible explanatory setting.

One of the leading non-Marxist philosophers to explore the gap between intentions and reasons has been Donald Davidson, particularly in his *Essays on Actions and Events*.[82] For Davidson, there is a weak sense in which every rationalization of an agent about his or her actions justifies what he or she does, but a person 'can have a reason for an action, and perform the action, and yet this reason not be the reason he did it'.[83] Desire and belief rationalize action therefore, yet the presence of such beliefs and desires is not sufficient to ensure that what is done is done with appropriate intention. Thus we may perform many intentional actions without forming an intention to perform them. 'It is a mistake to suppose that if an agent is doing something intentionally, he must know that he is doing it'.[84] John Searle gives a good example of the disjunction between intention and consciousness. I may want to kill my uncle. By sheer chance I run him over and kill him. However, although my intention has been satisfied I have not killed him *intentionally*.[85] Searle characterizes this distinction in terms of *prior intention* and *intention in action*. 'All intentional actions have intentions in action but not all intentional actions have prior intentions.'[86] Consequently, many intentions are not formed, if forming an intention presupposes conscious deliberation. Thus in many cases knowing the intention by which an agent acted does not allow us to reconstruct his or her actual reasoning, for the reasons that enter the account of an agent's actions do not necessarily constitute all the reasons for that agent's actions. This makes the representation of the intention of artists extremely opaque, if, as Davidson says, 'attributions of intention are typically excuses and justifications'.[87]

Knowing an artist's intentions therefore seems insufficient evidence for substantiating the social determinations of art. We cannot explain the causality of work by accepting that a certain action appealed to the artist.

Davidson resolves this problem in an intentionalist direction, hence his famous concept of a 'principle of charity'. If an infinite scepticism over intentions is to be avoided we must put ourselves in a provisional position of trust. Because an agent's beliefs and desires provide him or her with the 'premisses'[88] of a rational argument, if communication is to take place these premisses must be judged to be intelligible in some sense. This seems quite acceptable, and an obvious way of avoiding the disqualification of agents' explanatory reasons simply because they are false or highly dubious. But if this allows us to start a conversation, or begin to examine a set of intentions, it doesn't get us very far thereafter.

We may be able to recognize that someone's racism motivates his or her behaviour, but this does not mean that we thereby accept the reasons for such behaviour. Davidson's intentionalist theory, therefore, is incapable of addressing the genesis of intention, insofar as he abstracts intentions and their effects from a causal account of beliefs and desires, and therefore the possible critical *redescription* of intentions in the light of countervailing evidence. Davidson clearly fails to ask: what are the relations between material conditions, actions and the agent's intentions? Thus an account of intention that does not question how an agent *gets to believe* what he or she believes is obviously not an adequate causal account of intention at all. In the *Possibility of Naturalism*, Roy Bhaskar likewise criticizes those theories of intentionality that proceed solely from agents' meanings.[89] As with Davidson and Searle, Bhaskar argues that agents' reasons do not fully explain their actions. However, unlike in Davidson and Searle, mind is radically decentred from individual consciousness. 'There are things that agents do because they want to and things that they do because such action is expected of them.'[90] 'It is contingent whether one knows what one intends and whether what one intends is within one's power.'[91] The job of historical materialism, therefore, is to investigate how the gap between intentions and reasons is implicated in non-cognitive agencies of power, how agents' claims about their actions are actually connected to the world.

But how far does this get us in relation to the production of art? Does a critically causal analysis of the authorial claims of an artist enable us to discredit the work? That is, does knowing, for example, that a renowned political artist produced a series of paintings on the civil war in Bosnia in order to pay for a new Mercedes weaken or remainder their aesthetic value as pictures? Clearly not. What are the boundary conditions, then, between the critical demands of causal explanation and attributions of value? Are there any? This is one of the major areas with which the anthology is concerned.

For Inter Alia, this means opening out those accounts of the modern that would take a modernist such as Picabia to be, in conventional terms, 'playfully irreverent'. To argue that Picabia produced his forties 'monster' pictures (or 'monsters') because he wanted to break some rules about

modernist painting would, as they say, make 'his integrity to be an effect of incessant irreverence' (see p. 53). In short, to say that he produced the paintings in order to be 'naughty' explains little about why he produced the paintings in the specific ways he did. One of the problems with the kind of art history that suppresses this sort of inquiry, therefore, is the way it divorces intentions from technical decisions, and as such from the way intentions are *made out* of technical decisions. Intentions are not preformed entities that get illustrated at the point of artistic production (though, of course, beliefs and ideological commitments ontologically inform what might or might not be reasonably picked out), but generated out of the tension between given competences and the incompetence of certain moves tried out in the face of the resistance of given cognitive and aesthetic materials. Thus a history of modernism as a history of the successive 'ruination' of artistic antedecents does not explain why in particular such 'ruination' took the forms that it did. This is merely Wölfflin's 'art history without names' in updated guise. As such, Inter Alia argue that the 'structure of the work is not ancillary' to the intention to 'ruin' (see p. 53).

All this turns on the view, in fact, that the Cubist painter, for example, was not trying to ruin anything so simple as Cézanne's legacy, but trying to paint to the best of his or her ability within and against the conventions and codes of Cubist painting. Consequently, any adequate account of Picabia's work needs to address his appropriation of the avant-garde dialectic of identification and difference in terms of how the cognitive and aesthetic materials are organized, and not just in terms of his would-be Nietzschean dishonour of 'all received values'. For Inter Alia, this is a profoundly ideological matter. Thus Picabia's 'monsters', despite being pitched in against the dominant Surrealist cultural politics of the time, are not thereby ' "reactionary" as a result' (p. 54). In their conspicuous disregard for taste they set up an interestingly grievous hiatus in avant-garde politics of the period.

> The 'monsters' stake their integrity on the understanding that modernism had not only become acceptable to the social reality, but that modernism itself had been found to harbour hegemonic tastes. Picabia had not just broken with the institutions and tastes of authority, he had added the tastes of independent culture to his targets and taboos. (p. 54)

As modernism replaced academicism as Western capitalist culture's official art, Picabia turned to the production of 'philistine' paintings as a means of retaining his integrity.

For Inter Alia, therefore, Picabia offers an excellent example of the ways intentions can act in contrary ways to their self-imputed contents. Despite Picabia's political conservatism and his aristocratic background, he stays awake to the contradictions of modernist practice. The idea that artists with conservative politics or artists indifferent to 'theorizing' can still produce

affecting works has been a central problematic of the Marxist tradition on art, since Marx and Engels alighted on Balzac's novels. It is also a concern that is threaded through a number of these essays. Artists are in 'spite of themselves' able to produce works of a critical vivid nature, because ideology itself cannot hold at bay the objective material determinations that influence the intentions of practitioners, no matter what they actually think they are doing. Gen Doy deals with this in her essay on Cindy Sherman. Sherman has said emphatically that she is not interested in theory, nor has she been in any way directly affected by it. However, she has produced a range of works which deal with important questions around women's identity and sexuality. Doy takes this on as a way of addressing significant questions to do with ideology and consciousness. Sherman's work, she claims, may not be generated out of any sophisticated familiarity on her part with feminist notions of the male gaze, yet nevertheless it is causally connected to the specific historical and cultural realities of being a woman.

> Unless we take a materialist view of Sherman's development and argue that it is likely to be her own experiences in a 'real' material world which prompted her to question and eventually try to destroy dominant notions of fashion and beauty, I really don't see how Sherman as an individual was ever likely to escape from the subject positions she was already 'written' into. (p. 269)

(According, that is, to post-structuralists.) However, Doy is out not to defend an intuitist approach to artistic intention (on the contrary, she is rejecting Sherman's reasons *as* justifications), but to ask a simple question: 'Does theoretical awareness and understanding necessarily produce "good" art?' (p. 258).

This is also a concern of Catherine Lupton in her essay on Mary Kelly. Kelly's work has achieved a high-profile status in the art world through its theoretical commitments. These commitments, in fact, are seen successfully to represent and articulate moments within feminism which are particularly significant. Yet at the same, Lupton argues, the status of the work represses certain realities. 'The most signal absence from the discourse [around her work] is an acknowledgement of the negative consequences of the faltering and disruption of the political women's movement since the early eighties' (p. 237). Lupton outlines that it is not so much that these realities are disavowed by Kelly, as that Kelly's theoretical model – a post-Althusserian view of art as discursive political practice – is now 'perceived by sections of the feminist art community as part of the problem' (p. 239). In effect, Lupton criticizes the theoreticism and culturalism of Kelly's project. 'Theories of the production of sexed subjectivities through language and representation' (p. 239) are presented as if they were appropriate to the needs of all women. Theoretical feminism, therefore, has come to bear the burden of the political absence of the women's movement, producing in the process a

bureaucratically inflected feminist culture. Kelly's work becomes a kind of theoretically precious object of analysis establishing 'a limited hegemony of "correct" feminist art practice' (p. 247). Lupton, however, is attacking not 'theory', but how theory in art can easily achieve explanatory self-sufficiency at the expense of the contraditions of material reality. Feminist art practice is no different in this respect than modernism. Thus what is at stake here is the debate about the academicization of critical practice. How easily discursive 'smoothness and self-sufficiency' (p. 240) can promote critical closure.

This critique of discursive 'smoothness' is the focus of attention in Jessica Evans's essay on Victor Burgin, an artist who, like Mary Kelly, is indebted intellectually to a post-Althusserian/post-structuralist critical model. If there is an implicit class analysis in Lupton's approach, here it is quite explicit. Evans places Burgin's commitment to postmodernism within the sphere of class privilege of those who are in a position culturally to dismantle the ideology of the self-transparent subject. According to Evans, this signals in his work a certain aesthetic disdain for his audience. Despite postmodernism's avowed breakdown between the publics of high and popular culture, the 'fear of assimilation haunts the postmodernists, and here we can see that in order for the postmodernist's work to be seen as a *critical* practice . . . it is necessary for its codes and strategies to be exclusive to a non-integrated art sphere' (p. 215). In effect, for all his celebrated critique of modernism, Burgin's work appeals to the critical space of high culture. Burgin prioritizes the intellectual labour of thinking over the pleasure of the text. Moreover, and deeply ironically, Evans sees Burgin's commitment to a critical intertextuality as having its roots in Kantianism. Polysemy shares 'with Kant's project the notion of aesthetic pleasure as detached, disinterested and rooted in a relationship defined by distance, by the refusal of identification or merger with the object' (p. 219).

Doy, Lupton and Evans all offer radical redescriptions of authors' meanings as the basis for a critique of the recent postmodernization of critical practice. Terry Atkinson, Michael Corris and Jeffrey Steele touch on similar problems, but also deal with interpreters' meanings, and more complexly, the way authors' meanings and interpreters' meanings come to change places and interfuse. Terry Atkinson, in fact, probably deals with one of the most inscrutable of modern artists on this score: Andy Warhol. Warhol's intentional 'blankness' and the willingness of his interpreters to therefore 'fill in' the work with all kinds of meanings has made Warhol something of a paradigm case for the causal theory of representation.

Atkinson criticizes Tom Crow's political reading of Warhol's mid-sixties series of 'Disaster' paintings as anti-capitalist.[92] Crow's position is the 'intuitive' one, that is, the 'political unconscious' one: there are readings that stand outside the claimed intentions of authors. Atkinson, however, doesn't quite see it like that. He criticizes Crow for abstracting one set of works from

the wider set of intentions and patterns of reference in Warhol's career. As he says, it is hard to pull out any section of Warhol's career and use it against the dominant image of Warhol's history as a 'counter-revolutionary' (p. 170). As such, we need to be clear that the 'Disaster' paintings are 'embedded in . . . a general framework of Warhol persona-building' (p. 158). Atkinson, in fact, is suggesting that the Warhol-Catastrophes behind the 'Frontal-Dandy-Warhol' were developed by the artist to 'furnish this frontal figure with a notion of ideological intrigue which Warhol had intuited early and then developed quickly, since he knew it to be an irresistible consumer item to the proliferating cultural legions of late capital' (p. 161).

Is Atkinson saying, then, that texts cannot refer beyond authors' intentions? Obviously not. What he is saying is that there are rules that need to be respected in the making of meanings, and these turn on considerations of plausibility and coherence. The material and psychic continuities of Warhol's career override the possibility that in the 'Disaster' paintings he might be signifying 'otherwise'. However, the question Atkinson does not address in detail is that if Warhol's intentions in the 'Disaster' paintings *were* exposed as radical, would this make them any better as paintings? Why is this series so fascinating – that is, fascinating over and above some of the later work? Isn't the vividness of the work due to the way it stands as the contingent response to a series of objective conjunctural forces that served to pick out Warhol as the best, or most representative, index of those forces? Namely, the increasing demands on avant-garde artists to use photography as an assonant move within painting; the need to recognize the increasing spectacular power of the mass media *in* the artwork; and the developing gap between America's democratic self-confidence and its imperialist role both in South East Asia and elsewhere and at home. The 'Disaster' paintings may not be anti-capitalist, but they can at least be described as causally connected to a sense of anxiety about the real nature of capitalism.

The idea of the artist as 'intriguer', however, allows us a greater psychic complexity in our evaluation of reasons. Michael Corris ploughs this furrow in his treatment of Ad Reinhardt's statements of intention as essentially forms of dissemblance. Accordingly, Corris sees the dominant version of Reinhardt's work as inadequate, insofar as it slides over intricate questions of his political commitments, taking Reinhardt's own words at face value without testing them against the ideological conditions that produced them. As with Inter Alia, Doy, Lupton, Evans and Atkinson, there is a sense that what gets said by the author covers over what is objectively significant about the actions taken. In Reinhardt's case, this rests on the status of his political cartoons within his practice as whole; and the political ramifications this had for his development as an artist. Reinhardt's own statements would seem to confirm their subsidiary status within the modernist interpretation of his work. In short, the later works, the notorious black paintings, are bracketed

out from the vicissitudes of his political life. This has been absolutely convivial for those modernist and radical historians who don't want to be reminded of, on the one hand, the social content of the abstract works (their rejection of social reality in the name of a pre-figurative post-capitalist social reality), and, on the other, Reinhardt's practical Stalinism (his membership of the American Communist Party). The idea that a great artist might be a Stalinist and modernist is still too much to stomach for most shades of art historical opinion. Reinhardt was one of the few leading modernists of the thirties and forties to be politically active as a Stalinist. It is thus not too surprising that he was marginalized by the dominant Trotskyist culture of that period in New York. Corris claims that Reinhardt eventually purified his own past, eradicating the real links between his abstract work and political cartoons in order to forge a niche for his paintings in the market. Reinhardt spent a lot of energy in his later years trying to convince his peers that his abstract art had value only insofar as it was to be considered separate from his other activities. Lucy Lippard takes up this line, arguing that his aesthetics and his politics should not be confused. The fact remains though, as Corris says, that between 1936 and 1945 he published over 350 illustrations for *New Masses* and *Soviet Russia Today*. Moreover, these were illustrations that *followed* the Party line.

As with Inter Alia, Corris is reacting against the ideological sweetening that goes on in various accounts of modernism. Most of Reinhardt's influences stem from a political engagement with mass culture. This cannot be ignored in the evaluation of the abstract paintings. Thus, Corris argues, we need to treat their respective material conditions of production as identical. He points to the negation of touch and gesture in the late paintings as echoing his procedures in the illustrations. Significantly, then, for the causal theory of representation, Corris establishes the connection *between* activities. The historian needs to keep in mind that the work and life represent a *totality of practices*, some of which may be emphasized at the expense of the others by the artist and his or her interpreters for various ideological reasons.

If Arnold Hauser would have approved of this, it also finds sympathetic approval in Jeffrey Steele's essay on Robert Smithson. Smithson has recently been subject to a certain amount of postmodernization, in which his intellectual status as an artist has been travestied, or bracketed out from his work as a sculptor. He was concerned with criticizing and disrupting prevalent social and technical divisions of labour in art, and not with some aimless nomadology as his postmodernist interpreters would have it. For Steele, this institutes an unwarrantable 'taxonomic barrier between aesthetic judgement and productive intellectual labour' (p. 146). Essentially, Steele is out to defend the rational status of the artist as intellectual against all forms of neo-Kantianism. In sharp contrast to the 'political

unconscious' model, he sees artists' intentions as in principle as 'intelligible as those of any other productive agency' (p. 153, n. 13) and therefore open to epistemological scrutiny. If this places Steele along with the other contributors in direct opposition to American modernism, it also demonstrates his sceptical view of that whole tradition of Marxist aesthetics stemming from Marx's 1857 'Introduction'. The notion of there being an essential asymmetry between intention and aesthetic value disinvests the labour of the artist from the operations of reason, reinforcing the authoritarian anti-intellectualism of bourgeois culture. And this is the context, he explains, in which Robert Smithson's work can be best understood. Smithson was completely opposed to the idea of the separation of aesthetic assessment from artists' philosophizing. He virtually identifies *his* philosophizing 'with the main functionality of his art' (p. 146).

The broader picture here for Steele, as with Corris, is how we read the history of modern art since the thirties. For Steele, modernist history, the social history of art and the New Art History all systematically misrepresent scientific rationality – and by extension geometric form – as inherently oppressive. The supposed link between geometry and 'instrumental reason', so central to Western Marxism (Lukács, Adorno) and its conservative heirs (Foucault) continues to underpin both the older art history and the New Art History. For Steele, the occlusion of the European geometric/constructivist tradition after the international rise of American art since the fifties has been a profoundly imperialist experience. With the dominance of expressivist and figurative forms of art since the sixties, 'mathematical' art has received massive 'official approbation' (p. 143).

What Steele's essay compels us to ask is: do artists have any natural rights over the interpretation of their work? Within historical materialism, the answer must be yes, but only up to a point. Within modernism, the answer has been a resounding no. The recognition of intentions may invite us to participate in the artist's creativity, but they cannot ultimately influence our aesthetic experience. Interpretation issues, to quote Inter Alia, form a 'silent community between the sensitive viewer and the radiating artwork' (p. 57). Reclaiming an intentional world behind modernist practice, therefore, has been a principal concern of 'counterfactual' readings of modernist history. This history has been important not only in shifting interpretation away from the artwork as a vehicle of feeling, but in tying down the specific rhetorical moves of artists. For Fred Orton in his essay on Jasper Johns, this means recovering Johns's work from the abstractions of metaphorization. 'Metaphors offer the line of least resistance to those explainers who are unconcerned about the subtleties of figuration, rhetoric and stylistics within the language of art' (p. 117). As such, Orton is concerned with opening out a causal theory of representation to a de Manian 'ethics of reading'.

De Man has become the 'favourite' deconstructionist for historical

materialists – for good reason. Despite widespread misunderstanding, he does not promote the free-floating of the signifier. On the contrary, he always claimed meaning has to prevail upon a sensitivity to intention.[93] Today, however, there is such a 'compulsive distrust and fear of what is called formalism' (as Inter Alia put it, p. 57) that a respect for the uncertainty involved in what is learnt from looking at and evaluating art is immediately identified with a defence of the indeterminacy of meaning as such.

Orton, therefore, is concerned to reclaim Johns from both his modernist and radical critics, the radicals dismissing Johns for the very reasons the modernists were defending him. Looking at Johns's early bronze sculptures, such as *Painted Bronze (Savarin)* (1960), Orton sees an artist not so much producing metaphors of the 'artist's lot' as using various kinds of rhetorical devices to deflate the claims of modernism. Johns's allegorical use of synecdoche and metonymy in the bronzes relies on the very un-modernist notion that artworks have to be *read*. Their 'speaking otherwise' shifts the focus of critical attention away from the spectator as the rhapsodist of feeling to that of knowledgeable interlocutor. Working from within the confines of modernist practice, the bronzes raise ironic doubts about modernism's claims to autonomy and self-sufficiency.

The debate between the autonomy of art and social use value, between the aesthetic and the ideological, still rages within historical materialism. Paul Wood and Sean Cubitt offer classic expressions of competing positions. Like Orton, Wood looks at an artist, Gerhard Richter, whose work is formed *out of* a conflict with modernism. As with Johns, Richter has put modernism's claims to 'expressive power' in quotation marks. However Wood sees 'something important' in Richter's dialectical engagement with modernism that his radical 'deconstructionist' defenders are unable to see, and historical materialism fails to see at its peril: an aesthetic beauty and intractability in Richter's painting that remains unassimilable to other codes. In this sense, he argues, the autonomy of the aesthetic has been widely misunderstood by the left. Autonomy implies not self-reflexiveness and self-sufficiency but 'the mark of art with ambition to be more than cultural symptom' (p. 192). Attacking both traditional *affirmative* modernist art and the sponsors of radical counter-hegemonic intervention, he reasserts the moral function of aesthetic value as an extension of human experience beyond the routine alienations of daily living. Following Adorno, in conditions where the sublation of art into life is an impossibility the critical function of art lies with a recognition of the aesthetic dimension as the source of a wider repression in the culture.

> To paint thus, in the world of corporations, is both to accept with realism that such a world exists and one is of it, and with equal realism to exemplify at the level of imagination that it may be otherwise. The possibility of imagining such difference,

and of having grounds rather than mere desires for doing so, is a pre-condition of its realization. It is this which separates art, conceived as a moral act, from ideology. (p. 199)

For Cubitt, this seems a world away from the rapidly transforming relations of cultural production under late capitalism. Criticizing the resistance/recuperation school of cultural analysis, to which Wood owes a certain intellectual debt, he addresses Laurie Anderson's performance as an instructive example of how a new cultural dialectic is coming into being. The increasing marginalization of artisanal modes of cultural production under the impact of the new electronic technologies provides new forms of identity and experience that refuse to mark out art's relationship to the culture as one of aesthetic loss. Thus, for Cubitt, although it is crucial for historical materialism to see capitalism as an ongoing catastrophe, it is also important to see its gradual abolition of identity and self-hood under technological change as providing 'the emergence of another humanity, less strangled by the boundaries of individuality' (p. 290). This socialization of the faculties through technology is therefore always the aporia that haunts the defence of the 'aesthetic' debate. As Cubitt says, in profound contrast to Wood:

> In these days, the Great Artist is probably no longer possible, and certainly not necessary. It is in the accumulation of cultural acts, involving thousands, even millions, that we can find some germ of hope, some remnant of the concept of the future, to make this living worthwhile (p. 295).

Wood and Cubitt have brought us back to the traditional terrain of historical materialism and to the scandal that is at the very heart of Marxist art history, the New Art History and all other forms of counter-hegemonic history: why is it that certain artworks *are* so good, and remain so? A causal theory of representation may probe the ideological complexities of art in the interests of tightening up attributions of value, but is art, as Wood says, only ideology?

The sense of the aesthetic as a continuing problem for historical materialism has become the focus of attention for a number of recent writers on art and culture. Charles Harrison, in his work on modernism, has talked about the need for historical materialism to recognize the *corrective* value of a Kantian defence of the disinterestedness of aesthetic judgement.[94] T.J. Clark, usually castigated for his sociologism, has talked about historical materialism's need to accommodate an aesthetic dimension. Some of the most substantive writing recently on this question, however, has come from outside of the professional orbit of art history and criticism.

Working within the wider field of cultural theory, Terry Eagleton's *The Ideology of the Aesthetic*[95] and Michael Sprinker's *Imaginary Relations: Aesthetic and Ideology in the Theory of Historical Materialism*[96] both return a discussion of

aesthetics to the centre of historical materialism. Thus Sprinker argues: 'the genealogy of Marx's own thought suggests that Kant, Schiller, and Baumgaurten were as integrally important to the emergence of historical materialism as Hegel or Ricardo'.[97] Eagleton offers a similar kind of picture in which Marx's vision of a future communism is commensurate with the final aestheticization of human existence: 'Marx wishes to aestheticize morality, shifting it from a set of supra-historical norms to a question of the pleasurable realization of historical powers as an end in itself.'[98]

The construction of the notion of the aesthetic, then, is inseparable from its political function. For the eighteenth-century European bourgeoisie, the aesthetic is that which escapes or resists worldly reason, inviting the spectator to participate in an unmediated, spontaneous relationship to the world. In the crisis period of Absolutism, Kant will codify this as the imaginary resolution of truth and freedom and thought and feeling.[99] Invented, therefore, largely as a reaction to the degraded world of reason and politics, the aesthetic is an 'eminently contradictory phenomenon'.[100] On the one hand, it speaks of an illusory freedom from ideology and history, and, on the other, it negotiates areas of experience that cannot be readily collapsed into ideology. This basic contradiction is Sprinker's terrain of inquiry. Although the ideology of the aesthetic has had profoundly conservative effects, this does nothing to diminish the 'assertion that the modality of aesthetic cognition transcends particular historical determinations'.[101] The aesthetic faculty is a species-specific capacity that all humans possess. Thus classical Marxism, he contends, shares with bourgeois aesthetics the view that in art one attains freedom from ideological contingency and constraint. This has become a radicalized force in recent art history, as Harrison's and Wood's writing attests. As Wood says in this volume: 'fear of the aesthetic ... is ultimately nothing more than a tacit admission of fear of the tests of one's own experience' (see p. 193).

If Sprinker veers, via Althusser, towards a 'dual model' of the aesthetic, that is, something that is simultaneously ideological and non-ideological, Eagleton opens up discussion of the aesthetic to its more general definition as the sensuality of everyday life. Consequently, Eagleton's book is concerned not with reclaiming the aesthetic for Marxism in specific, technical ways, but with establishing the corporeal links between the pursuit of aesthetic experience (bodily pleasure) and the struggle for socialism. There are certain affinities here with Paul de Man's critique of 'aesthetic ideology'. Both writers reject the notion of the aesthetic as a specialized *artistic* activity. What is missing from *The Ideology of the Aesthetic*, however, in contrast to de Man, is an analysis of the particularities of aesthetic pleasure as a source of cognition. As de Man says:

> the *aesthetic* is not a separate category but a principle of articulation between various known faculties, activities, and modes of cognition. What gives the

aesthetic its power and hence its practical, political impact, is its intimate link with knowledge.[102]

The aesthetic as a practical category of experience tends to get downplayed by those who want to radicalize the aesthetic as a source of non-reconciliation. Thus how might a defence of the aesthetic as a transcendental source of pleasure be squared with the production of knowledge? All transcendental models invariably forget or suppress the continuously unfolding textual life of the artwork. For historical materialism, artworks endure and change over time because of the interpretive activity of readers and spectators. That is the use-value of an object/text depends upon the continual reproduction of an audience's, or audiences', capacity to understand and give credence to that object/text. Bourgeois culture now has a whole industry devoted to sustaining certain kinds of dominative readings of art and culture. How can a defence of the aesthetic as a radicalized disturbance of the bureaucratization and despiritualization of value challenge this, particularly when invested in painting? This is not to defend the relativism and earnestness of radical counter-hegemonic orthodoxy – Wood's comments on this score are absolutely pertinent. But isn't the former actually the distorted product of the latter, and no less a diminished option? Thus I detect a lack of *positionality* about Wood's defence of the aesthetic. How do you make 'beauty' as the antidote to 'war, crime and sickness' (p. 197 below) – even if that beauty is hauntingly inscribed in the *ruins* of modernism – without pushing art into yet another set of preconceived moves, only this time in the interests of an abstract notion of the 'good'? If the aesthetic is a metaphoric relation between spectator and artwork, as de Man contends, then in the name of critical realism the necessary motility of that relation should be ascribed to at all times. In short, the transcendental thesis fails to acknowledge the messy ideological challenges of evaluation, producing a phenomenalist reduction of the discursive reality of the social world to the sensuously empirical. As Jeffrey Steele notes in this volume, the implication of this is that intentions and meanings and aesthetic value become *radically* dissociated, leaving historical materialism with nothing more to do than offer encouraging remarks about how 'inspiring' and 'expressive' works are. This is exactly the reverse position of art history as social anthropology, and equally reductive.

Many of these problems were dealt with by Raymond Williams in his last writings, albeit in a register removed from the specific problems of art history. In fact, if there is a single influence above all others on this Introduction it has been his essay 'The Uses of Cultural Theory',[103] an attempt to provide a new dialectical map for cultural criticism out of the ruins of vulgar Marxism, formalism and post-structuralism. Looking back to the writings of Voloshinov, Bakhtin and Medvedev in the twenties, he sees

their break with the otiose dualisms of aesthetics/knowledge and society/ artwork as bringing formalist analysis and generalized Marxist categories into dialectical alignment. If the implications of the twenties had been followed through, he argues, 'by linking artistic specificity to the real and complex relationships of actual societies, it could have ended the formalist monopoly of those kinds of attention to art and its making which practitioners, above all, while they are working, must value'.[104] I'm not saying the buck stops here. A good deal of work now stands in this tradition. But nevertheless the spirit of this anthology very much concurs with these sentiments. The essays reflect a sophistication of analysis that gives back to historical materialism, to quote Williams, 'the socially and historically specifiable agency of [art's] making'.[105]

Notes

1. For example, Michael Corris, whose long-standing work on Ad Reinhardt took the form of an exhibition, 'Corrected Chronology', at The Showroom, London, from 9 July to 9 August 1992, which blurred the boundaries between conceptual installation and art historical scholarship.

2. See, in particular, *Patterns of Intention: On the Historical Explanation of Pictures*, Yale University Press, New Haven, Conn. 1985.

3. See for example Serge Guilbaut, ed., *Reconstructing Modernism: Art in New York, Paris and Montreal, 1945–1964*, MIT Press, Cambridge, Mass. 1990.

4. See Benjamin's 'Rigorous Study of Art: On the First Volume of the Kunstwissenschaftliche Forschungen'. First published as 'Strenge Kunstwissenschaft. Zum ersten Bande der kunstwis-senschaftlichen Forschungen', which appeared under the pseudonym Detlef Holz, on 30 July 1933 in the *Frankfurter Zeitung*. Reprinted in Walter Benjamin, *Gesammelte Schriften* Vol. 3, Suhrkamp, Frankfurt 1982, pp. 363–74. In this article, Benjamin champions Riegl over Wölfflin. In fact Benjamin's distaste for Wölfflin's historicism takes on an extreme character in letters he wrote to Fritz Radt in November and December 1915. Wölfflin's work is the 'most disastrous activity I have encountered in a German University', he says. Quoted by Thomas Y. Levin. 'Walter Benjamin and the Theory of Art History: An Introduction to "Rigorous Study of Art"', *October*, 47, Winter 1988, p. 79.

5. Max Raphael, 'The Marxist Theory of Art', in John Tagg, ed., *Proudhon, Marx, Picasso: Essays in Marxist Aesthetics*, Lawrence & Wishart, London 1981. See also Raphael, *The Demands of Art*, Routledge, London 1968, and *Arbeiter, Kunst, und Künstler*, Fischer, Frankfurt 1975.

6. Raphael, 'The Marxist Theory of Art', p. 75.

7. Ibid., p. 85.

8. Ibid., p. 76.

9. There is some confusion over just when the 'Introduction' was available in published form. Neither Martin Nicolaus in his Foreword to his translation of the *Grundrisse*, Harmondsworth, Penguin 1973, nor David McLellan's *Marx's Grundrisse*, Macmillan, London 1971, mention its publication in *Neue Zeit* or N.I. Stone's translation. For a discussion of publication details, see Maurice Dobb's introduction to *A Contribution to the Critique of Political Economy*, Lawrence & Wishart, London 1970.

10. For a discussion of dialectics during this period, see Roy Bhaskar, *Reclaiming Reality: A Critical Introduction to Contemporary Philosophy*, Verso, London 1989.

11. 'The Marxist Theory of Art', p. 76.

12. Ibid, p. 99.

13. See, in particular, Read's impassioned *The Politics of the Unpolitical*, Routledge, London 1943. It is interesting to note that in 1968 Read supplied the introduction to Raphael's *The Demands of Art*.

14. Benjamin's essay was delivered as a lecture at the Institute for the Study of Fascism, Paris, 27 April 1934.

15. October 1935, p. 39: 'Art can face the facts of social reality and point towards a method of their solution, or it can hide them and provide an escape from them.' For a sympathetic treatment of the period, see Lynda Morris and Robert Radford, *AIA: The Story of the Artists' International Association, 1933–1953*, Museum of Modern Art, Oxford 1983.

16. Klingender, 'Revolutionary Art Criticism', p. 40.

17. See, in particular, *Principles of Art History: The Problem of the Development of Style in Later Art*, Dover, New York 1950. The German edition, *Kunstgeschichtliche Grundbegriffe*, was first published in 1915, the first English translation in 1932.

18. First published in the *Burlington* magazine, reprinted in *Classicism and Romanticism*, Basic Books, New York 1966.

19. Routledge, London. Reprinted in four volumes in 1962.

20. Routledge, London.

21. It is more than likely that Hauser would have read the complete 1953 German edition of the *Grundrisse, Grundrisse der Kritik der Politischen Ökonomie (Rohentwurf)*, Dietz Verlag, Berlin.

22. *The Philosophy of Art History*, p. 105.

23. Ibid., p. 103.

24. Ibid., p. 126.

25. Ibid., p. 159.

26. Ibid., pp. 27–8.

27. See ibid., pp. 189–216.

28. Hauser taught at the University of Leeds, which has had a strong tradition since the fifties of critical engagement with art history and practice. T.J. Clark, John Tagg and Janet Wolff taught there, and Griselda Pollock, Terry Atkinson and Fred Orton have been there since the late seventies.

29. Joan Lukitsh, 'Practicing Theories: An Interview with John Tagg', *After Image*, January 1988, p. 8.

30. Althusser's influence was largely confined to the examination of methodology.

31. Pluto, London.

32. Ibid., p. 96.

33. Ibid., p. 115.

34. Ibid., p. 101.

35. See Althusser's 'A Letter on Art in Reply to André Daspre', in *Essays on Ideology*, New Left Books, London 1976.

36. *Art History and Class Struggle*, p. 71.

37. Ibid., p. 147.

38. Ibid., p. 179.

39. Ibid., p. 181.

40. See 'Taste and Tendency', in A.C. Rees and F.B. Borzello, eds, *The New Art History*, Camden Press, London 1986.

41. Both Thames & Hudson, London.

42. *Art History and Class Struggle*, p. 28.

43. *The Painting of Modern Life: Paris in the Art of Manet and His Followers*, Thames & Hudson, London 1985.

44. Ibid., p. 6.

45. Ibid.

46. As Perry Anderson says in 'A Culture in Contraflow – II', *New Left Review*, 182, July/August 1990, p. 90; 'One way of describing the work of T.J. Clark would be to say that with it a modern Marxism became for the first time central to the discipline.'

47. *The Painting of Modern Life*, p. 13.

48. Ibid., p. 13.

49. See, for example, the work of Tom Crow, in particular *Painters and Public Life in Eighteenth-Century Paris*, Yale University Press, New Haven, Conn. 1985.

50. See, for example, 'Abstract Expression', *Art-Language*, 5 (1), 1982.

51. *The Painting of Modern Life*, p. 20.

52. 'Marx' Clarkism', *Art History*, 8 (4), December 1985, p. 489.

53. Ibid., p. 490.

54. Ibid., p. 493.

55. Ibid., p. 491.

56. Ibid., p. 492.

57. Ibid., p. 491.

58. Ibid., p. 494.

59. Ibid.

60. Ibid., p. 495.

61. Ibid., p. 494.

62. Charles Harrison, Michael Baldwin and Mel Ramsden, 'Manet's *Olympia* and Contradiction (Apropos T.J. Clark's and Peter Wollen's Recent Articles)', *Block*, 5, 1981.

63. Ibid., p. 41.

64. Ibid., p. 35.

65. *Vision and Difference: Femininity, Feminism and the Histories of Art*, Routledge, London 1988, p. 158.

66. Thames & Hudson, London 1993.

67. Routledge, London 1992.

68. Ibid., p. 103.

69. Routledge, London 1981.

70. *Vision and Difference*, p. 7.

71. Ibid., p. 30.

72. For a discussion of asymmetrical relations in historical materialism, see David-Hillel Rubin, *Marxism and Materialism: A Study in Marxist Theory of Knowledge*, Harvester Press, Brighton 1977. See also Rom Harré and E.H. Madden's anti-Humean *Causal Powers: A Theory of Natural Necessity*, Basil Blackwell, Oxford 1975.

73. For recent discussions of class, see Ellen Meiksens Wood, *The Retreat From Class: A New 'True' Socialism*, Verso, London 1986; Ralph Miliband, *Divided Societies: Class Struggle in Contemporary Capitalism*, Oxford University Press, Oxford 1989; and Terry Eagleton, 'Defending the Free World', in Ralph Miliband and Leo Panitch, eds, *The Retreat of the Intellectuals*, Socialist Register 1990, Merlin Press, London 1990.

74. See, for example, 'Politics and Friendship', the fascinating interview with Derrida by Michael Sprinker in E. Ann Kaplan and Michael Sprinker, eds, *The Althusserian Legacy*, Verso, London 1993.

75. 'On the Conditions of Artistic Creation', *Times Literary Supplement*, 24 May 1974.

76. 'Seven Types of Obloquy: Travesties of Marxism', *Socialist Register 1990*, p. 9.

77. Ibid.

78. See Hauser's *The Philosophy of Art History*, in particular the section 'Educational Strata in the History of Art: Folk Art and Popular Art'.

79. See Griselda Pollock, 'Painting, Feminism, History', in Michèle Barrett and Anne Phillips, eds, *Destabilizing Theory: Contemporary Feminist Debates*, Polity Press, Cambridge 1992.

80. 'Art Histories', in Rees and Borzello, eds, *The New Art History*, p. 162. See also Rifkin's 'Can Gramsci Save Art History?', *Block*, 3, 1980.

81. For a realist reading of Marx, see Bhaskar, *Reclaiming Reality*. See also Derek Sayer, *Marx's Method: Ideology, Science and Critique in 'Capital'*, Harvester Press, Brighton 1979.

82. Oxford University Press, Oxford 1980.

83. Ibid., p. 9.

84. Ibid., p. 91.

85. *Intentionality: An Essay in the Philosophy of Mind*, Cambridge University Press, Cambridge 1983.

86. Ibid., p. 85.

87. *Essays on Actions and Events*, p. 48.

88. Ibid., p. 86.

89. *The Possibility of Naturalism: A Philosophical Critique of the Contemporary Human Sciences*, Harvester Press, Brighton 1979.

90. Ibid., p. 143.

91. Ibid., p. 122.

92. See Tom Crow, 'Saturday Disasters: Trace and Reference in Early Warhol', in Guilbaut, ed., *Reconstructing Modernism*.

93. See *The Resistance to Theory*, Foreword by Wlad Godzich, Manchester University Press, Manchester 1986. See also Christopher Norris, *Paul de Man: Deconstruction and the Critique of Aesthetic Ideology*, Routledge, London 1988.

94. See, for example, Charles Harrison and Fred Orton, 'Introduction: Modernism, Explanation and Knowledge' in Charles Harrison and Fred Orton, eds, *Modernism, Criticism, Realism: Alternative Contexts for Art*, Harper & Row, London 1984.

95. Basil Blackwell, Oxford 1990.

96. Verso, London 1987.

97. Ibid., p. 5.

98. *The Ideology of the Aesthetic*, p. 228.

99. *Critique of Judgement*, trans. James Creed Meredith, Oxford University Press, Oxford 1952. See also Terry Eagleton, 'The Poetry of Radical Republicanism', *New Left Review*, 158, July/August 1986.

100. Eagleton, *The Ideology of the Aesthetic*, p. 3.

101. *Imaginary Relations*, p. 12.

102. *The Rhetoric of Romanticism*, Columbia University Press, New York 1984, p. 264.

103. *New Left Review*, 158, July/August 1986.

104. Ibid., p. 28.

105. Ibid., p. 27.

1

Francis Picabia:

Another Failure to Interpret the Work

Inter Alia (Dave Beech and Mark Hutchinson)

A Few Words Before We Begin

During the eighties, there was some activity that sought to link the work of Francis Picabia to the likes of David Salle. Other well-established 'masters' were recruited for the same job. Using the names of the great, in the hope of gaining some of their sweet contagion, is not a new tactic, and nor is it restricted to the protocols of art criticism. If there is any anxiety in this clamouring for influence, it is venal and narcissistic. Certainly, there are careers at stake in these share-takings in bullish glitterati. Industries need markets so badly that they create them. And the drawing together of the likes of Salle and Picabia is good for business. The Picabia industry does well out of the marketability of an artist dead since 1953 who still manages to 'influence' the bright young things of today. But it's not just that exchange value has come to control aesthetic value – determine it in some cunning way – although it clearly does. Rather, the problem is that even if the artist isn't 'doing it for the money', the critic certainly needs to keep an eye on the market, for her/his job is not only to interpret and explain but to predict and advise. If such a cynical view has any purchase on our critical milieu, one would expect the work to slip away from criticism now and again. In this essay we look for a few of those slippages.

The con-fusion of Picabia and so-called postmodernists is a ruse. Presumably there is a vertiginous thrill involved in allowing oneself to fall for it. When Robert Rosenblum, the key mover in this sub-plot of the eighties artworld, has no truck with historical caution, he will sing:

> the late work may be casting a longer and longer shadow on tomorrow. Who knows how many more sparks will be ignited when this heavyweight of a lightweight master is re-examined by a new generation of artists and spectators eager to free themselves from the inherited catechisms of modern art.[1]

One might prefer to back-pedal a little, and agree: indeed *who knows?* One might also want to probe the historical, cognitive or aesthetic connections that are supposed to be so exhilarating here. And upon reading them one might well wonder what the basis of the excitement might have been. A parenthetical remark ties Picabia's later work to some eighties American writing on the ostensive basis of a simple intertextual trace: 'such appropriations of popular art into high art now strike us as familiar to the work of, say, Eric Fischl or Richard Bosman'.[2] As if modernism hadn't been riddled with the dialectic of 'high' and 'low' right from the start. But then, to top it off, Rosenblum gets Picabia to confer approval over Salle et al. (and over Rosenblums's criticism, to boot):

> he might have been delighted to note how, for instance, his *transparencies* ... were not only admired by Rauschenberg but later got a second lease on life in the overlapping, see-through, drawings that float like ectoplasm through the abstract spaces of David Salle's or Jim Sullivan's paintings.[3]

Well, thanks for nothing Francis; we were hoping to get you on our side. But that's art history for you: always ready to slip you a dud.

History

Hegel said that the Owl of Minerva flies at dusk, meaning that it is only after the day is done that it can be surveyed by wisdom. He was wrong. The Owl of Minerva always gets there too late. Hindsight is not wisdom, and historiography is not conclusive by virtue of being coherent. The implications for art history would seem to be bleak. Wouldn't any recovery and re-examination of modernism underestimate the internal complexity and heterogeneity of modernism itself, simply as a matter of course? Or does this follow only if art history conceives of itself as the Owl of Minerva?

The historical narrative that has the trajectory of modernist art culminating in post-war New York with 'flat' abstract painting on a grand scale is false, of course. We can extract from this conventional view two different (if related) points. First, the practice of history-as-hindsight gives a false explanation of the supposed *outcome* of history (in this case, American abstraction). Second, the same practice mis-recognizes the supposed *pre-history* of the supposed outcome (in this case, modernism). It would seem to follow from the second point that if late modernist American abstraction engenders closures for the intepretation of modernist art in this way then a recovery and re-examination of modernism will fail in its historiographical task if it does not re-write modernism *over the head of* American late modernism (instead of through its interpellating gaze).

It is clear that if this is a false narrative, then there is more to modernism

than a pre-history of Pollock and Reinhardt. Hence historians have switched attention from the masters of the modernist canons to the men and women written out of that history. This is very important work. However, treating modernism as a coherent text with neglected margins serves to re-invigorate the illusion that modernism had an identifiable project or unifying principle. If decanonization merely adds further narratives to the given narrative, we might get some sense of the end of a meta-narrative, but we will not necessarily end up with a better understanding of that which the meta-narrative set about to explain. Hence, *if* these masters are not the great figures of a great tradition, *and if* the dominant descriptions and evaluations of them are based on this bogus teleology, *then* their work too needs to be re-viewed and re-evaluated.

If art history is going to tell us anything about modernism, it must, first of all, take up the possibility that modernism was a quarrelsome, contested and fractured set of discourses. Then, as well as attending to modernism's neglected margins, it will abrogate the illusion of unity by attending to its internal divergencies and contradictions. This will include the suspicion that to take modernism at its word is precisely to underestimate the internal complexity and heterogeneity of modernism. The late modernist narrative that has American abstraction as its *telos* writes modernism itself out of history. So, if we are not to act as hysterics in relation to this massive cultural edifice, then it would seem advisable to attempt to by-pass the closures of late modernism without any bad consciousness. The point is not to get your history *right*, in the sense of ensuring that you have been objective, collected and collated all the facts and so on. The point is that the prevalent blindnesses to history are caused by current prejudices, idealist fantasies and ideology.

We will not try to give a new account of Francis Picabia's work – which we will save for those more able than ourselves – but, rather, try to suggest ways in which the established and expected accounts come to grief, and *might* be remedied. We do not do what we do, therefore, in the hope of by-passing the treacherous task of interpreting Picabia's works. Although, to be honest, we will not in fact go on to make much of an interpretation of the works, our failure is not meant to be a demonstration of any supposed impossibility; we do not foreclose such a treacherous task. It's simply that (1) the task is so laborious and subtle that we have no room here. And anyway, (2) before very much of this kind of work can be done it is advisable that the major indiscretions of more usual interpretations are identified and explained. We are not after a particular historiographical story, or 'position'. It's just that faced with the task of writing an essay about Picabia we find a paucity of tools and material, and what does happen to be available is inadequate in fundamental ways. Without intending to overlook other difficulties in Picabia interpretation, we will find the art historical suppositions attendant

on Picabia's involvement in Dada a recurrent source of unwarranted interpretive speculation. We will attempt to proceed with caution on this matter.

In the preface to the catalogue for the Picabia retrospective at the Peggy Guggenheim Museum in 1970, Thomas M. Messer, the museum's director, commented: 'We note a curious discrepancy between Picabia's accepted historic significance and the general lack of familiarity with the main body of his contribution as a painter.'[4] Notwithstanding the powerful interests behind the impulse to assimilate Picabia's so-called oeuvre into the categories and canons of established practices, the director had no doubt gleaned something; but presumably not that academic historians have found it difficult to resolve Picabia's (like other Dadaists') cantankerous and contradictory activities with their own professional need for clear and forthright explanation. That is, Picabia did not say and do the sort of things that art historians generally wish to explain – what they consider to be relevant for what *they* say and do. Consequently, we might locate the 'cause' of the aforementioned curious *discrepancy* in the discourses of art history, criticism and consumption.

It is a repeated manoeuvre of this essay to impugn Picabia interpretation in an attempt to find some way of examining the works. But before proceeding to examine some work (and finding some reason to dispute the conventional wisdom regarding Picabia interpretation), we will take a moment to review the conventional wisdom regarding Dada interpretation.

Helena Lewis has said, 'Dada, in essence,[5] was revolt against war.'[6] William S. Rubin claims that 'all that Dada manifested as its common denominator was the aim of subverting[7] modern bourgeois society.'[8] Willy Verkauf, more lyrical than most, expresses the Dada project as 'the hectic outcry of the tormented creature in the artist, of his prophetic, admonishing, despairing conscience'.[9] Hans Richter, who should know because he was there, makes a subtle distinction: 'Dada had no unified formal characteristics as have other styles. But it did have a new artistic ethic.'[10] André Breton, for his own reasons, said that 'Dada is a state of mind.'[11] Dawn Ades is more nuanced,[12] suggesting that 'Dada turned in two directions, on the one hand to a nihilistic and violent attack on art, and on the other to games, masks, buffoonery.'[13] And she even explains the reason for this duplicity with reference to the Dadaists' historical condition: 'the artist was still trapped in ... society's death throes.'[14] Indeed, Ades puts her finger on the problem: 'the Dadaists were after all painters and poets, and they subsisted in a state of complex irony, calling for the collapse of a society and its art on which they themselves were still in many ways dependent.'[15]

One feels that the historians would be happier if the Dadaists (and Picabia) had stuck to writing manifestos, performing outrageous acts on stage (and elsewhere), etc. That is to say, it seems as though the historians

would rather Dada had had nothing to do with art at all. And they might say as much: 'Dada works have their only real existence as gestures, public statements of provocation.'[16] The point seems to be that the discipline of art history endemically prioritizes historical coherence and explanatory rationality over the difficulties and contradictions of practical actions, which leaves it in a tricky situation vis-à-vis 'movements' such as Dada and individuals such as Picabia.

Dada interpreters are not helped by conventional assumptions about what a modernist art movement is supposed to be. To be sure, the very question of a modernist art 'movement' is suspect. Our attempt to impugn the security of Dada qua 'movement', therefore, does not involve the expectation of finding many counter-examples – if any. But for the art historian who still holds to the metaphor, there is presumably a sense that because Dadaists existed, and that certain things occurred, were produced, and so on, there must be some predicate or other which can cleverly sum it up.[17] Judgements about the art historian might depend on such skill. Careers are made on less.

Despite this, the usual response to the task of characterizing Dada results in empty predicates and self-contradiction. What is interesting about this is that art historians do in fact seem capable of asserting that something contradictory was going on with Dada, when they go to extreme lengths to fudge contradictions for other 'movements' and artists. It is worth entertaining the speculation that they are forced into this observation by the constraints of their discourse.

In particular, interpreters find it almost impossible to square Dada 'cabarets', manifestos and the like (namely, non- and anti-art) with their continued studio practices as painters, sculptors, etc. (namely, what look like fairly affirmative modernist works of art). This can result in interpreters asserting that some of the things that the Dadaists said were plainly in contradiction with what they did, and even that what they said was simply absurd. Clearly, some of the things that the Dadaists said were absurd. What is interesting is that, in the case of Dada, art historians are prepared to admit that some of the authorial statements are absurd, contradictory and at odds with their practices. This is interesting because art historians do not have the same difficulties and revelations when they are dealing with similarly absurd, contradictory and idealist remarks – for instance, in relation to the 'spiritual' nature of 'abstract art'.[18]

Don't misunderstand us. We are quite aware that Dada interpretation is not characterized by hermeneutic anxiety. Quite the contrary. The point is that Dada is interpellated in such a way as to suit the interests and protocols of art history.

The point is that art historians (even the most subtle and sympathetic) seem quite incapable of addressing Dada with any sense of historical

indeterminacy. Dada interpretation might turn out to be precarious – or even impossible – but the difficulties should not be shrugged off, nor logically imploded by the interests of the historian. Dadaists did not affirm their own – or anyone else's – practices like good modernists should, but nor did they simply set about to destroy; they did not do what they did without some sense of the value of their works. Dadaists were active in the self-definition and promotion of Dada; for example, the word 'Dada' was a rallying cry by the Dadaists themselves.[19] And they did not do what they did without any historical and aesthetic acumen.

We would like to suggest that it is neither the case that 'each Dadaist brought something different to [Dada] and came out with a different idea of what Dada was',[20] nor that Dada was *essentially* this or that. In short, we suggest that to ask for a definition of Dada is to ask for the wrong thing. We do not want to support any case for the idea that Dada melts into nothing once the inquirer bothers to examine it closely. Nor do we want to single out Dada as a special case. We are particularly interested to scrutinize interpretations of Dada as they link to the endemic aporia of an art history discourse that expects a unified object of analysis.

Picabia was a Dada artist, but he was many more things besides. And Dada, too, was many more things beside what he did. On occasion, Picabia was a supreme nihilist. On other occasions, Picabia was a severe polemicist. The same Picabia was a sometimes sincere and brilliant modernist painter. And, like other Dadaists, he oscillated between what look like affirmative modernist works of art, and what look like utter denunciations of art, civilization and existential life. It is worth keeping in mind that Picabia's active participation in Dada lasted only from the end of 1918 to early 1921. The impulse to characterize everything Picabia ever did, from birth to death, in the likeness of Dada should be resisted. And not least because it is difficult to know what that might mean.

It is not easy to speak of Picabia as a Dadaist up until August 1918, when he received an invitation from Tristan Tzara to join him in Zurich and collaborate with the Dada movement there (which had been active for about three years already). Critics who are sensitive enough to spot some 'nascent dada spirit'[21] leading up to that encounter are presumably overloaded with hindsight. But Tzara, for one, must have recognized something. And the fact that Picabia and Tzara immediately began an energetic exchange of letters and pamphlets also suggests that Picabia was already in some sense 'prepared' for Dada. Picabia came to Dada when it was already underway, and he withdrew from it just as its members were deciding whether or not to join up with Breton's Surrealism. Although Picabia began the work which would characterize his Dada art as early as 1915, his Dada career did not actually begin until early 1919 and was decidedly over by May 1921, when he turned against Breton.

There seems to be no reason for counting Picabia as inherently Dada through and through. He had always been somewhat erratic, both in his private life and his art, but one would need a questionable definition of Dada for this personal characteristic (or any other) to qualify him as essentially Dadaist.[22] Artistically, too, Picabia cannot easily be said to have been a precursor of Dada. He had been at the tail-end of the so-called 'banquet years', helping to develop Orphism and abstract art. He had been a prominent member of the original Puteux group, exhibiting in their second group show, the 'Salon de la Section d'Or'. And, of course, he was one of the artists who caused a frisson in New York with his work in the 'Armory Show'. He was, in short, a modernist artist.

On the other hand, Dada did not constitute or represent a crisis for Picabia; it did not involve a need for re-assessment. In fact, Picabia's work was admired by Zurich Dada before Picabia's arrival in that city.[23] As far as Zurich Dada were concerned, then, Picabia was already one of 'them', and his works were already exemplary. His arrival in Zurich, however, was by no means a seamless, inevitable convergence of Picabia's earlier preoccupations with the established community of the Dada movement. Picabia's arrival had a marked effect on Zurich Dada (apparently a shift to a more extreme and recalcitrant Dada, and the consolidation of Tzara's position in the group[24]). And judging from his enthusiasm for Dada on his return to Paris, after just over a fortnight, something had had an effect on Picabia.

Dada, for Picabia, was vehemently opposed to art, culture, civilization, bourgeois morality and the rest of that familiar catalogue of rogues. His art had its moments of scandal, ludicrousness, cheek and opposition. In Picabia's case 'anti-art' was largely an 'avant-gardist' conceit for the perpetual engagement with a disenchanted and sullied world which included art and therewith his own work. His art did not seek to abandon this commitment, to exculpate itself by claiming to have found a technical transformation that might transcend its social situation. Nor did it seek to dissolve itself in a suicidal bid to demonstrate and thus help bring about the end of art *as such*. Rather, his work registered the intractable difficulty of his determination to stick in the throat of polite society.[25]

For reasons of brevity we will not examine Picabia's later work in this essay. We will leave off about 1936. He produced a few 'abstracts' in 1937, and again in 1939. He made a number of terrible landscapes and sentimental portraits. After the war, and back in Paris, until his work came to an end in 1951 (after suffering a stroke and steadily declining to his death in 1953), he produced some extremely odd paintings. Their evaluation would require a more detailed study than we can provide here.

Before these Picabia produced a set of paintings during the Second World War which deserve a mention. They have been called his 'popular' or 'commercial' realist works. They are painted in a crude style. The

compositions, effects of light, and other aspects[26] derive from the mediating effects of photography and the technology for the reproduction of colour images in magazines, which was at an early stage. The figures are often distorted with feigned incompetence. The compositions can be sentimental, lightly erotic, or even bathetic. They are technically aberrant, but not obviously in any interesting way.[27] By trespassing on the terrain of mass culture, these paintings are even more aberrant than the machine pictures (which remained elegant and innovative) and the 'monsters' (which were ugly enough but did not use the conventions and appearance of mass cultural images). Picabia imported this rubbish into the studio and the gallery. It would seem, then, that by this time his integrity could only be maintained with the most perverse means and materials; it was only by renouncing taste, habit and artistic canons that his practice could survive. The 'commercial realist'[28] paintings, then, are undoubtedly interesting. The fact that they are not technically innovative, and yet gain their interest from their technical aberrance, is interesting in itself. The difficulty, though, is that there is nothing to recommend these pictures except that they manage (if they are successful) to cross the border between modernism and mass culture. A consequence is that they go some way to articulating this conflict, but not without suffering from it.

Abstraction

As far back as 1905, aged twenty-six, Picabia was faring adequately as a late Impressionist. In 1908, he met Gabrielle Buffet, a music student with an interest in Symbolism and Syntheticism. This particular encounter led to marriage as well as a change in the direction of Picabia's work. The work of 1909 and 1910 is, therefore, said to contain those 'esthetic convictions which pointed toward abstraction'.[29] There are two problems entailed by such an account. The first is that the outcome of three years' work is taken as the necessary and inevitable *telos* of the entire enterprise – which is bad history. The second, which is related, is that it is not a priori clear what abstraction was or had to be. The bad history can lead to a bad interpretation. In this section we will attempt to say some interesting things about Picabia's so-called abstract paintings without deciding beforehand what abstraction is, or should be. In fact we will proceed with a profound sense of doubt which is the result not of a methodological scepticism but of a genuine incapacity.

At the time of the 'birth of abstraction', the Parisian avant-garde was still in the middle of an attachment to Cubism, but not in such a way as to supplant the legacy of the 'bohemians' and the Symbolists. Apollinaire was a powerful figure, backing Cubism and arguing for 'simultaneity', as well as some kind of call to arms based on vague notions about purity, truth and innovation. Does it not seem quaint nowadays that Apollinaire should

exclaim: 'you can paint with whatever you like, with pipes, stamps, post cards or playing cards, candlesticks, waxed cloth, collars, painted paper, newspapers'?[30] If it does, then we need to do some work before we can understand anything about the so-called birth of abstraction. Similarly, unless we understand Apollinaire's assertion that 'resemblance no longer has any importance',[31] in the terms of a post-Cubist 'Symbolism' (without any sense of the teleological run up to American abstraction), we will fail to gain the slightest understanding of Picabia's supposed 'abstract' art.

There is an element of confounding 'good taste', presumably, in these deliberately provocative innovations; but there is also a celebration of modernist art, and especially its seeming renewal of expressive possibilities through the renewal of techical possibilities. These modernists were using purposely 'improper' materials and procedures in a campaign to upset the good bourgeois and the academic, but also in an attempt to 'express' things that conventional or older techniques, they assumed, would, by their nature, not permit. Nietzsche and Bergson were being digested, in a fashion; Symbolist ideas about esoteric representation were inspiring painters to look toward music for a model of aesthetic practice; modernist art was building for itself a reasonable market; and modernists were busy and delighted to be preparing a 'new art for a new age'.[32]

It was only after 1911 that Picabia's ostensive 'search' for abstraction ceased to be rooted in the conventions of Cubist and Fauvist landscape painting. By the time of the Armory Show of 1913, however, he was consistently producing paintings which included only a jumble of shapes and colours. Some of these paintings look like detailed depictions of confetti. They are schematic and stylized. Shapes depict facets and forms, but these do not add up to figures or objects. They approximate a kind of crass Cubism which has been transformed into a style. That is to say, ironically enough, they don't have the iconic duplicity of a Cubist painting (that is, that the marks of a Cubist painting – after, say, 1910 – never settle between being mere marks and being representations of facets and objects) precisely because Picabia thinks he is not representing anything, because he is not looking at anything. The shapes, facets and forms are, nevertheless, unmistakably shapes, facets and forms – and, in this sense, settled. But this does not mean that the question of how to interpret these paintings is easily resolved.

Picabia called these paintings 'psychological studies'.[33] And in an interview with an American journalist at the time of the Armory Show, he is reported to have said:

Nearly all painting, now and always, has attempted in part at least to reproduce objects in nature. . . . Aristotle said that art is a copy of life. But that is just exactly what art is not. Art is a successful attempt to render external an internal state of

mind or feeling, to project on to the canvas emotional, temperamental, mental, subjective states.[34]

We do not doubt his honesty, sincerity or faith in such a statement. But, given that this statement is absurd (what could a feeling look like? how would a transference be effected between the so-called 'internal' to the 'external'?), we find nothing much in it to guide our interpretation of the work.[35] According to Camfield, per contra, the 'psychological studies' – especially of 1913 – are more or less 'readable'. He says, 'the formal properties of these compositions do evoke psychological responses in accord with their titles'.[36]

Can Camfield explain why these paintings are easily mistaken for paintings which don't in fact 'refer' to anything except other paintings? Does he not recognize the possible discrepancies between Picabia's claims and the paintings themselves? We would expect, quite naturally, that an absurd authorial claim would be *independent* of the painting of which it was supposed to be made. Moreover, we find that the possible discrepancies between what artists *intend* and what their paintings look like are, in the case of 'abstract' paintings in particular, exacerbated. We do not rule out the possibility that discrepancies and mis-recognitions are a necessary condition of abstraction in painting.

These discrepancies go against the assumption that *intention* is causal – or even at the very least amounts to privileged information for the explanation of a painting. In the case of art interpretation – understanding that term to refer to a wide range of critics, historians and others, both professional and pedestrian – when causality is not being valorized in fetishistic form in the privileging of the authorial report, causality is often thought of as a misleading burden. Aesthetic judgement is supposed to conform to the sovereignty of the viewer, and s/he can 'interpret' at will. But our interest is to examine the works on the assumption that the relationship between the work and the authorial voice cannot be decided beforehand. Even if *intention* is a causal factor of action (an assumption which ought to be scrutinized most carefully), then it does not follow a priori that it is a causal factor of the painting which results from action. Only some instances of cause will pass from one stage to the next, and *intention* can expect no direct access from one to the other.

If the relation between intention and meaning or interpretation is prone to difficulties of this type, then we can begin to examine the relation between intentions as meaning-fixers and intentions as acts of performative closure. Beliefs do not have to be valid in order to act as conditions and causes of paintings. Thus, we do not need to doubt that Picabia's beliefs and commitments vis-à-vis abstraction, Symbolism and so on determined (to some extent) the way he made, as well as conceived of, the paintings.

Picabia offers a clue about how these beliefs might have informed his

painting. A little over a month following the publication of the article cited above, he had an article of his own published in *The New York American* where he tells us: 'I absorb these impressions . . . then when the spirit of creation is at flood-tide, I improvise my pictures as a musician improvises music.'[37] Thus, regardless of the absurd claim that these paintings express his emotions and so forth, it is quite clear that the false assumptions about the paintings determine a technique involving 'improvisation'.

We assume that this technique makes use of aleatory procedures (hence the reference to 'improvisation'), but it will also be connected, we would expect, to a morphology of art informed by Cubism, Fauvism, Symbolist ideas about representation and abstraction, and the technical requirements of disavowing resemblance and iconicity. Moreover, we would expect that the paintings would be determined by the perceived imperatives of the recent history and morphologies of modernist painting *over and above* the desired improvisatory modus operandi. That is, it is likely that the suggestion that he improvises like a musician permits a certain kind of interpretation of the work; it puts the viewer in a benign position vis-à-vis the painting.[38] We are not claiming that Picabia's purpose was to pull the wool over the eyes of the uninitiated, for we take it that the suggestion would be exemplary for his own interpretation, and act as a condition of his practice. Our point is to put in question the first-order 'meaning' of the statement by postulating a possible legislative function for it.

The authorial voice, then, does three things. First, it informs us of the misguided beliefs with which the artist is working. Second, it effects a performative closure on the way he works (that is, it guides him to 'improvisation'). Third, it effects a suitable model by which the viewer can situate her/himself vis-à-vis the painting so as to preclude improper (whether philistine or fatal) concerns.

Evaluations of Picabia's 'abstract' paintings will have to take these reservations into account, but will have other work to do. The 'psychological studies' can claim some credit for their novelty and so on, and must have been challenging and countervalent vis-à-vis established practices (and especially vis-à-vis the academy and bourgeois taste). In short, if they were merely 'modernist', they were not thereby devoid of a certain unsettling force. Let's not forget that the glimmer of daylight which 'abstraction' once promised nowadays orbits on yellowed wings. In postulating a degree of absurdity in these works we are not therewith claiming that they were acquiescent and backward.

Machines – Pictures

Picabia did not discontinue his 'abstraction' for any of those licentious reasons for which he is much famed. He was conscripted into the French

Army in 1914 after the declaration of war. Family connections saved Picabia from anything too dangerous and strenuous. For a while he was a chauffeur, and then he was 'dispatched' to purchase sugar for the Army. On his way to his official destination, he happened to pause in New York. During the summer of 1915 (in fact until his wife travelled to New York to fetch him and remind him of his business for the Army), Picabia resumed his artistic interests. Duchamp and a handful of other French artists (amongst other people) kept him company. Picabia began a series of new works which start out perhaps as not entirely dissociated from the 'psychological studies'. They can still be combinations of bits and pieces which are supposed to add up not to a whole 'picture' but to an 'expression'. These were sometimes photo-collages, sometimes reworked photographs, sometimes drawings or paint-ings. Instead of 'abstract' shapes and colours, the elements of these works were springs, pipes, joints, wheels and the like. In one form or another this period persisted until 1922.

Picabia had identified these works as 'mechanical symbolism'.[39] It is unfortunate that he has here chosen a name for his new work which suggests a great deal of continuation between these and the earlier 'psychological studies'. These works might have started out in continuity with the earlier paintings, but they soon became narratological and diagrammatic. They are iconically and pictorially cryptic, but they are not 'symbolic'. Picabia is still making pictures *about* his experiences, prejudices, fantasies and so on, but he doesn't have to *assert* that the works 'express' them – he makes pictures with retrievable 'content'.

A drawing of a propeller with its shaft absent entitled *ass* (1917) is quietly humorous. This picture is not 'symbolic'; the propeller is not a 'symbol' of, or for, an ass; the propeller *resembles* an ass (if by 'ass' we mean slang for anus).[40] Not every aspect of the drawing of the propeller resembles every aspect of an anus – it would not count as a good resemblance of one. And, if the title did not suggest it to us we might not make the connection at all. But once the suggestion is made the resemblance is clear. His portrait of Apollinaire depicts a bulky machine with a funny head raising itself from a sturdy collar. Other pictures, such as *Universal Prostitution* (1916–17), depict bodily functions (for example, ejaculation, insertion, intercourse) as mechanical actions. Again, with these pictures there is no difficulty in seeing the resemblance (seeing, say, a barrel shooting dots and words *as* an ejaculating penis).

Some of the others, it has to be said, have no clear interpretation of this sort. The fact that he made them is neither incidental (an aberrance vis-à-vis the other pictures), nor privileged (a counter-example against the idea that the other pictures resemble things). We would expect that Picabia was attempting to do a number of different things with his new-found resource. Even the most 'unreadable' of Picabia's machine works, nevertheless, are

distinct from the 'psychological studies' insofar as they are iconic. (Even if one insisted that they are simply expressions of his feelings [or whatever] with the supplement of being represented via the depiction of cogs and so on, one must at least admit that this 'supplement' has more than an incidental effect on the paintings.) It is not simply that these pictures *look different*: they do different things – behave differently, if you like.

Camfield attempts to dissuade anyone who would like to see the machine pictures as iconic, explaining that 'although it is possible to perceive the lamp as an upright iconlike[41] figure, Picabia was primarily interested in functional analogies.'[42] In the service of this argument he singles out the machine portrait of de Zayas (1915), of which he says 'until all of the machine parts can be identified and properly associated with each other and with the cryptic inscriptions, the privacy of Picabia's portrait of de Zayas will not be violated.'[43]

We can make very little sense of the evocatory interpretation which recognizes psychological responses in the formal properties of the paintings, except, perhaps, that Camfield means that the viewer must make the best of the scarce information available. Such a viewer might well get on best with iconic paucity because this transposes the sense of making the most of the situation into a powerful sense of aesthetic engagement. While it is understood that some of these pictures represent (in the manner suggested above) various bodily functions and so on, and it is further understood that some part of the character of these representations derives from some prejudices and beliefs of Picabia, it is not at all understood that a much stronger case can be made for the causal connection between Picabia's 'inner self' and these pictorial products.

As to the claims that the machine works are enigmatic, despite appearances, because Picabia was interested in functional analogies, Camfield is probably half-right. It is more than likely that Picabia was indeed interested in such functional 'readings' of the portraits and so on (and we will look at this aspect presently), and even that this aspect might override the iconic aspect (the de Zayas portrait would be a fine example of this). But it is neither accidental not incidental that many of these machine pictures are recognizably *of* persons, parts of the body, actions, and the rest. This is because it is fundamental to the machine works that they represent one thing (state of affairs, etc.) through the representation of another (cogs, wheels, etc.).

The machine works articulate and de-stabilize the 'reading' of the pictures by operating on two pictorial levels at the same time. The elements of the representation are already representations. One is not left with ambiguity and enigma; the result is duplicity. Each interpretation requires the bracketing of the other. The gun *is like* a penis (and is perhaps therewith a synecdoche of masculinity), but the gun never *becomes* a penis, is never

mistaken for a penis. The point is not quite the privileging of iconic works over non-iconic (for example, so-called non-figurative, non-representational, abstract) works, but if, for whatever reason, the displacement of conventional categories is to be valorized, then the duplicitous machine pictures are a better bet than the stable 'psychological studies'.

Machines – Modernism

Mechanical parts and fantastic machines, however, were not merely formal elements for Picabia's 'mechanical symbolism'. Bergson's philosophy, the cheeky ridicule of people and sex as reducible to mechanical movements,[44] and the strand of modernist thinking which celebrates technological advance are all at work here. Or, simply, mechanical parts were culturally loaded for Picabia, and his decision to employ the resource was informed by this. In particular, we are interested in the relation which held between this cultural baggage and the expectations (or, exclusions) of modernist art.

There is some comicality involved in depicting persons and sexual activity (and even some far-fetched attempts to depict emotions, perhaps) *as* machines. We are interested in the further bathos involved in the use of mechanical parts within the lexicon of art. Building pictures out of machine parts contrasts with abstraction in this respect. Abstraction was, despite its initial reception, sensitive and urbane enough to get along in the hallowed sphere of 'superior' culture. Machine parts, on the other hand, contaminate this sacred space by dragging in some aspects of the industrial and commercial world – and indeed the catalogues and magazines from which he culled these images.

In shifting from the 'psychological studies' to 'mechanical symbolism', Picabia had, in today's parlance, gone some way to crossing the border from 'modernism' to 'avant-gardism'. These concepts are apparently transparent to some; we do not take them to be very clear notions. None the less, the fact that this unsteady border would categorize Picabia's pre-war work as 'modernist' and his machine works as 'avant-gardist', should not go unnoticed. In this section we will take a look at the supposed distinction between modernism and avant-gardism, and test it by seeing how useful it is in explaining anything about Picabia's work. First, a brief rehearsal of the two terms.

Modernism is assumed to be affirmative and seeks to consolidate its aesthetic hegemony and 'truth' by excluding everything that is not 'essential' to it. One of the key exclusions of modernism is said to be mass culture (or kitsch, for some). Modernism is said to have produced itself out of a deep anxiety about art's contamination from mass culture (but also domesticity, politics, business, etc.), establishing its opposition to a debased or ersatz

commercial culture produced for entertainment, quick thrills and/or profit. Thus the relation between modernism and mass culture is seen as antagonistic. Modernism is not, therefore, a priori independent. It could be, for instance, that its purpose derives from its assumptions about the essence of aesthetic experience, which in turn derive from nothing other than anxiety toward its cultural *other*. That is to say, the self-identity of modernism might well belie the furtive dialectic between itself and mass culture.

Avant-gardism, on the other hand, is assumed to be critical, and, strictly speaking, is supposed to unite political radicalism with artistic radicalism. The antipathy between modernism and mass culture is assumed to be reversed: avant-gardism is supposed to articulate and exacerbate this dialectic in provocative displays of self-contamination and aberration. Its techniques, according to this story, are therefore contrary to the exclusivity of modernism, and it seeks to contaminate art by importing elements from 'outside'. Ultimately, it is said, the objective of the avant-garde is to merge art and life, annihilating art in the process.[45]

It is not clear whether a theory/practice that sought to cut across this distinction (between modernism and avant-gardism) would be illicit. We are not sure whether this distinction is intended to harbour *logical* limitations for practice. Historically speaking, the artists concerned did not distinguish themselves as either modernists or avant-gardists, one thing or the other. Often the terms were used interchangeably, and certainly the terms were used 'incorrectly' at the time. The two putative practices were never clearly demarcated, bled into one another, and were seen as fully compatible – and largely remain so.

The distinction seems to have been instigated by the taxonomical needs of art history. There's nothing wrong or unusual in this, as long as we bear in mind what the distinction *cannot* explain. Picabia, for his part, took his task to be located somewhere across this theoretically neat division (without recognizing the division at all). His invectives against Cubism, for instance, were not proof of his avant-gardism qua turning away from modernism. Or rather, if Cubism represented a remaindered practice of art (namely, the artist contemplating and depicting the world as objects), and a rotten morality of art (namely, the privileging of aesthetic experience in art at the cost of life), and so on, then this was not a result of remaindering modernist art *as such* ... Picabia's famed 'anti-art' might have been 'avant-gardist' but this did not preclude him thinking of himself as 'modernist' – or indeed from doing supposedly 'modernist' things.

After the war, Picabia made some works which were more parodic and provocative than (and made at the same time as) the machine pictures: for example, *The Blessed Virgin* (1920), basically a splash, and *Portrait of Cézanne, Portrait of Rembrandt, Portrait of Renoir, Still Lifes*, an assemblage consisting of not much more than a contorted monkey. This could mean that there is an

unswervable discontinuity between Dada activities such as making a drawing on a slate that was erased as it was produced, and a more conventional studio practice, albeit with the building of a picture out of bits and pieces of a clock. Or it could mean that a continued commitment to a studio practice at a time when art was being assimilated bit by bit by a barbaric society would necessarily involve some techniques of displacement, negation or irony. If so, do not the machine pictures permit Picabia some room for manoeuvre in this respect? At any rate, the machine works were capable of sustaining a radically ironic distance from the growing timidity of modernist art by resorting to decidedly non-improvisatory, non-'pure', techniques, and extra-artistic, mundane resources.

Evaluations of the machine works should be linked to the political and cognitive achievements of Dada, the social situation of his modernism/avant-gardism, and the particular intricacies of the historical predicament. The border between modernism and mass culture, and the value of various strategies for overcoming, piercing, crumbling, questioning, this border, will have quite a lot to say about the accomplishments of Picabia's Dada works. It doesn't seem to matter very much whether Duchamp beat Picabia to this novel resource of machine parts. Nor does it matter much if his machine pictures generated 'plastic innovations'. For the point was never to renew the material and intellectual resources of art, but rather to displace the given in order to gain a little time before one's integrity turned into indignance.

Integrity

What happened to Picabia's integrity? With Dada behind him, Picabia began to produce drawings and paintings that are puzzling in a very different manner from the machine pictures. These pictures, which in numerous styles and media take him, more or less, from 1923 to 1927, have become customarily named the 'monsters'. The 'monsters' include joke-sketches about Surrealism, through graphic figurative pictures, to scruffy collages using matches, combs, tooth picks and the like.

Two available explanations compete for authority. The first works toward the understanding that the 'monsters' have forsaken Picabia's erstwhile artistic integrity. The second preserves a sense of Picabia's avant-gardist integrity with reference to much the same features of the pictures. The first explains the work as self-indulgent *retirement* pictures, stressing the coincidence of the beginning of this ugly and incompetent work with Picabia's move to the Midi. In the assertion that Picabia had turned to painting as leisure (that is, devoid of responsibility), such an account disguises its own inability to speak. It is not obvious, however, that these pictures look the way they do because Picabia had given up being serious (that he had forsaken his

'integrity'). They might indeed have been pleasurable to make, but they do not appear to be produced on auto-pilot, so to speak. In fact, quite to the contrary, the definite and deliberate incompetence and ugliness of this work suggests the opposite of self-indulgence, namely, intellectual sublimation.

The second explanation leaves his integrity intact by proposing that 'perhaps, after all, it is only the irreverence that counts in Picabia.'[46] On this account, Picabia made the 'monsters' because he wanted to break some rules – just like, so it is often thought, Dada set out to break rules. This would take his integrity to be an effect of incessant irreverence. Apart from the logical problems of such an account, there is not much to recommend it for explanatory purposes. To be sure, they do not come across as earnest pictures. However, although the 'monsters' are likely to have been made with a degree of burlesque, if they seem reducible to irreverence, they are not so reducible without residue. And moreover, to reduce the 'monsters' to an intention to be naughty says nothing about why he did these in the way that he did, rather than, say, do something else that was equally – or perhaps more – naughty.

This notwithstanding, the idea that the 'monsters' are ugly qua iconoclastic ruinations of 'taste' is compelling. It does not follow that the aim of the works is just this ruination. The structure of the work is not ancillary to such an intention. We find it further compelling to think of the ugliness of the 'monsters' as built of a half-right philistine devaluation of 'superior' culture. In saying this, we are not claiming Picabia for that capacious signifier, the 'left'. Merely, we think it is worth entertaining the thought that these aberrances are imports from an intellectual world alien to orthodox modernist practices. Furthermore, by annoying the taste of modernist orthodoxy, the 'monsters' disclose the assimilation of modernism by social reality. Modernism/avant-gardism based its hegemony on an explicit claim not to 'taste' but to 'truth' of some sort. (The supposed dis-taste and incompetence of early modernism was an effect of cognitive, political and 'realist' aspirations – and was always distasteful to some specific groups, not the modernists themselves.) Picabia, on the other hand, seems to be deliberately making ugly and apparently incompetent pictures – distasteful in particular to his modernist peers, or even his own modernist past.

After the war, there was no return to the critical ebullience of the pre-war period. The death of Dada and the birth of Surrealism did not by any stretch of the imagination signal the end of a politically discontent artistic project, but clearly the programmatic, organized character of Surrealism turned the shudder into a disciplined struggle.[47] Surrealism continued to batter on the wall of bourgeois reality. But modernist avant-gardism had undergone yet another decisive shift. Surrealism transposed the avant-garde 'movement' from a fairly spontaneous and organic affiliation to a force that might withstand the difficulties of a desperate situation. After the Second World

War, nothing like it would be seen again.[48] Thus, Surrealism signalled the end of the 'spontaneous and organic' avant-garde.

Picabia's retreat from Dada coincided with Breton's ambition to change the nature of the Parisian avant-garde. Picabia apparently saw Breton's influence as signalling a definite decline. The pictures known as the 'monsters' were made during the period in which Surrealism was developing further and stronger links with Marxism and looked toward the Communist Party – though its members were only permitted to join in 1927.[49] None of this would have pleased the Nietzschean (or disaffected bourgeois) hatred of socialism and 'the herd' in Picabia.

The 'monsters' are not 'reactionary' as a result. We want to offer the argument that the question of taste in the 'monsters' is linked to the question of integrity. Furthermore, we want to use this argument to show that the 'monsters' were neither simply nihilistic nor a reactionary turn away from his erstwhile radicalism.

The 'monsters' are characterized by a conspicuous disregard for taste. The machine works, though certainly interesting and aberrant, seem elegant by comparison. What permitted the machine works their space for critique was the way they sidled up to questions about abstraction and representation at the same time as pursuing a thoroughly non-bourgeois and non-academic taste. This is what constituted their integrity. The so-called 'monsters' did away with all of this. They seem to have abandoned every historical and aesthetic achievement ever since the moderns started to hire galleries of their own. Hence the question of whether the abrogation of the tastes of independent culture negates artistic integrity.

The 'monsters' stake their integrity on the understanding that modernism had not only become acceptable to the social reality, but that modernism itself had been found to harbour hegemonic tastes. Picabia had not just broken with the institutions and tastes of authority, he had added the tastes of independent culture to his targets and taboos. In doing so, it can be argued, Picabia indicts modernism for presuming authority over aesthetic taste.

The status of Picabia's integrity in the 'monsters', therefore, depends upon the fate of modernism. As modernism replaced academicism as the official art of modern capitalist society, so that modernist taste became official, a degree of tension ensued between modernist taste and modernist integrity.[50] Insofar as the centripetal movement of modernism from the marginalization of the early modernists to the apotheosis of the modernist artist brings about the collision of taste and integrity, the question of taste becomes entangled within the question of integrity. It does not seem profitable to reduce the distaste of these works to some convenient notion of nihilism. No Dadaist ever made pictures as awful as these. The assimilation of modernism brings about new difficulties for the pursuance of artistic integrity. The autonomy of modernism is no longer simply emancipatory. Modernist tastes have become powerful.

Picabia turned to producing 'philistine' paintings as a means of retaining what we are calling his integrity. He managed to stay awake and maintain his belligerent aesthetic integrity *despite* his political complacency. (To be sure, this is not as rare as one might think in the history of art.) Without any sense of certainty, we find the idea that the 'monsters' could permit Picabia the necessary aberrance to continue his struggle against habit and politeness sufficiently compelling.

Having made these remarks, we are not fully convinced by ourselves. It is possibly an inopportune moment to re-assess Picabia's 'monsters' given the amount of 'bad painting' and contrived irreverence there is about. One is perhaps likely to associate Picabia with such work and celebrate or condemn him on that account. Equally, the fact that there are plenty of critics around who are desperate to ridicule and demerit modernism presents a far too convenient alibi for Picabia's hostility to modernist taste. Can we get away with talking about the 'monsters' in relation to 'taste'? Isn't this just an adequately amorphous notion to use in order to cover up our ignorance of the work?

Material

The 'monsters' became the 'transparencies' which then – so convention has it – became the 'superimpositions'. There was no distinct break or crisis, only a gradual transubstantiation. As their name indicates, the 'transparencies' are characterized by a collision of two or more overlayed images such that the earlier images can be seen through the later ones. Some are rather simple and elegant, whereas others are sated with images to the point of clumsiness. The technique requires that the images which are overlayed are principally linear with only minimal tonal gradations and colour. The 'superimpositions' which followed differ largely insofar as the collision between the images involves the latter images obscuring the earlier ones.

With scant confidence in the supposed teleology of modernism it is difficult to 'locate' paintings like these. Without such a framework what sense can we make of the work? Such an anxiety does not necessarily warm us to a pluralism which promotes the most second-rate of 'expressivist' tendencies. Our interest is to interpret Picabia's 'transparencies' with some regard for what they are, what they do, and how they do it. We will proceed, therefore, by examining the works.

We begin from the assumption that the paintings generate and legislate interpretations. That is, principally, that the structure of the paintings will preclude some interpretations from the outset, and favour others. We do not know of any reason to discount the possibility that the paintings will foreclose interpretations which the artist *intends* them to have. In fact, generally speaking we would expect this. And, in this particular case, given that

Picabia described the 'transparencies' as 'the resemblance of my interior desires',[51] we would indeed expect the pictures to legislate against Picabia's authorial voice. Camfield, however, accepts Picabia's word, and then, finding the paintings enigmatically unforthcoming with fragments of Picabia's soul, falls into silence. He is not alone in doing so.[52] One might well wonder if any of the Picabia interpreters ever bothered to look at the paintings at all. They need only to have read what Picabia said and wrote about them. Our frustration with them is a mark of the fact that we have something at stake. There is, as we have said, no necessity to take Picabia at his word. His assertions have no natural rights over the interpretation of the paintings.

The 'transparencies' are more than a little silly. If they are first-order attempts to build complex images, then they are somewhat desperate. Desperate paintings are perhaps the requisite of a desperate situation, but they remain, none the less, a bit silly. But not just silly, these paintings are overdetermined and perversely elaborate in their production. Have these interpreters not noticed that the 'transparencies' *are* so weird? Have they gone out of their way to ignore or marginalize this fact? There seems to be at work a systematic repression of a detailed interpretation of the *artistic material*,[53] given that these paintings in particular seem to call for such an analysis.

Is it far-fetched to suggest that the threat lurking within the repressed interpretation is the loss of – or severe discomfort for – the 'self' (the kind of 'self' which is promised in the post-Kantian aesthetic judgement)? Picabia's statements about the 'transparencies' promise this free-wheeling 'self' in glorious abundance: he claims to have painted his inner self, with a means of production that simply records in an immediate fashion his internal desires. This leaves the unabashed interpreter to read off the apparent residues of emotional, sexual, personal, psychological, private, expression. Although it is quite likely that these individual interpreters do in fact have some investment in this image of the self, we do not rest our case on their individual pathologies. It is more important that the interpretation industry reproduces this repression by inculcating techniques that entail it. The repression is not only systematic, it is structurally perpetuated. (To make distinctions between this repression functioning for the entire social system, or merely functioning for the propagation of the little powers of the discipline in question, would take some degree of subtle work.)

Let us extend this argument that there is a systematic repression at work by speculating about possible causes or reasons. This will then help us to dispel some common mystifications and idiocies, in order better to interpret Picabia's 'transparencies'. Initially, we would like to clarify the fear which represses interpretation of the artistic material *in favour of expression, feelings*, etc. We mooted that this repression could be based on a fear for the

post-Kantian self. In the case of the 'transparencies', this is compatible with the support of the voice of the artist. However, the function of the repression is not to privilege the authorial voice. Most interpreters are happy to discount or meddle with authorial comments when the need arises. Is it not that the purpose of the said repression and the support of Picabia's version of events is a fear for the *integrity of interpretation*? If, in the process, they safeguard a certain model of authentic artistic expression, it is only because this is suitable for their practice of interpretation.

The repression is not a local problem for interpreting these paintings, or even for Picabia interpretation. The issue is the status of the artistic material. It is still presumed by most interpreters, we notice, that the artistic material is something lowly (for example, the 'means' or the 'tools' – in short, a dumb resource), for the seemingly magical moment of artistic creation/expression etc. What is at stake in such *doxa*? The interpreters themselves will have been taught to be interpreters and thence judged according to their emotional/ aesthetic sensitivity. The degree to which they manage to assimilate themselves to the discourses of art and aesthetics as the practices and experiences of catharsis and the retrieval of the self will determine their skill in their field and will prove their personal quality as sensitive observers of art. The devaluation of artistic material for the purposes of immediate expression and free interpretation, then, is linked to the mechanisms of acculturation pertaining to art interpretation.

At the coalface, as it were, the emphasis we are exploring is associated with the devaluation of artistic material in another sense. There is, today, a compulsive distrust and fear of what is called formalism. The point would seem to be related to the idea that if the artistic material is merely a dumb resource, and is nothing apart from the artist's self behind it and the interpreter's self before it, then we should only talk about 'form' as a way of talking about these selves – only as a 'means' never as an 'end in and for itself'. So-called 'formalism' is taken to be a dead-end, dealing in mere metal rather than the coinage of aesthetic interpretation. Does this mean that the fear of 'formalism' and the assumption that the artistic material is mere means is also tied up with the fear for the post-Kantian self? Whether or not, the supposition that to make a detailed interpretation of the artistic material will issue meagre results because 'form' is lifeless (a mere 'object' without a 'subject', perhaps) depends upon a model of the relations between the artist, artwork and interpreter that mystifies the very possibility of 'meaning' and the mechanisms of communicative interchange. Do we need to point out that interpretations don't issue from a silent community between the sensitive viewer and the radiating artwork? The cause/effect presumptions of such a model are an inversion of those which it practises.

What we have tried to put in question is the impulse toward a freedom of interpretation which is largely an interpretation with very little

responsibility. A painting is not merely the dumb conduit between the two supposed exemplary subjects 'artist' and 'interpreter'. The technologies of knowledge are themselves active in this process. It would seem that if one is seriously interested in interpreting works of art without the mystifications and idiocies of presuming that the artistic material is practically empty (and all that that entails), then some detailed interpretation of the artistic material would be a good bet.

To answer the question, why do the paintings look the way they do, one must first examine what the paintings look like. We have provided a very brief description already. Let us add that whatever else they were, the 'transparencies' were a disruptive collision of themes, styles, cultures and time. A 'simple' 'transparency', such as *Aello* (1930), might consist of only two images – say, a landscape 'backdrop' and a couple (of angels) overlayed predominantly in line. A more complex one, like *Luscunia* (1929), incorporates numerous images of different types – say, mythical figures, trees, birds, a mask and a few stray arms and hands – which often disappear without trace as lines merge into one another or simply terminate. Spatial relationships are suspended as a matter of course. Iconically, the paintings interrupt and confuse the integrity of each image. Lines, eyes, shapes, leaves, marks, are foregrounded and given some autonomy – or can even be completely cut off – from their respective iconic wholes by a simple process of addition.[54] In a nutshell, the process of overlaying disturbs the natural connections between iconic parts and icons.

Thus the 'transparencies' disrupt their own structural features. In doing so, they call into question the status of the picture. The relation between the disruption and the calling into question is not obvious. The task, which we will fail to accomplish, is to identify the manner in which these paintings 'turn back upon themselves' in order to put their 'means' (iconic parts) and 'ends' (icons) under stress. One thing we can say is that they do what they do not by refusing to use any disreputable pictorial devices, but, rather, by overloading the painting with such devices. The devices do not 'cancel out' one another. They add up to a totality that is bigger than the image of which they are a part.

If these paintings trade on discontinuity, displacement and rupture, and by these means disconfirm the synergy between element and totality, then they need to be interpreted in two opposing ways. If we look at them from the point of view of those expectations associated with the proper functioning of iconic representation, then these pictures will get described in terms of rupture and so on. However, we can also look at them from the point of view of the disconfirmation of these expectations. This disconfirmation is not a straightforward affirmation of a different pictorial principle;[55] it cannot be taken as a negation of what we've just called the 'proper functioning of iconic representation', because it contains and depends upon such functioning. To

look at the 'transparencies' from the point of view of this disconfirmation, then, is not simply a matter of pretending to suspend the expectations and knowledge with which we interpret pictures. This would be, at once, too easy and quite impossible. No, this second interpretation is not an alternative, but a supplement. To look at the paintings from the point of view of this disconfirmation might consist of nothing more than to oscillate between one image and another. If we had a detailed interpretation of the paintings in terms of how they are structured to disturb these relations, then we would be in a position better to evaluate them as items both in Picabia's oeuvre and in the trajectories of modernist art.

Just to get the ball rolling, we would like to suggest two more aspects of the 'transparencies' which should form part of a detailed interpretation of them as artistic material (we have already looked at them, briefly, in terms of iconicity). First, what we need to know is what happens to the status of the painting as a *representation* when it is put iconically under stress. The resulting painting will not only be iconically aberrant, it will create cognate trouble for its status as a representation. The fairly classic categories of a painting (surface, space, composition, ground, image, etc.), as well as questions at the level of process, technique, agency, and so on, will all be affected as the ground on which they regularly function (that is, iconicity[56]) is made to unravel itself. More or less the same things happen in the 'superimpositions' as in the 'transparencies', insofar as they both call into question the initial leap of faith which is required to 'enter' the picture (namely, agreeing to this particular fictional mise-en-scène).

Second, and presumably most importantly, we would need to ascertain what is retrievable from such a painting. This would involve the need to take a side-ways glance at the common idea that these paintings are enigmatic to interpretation (perhaps because they are private, or too complex). This could well lead us to question the border which separates the images as artistic resource, and as interpretative object. The image derived from a myth, or a painting (by Botticelli or Piero della Francesca), or both, begins with a fairly fixed 'meaning' for the adequately informed observer. Picabia selects images, say, because he knows what they 'mean' within their respective narratives. But, on the other side of the border, things are far from clear and hermeneutically 'closed' – even if they were in the first place. There is no necessity for everything to carry forward from one side to the other. The task is not to ascertain precisely what Picabia knew of the image, for even the artist would not necessarily have any way of deciding what these familiar images 'meant' in their new environment and with these new neighbours. We would expect, then, that if these pictures remain enigmatic to the adequately informed observer, it is not because they are private or too complex. Rather it is likely that the enigma of interpretation would be related to the structural character of paintings that look like this.

Notes

1. 'The Later Works', catalogue essay, Mary Boone-Michael Werner Gallery, 1983, reprinted in *Picabia, 1879–1953*, Scottish National Gallery of Modern Art, Edinburgh 1988, p. 47.

2. Ibid., p. 47.

3. Ibid., p. 46.

4. In William A. Camfield, *Francis Picabia*, Solomon R. Guggenheim Museum, New York 1970, p. 9.

5. What might count as either a necessary or a sufficient condition?

6. Helena Lewis, *Dada Turns Red: The Politics of Surrealism*, Edinburgh University Press, Edinburgh 1990, p. 1.

7. This could not be true unless one thought that tampering with the protocols and intricacies of art amounted to subversive behaviour. And if one did think such a thing, then Dada would certainly not be unique amongst modernist movements. If, on the other hand, one expected a bit more for the claim, then Dada would certainly not suffice.

8. William S. Rubin, *Dada and Surrealist Art*, Thames & Hudson, London 1969, p. 10.

9. Willy Verkauf, ed., *Dada: Monograph of a Movement*, Alec Tiranti Ltd, London 1957, p. 12.

10. Hans Richter, *Dada: Art and Anti-Art*, Thames & Hudson, London 1965, p. 9.

11. André Breton, 'Dada Manifesto', *Littérature*, 13, May 1920.

12. Dawn Ades, *Dada and Surrealism*, Thames & Hudson, London 1974. Ades, on the face of it, seems to offer something. She rightly presumes that if an artist is involved in some sort of attack on art and society s/he will necessarily be caught in something of a dilemma. The only problem is that the alternatives which she describes are fatuous: they neither fit the historical facts, nor say very much about the Dada movement.

13. Ibid., p. 4.

14. Ibid.

15. Ibid.

16. Ibid., p. 15.

17. The story of Dada goes like this, more or less. It was born in Zurich in 1916 at the Cabaret Voltaire, amidst the First World War, which had brought to an abrupt end an artistic culture of dynamic discontent. As early as 1917, its founder members were breaking away from one another. Huelsenbeck returned to Germany to found Berlin Dada in February 1918. In January 1920, Tzara was in Paris to collaborate with Picabia and Breton on Paris Dada. So-called New York Dada was allied in a very loose way – we will see how Picabia's New York work of 1915 entailed a definite shift in his work, but that it is difficult to talk about his pre-1919 work as Dadaist. Notwithstanding anything that individual Dadaists did afterwards, Dada died in Zurich, then Berlin, and later in Paris.

Whether one believes that Dada *had to die* because its life was based on mortality (an apocryphal tale, we would suggest, related to the anxiety that Dada was so utterly chaotic and aberrant that if it hadn't died we might have!), or that Dada lived on in Surrealism and then in Rauschenberg and Johns et al. (a story that requires very particular interpretations of Dada, according to the interests of Surrealism, and those of the American iconoclasts), Dada fell apart as even a loose affiliation around 1922 and there was nothing much left of it by the following year. The question of the nature of the death of Dada is linked to assumptions about the character of its life, as is clear in statements such as 'the constant, directionless activity was, in the end, destructive of Dada itself' (Lewis, *Dada Turns Red*, p. 16).

18. See Charles Harrison, 'The Ratification of Abstract Art', in M. Compton, ed., *Towards a New Art: Essays on the Background to Abstract Art, 1910–20*, Tate Gallery, London 1980.

19. And although there is some contention over the exact derivation and authorship of the name, it is certain that originally someone, or some small group, made a more or less intentional decision to use the name. The point is, the Dadaists coined the name intentionally, and used it deliberately as part of their active self-definition. But when the name started to catch on, any 'original' meaning or suggestion which it might have had was left behind. The word becomes more like a shibboleth, a password, than a name. The status of the word itself adds to the already burdensome difficulties of definition.

20. Ades, *Dada and Surrealism*, p. 28.

21. William A. Camfield, *Francis Picabia: His Art, Life and Times*, Princeton University Press, Princeton 1979, p. 99.

22. Despite the fact that Camfield talks about Picabia's 'nascent dada spirit', he also warns against what he calls the 'dada complex' amongst commentators. Camfield does not go along with the idea that Picabia's pre-Dada work was intended to 'mock and mystify' (ibid., p. 77) and prefers to weed out 'some unexpected constancy within the seemingly erratic evolution of his work' (ibid). His taboo on the 'dada complex' suffers from its own complex; and one wonders why he is so keen on 'constancy' – is he after historiographical elegance, a sign of his own skill? – and is this linked to his commitments to the expressive authorial self, artistic creativity, aesthetic psychologism, etc.?

23. Shortly after Tzara contacted Picabia in Switzerland inviting him to Zurich, Picabia sent a number of the machine paintings to an exhibition for the Salon d'Art Wolfsberg. They were admired by the Dadaists but the director of the Salon turned them away, having 'decided he could not exhibit such things' (ibid., p. 118).

24. See Richter, *Dada: Art and Anti-Art*, p. 71.

25. It is worth remarking how exotic this project sounds today.

26. Some, for instance, are emphatically momentary, such as *The Corrida* (1941) and *Spring (M. and Mme Romain)* (1942).

27. By the early twenties Picasso had turned away from the subtleties of an unremitting Cubism toward a fairly sanitary figuration. Picabia's art after Dada is often thought of in relation to this supposed general reactionary swing. It is part of the intention of this essay to render such a statement inoperable.

28. We side with those who call them 'commercial' rather than 'popular' for obvious reasons related to the political implications of the latter.

29. Camfield, *Francis Picabia* (1970), p. 17.

30. Quoted in ibid.

31. Quoted in Dawn Ades, *Dada and Surrealism Reviewed*, Arts Council of Great Britain, London 1978.

32. See Compton, ed., *Towards a New Art*, especially footnote 1 to Norbert Lynton's 'The New Age: Primal Work and Mystic Nights'.

33. See Camfield, *Francis Picabia: His Life, Works and Times* (1979).

34. Quoted in ibid., p. 46.

35. Camfield remarks that in these paintings 'his personal affairs were transformed into abstract compositions suggestive of more universal longings, frustration and despair' (ibid., p. 22). But how could he? How does Camfield know? What is the supposed connection between the 'personal affairs' and the 'abstract compositions'? What is supposed to occur *between* one so-called 'state' and another? Is there any way of assessing the success of this 'transformation' which is not equivalent to making aesthetic judgements about the painting? Etc., etc.

36. Ibid., p. 64.

37. Quoted in Camfield, *Francis Picabia* (1970), p. 21.

38. The suggestion is that this is precisely the kind of proposition which inculcates the 'dogmatic heuristic' which Charles Harrison inveighs against in his essay 'The Ratification of Abstract Art'.

39. Camfield, *Francis Picabia* (1970), p. 23.

40. The word 'ass', of course, might also refer to an ass. It is not impossible to make a case for the picture to resemble an ass: two wings of the propeller prick up like ears, and so on. The point is not to interpret the picture (in the sense of tying it down to a definite meaning), but to show how the picture works. The picture works in the same way in either case, except that using the word 'ass' to refer to an anus involves yet another level of figural meaning.

41. The term 'iconlike' refers to the tradition of icon painting, not to iconicity.

42. Camfield, *Francis Picabia* (1970), p. 82.

43. Ibid., p. 84.

44. This goes against Donald Kuspit's idea that the machine pictures were essentially misogynistic in that 'she ["woman"] was converted directly into a machine, which made her at once less mythic and more inhuman' ('Francis Picabia', *Artforum*, September 1989, p. 140). We do not wish to deny that Picabia was misogynistic, only that his use of machines was not directed at that impulse.

45. This is a very brief description of sometimes very sophisticated and detailed arguments. For more subtlety *cf.*, for instance, Peter Bürger, *The Theory of the Avant-Garde*, trans. Michael Shaw, Manchester University Press, Manchester 1984; Andreas Huyssen, *After the Great Divide*, Macmillan, Basingstoke 1986; and Raymond Williams, *The Politics of Modernism: Against the New Conformists*, Verso, London 1989.

46. Kuspit, 'Francis Picabia', p. 140.

47. Breton built Surrealism on the bases of Marx and Freud. Surrealism argued lucidly for the freedom of art and the freedom of all under Communism. Surrealism is thus unlike any other previous avant-garde movement. Its discipline and lucidity led to expulsions on the grounds of orthodoxy. Its manifestos were not literary gestures of inchoate resentment and rebellion, but statements of their principles and intentions. Surrealism can be credited with an abundance of political, moral, aesthetic and historical nous. In indicating that Surrealism incorporated a shift in the history of the avant-garde, we are merely pointing out that it took the idea and practices of a 'movement' and did something to it.

48. Situationism, it might be said with justification, was just such a post-war 'avant-garde'. Situationism was disciplined, issued pamphlets, etc., and even became involved in expulsions of members for presumed heterodoxy. Situationism, however, for good or ill, was less an artistic avant-garde than an aestheticized political avant-garde.

49. See Lewis, *Dada Turns Red*.

50. It has not gone unnoticed in art historical circles that Picabia's 'monsters' appeared at the same time as numerous other erstwhile modernists 'reneged' on their past to figuration and the like. We are attempting to find a way in which to think of Picabia's turning against modernism without having to protect the integrity of modernism at the same time.

51. Quoted in Camfield, *Francis Picabia* (1970), p. 233.

52. Sarah Wilson describes them as 'memories of images' (in the essay 'Transparencies 1924–1932', in *Accommodations of Desire*, Kent Fine Art, New York 1989); Donald Kuspit stresses Picabia's 'irreverence' and 'homeless sexuality' ('Francis Picabia', p. 140).

53. By artistic material we do not mean stone or paint, we mean the whole gamut of materials (including cognitive and cultural ones – thereby including, for instance, the conventions and resources of iconicity), which go into the composition of the work. We do not discount psychological, intentional and other 'causes', but we certainly do not privilege them, nor – under the current intellectual circumstances – do we recommend them in the manner of conventional usage. What we have called the 'artistic material' we take to be a technology of knowledge.

54. It is interesting to note that the more usual means during modernism – and later canonized by late modernists – by which to foreground the elements of a picture would derive from processes of *subtraction*. Cubism, for instance, separated the depiction of planes, form and light from the depiction of objects by spoiling the picture's coherence and reducing the lexicon of picture-making.

55. It's not that this is impossible. Theoretically speaking, iconic interpretation is generated from a set of conventions which, once learned, permit a practically infinite variety of possible novel icons which can be interpreted on the basis of the knowledge of the original conventions. The relation between the conventional and the 'natural' aspect of iconic interpretation is as yet undertheorized and enigmatic.

2

The Difficult Freedom of

Ad Reinhardt

Michael Corris

Drawing on a virtually unknown body of work consisting of illustrations, cartoons, and graphic designs by Ad Reinhardt (born: 1913, Buffalo, New York; died: 1967, New York) published in the magazine *New Masses* between 1936 and 1945, I intend to examine the various available interpretations of the artist's relationship to the left and argue for an alternative view.

In particular, I will show that Reinhardt's involvement with the American Communist Party (CP-USA) during the thirties and forties was far more extensive and has far more relevance to his development as an artist than previously thought.[1] Furthermore, his relationship to Marxism and the Party was not merely 'intellectual' and 'aesthetic'[2] but rather political, as demonstrated by, among other activities, his production of more than 350 editorial illustrations, advertising designs, full-page cartoons and magazine covers for *New Masses* and *Soviet Russia Today*.[3] (See Figures 1 and 2.)

In fact, Reinhardt's extraordinarily vigorous involvement with the cultural and political life of the Communist movement in New York City begins prior to his graduation from Columbia University in 1935 and continues, in one form or another, virtually until the end of his life. In this essay, however, I will concentrate on the period between 1936 and 1950.

New Masses was a magazine which began publishing as a political and cultural monthly in 1926 under the direction of an openly Communist leadership but with an editorial policy that encouraged the participation of intellectuals outside the Party.[4] The doctrinal shifts of the Sixth Comintern Congress and the promotion of a 'proletarian literature' in the Soviet Union formed the basis for an editorial focus which sought to transform *New Masses* into 'the cultural organ of the class-conscious workers and revolutionary intellectuals'. By 1934, *New Masses* was being published as a weekly; its peak of popularity was reached during the Popular Front period of the late thirties. Reinhardt's initial contribution to the magazine was as a cartoonist

ART HAS NO HISTORY!

"I Withdraw My Name from the Trotsky Committee" *A letter by* M. A. Hallgren

NEW MASSES

FEBRUARY 9, 1937 FIFTEEN CENTS A COPY

Not All Rubber Stamps

SOME PROGRESSIVES
IN CONGRESS

M. R. Bendiner

Who Is "The God of Floods"?

Edwin Rolfe

The Moscow Trials

An Editorial

Figure 1. Cover illustration. *New Masses*, 9 February 1937. Private collection, New York.

and illustrator working under the pseudonym 'Darryl Frederick' and took place at a moment when the publication was considered to be central to the interests of the literary-political left. According to Paul Buhle, the class shift of *New Masses* during the Popular Front period 'from a fantasized constituency to a real one marked its new importance. . . . The magazine now

Figure 2. Cover illustration. *Soviet Russia Today,* July 1937. Courtesy Research Center for Marxist Studies, Inc., New York.

correctly saw itself as the expression of a large-scale turn in popular middle-class opinion ... it implied without ever adequately stating that Marxist ideas had a place in American life.'[5] *New Masses* of the mid-thirties was well suited to an individual like Reinhardt, himself a graphic designer conversant with the intellectual and cultural world of the middle class.

Reinhardt's connection to graphic design stretches back to his childhood and is of central importance to our understanding of his early political engagement and subsequent studio practices of the forties. Throughout secondary school he had been a precocious cartoonist and illustrator who seemed poised for a promising career in commercial art. Yet Reinhardt resolved early on – apparently over the objections of his parents – not to pursue commercial art professionally.[6] However, despite his stated interest in fine art, he decided against attending art school and paradoxically accepted a scholarship offer to Columbia University in 1931. A liberal arts education, while valuable in its own right, promised Reinhardt no concrete outcome on a par with that offered by training in either applied or fine arts. On the other hand, Columbia's considerable academic prestige was surely a factor in his decision.

From the mid-thirties, Reinhardt began to weave a pattern of subsistence

and studio work which would be maintained for a decade. While a university student, Reinhardt had worked in professional graphic design studios during summer vacations. Compelled to support himself financially, he continued to solicit freelance graphic design work after graduation and consistently divided his energies between commercial art and design and the milieu of abstract art. Through an examination of Reinhardt's visual output of the latter half of the thirties and well into the forties we find that the demands of graphic design occupied a significant part of his attention, if not his creative energies. That Reinhardt invariably took his commercial art work seriously is attested by his development of innovative design practices and participation in the trade union movement's organization of graphic designers and newspaper staff artists. During this period, Reinhardt worked concurrently as an artist, labour organizer, political activist, illustrator and typographic designer. Accommodating the split between fine and applied art was not so easily effected, however; the few available texts of that period suggest that the pressure for some sort of integration of practices was high. Consequently, an adequate theorization of Reinhardt's practices demands more than an enumerative description of these diverse social roles.

To the editors of *New Masses*, Reinhardt must have seemed an extraordinary catch. Here was an individual possessing a considerable and original talent for illustration and cartooning; an aspiring artist of working-class background, sympathetic towards the political organization of labour; and a university graduate with a strong interest in culture and art. Indeed, Reinhardt's profile fits, in many respects, that of the ideal Popular Front recruit to the CP-USA. Like his friend and fellow abstract painter Harry Holtzman, Reinhardt epitomized a new type of New York artist of the thirties: one who gravitated towards Parisian or Neo-Plasticist aesthetics, militantly defended modernist abstraction as virtually a sub-discipline of the social sciences, was seemingly indifferent to the bohemian trappings associated with an older generation of New York artist-radicals, and responded to the practical appeals of the political left. The social environment of these 'artist-intellectuals' entailed its own 'culture' of abstract art; partially defensive, but invariably 'progressive' and collectivist. This is encapsulated by the tenor of Holtzman's plea, addressed in 1936 to New York abstract artists, for the establishment of 'an artists' cooperative and workshop school to be jointly financed and devoted to the advancement of abstract art in the United States'.[7] That Reinhardt shared these values is suggested by his assertions, throughout the late thirties and forties, that paintings are not simply meaningless or decorative compositions of colour and line, but objects of intellectual as well as aesthetic complexity. Throughout the forties, Reinhardt took on the role of popular proselytizer, authoring and designing broadsheets for the American Abstract Artists (AAA) and using the mass media to explain to the 'general public' the proper 'culture' of reception of abstraction in art.[8]

The tensions arising out of the specific nature of Reinhardt's ambiguous class location – exemplified by his relationship to the dual worlds of mass art and high art – are generally overlooked. But they do play an important role in shaping his early practice, his articulation of the relationship between what we might crudely refer to as 'art' and 'politics'. In this regard, we need to pay particular attention to Reinhardt's orientation towards Communist political culture at that time; a 'culture' that has been aptly characterized as a reflection of a false dichotomization of political struggles into 'culture on the one side and class-conflict on the other'.[9] It is now clear that Reinhardt's views on 'art' and 'politics' were initially couched in Marxist terms. Although ideologically heterodox from the start – they are a hybrid of thirties Marxism-Leninism and Neo-Plasticism – they were not for that reason necessarily unique. Nor, contrary to popular belief, were they especially challenged by the Party during the late thirties through mid-forties. This last factor gave Reinhardt and other non-figurative artists the opportunity to establish a necessary discursive space on the left. Their positions subsequently took on the rhetoric of revolution alongside historicist claims for the centrality of the practice of abstraction in art; the latter being a practice held to be necessarily progressive and modern. In defence of their call for the integration of abstract art and revolutionary politics ample precedents were cited: amongst others the work of the Soviet avant-garde, Picasso and Léger. It seems to me that at least the first decade of Reinhardt's career is inextricably linked to his involvement with Marxist-Leninist doctrine. Certainly, Reinhardt's dissenting relationship to the New York art world throughout the forties becomes more intelligible when grasped against this background; to the familiar series of uncomfortable ideological confrontations with 'Abstract Expressionism' we must surely add Reinhardt's commitment to the 'difficult freedom' of the modernist left.

'Hack!'

In October 1933 Reinhardt published a cartoon titled 'Hack!' in the magazine *Jester*.[10] (See Figure 3.) It is tempting to read it as the artist's first potent self-reflection on the social location of the practice of modernist art. The pertinence of such a reading is somewhat deflated by recalling Reinhardt's Wildean editorial statement of 1935 written for *Jester*: 'We dislike pseudo-people and smug stupes and the aesthetically insensible. We are going off on our high horse. We want to be respectable. We like radicals. We are doggedly determined to be different and much funnier. We hate [the conservative]. He has bad taste.'[11] As inflected by jejune sarcasm as 'Hack!' may be, it nevertheless remains something of a precedent for Reinhardt in its depiction of a confrontation between 'high' and 'low' art which is refracted significantly through class, rather than mere 'taste'.

"Hack!"

Figure 3. 'Hack!' *Jester*, October 1933. Courtesy Columbia University, Columbiana Collection.

Had Reinhardt not represented the characters so clearly as stereotypes of 'worker' and 'aesthete', we might have been inclined to read the cartoon entirely through the irony of the editorial. As it stands, however, 'Hack!' triggers a crucial interpretive shift: it is an inducement to revise our conception of the cultural space within which we place Reinhardt's work. A significant feature of that 'space' is the *equivalent cultural value* of 'fine' and 'applied' art.[12] This, of course, is not what 'Hack!' explicitly represents. Rather, the cartoon suggests the propriety of an attitude of resentment or class bias towards a particular type of 'fine art' practitioner. It prepares the ground for a more extensive attack on the existence of cultural inequity amongst artistic practices within bourgeois society.

The originating ground of 'Hack!' is not yet the rich aggregate of practices Reinhardt would experience as artist and graphic designer during the thirties, but merely the desire to take a swipe at a certain type of snobbery. Not until the early forties, in a polemic titled 'The Fine Artist and the War Effort', can we locate in Reinhardt's writings what seems to be an

appropriate and convincing caption for that cartoon: 'Exactly how less creative *are* the artists who change our world every day ... with their practical limitations, than the fine artists, with their imaginative restrictions?'[13] As it stands, the cartoon of 1933 fascinates us because of Reinhardt's choice of caricatures. Why is a *worker* being debased by a *dandy*? And a *painter*, no less! This brittle melodrama of the confrontation between the aesthetic extremes of highbrow and low class is retrieved from pathos by an ambiguity of representational detail. Whose voice cries 'Hack!'? It is this indeterminacy which shatters our expectations and ultimately has a great deal to do with what 'Hack!' can be a picture *of*. Addressed *to* the worker by the Uptown artist, the epithet 'Hack!' is clearly a slur; the diction of which has been termed elsewhere 'class racism'.[14] The same insult launched by the sign-painter would be just as confrontational, but with real irony, and capable of enticing us to pose the question: 'Who is an "artist" and why?'

In 1933, Reinhardt was not likely to have been exercised by such portentous questions. By 1946 – as his tour de force 'Political Cartoon'[15] demonstrates – he supplies us with a very nearly perfect reply. Reinhardt's subsequent caricatures of artistic types – his so-called art satires of the fifties – would become the symbolic representation of his reckoning with the social formation of the New York School. Placed in this context, 'Hack!' is but the first of many representations of the self-arrogating privilege of a certain type of artist. The artist is depicted as an aesthete and the encounter is staged between aesthete-artist and working-class artisan, rather than between the aesthete-artist and 'authentic' artist.

The cultural space within which Reinhardt worked during the mid-thirties to later forties was awash in sentiments proclaiming 'aesthetic values are inherent in all the activities of life'.[16] In terms bordering on the instrumental, abstract art is insistently referred to as 'propaganda' for the positive social value of 'integration' by left followers of Mondrian, like Charmion von Wiegand (artist, historian and partner of Joseph Freeman, a noted editor of *New Masses*), and Balcomb Greene. The latter, praising Léger, writes: 'It has remained for the artist, as specialist, to make paintings whose function is to integrate individuals, by clarity and courage transforming them from defensive human beings.'[17]

Reinhardt also wished to go beyond the social conditions of the capitalist division of labour, to actualize modernism's presumed revolutionary potential in a world of the near future where 'imaginative plastic activity, in its purest and most abstract form' is no longer a decoration, or a picture of anything, and cannot be misunderstood. But to do so would entail moderating or transcending the glaring idealism of Neo-Plasticism; already derided by some fellow travellers as 'a program of watchful waiting for the artist in the ivory tower – albeit with a fresh coat of red paint'.[18] To this end, Reinhardt asserts that

Mondrian, like Marx, saw the disappearance of works of art when the environment itself became an aesthetic reality. In its dissatisfaction with ordinary experience, the impoverished reality of present-day society, an abstract painting stands as a challenge to disorder and disintegration. Its activity implies a conviction of something constructive in our own time.[19]

'Disorder and disintegration' soon becomes 'disorder and insensitivity'; but not until 1946, when Reinhardt's faith in the project of reconciling Mondrian with Marx had faded.[20]

Social encounters inscribed in terms of 'high' and 'low' culture are often understood to be allegories for class struggle. Whatever sophicated irony or class resentment may be recoverable from 'Hack!' by reading in a degree of sympathy for the 'low' or 'commercial' artist, issues of class remain undeveloped by Reinhardt. For if the aesthete is mocked, the working-class sign painter is not necessarily elevated, and the 'direct and complete social participation of all of the people in cultural and creative activities' remains unfulfilled.[21] Powerful arguments which focus our attention on the potentialities and cultural dynamics of 'fine' and 'applied' art – ways and means to elevate the sly hero of Reinhardt's cartoon – are to be found in the discourse on modernist art and mass culture; but not necessarily where or when we expect to find them. Here, obviously, Meyer Schapiro comes up for the count. Not via a rehearsal of the concepts of his 'Social Bases of Art' (1937) nor 'Nature of Abstract Art' (1937); rather, through a reading of his virtually uncited 'Public Use of Art'.[22]

Schapiro wrote 'Public Use of Art' – also the name of a committee of the Artists' Union – as a contribution to the ongoing debate on the strategy to be adopted by artists struggling for the continuation of government support for art through the Works Progress Administration's Federal Art Project (FAP).[23] The article was published in *Art Front*, the official publication of the Artists' Union, an organization recognized as the de facto bargaining agent for the artists employed by the FAP.[24] Gerard Monroe points out that '[i]n the fall of 1936, President Roosevelt ordered the Works Projects Administration [WPA] to pare its rolls in keeping with the expected absorption of workers by industry during an apparent upturn in the economy.'[25] Responding to this crisis, the Artists' Union called for resistance to the efforts by the government to eliminate artists' jobs. Going beyond the demand for job security in this instance, the Union called for the FAP to 'become a permanent feature of our social and national life'.[26] Schapiro raises this key strategic demand, asking: 'What can artists do to maintain these projects and to advance them further toward a really public art?' Schapiro replies that 'artists must develop a *public art*, which implies a specific constituency, even though the WPA/FAP also supports and accepts art that is "freely created work"'.[27]

The call for a 'really public' art is actually a veiled attack on the FAP for Schapiro argues that there is a real difference in the economic and political interests of artists and workers. Witness the artists' response to this crisis: they are agitating for a permanent programme of government employment, ignoring the fact that there has never been any real support for such projects which exclusively benefit artists. The workers, says Schapiro, want to return to full-time employment, to fight to obtain social insurance, to return to the prospects of skilled labour, and higher earnings based on a union scale of wages. The artists, on the other hand, 'would rather maintain the projects than return to their former unhappy state of individual work for an uncertain market'.[28] The belief shared by artists working for the FAP that they had somehow been transformed into 'art workers' is a delusion arising from a bureaucratic necessity: artists are not really employees of the government, 'they are simply on emergency projects'.

For Reinhardt, the most compelling concept presented in 'Public Use of Art' would have been the assertion that 'a public art already exists', in the guise of comics, magazine pictures and the movies. The public responds to these forms, according to Schapiro, with a type of enthusiasm unmatched by the artistic painting and sculpture of our time. He swiftly moderates his populist tone, introducing a more sombre and scathing analysis of the mass media: 'It may be a low-grade and infantile public art, one which fixes illusions, degrades taste, and reduces art to a commercial device for exploiting the feelings and anxieties of the masses; but it is the art which the people love, which has formed their taste and will undoubtedly affect their first response to whatever else is offered them.'[29] The artist has a choice: if he or she 'does not consider this to be an adequate public art, would his present work, his pictures of still-life, his landscapes, portraits *and abstractions*, constitute a public art?' Reinhardt concurs with Schapiro on this point, stating 'magazines and movies began to make better pictures and cheaper. They gave people more entertainment and more information. (The motion picture taught people more about our natural world than centuries of representational painting.)'[30] Thus, it is Schapiro's argument that is invoked when Reinhardt articulates his eventful separation of 'picture' purpose from 'painting' purpose.

Schapiro never specifies the link between the popular – not populist – forms of mass media and high art; he uses the example of mass media essentially to *cow* the Social Realist. Reinhardt, on the other hand, was one of the few modernists of the thirties possessed of sufficient artistic versatility to have remained unfazed by Schapiro's claim that politics and the subordination of art to the interests of the working-class struggle would necessarily dominate the current historical period. Reinhardt could actually enact the political side of that claim without compromise; it is worth recalling here that he did not come to politics as a fine artist. To make the argument stick for the

abstract painter in general, however, was risky as it meant that Reinhardt had to invoke a Marxified version of Neo-Plasticism; the latter being a doctrine which Party bureaucrats associated during the forties with ultra-left (that is to say, Trotskyist) aestheticism.

When Schapiro asks for whom the artist paints or carves, and what value this work can have for the new audience of class-conscious workers, we can gauge how thoroughly Reinhardt had internalized these problems, which he articulated as '[w]orking towards a synthesis of the arts, to an eventual absorption of the imaginative artist in a more collective and anonymous job of creating better places for people to live in.'[31] The new conditions for a politicized Neo-Plasticism constitute Reinhardt's ultimate justification of abstract art; but one which is grounded in the knowledge that without the political and economic transformations set out in an abbreviated form in 'Public Use of Art' there will only be the possibility of an art, in Schapiro's words, of 'utmost banality and poverty of invention'. Reinhardt's political practice, along with his texts of the forties, is consistent with a belief that real change in art is possible along the lines envisioned through solidarity with the workers and the active support of their real interests. It challenges the notion that the artist's own 'insecurity and the wretched state of our culture can be overcome within the framework of our present society'.[32] Perhaps the reason we do not find other, earlier texts by Reinhardt which directly address the political struggle and wave the red flag is because they would have been redundant. Reinhardt's political 'thought' was elaborated at the drawing board, in the union halls, and on the picket line.

Portrait of the Artist as a Young Communist

During the mid-thirties, Reinhardt participated in an extensive social network of artists and writers who had become involved with organizations and publications associated with Popular Front politics, such as the American Artists' Congress and *New Masses*, and quickly gained entry into Communist circles. There, he enjoyed the support of friends and acquaintances who also shared an interest in graphic design, illustration and painting.

In addition to *New Masses*, Reinhardt worked for *Soviet Russia Today* – an illustrated monthly magazine first published in 1931 by the Friends of the Soviet Union (FSU).[33] Employing the pseudonym 'Darryl Frederick', Reinhardt contributed illustrations, including the design of colour covers, to several issues throughout 1937 and served on the editorial board. A decade later, Reinhardt illustrated articles for the magazine which argued for an end to anti-Soviet, anti-Communist press propaganda and the normalization of US–Soviet relations.[34] (See Figure 4.)

Figure 4. 'Communist Fronters . . .' *Soviet Russia Today,* March 1947. Courtesy Research Center for Marxist Studies, Inc., New York.

Abe Magil, an editor of *New Masses* from 1940 to 1948, asserts that Reinhardt had functioned as de facto art director for *New Masses* for at least one year between 1939 and 1943, in addition to having been, since 1936, one of its most prolific graphic contributors.[35] According to documents recently obtained through the Freedom of Information Act by the art historian David Craven, FBI surveillance of Reinhardt began in mid-1940, and the artist was later considered for custodial detention, because of his 'membership and apparent activity with the Communist Party'.[36] It is Reinhardt's work in *New Masses* that figures as important evidence in early FBI field reports.

The variety of aliases and forms of signature to be found identifying this body of work include the single letter 'R', or 'f'; which may stand for 'Roderick', 'Rodney' or 'Frederick'.[37] The pseudonymous signature of 'Darryl Frederick' can be found in Reinhardt's distinctive uncial-like hand, and is often abbreviated by the initials 'df'. When Reinhardt inscribes his works with his given name, he frequently signs his surname in upper case characters. Other works credited to Reinhardt portray the distinctive 'aR' monogram. Earlier works tend to be signed or credited 'Ad F. Reinhardt'; this is consistent with the artist's use of the fully initialled form of his name 'A.D.F. Reinhardt' on virtually all letterheads and exhibition rosters of the AAA throughout the late forties. As Reinhardt's full name is 'Adolph Dietrich Frederich Reinhardt', it is obvious that many of the aforementioned pseudonyms are concoctions of his surname and Anglicized middle names.

To the best of my knowledge, Reinhardt abandoned the use of pseudonyms when he ceased working for *New Masses*.

During the early forties, prior to US involvement in the Second World War, the harassment of Communists and suspected Communists was stepped up. The Party believed this was principally in response to their political line, which, since the Nazi invasion of Poland in 1939, had characterized the ongoing war in Europe as 'phony' and 'imperialist'.[38] The CP-USA, following directives from Moscow, vigorously opposed US war preparations, as well as interim measures – such as material and financial aid by the US to Great Britain, France, or Poland – which the Party believed correctly would lead to direct military intervention. In a 1940 policy statement titled 'The People's Road to Peace', Earl Browder – the General Secretary of the CP-USA from 1934 to 1945 – identified the Party's first task as to 'keep our country out of the European war . . . to inform and educate the masses in the program of the socialist way out of the crisis'.[39]

The CP-USA became more critical of Roosevelt's moves away from neutrality, which included the amendation in November 1939 of the Neutrality Act, and the Lend-Lease Act of early 1941. These new laws enabled the US to support Great Britain materially in its military efforts against Germany while technically remaining outside the conflict. The CP-USA interpreted the policies of the 'War Party of the American bourgeoisie' – Browder's epithet for the Democratic Party – to mean that 'Wall Street is preparing to take America into the war to save the British Empire from collapse.'[40] Speaking to an anti-war mass meeting sponsored by the Young Communist League in New York City, Browder predicted that: 'The second imperialist war, through the struggle of the masses to bring it to an end, will give birth to a socialist system in one or more other countries.'[41] This political line was dutifully reflected in the editorial content of *New Masses* during 1940, and all Reinhardt's cartoons which address foreign and domestic policy issues related to the so-called 'imperialist war'.[42] (See Figures 5–9.)

As Party attacks against Roosevelt's foreign policies became increasingly vituperative, the administration responded with a widespread campaign of intimidation directed at the Party and its supporters in an attempt to limit its political effectiveness in organizing anti-war sentiment. For instance, the Voorhis Act – which took effect on 1 January 1941 – was intended to compromise the legal existence of the CP-USA by compelling it to register as an agent of a foreign power on the grounds of its membership in the Communist International (Comintern). The Party effectively evaded this trap by dissolving its affiliation with the Comintern and modifying its constitution to conform to the wording of the Act. The federal government replied by intensifying its offensive; in March 1941, Browder was prosecuted and convicted on a technicality relating to a 1937 passport application for which he was sentenced to a four-year prison term.

Figure 5. 'Idle Hands . . . Idle Hands . . . Now let's see . . .' *New Masses*,
20 February 1940. Private collection, New York.

Figure 6. Cartoon. *New Masses*, 10 December 1940. Private collection, New York.

Figure 7. 'I deeply appreciate your action in this matter, Winston.' *New Masses*, 25 February 1941. Private collection, New York.

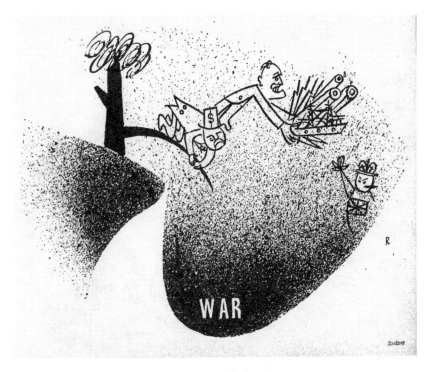

Figure 8. 'WAR.' *New Masses*, 14 January 1941. Private collection, New York.

The German invasion of the Soviet Union in June 1941 led to a crucial reversal of the Party's position on US neutrality. After the US declaration of war on Germany and Japan following the Japanese attack on Pearl Harbor on 7 December, the relationship between the CP-USA and the US government began to improve steadily. The Party became one of Roosevelt's most enthusiastic supporters, urging repeatedly for the Allied initiation of a second front against Germany. It even ignominiously provided the US government with documents in connection with the trial and conviction of Trotskyists prosecuted in 1941 under the statutes of the Smith Act.[43] Roosevelt, recognizing the role being played by the Soviet Union in the eventual defeat of Germany, was now eager to forge a strong alliance with Moscow; Browder's sentence was commuted in May 1942 'to strengthen national unity'.[44] The immediate pre-war 'Red scare' was over, and the political tasks of the future were now defined as 'the consolidation of the united nations' total war effort against our common enemies'.[45]

Despite the cumulative negative effects of years of unpopular positions on the Party's influence among the left-wing intelligentsia – the support of the Moscow trials in the late thirties, the Hitler–Stalin pact of 1939, and the

Figure 9. 'You're a menace to civilization!' *New Masses*, 2 January 1940.

Soviet invasion of Finland in November 1939 – the CP-USA was able to maintain its traditional social base. Although the Party suffered losses to a higher degree than Browder had predicted, defections were not numerous and it continued effectively to mobilize labour and certain factions of the middle class against war preparations during the late thirties.[46] Nevertheless, the alliances the Communists had formed and carefully nurtured through

the Popular Front years were devastated. 'Fellow travellers and liberals who made anti-fascism their main concern [and] were bound neither by a sense of Party discipline nor by the priority to defend the Soviet Union'[47] – a group exemplified by artists who had joined the American Artists' Congress – abandoned the Party and Party-dominated mass organizations. Reinhardt, however, was not among them; he remained a fellow traveller throughout the period of 1939–41.

The FBI surveillance of Reinhardt began in July 1940 in the context, in my opinion, of the administration's anti-Communist sweep of the early forties. The surveillance investigation was triggered by information communicated to the Division of Investigation of the Federal Works Agency, WPA, which had indicated Reinhardt was a member of the CP-USA: 'C.D. Hollinger, Field Agent in Charge, WPA, Division of Investigation … was interviewed and advised from his records that Informant #1 had furnished his office with information that subject was a member of the Communist Party and subject resigned [WPA] before any investigation of this allegation was conducted.'[48] At the time of the FBI's initial investigation, Reinhardt had already been drawing cartoons and illustrations for *New Masses* for four years: 'In November 1940 [Reinhardt] was employed by Weekly Masses Company, Incorporated … as Art Director … this firm publishes the weekly magazine "New Masses".'[49] The FBI checked issues of *New Masses* dating from 31 December 1940 to 8 July 1941 for evidence of Reinhardt's work. Six of Reinhardt's illustrations were identified in what seems to have been a fairly desultory investigation; the agent failed to identify cartoons credited to 'Rodney' or 'Rodney Frederick' as the work of Reinhardt; nor did he widen the search of *New Masses* to include issues published prior to 31 December 1940.[50] The first FBI report states that Reinhardt voluntarily resigned from the FAP in late 1940 'during the course of investigation for private employment'. Apparently, Reinhardt was dismissed earlier, in August 1939, because of continuous employment for more than eighteen months. Reinhardt was then re-employed by the FAP at the end of January 1940, only to resign in December of the same year.[51] What the FBI did find of Reinhardt's in *New Masses* between December 1940 and July 1941 was fairly innocuous: the field agent reported that 'the sketches in themselves did not have any specific Communistic significance' and noted that Reinhardt's name 'was not mentioned on any of the editorial pages as an art contributor'.[52] While Reinhardt's *New Masses* cartoons and illustrations between summer 1939 and June 1941 are the most chillingly subservient to the Party's political line, astonishingly none of them is cited by the FBI. The FBI pursued various leads – there is a good deal of blotting out of names of informants on all the field reports – yet neither a criminal record under Reinhardt's name in the New York Police Department files, nor evidence that the artist had voted for or registered with the Communist Party in 1936

and 1939, could be found.[53] The investigation seems to have been closed shortly thereafter, in 1942; roughly coinciding with Roosevelt's pardon of Browder.

In 1958, Reinhardt was requested by the Passport Office to submit an affidavit concerning the allegation that he had been a member of the CP-USA in the thirties and had been affiliated with other organizations described as Communist-controlled or as Communist fronts. Reinhardt complied with this request, stating:

> I was never a member of the Communist Party. I was a member of the American Artists' Congress and I permitted my name to be used as a sponsor of the Cultural and Scientific Conference for World Peace. I was never an 'art director' of 'New Masses' or a 'member of the editorial council' of 'Soviet Russia Today', but worked occasionally for those magazines as technical advisor with regard to typographical layout and art work. I illustrated a pamphlet once for the American Jewish Labour Council and helped a friend of mine conduct an experimental 'cartoon' work shop for a few weeks one semester at the Jefferson School of Social Science. I was a freelance typographical designer and artist in the late 1930's and early 1940's, and none of my jobs had anything to do with the politics and editorial policies of the magazines, organizations, and institutions mentioned above.[54]

Reinhardt's response, while technically correct, is measured and clearly misleading in terms of his actual duties and responsibilities at *New Masses*. As de facto art director of *New Masses* during the late thirties and early forties, Reinhardt was not simply producing work on specification. His illustrations helped to shape the rhetorical tone of the magazine's political line; moreover, Reinhardt apparently exercised a degree of control over their interpretation, as he also wrote the captions accompanying his cartoons.[55] In all respects, he was considered by the editorial board to be a Party member. Based on Reinhardt's denial of his membership in the CP-USA, the Criminal Division of the Department of Justice considered prosecuting him for fraud against the government. Reinhardt was never charged, however, since his connection with the CP-USA had 'existed at a period some twenty years before the denial in question' and the Department of Justice concluded that such a prosecution would be unsuccessful.[56]

Was Reinhardt a Party member? Faced with the myriad elisions contained in the FBI report as currently available, it seems important to bear in mind the often ignored but crucial distinction between the Party itself and its various front organizations or independent organizations on whose executive committees Party members sat; in short, the difference between Party members and Party sympathizers or 'fellow travellers'. It is a commonplace to point out now, so many decades after the height of the McCarthyite 'Red scare', that during the Cold War rank-and-file members of mass organizations agitating for nuclear disarmament, world peace, and

so on – regardless of the relationship of those organizations to the CP-USA – were routinely tarred with the same brush as Party members. This is not to naïvely deny the existence of CP-USA 'front organizations' operating under the guise of mass organizations, but merely to emphasize that such distinctions – either out of ignorance or design – were routinely glossed over by the press, and encouraged by the FBI and other governmental agencies in the zealous pursuit of Communists.

While much of the so-called intelligence found in the FBI reports on Reinhardt that is not blotted out is circumstantial, evidence from other sources unequivocally points to Reinhardt's Communist *sympathies*. In 1966, Reinhardt – in an unpublished draft of his 'Chronology' – refers to himself as having been a 'fellow traveller' in 1935. Now 'fellow traveller' is an extremely ambiguous term; and intentionally so. According to Joseph Starobin, it was common practice for the CP-USA to allow Party members who were prominent public figures in fields such as literature or art the choice to mask the fact of their membership so they could be more effective spokespersons and organizers within mass organizations. It is true that Reinhardt was an organizer in the trade union associated with the graphic design industry; a member of the United American Artists (formerly the Artists' Union); and generally active in organizations with close ties to the CP-USA. Magil asserts that Reinhardt had been a member of the Party during the thirties and forties, thereby confirming the FBI's reports, and contradicting Reinhardt's affidavit of 1958.[57] If Magil is correct, then Reinhardt was probably what was known in the Party's argot as a 'submarine'. I am inclined to believe Magil; although the length of Reinhardt's Party membership – which has never been established – is likely to remain a mystery.[58]

Abe Ajay's recollections of Reinhardt's relationship to the CP-USA, while falling short of asserting Party membership, nevertheless point to a sympathetic tie: 'Reinhardt never red-baited; [he] never was attracted to the people who were "running the show", except Dave [Crockett] Johnson, Bruce Minton, Joe Starobin. They [the Party stalwarts] could do it on a *political* level, but not art. [They were] so serious and unable to conduct an aesthetic argument on an abstract level.'[59] This view represents Reinhardt's political engagement as that of a fellow traveller: that is, a Party sympathizer who contributed to Party causes, but was perhaps unwilling to undertake all the rigours of Party life; may or may not have paid Party dues or possessed a Party card; was not bound by Party discipline; and reserved the right to disagree publicly on an aspect of the Party's agenda.[60]

Confirmation of Reinhardt's Party affiliation would help to explain the more puzzling aspects of the artist's behaviour after 1945 and add much-needed detail to the relatively barren biographical picture of the thirties and forties. For instance, did Reinhardt's move to the staff of *PM* in 1943 – a magazine reviled by the CP-USA and viciously attacked by him in a cartoon

drawn for *New Masses* in 1940 and published under the pseudonym 'Rodney' – signal the end of his involvement with the CP-USA?[61] Or, was it merely the opportunity of steady, better-paid employment? We know that Reinhardt participated in 1937 in the formation of the Book and Magazine Guild; was he fired from *PM* in early 1947 because he was identified as a *Communist* labour organizer within their ranks? Or, was it simply a trade union dispute, as the artist claims?[62] Is Reinhardt's pro-Soviet, anti-imperialist stance of the late forties the expression of support of an 'independent' socialist, a 'fellow traveller', or a committed Stalinist? What accounts for Reinhardt's decision to diminish his political activities significantly after around 1950, even though he had successfully weathered the first wave of post-war anti-Communism?

In interviews with the author, Magil could offer no explanation for Reinhardt's withdrawal from *New Masses*, claiming no recollection of a falling-out between the artist and the editors. Magil, who knew Reinhardt personally, describes him as being very reserved, serious and conscientious and not socially involved with any of the other editors, aside from Crockett Johnson. Most of the artists who had contributed to *New Masses* donated their work, but as an 'art editor' (as Magil describes him), the artist would have been paid a salary of about $25 per week before the war. Reinhardt's marriage in 1940 to Mary Elizabeth Dearmand Decker prompted a five-dollar raise. These salaries, however, were as often as not unpaid due to *New Masses*' chronic financial problems; this lack of financial security would help to explain Reinhardt's constant need to pursue additional freelance design work.

Others associated with the magazine claim Reinhardt left *New Masses* because of long-standing, hostile criticism towards his position on aesthetics and his artistic practice. Charles Keller – an art editor of *New Masses* from 1945 to 1947 – dates Reinhardt's departure around 1946 and attributes it to just such a disagreement with the editor Joseph North. But Keller's late dating suggests that Reinhardt had continued to work for the magazine beyond 1945, perhaps in the capacity of a 'paste-up' or layout artist, rather than as a cartoonist and illustrator.[63] However, I believe Keller to be mistaken in his recollection. Reinhardt's withdrawal from the Party probably did not coincide with his departure from *New Masses*. After 1945, he continued to participate in other political and cultural activities sanctioned by the CP-USA.

Reinhardt published no *new* artwork in *New Masses* in 1944 and 1945; one finds instead earlier examples of his work being reprinted, some of which date to his student days at Columbia or are taken from his work for the Political Action Committee (PAC) of the Congress of Industrial Organizations (CIO).[64] The cover of the issue of 31 July 1945 – Reinhardt's last published illustration for the magazine – is a reprint of a design produced in 1942. Later

that year, however, Reinhardt published a review in *New Masses* on the North American painter Stuart Davis; after 1945, no new graphic design work attributable to Reinhardt appears in the magazine.

Settling the issue of Reinhardt's *official* membership in the CP-USA is a minor detail and probably futile; in any case, a negative finding would hardly alter the fact of his political engagement, or necessarily change the basic thrust of my thesis. It is more to the point to understand how Reinhardt's overt and consistent sympathy with the Party's political line would have been received as a sign of de facto Party membership by those artists and critics of the New York School for whom the issue of precise political allegiance mattered a great deal. This may explain the substantial gaps in accounts of roughly the first third of Reinhardt's productive life. In connection with Lippard's monograph of 1981, Reinhardt had not only feigned indifference towards biography, but apparently actively discouraged it.[65] A number of statements put forward by Reinhardt on his political background so obviously contradict historical evidence that they appear to be deliberate attempts at dissimulation. For example, Reinhardt repeatedly evaded the issue of his involvement during the thirties with Communist politics or left-wing organizations. His remark on his experience with organizations such as the Artists' Union and the American Artists' Congress (1936–9) is typical: 'From a political point of view, I don't really know what went on, but I'm sure that the political thing wasn't very serious except for some artists who felt they needed it in relation to their art.'[66] Of course, there can now be little doubt that Reinhardt, during the thirties and forties, was anything but a political naïf: with regard to the AAC, he certainly would have had first-hand knowledge of the political struggles that took place in the Executive Committee between Communist and Trotskyist factions. After the demise of the AAC, Reinhardt joined the Artists' League of America: a Party front organization formed in 1942. Above all, it is Reinhardt's political cartoons which most dramatically demonstrate his consciousness of the serious political stakes being played for in *New Masses* and other mass cultural organizations. Reinhardt's cunning phrase – 'some artists who felt they needed [politics] in relation to their art' – is a red herring clearly intended to evoke the image of a painter of Social Realist pictures in thrall to the CP-USA, rather than an abstract artist associated with the AAA. And yet, as disingenuous and factually inaccurate as Reinhardt's account of his political activism may be, it has proven to be remarkably resilient and convincing.

Reinhardt was understandably reluctant to reveal the true nature of his political activities of the thirties and forties. As late as 1966 – while Reinhardt was drafting his famous 'Chronology' – he was not willing to disclose his involvement in the 'anti-war, anti-fascist demonstrations' of the mid-thirties, let alone admit to having been a 'fellow traveller'. This, despite the fact that

many of his contemporaries had also been open supporters of one or another of the political factions on the left during the thirties, including the CP-USA. In retrospect, their radicalism could be excused as youthful, idealistic enthusiasm to an extent unavailable to Reinhardt, most likely because of his continued, though greatly reduced, post-war involvement with Party-affiliated organizations.

Let's look briefly at how Reinhardt's 'Chronology' colludes in the misrepresentation of his political activism. From his point of view, that text was conceived to be a caustic travesty of a particularly egregious type of artistic self-aggrandizement; in fact, it was intended to be a direct parody of one authored by Robert Motherwell.[67] Reinhardt's 'Chronology' is constructed as an ironical historical narrative; which means, simply, that criticism directed at it based solely on the presumption of its historical veracity would be misplaced and narrow. Nevertheless, historians and critics of art have repeatedly treated Reinhardt's 'Chronology' as principally a historical record and interpretive key to his practices. This frankly desultory approach to historical research has serious ramifications, as a comparison of the 1966 Jewish Museum catalogue version of the 'Chronology' with unpublished draft versions demonstrates. In addition to Reinhardt's deletion of seemingly uncontroversial references to commonplace Depression-era political activism like 'anti-war, anti-fascist demonstrations', we also note that prior references to *New Masses* have been deleted. While the cumulative effect of eliminating certain historical details from the 'Chronology' becomes synergistic and causes a profound shift in the rhetorical force of the text, that cannot be Reinhardt's sole motivation for having made these specific cuts. For example, he forward dates by two years – to 1944 – the publication of his first collaged cartoons, or 'cartoon *collés*'. This was done, in my opinion, because Reinhardt must have felt it to be preferable to describe the emergence of this type of work in the context of a *newspaper* rather than a *weekly magazine*, where they had originally appeared. This neatly avoided any association with the Communist magazine *New Masses*, favouring instead the politically less inflammatory *PM*.[68] In another instance, Reinhardt fails to mention an attack against his *PM* art comics launched by the *Daily Worker* in 1946, although he does refer to an *earlier*, alleged attack by Mike Gold, also of the *Daily Worker*.[69] Here timing is everything; Reinhardt's skilfully edited 'Chronology' serves to reinforce the myth of the artist's non-Communist, yet progressive, political past. While of considerable *materialist* irony, the 'Chronology' is universally deemed politically unexceptional and routinely quoted by those who chose to remain uninformed or disingenuous with respect to the ideological struggles of the thirties and forties.[70]

Notwithstanding Gold's alleged attack on Reinhardt in 1941, the artist continued to work at *New Masses* throughout the war, producing a

substantial number of illustrations and maps under a variety of pseudonyms, through 1943. These maps accompanied detailed accounts of the disposition of military and resistance forces in connection with the German–Soviet War, which began in late June 1941 with the Nazi invasion of Russia. An individual writing under the pseudonym 'Colonel T', whom the editors had claimed to be a US Army officer close to military intelligence, provided expert commentaries on the battles. As the fighting along the Russian front intensified, Reinhardt's map-making illustrated Colonel T's elaborate projections of the global strategy of the Axis to encircle the Soviet Union. Much of this sort of journalism (increased after the entry of the US into the war) was intended to rally support for the opening of a second front in Europe. The majority of these maps of Reinhardt's remained unsigned, although we occasionally find the signature 'Rodney Frederick'.[71] After US entry into the war, the scope of military coverage widened to include an analysis of the US–Japanese Pacific theatre. During the war, the prestige of the Party increased by virtue of its identification with the military victories of the Soviet Union. Consequently, Reinhardt became less reluctant to disguise his association with *New Masses*. In 1944, he openly exhibited political cartoons and 'cartoon *collés*'; the invitation card, which he designed, featured the collaged image of a forlorn Hitler exactly as it had appeared two years earlier in *New Masses*.[72]

An attack in 1946 against the artist's highly regarded 'How to Look ...' series of pedagogical 'art comics' signalled a dramatic shift in the Party's estimation of artists such as Reinhardt and abstraction in general.[73] The unfriendly *Daily Worker* article – 'Art Today: Lessons in Utter Confusion' – was one of a series of denunciations of abstract art in favour of a realist, 'people's art' authored by 'Marion Summers' – the alias of art historian Milton Brown.[74] Brown – later a colleague of Reinhardt's at Brooklyn College – accuses him of reiterating the theories and rationalizations of a historically prior avant-garde in order to advance them as a code of universal artistic principles. In conclusion, he notes that 'Reinhardt is apparently not as interested in teaching people how to look at art as he is in proving that abstraction is the true art and Mondrian is its prophet.'[75]

It has been suggested that such sectarian attacks ultimately reflected the failure of the CP-USA, after the departure of Browder, to come to grips with the specific possibilities for social transformation in post-war US society. The decline and isolation of the CP-USA – generally thought to have commenced at this point – is historically complex and bound up with the parellel histories of groups outside the Party, particularly organized labour. Other factors include the USA's reaction to the new role of the Soviet Union in world affairs; the traumatic removal in 1945 of Browder as General Secretary and his subsequent expulsion from the Party one year later; the further rupture of political alliances over opposition to the Marshall Plan; support for Henry

Wallace's unsuccessful 1948 presidential bid; and the beginning of the expulsion of left-wing-led unions from the CIO.[76] Starobin and others describe how the CP-USA responded to the growing wave of anti-Communist attacks by launching its own, internal 'witch hunt' in the late forties, and going 'underground' in 1950–51.[77] The *Daily Worker*'s attacks against Reinhardt and his aesthetics – which came in the wake of the Albert Maltz affair and the revival of the old cultural slogan 'art is a weapon' – point to the Party's growing impatience with avant-garde art, and its reluctance to continue friendly debate with its adherents.[78]

Using the opportunity of a modest art review, Reinhardt's article in *New Masses* in 1945 on the work of Stuart Davis manages to be a bold, if laconic, statement of his creed on abstraction in art: 'Abstract art or non-pictorial art is as old as this century and though more specialized than previous art, is clearer and more complete.'[79] Because Reinhardt also used the review as an opportunity to criticize Davis for his 'present political inactivity', it is often cited as proof – without reference to the former's Party involvement – that he was a committed activist who had vigorously separated his politics from his art. Indeed, there is a separation to be drawn here; but its significance is altered when we grasp it as a polemic directed to the proponents of Social Realism under conditions of political solidarity with the Communist movement. The significance of Reinhardt's review, therefore, is structured along two axes: the first presumes abstract art's progressive qualities to be already acknowledged as uncontroversial; while the second, less noble, patronizes the editor's deep-seated artistic prejudices. Nevertheless, Reinhardt's attitude seems out of step; the phrase 'present political inactivity' as applied to Davis is anachronistic and telling for by this time Davis had already retreated from political activism. The implications of the remark – the suggestion of the possibility of constituting, even now, something like a *politicized* abstract painter – would not have been lost on the editors. No matter how sympathetically they may have viewed the position articulated by Reinhardt in the review, the tendency to continue to equate all non-figurative art with reactionary 'art-for-art's sake' was strong. The point of the review may have been entirely different for Reinhardt: the opportunity to fire a parting shot, to reiterate an argument that he had been making to the same audience for nearly a decade.

Collage, Cartoons and Covert Sketchbooks, 1936–1945

In July 1936, Reinhardt published his first cartoon for *New Masses* under the alias 'Darryl Frederick'. By mid-1937, examples of his *New Masses*

illustrations were included in a public exhibition titled 'Spot Use of Drawings', which took place at the Picture Collection of the New York Public Library.[80] The inclusion of *New Masses* in that exhibition indicates something of the reception and acceptability of the political ground occupied by the magazine at the height of the Popular Front against fascism. It also reflects the fact that many of *New Masses'* contributors were illustrators or cartoonists already well connected to the mass bourgeois press.

Between 1938 and 1939, Reinhardt published roughly seventy items in *New Masses*, all of which are identified under the artist's given name. As we have seen, this 'open' period did not extend into the next decade. In 1940, we find substantially fewer items by Reinhardt and more reliance on pseudonyms: only around one-fifth of the total works are credited to 'Reinhardt'; the remainder having been identified by the pseudonyms 'Frederick' (a shortened version of 'Darryl Frederick'), 'Rodney' and 'Roderick' (an amalgam of 'Rodney' and 'Frederick'). The fact that Reinhardt was re-employed by the FAP in January 1940 may have contributed to the relative dearth of *New Masses* political illustrations by the artist that year. Considering the FBI's surveillance of the artist at that time, Reinhardt would have certainly considered it prudent to conceal the fact of his employment by *New Masses*.

In 1941, the pattern of disguised identity continues with the appearance of the alias 'Rodney Frederick'. Reinhardt plunged deeper into anonymity; nearly half of the artist's published works – for the most part maps detailing military campaigns and dire projections of the global strategies of the Axis forces – were left unsigned and unattributed. The three illustrations which are credited with the artist's given name are reprints of images dating from late 1937 through to 1939 – the 'open' period of Reinhardt's involvement with *New Masses*. The use of Reinhardt's earlier cartoons and illustrations in this way by the magazine is revealing: a cartoon drawn by Reinhardt in 1938 on the general theme of Japanese imperialism is resurrected by the editors after the entry of the US into the war in 1941, to effect the impression of doctrinal continuity, to vindicate their previous political analysis, and to legitimate the claim that the Party had not abandoned their opposition to fascism during the so-called 'imperialist war' period. It appears in the 16 December 1941 issue of *New Masses* – which probably hit the streets quite soon after the US declaration of war against Japan and Germany on 7 December – positioned among a half-page assortment of anti-Japanese political cartoons, most of which date from the mid- to late thirties, the period of continued Japanese military expansion in China.

In 1942, there is a creative burst from Reinhardt with the appearance in *New Masses* of the illustrational technique termed 'cartoon *collé*'; literally, 'pasted' cartoon. An article in *PM* provides insight into this technique and Reinhardt's commercial art studio habits in general:

HIS MASTER'S VOICE

Figure 10. 'His Master's Voice.' *New Masses*, 14 July 1936. Private collection, New York.

> Collage is the technique of half paste-up, half drawing. [Reinhardt] scouts around second-hand book stores for old 19th Century books, cuts out the illustrations, and piles them into a big envelope. Then, when he has to illustrate a story with a 'spot' he digs into the envelope and comes up with the weird people, animals, buildings, flora and fauna which you see in his *PM* sketches. He pastes these figures up, then draws in whatever else ought to be included – and there you have a Reinhardt 'spot'.[81]

Lippard also observes that Reinhardt was an obsessive clipper of reproductions, art and otherwise, from magazines, books and newspapers. In this regard he was merely following the customary studio practice of maintaining a collection of images termed a 'picture morgue' or 'swipe file', and consistently cannibalized, copied and adapted older illustrations in order to produce new ones.[82] One example is Reinhardt's very first cartoon for *New Masses*, 'His Master's Voice'; a caricature which borrows the famous RCA-Victor logo of dog and gramophone. (See Figure 10.) Reinhardt's 'swipe files' functioned as important aids for design visualization and figured in the overall rationalization of the design process. Earlier artwork would be routinely cannibalized for the creation of new designs, thereby rendering drawing redundant. Selected items could be traced, assembled, conjoined and rearranged to achieve the desired image in a productive rhythm close to the give-and-take working practice of collage-making. A significant number of Reinhardt's works published in *New Masses* are cannibalized from

drawings dating as far back as the early thirties;[83] others form the basis for later commercial art assignments. (See Figures 11 and 12.)

The implications of collage as a resource of expression for Reinhardt's fine art are considerable. Reinhardt had already been experimenting with collage techniques in connection with his paintings as early as 1939. Lippard suggests that the introduction of new materials and techniques had a profound effect on the nature and formal focus of his work: 'Autonomous forms had begun to disappear ... a process accelerated by his increased use of collage.'[84] In a statement of the late forties, Reinhardt remarked on the importance of collage, characterizing it as a combination of 'spontaneous and accidental aspects, along with the perfectly controlled'.[85] These later developments are more significant; most critics cite them as marking Reinhardt's transition away from 'student work' and a prior, Mondrian-esque *protocol* of painting. In 1940, Reinhardt began to use black-and-white and colour newspaper and magazine photographs for his collages, in place of coloured paper. He sliced up and re-arranged these new raw materials into patterns designed to produce the maximum defamiliarization of the source imagery. Yet the spatial effect, as Lippard notes – with a nod in the direction of Pollock and things to come – was paradoxically one of continuity, not fragmentation; a new, all-over surface that seemed to enable Reinhardt to defeat the dead-end of Cubism.[86]

The correspondence which obtains between Reinhardt's fine and applied art techniques is revealed in a small, visually stunning work dated circa 1941, titled 'Collage'. There Reinhardt departs from his previous practice of employing newspaper or magazine reproductions as source material for his collages, turning instead to the use of eighteenth- and nineteenth-century line engravings. The significance of this shift can be appreciated at once in the optical finish of the work. The dull greyness of poor-quality, coarse-screened half-tone reproductions – the sort which are found routinely in newspapers and magazines – yields to the sharply focused patterns and crisp tonalities presented by the unadulterated black lines of engraved prints.[87] Reinhardt immediately took advantage of this difference; the paintings modelled after these new-type collages are structurally harsh and schematic. The surface of Reinhardt's paintings – which remain remarkably consistent throughout his entire painting oeuvre – are immaculate, smooth and velvety. It is a surface whose tactile associations are closer to those achieved through serigraphic or offset printing than oil painting.[88]

My allusion to mechanical printing processes is intended to highlight the material circumstances which surrounded Reinhardt's artistic practice throughout the early forties. His fine art production – from the late thirties through the late forties – was in fact largely *experimental*, stylistically in *disarray*, and *freely inflected* by technical and formal 'influences' from both 'fine' and 'applied' art practices. Lippard also characterizes Reinhardt's

Rodney

painting during this rich, but admittedly disorienting, period as 'experimentation'.[89] But what I am suggesting, I believe, goes beyond that description, to postulate a *reciprocal* relationship between applied and fine art, whereby Reinhardt's illustration and cartooning output is seen as an opportunity to work out problems originating in his painting practice. In short, Reinhardt exploited the opportunity of the production of illustrations and cartoons in such a way that they began to function as a *surrogate* for sketching and drawing; a covert notebook for the planning of paintings.

One difference between the two bodies of work is, of course, the respective uses to which they are put. Reinhardt seems to be quite clear on the distinction between the *communicative* potential of mass media art forms – cartoons or 'comics' – and figurative, Social Realist, 'fine' art paintings. Before he was a 'fine' artist, however, Reinhardt was a graphic designer and illustrator; so it is not unlikely that the *mechanical* procedures and so forth Reinhardt had learned first in the context of applied art practice would have made a deep impression on his general habits of work in visual arts. For a young and relatively unformed painter, such habits would not necessarily be readily discarded or considered to be irrelevant resources for the solution of problems encountered in fine art studio practice. This attitude is arguably expressed in the organization of Reinhardt's work, his creation of collage-based 'models' for paintings, and the handling of paint to produce the required 'finish' of the completed work. But I also want to stress that for Reinhardt the connection between applied and fine art is not merely technical. As demonstrated by his statements which picture a world devoid of divisions of *labour* – albeit one fully receptive to the political and cultural potential of freely chosen divisions of *function* – Reinhardt expressed a relatively generous position towards the diffusion of techniques across the

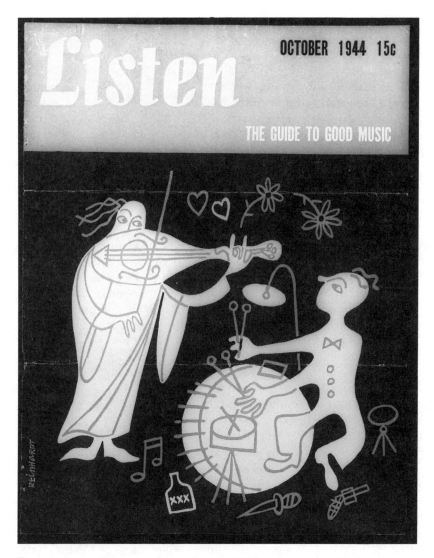

Figure 12. Cover illustration. *Listen,* October 1944.

boundaries of 'high' and 'low'. Above all, it would have been Reinhardt's experiences in the field of graphic design that would have accounted for this predisposition to accept certain sorts of applied arts studio practices to be reasonable ways to work out and execute abstract paintings.

We can point to the general effects of Reinhardt's early willingness to tackle his fine art production in this manner. Some of these are reflected in

latter discourse on his work, which speaks of intensive, ritualized processes of work, editing and formal simplification typical of the working practices of a graphic designer. During the twenties and thirties, the graphic design profession drew attention to itself by claiming competences generally ascribed to the 'creative process' of fine art, and endowing its practice with a degree of social significance.[90] Reinhardt also recognized and valued the technical expertise of the commercial artist – 'Modern advertising requires of the layout man a greater variety of knowledge than almost any other branch of advertising art'[91] – and the discipline of graphic design which implies a clear and definite reason for everything done on the page – 'The skillful designer of advertising strips his layout to absolute essentials.'[92]

The commercial artist of that period was encouraged to grasp 'movements in art' and 'new products with their modern design' with particular vigour as resources of expression accessible and useful to the field, rather than as exotica comprehensible only to the connoisseur of modern art. This type of cultural levelling would undoubtedly have appealed to Reinhardt (recall his *Jester* editorial statement). And while he would probably have associated such precepts with the ongoing development of graphic design as a modern profession, they would also have suggested to Reinhardt a means to recover that practice from the abyss of the routine, the mechanical and the hack.[93] (The cultural anxiety routinely expressed by graphic designers relative to fine art is analogous to the epistemological concerns some social scientists experience in the face of so-called 'hard' sciences like physics.) That Reinhardt sympathized and identified with the values and social aspirations implied by the rationalization and professionalization of design is suggested by his objections to the exclusion of commercial and industrial artists from the Artists' Council of Victory. While some of the arguments are obviously ideologically motivated and in step with Party politics, that should not distract us from noting that this statement is Reinhardt's most comprehensive representation of the political commonality of avant-garde artist and worker.

While the Party apparently had little difficulty in reconciling its politics with developments in the sphere of popular culture, fine art was a far more controversial matter. Reinhardt's attempts to argue the case for the virtues of abstract art before the editors of *New Masses* are not entirely removed from the above-mentioned synthesis. In one instance, he opens his argument by challenging the conventional view that paintings of recognizable subject matter are perfectly suited to be transparent mediums for the communication of political ideology. Introducing a more formalist vocabulary and drawing on notions of the civilizing effects of *order and balance* – terms normally associated with Mondrian's doctrine of Neo-Plasticism but which, as we have seen, are also found amongst the canons of commercial art practice – Reinhardt argues, for example, that Gauguin and Van Gogh

Figure 13. 'You, Peewee, have to be Hitler.' *New Masses*, 12 August 1941. Private collection, New York.

represent 'a crisis of bourgeois society as capitalism created disorder and insecurity'.[94] By contrast, Cubism – which is based, according to Reinhardt, on Cézanne's original separation of subject matter from colour structure – stresses the 'unity, totality, connectedness of things in its single, one world. In cubist paintings one finds a discipline, a consciousness, an order that implies *man can not only control and create his world, but ultimately free himself completely from a brutal, barbaric existence.*'[95]

Reinhardt's preoccupation with the problem of working-out and working-through the link between the 'homogeneous surface of the all-over canvas with the compositional balance inherited from Synthetic-Cubism' was particularly acute at this time.[96] Ajay perceptively contrasts Reinhardt's 'slightly wooden, born-again Cubist' cartoons of the thirties to works such as 'You, Peewee, have to be Hitler' (see Figure 13), remarking on the latter's struggle to break free of that legacy. In his discussion of this often confusing period, Yve-Alain Bois insists Reinhardt had tried 'Mondrian's pictorial rhetoric and could see for himself that it was more or less an ad hoc system, unsuitable for use by others.'[97] Bois and Lippard concur that Reinhardt's collages of 1940 were important for the elimination of geometry, projection, sketching and drawing in the artist's work; but it is Lippard, with the advantage of a profoundly more global view of Reinhardt's practices, who is able to make the link between *how* the collages were physically made and *what* some of Reinhardt's paintings looked as though they were *of*. Speaking of Reinhardt's work of the early forties, Lippard asserts: 'There are oils from this time showing how the brush served the *same function* the scissors did in the

collages, even to the point of *simulating* the angular sickle or blade shapes of a cut edge.'[98]

Of all the commercial art techniques incorporated by Reinhardt, none is more dramatic and relevant to the working out of problems in painting than his use, beginning in late 1941, of Ben Day patterns. Reinhardt's extensive experimentation with this material is first evident in maps produced for *New Masses* late in 1940; clusters of similar examples continue to crop up throughout 1941 and 1942.[99] (See Figures 14 and 15.) Where Reinhardt combines pre-printed Ben Day patterns with freely expressionistic drawing, the illustrations are often wild and incoherent, particularly in comparison to those of the latter half of the thirties. In some cases, images are produced without recourse to drawing, having been directly composed through the judicious overlapping of half-tone patterns. This was a significant step for Reinhardt, who eventually eliminated all drawing from his illustrations. When this technique was pushed to the extreme we find pictures so occluded by moiré interference patterns as to be nearly unrecognizable, as in 'Nazi spokesman asks for humane warfare.'[100] Illustrations such as 'Hello, DNB, what towns have we captured today?' (Figure 16) and 'It's all right, Herr Kapitan, Wheeler will fix it'[101] appear on the page as inchoate blots.

These works – perhaps unprecedented in illustration – reveal Reinhardt's intention to transgress the layout artist's cherished principle of balance. An examination of Reinhardt's collages and paintings of 1940–43 suggests he mobilized his paintings and illustrations to systematically destroy in his work Mondrian's concept of composition as 'balances and counterbalances, the relational idea'. One notes how many examples of images which are 'frighteningly all-over, seeming to be arranged almost at random' exist in Reinhardt's body of illustrations and paintings.[102] (Martin James has spoken of Reinhardt's practice of the early forties of washing his collages under a faucet.[103])

The problems raised by these works increasingly approach one of specifying the minimum conditions for the fulfilment of the charge to make a painting or cartoon. What such images might look like and how they might be made seems to have becoming increasingly clear to Reinhardt by the end of the forties. Scanning those corresponding bodies of work, we find numerous examples of painting and illustrations having been made through the act of successive superimposition of regimented patterns. In the case of Reinhardt's cartoons, one finds the use of Ben Day pattern over Ben Day pattern – which produces a moiré pattern – and Ben Day pattern over frantically scribbled line. In the paintings, there are superimpositions of line and precisely measured brush stroke over brush stroke as, for example, in Reinhardt's so-called 'Persian Rug' series of the late forties.

The comparisons between painting and illustration I am arguing here suggest that the frequently cited 'tension' in modernism between high art

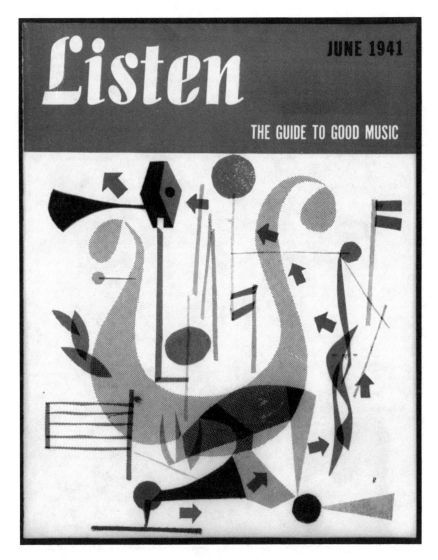

Figure 14. Cover illustration. *Listen*, August 1941.

and mass culture is not irrelevant to the story of Reinhardt's art; moreover, the influence here seems to be genuinely multi-directional. During the late thirties, for instance, we find numerous examples of Reinhardt's illustrations – compact, Cubist-inspired, and often using letterforms as compositional elements – which seem to conform precisely to Davis's prescriptive notion of the whole picture as a psychological gestalt. (See Figure 17.) By interpolat-

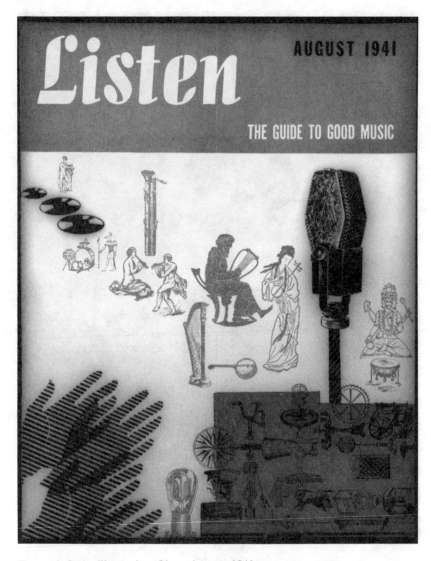

Figure 15. Cover illustration. *Listen*, August, 1941.

Figure 16. 'Hello, DNB, what towns have we captured today?' *New Masses,*
12 August 1941, p. 5. Private collection, New York.

Figure 17. 'The New Deal.'
New Masses, 5 July 1938.
Private collection, New York.

ing these stylistic devices on to the field of illustration, I do not believe Reinhardt was necessarily parodying them as much as acknowledging their real potential for effecting a cross-fertilization between 'high' and 'low' visual art.

While Reinhardt had already articulated his desire to separate a 'painting-reason' from a 'picture-purpose', that ambition had been only incompletely realized at that moment.[104] Reinhardt must have begun to sense that the distinction he was drawing was complex; it could not simply be a matter of distinguishing between the instrumental use of paintings *as* pictures in the context of political activism, but also one of sorting out the proper means by which either a painting *or* a picture is produced. During the early forties, he would have been less inclined to enact a hermeticism of graphic design and fine art studio *production protocols* precisely because he had not yet determined what a painting must be *of*. (This was not the case, of course, by the mid-fifties.) In the literature on Reinhardt, comparisons between so-called 'autonomous' bodies of work of this sort are considered illicit and are simply ignored. Following Reinhardt's dictum that 'art is art; everything else is everything else', the critical consensus has been to take as self-evident such a distinction between practices. It seems to me that this begs the question of the dynamic and historical relationship between the artist's practices; a relationship which reverberates throughout the body of Reinhardt's *New Masses* cartoons and frames the artist as mired in the dialectic between 'high' and 'low', the salon and the gutter.

It may be the case that Reinhardt is not exempt from that general theorization of modernism's prime condition of cultural production, often abbreviated as 'that of which a picture is *made* has a bearing on that which a picture is *of*.' À propos this problem, we find some comfort in Lippard's insight that Reinhardt's 'expanded use of the collage medium brought [the artist] dangerously close to fusing two aspects of art which he considered permanently opposed – the pictorial, or picturesque, and the abstract'.[105] Lippard did not have the evidence of a large, parallel body of technically complex illustrations to reflect upon, and too quickly metaphorizes these contrasting terms into the much more loaded ones of 'life' and 'art', simply rehearsing a distinction of Reinhardt's which is best overlooked in this context. Consequently, she does not acknowledge the possibility that some of Reinhardt's paintings might have begun to look quite a good deal like his illustrations – and for good reason – as shared techniques and the will to use them in this instance led to similar visual outcomes. That this 'isomorphism' of the early forties was relatively short-lived – it persisted for a few years, having disappeared by the end of the decade when Reinhardt abandoned producing such illustrations – does not deny its significance as a bridge to his next important body of painting.

How to Look at Reinhardt

While Reinhardt was alive, probably no one outside the small circle of *New Masses* associates and the FBI knew of his use of aliases. Subsequently, no mention of them is made in Thomas Hess's *The Art Comics and Satires of Ad Reinhardt*;[106] Lucy Lippard's catalogue essay accompanying Reinhardt's retrospective of 1966;[107] her 1981 monograph *Ad Reinhardt*;[108] or Annette Cox's *Art-as-Politics: The Abstract Expressionist Avant-Garde and Society*.[109] After Reinhardt's death none of his pseudonymous illustrations could be found among those portions of his papers made public by his heirs; only a handful of illustrations published in *New Masses* under Reinhardt's name had been included in the original bequest to the Archives of American Art.

The portrayals of Reinhardt's early relationship to the political culture of the left are especially problematic because of the relative lack of documentary material; discussions of this period consequently tend to be perfunctory. This state of affairs is reinforced by the judgement that Reinhardt's artistic practice in general prior to the early forties, while significant in its own right, is qualitatively less important than his so-called 'black paintings' of the later fifties and sixties. Assertions by artists and historians of Reinhardt's importance as a precursor for Minimal and Conceptual Art have also contributed to the adumbration of the artist's earlier work, despite their insistence that all aspects of Reinhardt's practice must be acknowledged.[110] One might have expected the resurgence of interest in the study of post-war North American art to catalyse a complementary investigaton into the political and artistic practices of Reinhardt during the thirties and forties. Yet research on Reinhardt seems to have scarcely benefited from the results of those studies, perhaps owing to the fact that their focus is on the history of the artists and intellectuals identified with the anti-Stalinist left.

Working under conditions of authorship that suggest a problematic steering of the study by Reinhardt, Lippard was encouraged in her monograph to eschew the biographical and the political in order to focus on the period during which the 'black paintings' had emerged.[111] The text, which was completed by 1969, should have been published shortly afterwards. Owing to a dispute with the publisher the project languished for nearly a decade, remaining unpublished until 1981. The manuscript was then published in its original form, excepting the addition of a brief Postscript, composed around 1971. The latter is a brisk exercise in the construction of a 'Reinhardt for our time', and deals mainly with the influence of Reinhardt's late paintings and art polemics on artists such as Frank Stella, Carl Andre and Joseph Kosuth.[112] Unfortunately, the publishing lag would prove damaging to her intellectual project: short of rewriting the manuscript, Lippard was effectively barred from revising her

text in light of the insights to be found in the aforementioned revisionist historical studies which had begun to be published during the mid- and late seventies;[113] insights, in my opinion, which would have been pertinent to her project.

The moments of irresolution and doubt to be found peppered throughout Lippard's text are far more valuable to consider. At various points, she implies that there are important cultural consequences to Reinhardt's insistence that the practice of art *in itself* is not necessarily a socially responsible act. But those claims are too faintly articulated to make much of an impact on the overall thrust of her argument. Indeed, one of the most frustrating of Lippard's evasions occurs in her interpretation of a conversation between Reinhardt and the art historian Irving Sandler. Referring to an earlier discussion on the importance of Marxism to Reinhardt's aesthetic during the thirties, Lippard asserts:

> Reinhardt saw his work as materialist and historical, and related his interest in the synthesis of opposites to the Marxist concept that contradictions are inherent in every phenomenon. ... Perhaps it was in this regard that he told Irving Sandler, 'The Communist issue was very important in the thirties.' The fact remains that his own interest in Marxism was intellectual rather than actively political.[114]

When Lippard projects Reinhardt's criticism of the Abstract Expressionists on to the political-cultural climate of the late sixties by invoking the 'shade and the spirit of Reinhardt's individual conscience' alongside that of the Art Workers' Coalition of 1969, she misconstrues his radicalism.[115] It is simply not possible to generalize Reinhardt's political-cultural prerogative in this way without risking its reduction to the caricaturial 'individual conscience' in revolt. In fact, Reinhardt's political beliefs and practices are often distorted in just this manner, and attributed to a vaguely liberal-minded 'social conscience', recuperated to the myth of 'irascibility', or explained away by referring to the artist's supposed perception of a universal betrayal of art by his colleagues. The Reinhardt thus constituted is more or less a jumble of churlishness: the 'stormy petrel' of the New York art world; the antagonist who quips 'a cleaner New York School is up to you!'

Reinhardt's attacks against art after 1950, while relentless, were fuelled by more than moral outrage. Admittedly, there is bitterness, resentment and a highly personalized sense of betrayal to be found in those attacks; but it was to my mind a deeply felt *political* – rather than aesthetic or moral – failure on the part of his contemporaries against which Reinhardt had raged. My account of Reinhardt during the thirties and forties emphasizes throughout a portrayal of the artist as a social and political being who, while *also* painter, graphic designer, and so on, may not have necessarily shared our understanding of the significance of those diverse social roles.

Since his death in 1967, there has hardly been a shortage of statements on the sort of political being Reinhardt was *not*. Exposing Reinhardt's political affiliations during the thirties and forties has become more than an exercise in the correction of errors and omissions encountered in the various narrative histories of the artist. One consequence of assembling a more accurate and vivid historical picture of Reinhardt's political engagement is a corresponding loss of confidence in the legitimacy of earlier interpretive models of Reinhardt. Historians and critics repeatedly resort to the use of Reinhardt's dogmatic assertions on the autonomy of art as an alibi to expunge or marginalize every one of those practices which fall outside the conventional realm of fine art painting. While practical considerations have required this essay to focus primarily on the first half of Reinhardt's life-work, it is none the less tempting to project our dissatisfactions forward – to encompass the artist's practices of the fifties and sixties, with the aim to test the larger claim that Reinhardt's canonization as a *post-war* artist is significantly dependent upon the marginalization or suppression of all but his 'fine' art practices.

Unless we theorize Reinhardt's practice to include more than his painting, and specify the nature of the relationship between 'high' and 'low', none of this will matter much. This is why any study of Reinhardt that seeks to re-evaluate the significance of his political activism must attend to the issue of Reinhardt's *versatility*. That is, his ability simultaneously to enact and integrate the multiple roles of artist, graphic designer and political activist. Such a description of Reinhardt serves to give prominence, shape and sense to an interpretation which conceives of the artist as a complete social being. It is precisely the fact of this *social* 'background' which must be constantly held in mind, so we can concern ourselves with a different sort of social network constituting and engaging a different sort of public for abstract art during the forties and fifties.

Certainly, the institutional curatorial tendency since the seventies has been towards an increasingly universalized – that is to say, *aestheticized* – image of Reinhardt. Undoubtedly, the progressive fractionation and emptying of the historical Reinhardt greatly aids such ambitions. At the most recent retrospective exhibition devoted to Reinhardt, for instance, one finds everything else but the paintings either marginalized or ignored.[116] These types of historical reconstructions remain a far cry from the Reinhardt of the early forties: an individual saturated with workerist sentiments, talking passionately of the inherent aesthetic value of all of life's activities, reflecting on a 'social structure which permitted the artist only an independent and selfish relation to art', and committed collectively to the task of helping people obtain and create art where it is absent.[117]

Notes

Support for this research was provided, in part, through a grant from the Swann Foundation for Caricature and Cartoon, New York (1985). Earlier versions of this essay were presented at the Universities of Brighton, Leeds, London and the College Art Association Annual Convention (1991). The author would like to thank Robert Nickas for his assistance throughout the initial phase of research on Reinhardt's pseudonymous illustrations; Andrew Hemingway, for his thoughtful and generous critical support; Lottie Gordon, Trustee, and Ann Matlin, Librarian, of the Research Center for Marxist Studies, Inc., New York, for granting permission to photograph original illustrations by Reinhardt in their collection; the staff of the Tamiment Institute Library and Wagner Labour Archives; and Hollee Haswell, curator of Columbiana Collection, Columbia University in the City of New York.

Illustrations by Ad Reinhardt for the periodicals *New Masses*, and *Soviet Russia Today* – which had appeared either under his own name or the aliases 'Darryl Frederick', 'Rodney', 'Frederick' and 'Roderick' – were produced by the artist on a work-for-hire basis. Unless otherwise stated, the rights of reproduction for such works reside with the publisher. To the best of our knowledge, none of the original copyright holders and/or publishers of the aforementioned periodicals have applied for renewal of copyright. The cartoon 'Hack!' is reproduced by permission of Columbia University, Columbiana Collection.

Regrettably, the Estate of Ad Reinhardt has refused permission to reproduce works of the artist for which they hold the rights of reproduction.

1. For an early partial account which touches on the nature of Reinhardt's political activism, see Annette Cox, *Art-as-Politics: The Abstract Expressionist Avant-Garde and Society*, UMI Research Press, Ann Arbor 1982.

2. See Lucy Lippard, *Ad Reinhardt*, Harry N. Abrams, Inc., New York 1981, p. 25.

3. Of the hundreds of illustrations and cartoons produced by Reinhardt for *New Masses* during the period of 1936–45, only four have been subsequently reprinted: a small, incidental illustration of the thirties is found in Joseph North, *New Masses: An Anthology of the Rebel Thirties*, International Publishers, New York 1969, p. 208. In Annette Cox, *Art-as-Politics*, one finds Reinhardt's 'The Unhappy Warriors' (*New Masses*, 10 October 1939, p. 15), 'Millennium' (*New Masses*, 6 February 1940, p. 7), and 'Returned, No Thanks' (*New Masses*, 3 January 1939, p. 15). The latter is also reprinted in Ralph E. Shikes and Steven Heller, *The Art of Satire: Painters as Caricaturists and Cartoonists from Delacroix to Picasso*, Pratt Graphics Center and Horizon Press, New York 1984, p. 115. A further one-half dozen or so political cartoons and illustrations may be found among the Ad Reinhardt Papers, Archives of American Art, Smithsonian Institution, Washington, DC.

4. Editors during the period 1936–45 included: Joseph North, Joshua Kunitz, Ruth McKenney, Crockett Johnson, A.B. Magil and Samuel Sillen. Magil became executive editor in 1946 and presided over the demise of the magazine in January 1948, whereupon it continued under the new consolidated title *Masses & Mainstream*. For a sympathetic history of *New Masses* from the point of view of one of its editors, see North, *New Masses*, pp. 21–36.

5. Paul Buhle, *Marxism in the United States: Remapping the History of the American Left*, Verso, London 1987, p. 178.

6. No doubt this course would have been met with disapproval by his father: a skilled worker and union organizer who was, according to Abe Ajay, 'an "old style" German Socialist; a Social-Democrat'. Abe Ajay, interview with the author, 8 October 1985. Abe Ajay is an artist and illustrator who was active in the Artists' Union and a contributor of political cartoons to *New Masses* during the late thirties. It was there that he met Reinhardt, with whom he initiated a life-long friendship.

7. Quoted in Susan C. Larsen, 'The American Abstract Artists: A Documentary History 1936–1941', *Archives of American Art Journal*, 14 (1), 1974, p. 2.

8. Reinhardt's use of the mass media in this way includes a series of art comics for the newspaper *PM* – published throughout 1946 under the general title 'How to Look . . .' – and a little-known illustrated art broadcast on TV station WCBW in New York City on 27 April 1946.

9. Buhle, *Marxism in the United States*, p. 156.

10. *Jester* was a satirical magazine edited by students of Columbia University. Reinhardt's first cartoon for *Jester* appeared in the issue of November 1931; reprints of Reinhardt's illustration crop up as late as 1937.

11. See Peter Frank, 'Ad Reinhardt, '35.', *Columbia College Today*, VIII (2), Spring/Summer 1981, p. 38.

12. This by no means implies an equivalent instrumental value, as Reinhardt makes clear in several texts of the early forties.

13. Ad Reinhardt, 'The Fine Artist and the War Effort', in Barbara Rose, ed., *Art-as-Art: The Selected Writings of Ad Reinhardt*, Viking Press, New York 1975, pp. 176–7.

14. As used by T.J. Clark. See 'In Defence of Abstract Expressionism', unpublished paper, delivered at the International Congress of Historians of Art, Berlin 1992.

15. See *Critique*, 1 (1), October 1946, p. 13.

16. Reinhardt, 'The Fine Artist and the War Effort', pp. 176–7.

17. Balcomb Greene, 'The Function of Léger', *Art Front*, January 1936, p. 9.

18. Charmion von Wiegand, 'Five on Revolutionary Art', *Art Front*, September/October 1936, p. 10.

19. Ad Reinhardt, 'Abstraction vs Illustration', unpublished lecture, 1943, reprinted in Rose, ed., *Art-as-Art: The Selected Writings of Ad Reinhardt*, p. 49.

20. Cox claims that 'It was only in Reinhardt's writings in the 1940s that we can find any attempt on his part to try to reconcile his political radicalism with the style of painting that he preferred.' (Cox, *Art-as-Politics*, p. 110.) This is misleading insofar as it implies that Reinhardt actually strove for such a synthesis of 'politics' and 'art' in a Zhdanovite mould.

21. Reinhardt, 'The Fine Artist and the War Effort', p. 173.

22. Meyer Schapiro, 'Public Use of Art', *Art Front*, November 1936, pp. 4–6.

23. The Works Progress Administration's Federal Art Project (FAP) was a work-relief programme for artists initiated in 1935. For a general introduction, see Richard D. McKinzie, *The New Deal for Artists*, Princeton University Press, Princeton, New Jersey 1973, and Francis V. O'Connor, ed., *Art for the Millions: Essays from the 1930s by Artists and Administrators of the WPA Federal Art Project*, New York Graphic Society, Boston 1975.

24. Gerard M. Monroe, 'Artist as Militant Trade Union Workers during the Great Depression', *Archives of American Art Journal*, 14 (1), 1974, p. 8.

25. Ibid.

26. Boris Gorelik, 'The Artist Begins to Fight', *Art Front*, January 1937, p. 4, cited in Monroe, 'Artist as Militant Trade Union Workers during the Great Depression', p. 8.

27. Schapiro, 'Public Use of Art', p. 4.

28. Ibid.

29. Ibid.

30. Ad Reinhardt, 'Paintings and Pictures', lecture, 1943, reprinted in Rose, ed., *Art-as-Art: The Selected Writings of Ad Reinhardt*, p. 118. Incidentally, we can also begin to appreciate how the following remark, made in 1960, could have easily been taken to support a far more politically liberal view of Reinhardt's theory of art: 'In the thirties, it was wrong for artists to think that a good social idea would correct bad art or that a good social conscience would fix up a bad artistic conscience. It was wrong for artists to claim that their work could educate the public politically or that their work would beautify public buildings.' Ad Reinhardt, 'On Art and Morality', 1960, reprinted in Rose, ed., *Art-as-Art: The Selected Writings of Ad Reinhardt*, p. 152.

31. Reinhardt, 'Paintings and Pictures', p. 120.

32. Schapiro, 'Public Use of Art', p. 6. Lippard claims that Schapiro significantly influenced Reinhardt's earliest artistic and political practices and also helped to set the stage for 'the first of [Reinhardt's] many distinctions between art and life', his fascination with 'art for art's sake', and his pursuit of abstract art (Lippard, *Ad Reinhardt*, p. 10). Reinhardt summarizes his relationship with Schapiro in a draft of his 'Chronology': 'courses with Meyer Schapiro, who suggests joining campus radical groups; becomes fellow-traveller; anti-war, anti-fascist demonstrations' (ibid., p. 199). Schapiro claims to have seen little of Reinhardt after the artist left Columbia, yet they both were active during the same time in organizations such as the Artists' Union (AU) and the American Artists' Congress (AAC). While Reinhardt and Schapiro evidently supported opposing political positions – particularly in the AAC during the crisis in 1940 relating to the invasion of Finland by the Soviet Union, which Reinhardt

supported – both populated roughly the same avant-garde milieu. While there is no evidence to suggest that their political differences were acrimonious, it would seem that a causal link between Reinhardt's art and Schapiro's post-1936 thought is doubtful. During the late thirties, Reinhardt was working within (and, at times, against) a political and ideological ground different from that of Schapiro's. Reinhardt's position on abstract art echoes that of Schapiro's found in 'Nature of Abstract Art', but only when both their statements are taken out of context. Reinhardt's early conception of artistic practice is much closer to the ideology typified by Stuart Davis: a Marxist and anti-Trotskyist who 'justified modernism with a Popular Front conception of political progress'. Davis criticized Schapiro for viewing abstraction in art as being 'only the expression of the socially isolated artists' and failing to recognize the 'social meaning of the function of abstract art itself'. (Andrew Hemingway, 'Fictional Unities: "Antifascism" and "Antifascist Art" in 30s America', *The Oxford Art Journal*, 14 (1), 1991, p. 116.) For Davis and Reinhardt, the valuation of abstract art as a practice with intrinsic 'social meaning' was not taken as licence for political quiescence; nor did it imply painting to be an abstract language to express a critical social consciousness (a programme which would later be identified with the leftist apologists for Abstract Expressionism). (See Serge Guilbaut, *How New York Stole the Idea of Modern Art: Abstract Expressionism, Freedom, and the Cold War*, trans. Arthur Goldhammer, University of Chicago Press, Chicago 1983, p. 155.) Clearly, Reinhardt was aware of the importance of such distinctions to the concept of art's autonomy and acted upon them as well.

33. The FSU was a mass organization established around 1929 to 'mobilize the masses for militant action against war and in defense of the Soviet Union', normalize trade relations, and popularize the successful building of socialism in the USSR. *Soviet Russia Today* severed relations with the FSU in December 1937, but continued to publish, under various titles, until 1986.

34. See Irving Flamm, 'The USA and USSR can and MUST get along', *Soviet Russia Today*, February 1947, pp. 10–11; and Corliss Lamont, 'When Liberals See Red', *Soviet Russia Today*, March 1947, p. 13. Some of these pages may also be found amongst the artist's papers; see Ad Reinhardt Papers, N/69–104, frame 49.

35. Abe Magil, interview with the author, 30 April 1985.

36. I would like to thank Professor David Craven for making these documents, obtained under a Freedom of Information Act request, available to me. For a discussion of these reports, see David Craven, 'New Documents: The Unpublished FBI files on Ad Reinhardt, Mark Rothko, and Adolph Gottlieb', in David Thistlewood, ed., *American Abstract Expressionism*, Liverpool University Press and Tate Gallery, Liverpool 1993.

37. The name 'Frederick Michaels' is also found on the *New Masses* masthead during the period under discussion.

38. 'The war that has broken out in Europe is the Second Imperialist War. The ruling capitalist and landlord classes of all the belligerent countries are equally guilty for this war. This war, therefore, cannot be supported by the workers. It is not a war against fascism, not a war to protect small nations from aggression, not a war with any character of a just war, not a war that workers can or should support. It is a war between rival imperialisms for world domination.' William Z. Foster, *History of the Communist Party of the United States*, Greenwood Press, New York 1968, p. 387.

39. Cited in Philip J. Jaffe, *The Rise and Fall of American Communism*, Horizon Press, New York 1975, p. 43.

40. Earl Browder, *The Second Imperialist War*, International Publishers, New York 1940, p. 289.

41. Ibid., p. 298.

42. For example, in 'You're a Menace to Civilization!' (*New Masses*, 2 January 1940, p. 12) we find a crisp vilification of capitalism and a sardonic reminder of Marx's notion of history as class struggle; 'Idle Hands...' (*New Masses*, 20 February 1940, p. 10), 'Lift the Embargo... To Keep Out of War!' (Rodney; *New Masses*, 10 December 1940, p. 5), 'I deeply appreciate...' (Rodney; *New Masses*, 25 February 1941, p. 9), and a depiction of the Union Jack flying over the Capitol Dome ('Rodney'; *New Masses*, 15 April 1941, p. 15) all attack the proposed US–UK alliance.

43. The Smith Act of 1940, as Foster unironically notes, prohibits teaching and advocating the overthrow of the US government by force and violence; it was the same law under which the CP-USA was prosecuted in the late forties. See Joseph Starobin, *American Communism in Crisis, 1943–1957*, University of California Press, Berkeley 1972, p. 196.

44. Jaffe, *The Rise and Fall of American Communism*, pp. 48–50.

45. '1942: Crucial War Year', *New Masses*, 13 January 1942, p. 18.

46. Fraser M. Ottanelli, *The Communist Party of the United States: From the Depression to World War Two*, Rutgers University Press, New Brunswick, New Jersey 1991, p. 198.

47. Ibid., p. 199. It has been pointed out by other historians that the Communist Party lost much support and credibility with its swift change of line after the signing of the Hitler–Stalin pact; see Michael Goldfield, 'Recent Historiography of the Communist Party USA', in M. Goldfield, ed., *The Year Left*, Verso, London 1985. This was true mainly among intellectuals and artists, as suggested above, although not necessarily the case among the working-class and African-American members of the Party. See Starobin, *American Communism in Crisis*, p. 32; and Harvey Klehr and John Earl Haynes, *The American Communist Movement: Storming Heaven Itself*, Twayne Publishers, New York 1992, p. 94.

48. Ad Reinhardt file, US Department of Justice, 100–49569-1, 16 October 1941, pp. 1–3. The FBI recruited hundreds of informants within the CP-USA in the forties and continued to recruit more even as the party shrank in the fifties according to Klehr and Haynes: see *The American Communist Movement*, pp. 129–30.

49. Ad Reinhardt file, US Department of Justice, 100–49569-3, 5 January 1955, p. 4.

50. 'At the New York Public Library, 42nd and Fifth Avenue, the writer [field agent] checked all issues of the New Masses from December 24, 1940, to July 8, 1941, and located the following sketches designated by the symbol "R" which appeared to be similar to subject's [Reinhardt's] symbol on his drawings in the WPA publications:

Date of Issue	Page	Matter of Sketch
12/31/40	21	Soldier
1/21/41	26	Lion
4/29/41	8	Electric Power Station Terminal
6/24/41	13	Soldier with rifle, gas mask, helmet, etc.
7/1/41	31	Seashore Scene
7/8/41	31	" " ,

(See Ad Reinhardt file, US Department of Justice, 100–49569-1, 16 October 1941, p. 5.)

51. Reinhardt claims he was fired from the FAP in 1941. See the artist's 'Chronology', reprinted in Rose, ed., *Art-as-Art: The Selected Writings of Ad Reinhardt*, p. 6.

52. Ibid.

53. The absence of Reinhardt's name from the electoral register of the CP-USA proves nothing. For a discussion of the voting habits of Party members and supporters during the 1936 and 1940 presidential election, see Ottanelli, *The Communist Party of the United States*, pp. 180–81.

54. Ad Reinhardt file, US Department of Justice, 100–49569-10, p. 3. The catalogue of the Jefferson School of Social Science, according to an FBI memorandum dated 17 October 1946, lists Reinhardt as an Instructor for the 'Creative Cartoon Workshop (335)'.

55. Abe Magil, interview with the author, 30 April 1985.

56. Ad Reinhardt file, US Department of Justice, 100–49569, 12 May 1958, pp. 1–2.

57. Abe Magil, interview with the author, 30 April 1985.

58. According to Magil, documentary evidence of Reinhardt's Party membership is non-existent. With regard to the process of withdrawal from the Party, Magil notes that 'most members who left ... didn't do so in a formal sense, but simply dropped out.' Abe Magil, correspondence with the author, 4 October 1993.

59. Abe Ajay, interview with the author, 8 October 1985.

60. See Mari Jo Buhle, Paul Buhle and Dan Georgakas (eds), *Encyclopedia of the American Left* Garland Publishing, Inc., New York 1990, s.v. 'Fellow Travelers', by Dan Georgakas, p. 227.

61. See 'Editor's Note – NM's staff artist's suggestions to PM's Christmas subscription drive', *New Masses*, 17 December 1940, p. 13. This sarcastic send-up of *PM* magazine is a composite of nine vignettes, placed against either white or greyish, half-tone grounds arranged in a checkerboard pattern. The attack against *PM*'s editorial policy in support of US intervention in the war in Europe is bluntly stated in nine different ways; literally, *PM* is for jack-asses, *PM* is murder, *PM* is a sour note, and so on.

62. Reinhardt's membership in the Book and Magazine Guild was initially for the period

1937–38. As an artist employed under the WPA/Federal Art Project, he would have been barred from any other employment. Reinhardt continued to participate in labour organizations, however, and joined Local 18 of the United Office and Professional Workers of America (UOPWA) in 1938. From 1939 to 1941, he was a member of the United American Artists (officially, Local 60 of the UOPWA). From 1943 to 1947, he was a member of the American Newspaper Guild. In an early draft version of his 'Chronology', Reinhardt notes: '1946. Elected chairman of Newspaper Guild local.' See Ad Reinhardt Papers, N69/99. To the best of my knowledge there is no record of any labour dispute at *PM*'s New York office in 1946, or 1947. But a great deal has been reported concerning the anti-Communist Party drive throughout the unions affiliated with the CIO.

63. Charles Keller, interview with the author, 28 August 1985.

64. The CIO's Political Action Committee (PAC) was 'a powerful electoral machine that worked with the Democratic Party' and welcomed the participation of Communist activists during the mid-forties. (See Klehr and Haynes, *The American Communist Movement*, pp. 98–9.) The CIO's PAC was hot news in 1944 because of the political influence it wielded in national elections, and the concern that Roosevelt might not be re-elected: 'The history of three Roosevelt victories has been: the more voters at the polls, the bigger Mr Roosevelt's success. The PAC aims to get them there.' (*The Nation*, 12 June 1944, p. 31.) Illustrations by Reinhardt and Ajay excerpted from the CIO PAC pamphlet no. 2, *Organizing Your Community: Every Worker a Voter*, accompany that article. Reproductions of Reinhardt's election day reminder cartoons, also produced for the PAC, can be found in a number of issues of *The Guild Reporter*, in 1944. *The Guild Reporter* was the official weekly newsletter of the American Newspaper Guild. Cf. n. 62 above.

65. Lucy Lippard, in interview with the author, 1 December 1985. See n. 2 above for monograph details.

66. Idem, *Ad Reinhardt*, p. 23.

67. See Thomas Hess, *The Art Comics and Satires of Ad Reinhardt*, Marlborough Gallery, Rome 1975, pp. 12–14.

68. These sophisticated satires of Axis political figures by Reinhardt were displayed prominently in *New Masses*. In the issue of 3 March 1942 they were showcased in a full-page illustrated feature titled 'Four Moods of Der Fuehrer' and subtitled 'An adaptation of last century [sic] technique to contemporary ideas by Ad Reinhardt'. Some of the illustrations were dated as early as June 1941. The same collage technique had also been applied by Reinhardt to the solution of commercial art problems a good deal more mundane than the production of political cartoons; see the artist's cover illustration for *Listen* magazine, August 1941.

69. See Lippard, *Ad Reinhardt*, pp. 198–203; Lucy R. Lippard, *Ad Reinhardt. Paintings*, New York, The Jewish Museum, 23 November 1966–15 January 1967, pp. 30–36; and the autograph draft manuscripts of 'Chronology' found in the Ad Reinhardt Papers, Archives of American Art. Compare, for example, entries for the years 1932–35 as found in Reinhardt's 'Chronology' in Lippard's *Ad Reinhardt* (published in 1981) with those of the same years in the exhibition catalogue for his first retrospective at The Jewish Museum, New York (published in 1966). While both chronologies were authored by Reinhardt for the occasion of the retrospective, only one was intended for publication. The version subsequently published by Lippard in 1981 differs significantly from the one published by Reinhardt in the museum catalogue.

70. 'In 1966,' remarks Thomas Hess, '[Reinhardt] had written to me: Hey Tom: How are the old chronologies coming? Got a good one for me? In your chronic files? ... I'm having my first retrospective. (Note for your files.) So shuffling paintings around to see what kind of a past to make. What kind of a past ought I make these days in this time?' Hess, who had already discounted Reinhardt's involvement in Stalinist politics, asserts the anodyne view that Reinhardt's own chronology is 'masked by satire ... a tribute from a man who hated to give tributes to early training and a memorial to youthful experiences'. Hess ought to have known better. See Hess, *The Art Comics and Satires of Ad Reinhardt*, p. 13.

71. See, for example, *New Masses*, 8 July 1941, p. 10, and 15 July 1941, p. 8.

72. The exhibition took place on 13–25 March 1944, at Macy Hall, Columbia University Teachers' College. The image reprinted on the invitation card is found as part of a full-page display of Reinhardt's 'cartoon *collés*' in *New Masses*, 3 March 1942, p. 8.

73. The art comics are a series of cartoon-strip-style 'cartoon *collés*' which had been

published regularly throughout 1946 in *PM*, a New York daily that had established itself earlier in the decade as a self-proclaimed 'independent' socialist newspaper.

74. See 'Art Today: Lessons in Utter Confusion', *Daily Worker*, 19 May 1946, p. 14. Other articles by Summers include: 'Social Art Must Breathe the Air of the Common Man', *Daily Worker*, 7 April 1946, p. 14; 'The Social Artist Can Move Only into the Workers' Orbit', *Daily Worker*, 14 April 1946, p. 14; and 'Abstract Art and Bourgeois Culture', *Daily Worker*, 2 January 1947, p. 11.

75. Summers, 'Art Today: Lessons in Utter Confusion', p. 14.

76. For a discussion of Browder's ill-fated analysis of the Teheran pact, and his refusal to accept the CP-USA as an instrument of Soviet policy, see Jaffe, *The Rise and Fall of American Communism*.

77. See Starobin, *American Communism in Crisis*, pp. 150–51, 173; and Ottanelli, *The Communist Party of the United States*, pp. 213–16.

78. Albert Maltz wrote an article in response to a piece by Samuel Sillen, literary critic of *New Masses* and literary commentator for the *Daily Worker*. Maltz's article, 'What Shall We Ask of Our Writers?' (*New Masses*, 12 February 1946), took issue with the concept that 'art is a weapon'. In the text, Maltz supported writers such as James T. Farrell and Richard Wright who had since either left the Communist movement or become Trotskyists. According to Starobin, 'Maltz's rejection of the concept that "art is a weapon" immediately caused a storm' (*American Communism in Crisis*, p. 137). Sillen attacked Maltz in a series of six articles in the *Daily Worker* in February 1946. For a discussion of the post-war emergence of Zhdanovism in the CP-USA, see Starobin's analysis of the affair (ibid., p. 136). I am indebted to Andrew Hemingway for this reference.

79. Ad Reinhardt, 'Stuart Davis', *New Masses*, 27 November 1945, p. 15.

80. Included in the exhibition was the work of illustrators and artists associated with magazines like *New Yorker*, *Esquire* and *Harper's Bazaar*. Of the thirty-two artists whose work is shown, thirteen were *New Masses* contributors, including Abe Ajay, William Gropper, Theodore Scheel, and Anton Refregier. See 'Between Ourselves', *New Masses*, 9 March 1937, p. 2.

81. 'Meet *PM*'s Ad Reinhardt', *PM*, 13 May 1946.

82. The range of Reinhardt's professional graphic design experience was truly impressive. Writing in 1944, the artist recounts: 'Since 1936 I've worked in book, magazine, and newspaper publishing as an artist [graphic designer], typographer and layout man and as a cartoonist, muralist and exhibit designer elsewhere.' (Ad Reinhardt Papers, N/69–100, frame 168.)

83. To cite but a few of the cross-references to be found within the body of Reinhardt's illustrational work: a crouching figure, possibly a Greco-Roman wrestler, rendered in bold strokes, then overlaid with a slightly occlusive stipple pattern, credited to 'Rodney' (*New Masses*, 18 February 1941) is based on a Reinhardt illustration dating from his Columbia University student days. A spot drawing – the term given to a small work of graphic design generally used to break up the visual monotony of columns of type – credited to 'Rodney' (*New Masses*, 21 January 1941) is actually a reprint of one published twenty-six months earlier, and credited to Reinhardt (*New Masses*, 8 November 1938). A charming pen and ink line drawing used to illustrate a feature column and credited to 'Rodney' (*New Masses*, 4 February 1941), turns up three years later as the model for a Reinhardt cover for *Listen* magazine (October 1944). Another spot illustration credited to 'Frederick' (*New Masses*, 17 December 1940) is really an illustration produced by Reinhardt around 1932. The depiction of President Franklin D. Roosevelt as a drum major appearing in a cover design by 'Darryl Frederick' for the 9 February 1937 issue of *New Masses* is also a drawing of Reinhardt's from the early thirties.

Incidentally, Reinhardt's habit of cannibalizing his own artwork enables us to authenticate works originally identified in *New Masses* under pseudonyms, thereby helping to establish the true extent of Reinhardt's graphic art production. Ajay has suggested that Reinhardt may have employed multiple pseudonyms to disguise the fact that, after 1939, he often had to shoulder an inordinate burden of work; to give the impression of many more contributors to *New Masses*.

84. Lippard, *Ad Reinhardt*, p. 30.

85. Ad Reinhardt, 'Reinhardt', *Arts and Architecture*, January 1947, p. 20.

86. Lippard, *Ad Reinhardt*, p. 31.

87. 'Half-tone' is the term signifying the end product of the photographic process that

converts the continuous tones and shades of an original artwork for reproduction into a dot formation that can be printed to visually reproduce the tonalities of the original. See Eric Chambers, *Reproduction Photography for Lithography*, Graphic Arts Technical Foundation, Pittsburgh 1979, p. 179.

88. Even the so-called 'Persian Rug' paintings of the late forties exhibit this sort of matte surface, despite the chaotic nature of myriad, small overlapping areas of colour. A stronger contrast to the materiality of Davis's, or Mondrian's paint handling – not to mention that of the Abstract Expressionists of the late forties – could hardly be imagined.

89. Lippard, *Ad Reinhardt*, p. 39.

90. 'If there remains any doubt in your mind that the capable layout artist performs an important public service in mid-Twentieth Century America, you need only look about you.... the United States has more than 13,000 newspapers, daily and weekly, large and small. Practically all carry advertisements which have been prepared by advertising agencies for the business firms of the country. Here alone is a vast market for the creative skills of the men and women who know how to replace chaos with order, beauty, and power.' (Frank H. Young, *Technique of Advertising Layout*, Crown Publishers, New York 1935, p. 9.) This is a typical example of the hyperbole attached to the profession of advertising design at that time.

91. Ibid., p. 15. 'Some of the things he is expected to know include advertising, salesmanship, human nature and current trends in publicity requirements. He must possess a well-grounded art education, embracing figure drawing, composition, color, design and lettering ... he must know the limitations for reproduction of pen and ink, wash, dry brush, water color, tempera and oil renderings and photography. He must possess a real knowledge of typography and a comprehensive understanding of the various processes of printing and plate making.' Ibid. This is a fairly accurate inventory of the commercial art skills possessed by Reinhardt.

92. Ibid., p. 65.

93. It is worth pointing out that 'graphic design' is already an antiquated usage. During the seventies, 'graphic designers' – formerly identified as 'layout artists', 'commercial artists' or 'newspaper artists' – began to favour the omnibus term 'communications design', with all the managerial overtones that term implies. The course of modernization and professionalization of 'graphic design' practice can also be charted by following the corresponding shifts in nomenclature adopted by university departments devoted to that discipline, or the fact that they currently quite easily co-habit the academic space once reserved solely for the 'fine arts'. Witness, for example, the recent attempts to subject letter-form to semiotic analysis. See Ellen Luptin and J. Abbott Miller, 'Type Writing: Structuralism and Typography', *Émigré*, 15, 1990, pp. 24–31.

94. Reinhardt, 'Abstraction vs Illustration', p. 48 (see n. 19 above).

95. Ibid. (My emphasis.)

96. Yve-Alain Bois, 'The Limit of the Almost', in *Ad Reinhardt*, The Museum of Modern Art, New York 30 May–2 September 1991, p. 17.

97. Ibid., p. 19.

98. Lippard, *Ad Reinhardt*, p. 39. (My emphasis.)

99. Ben Day patterns are named after Benjamin Day, the inventor of a mechanical reproduction process allowing for the application of tints and shading patterns to black and white line artwork. The original process was somewhat cumbersome, involving the use of printer's ink and celluloid films. During the thirties, pre-printed sheets of rub-down or self-adhesive shading mediums marketed under the names 'Craftint', 'Grafa-Tone' and 'Zip-A-Tone' were available to commercial artists, greatly facilitating the ease with which such effects could be reproduced. See Willard C. Brinton, *Graphic Presentation*, Brinton Associates, New York 1939, p. 419. For examples by Reinhardt, see the advertising illustration in *New Masses*, 27 May 1941, and the cover illustrations for *Listen* of June and August 1941.

100. *New Masses*, 26 August 1941.

101. Credited to 'R. Frederick', *New Masses*, 18 November 1941, p. 4.

102. Bois, 'The Limit of the Almost', pp. 19–20.

103. Ibid., p. 20. See, for example, 'Abstract Painting' (1941); a series of four untitled gouaches (1942–43); 'Abstract Painting' (1943); and 'Abstract Painting' (1945).

104. 'Abstraction vs Illustration', p. 49 (see n. 19 above).

105. Lippard, *Ad Reinhardt*, p. 34.

106. See n. 67 above.

107. Lippard, 'Ad Reinhardt', in *Ad Reinhardt. Paintings*, pp. 10–29. See n. 69 above.

108. See n. 2 above.

109. See n. 1 above.

110. Lippard cites Carl Andre, who recalls that 'Reinhardt was quite an influence.... His various doctrines about what art is not about, all those no's, were very helpful.... Reinhardt stripped down the cultural assumptions about art and I think that was a very important work.' (See Lippard, *Ad Reinhardt*, p. 193.) Following Joseph Kosuth's and Christine Kozlov's lead, Lippard asserts: 'The two artists historically most pertinent to Conceptual Art are Reinhardt and ... Marcel Duchamp.... Reinhardt is important to [Conceptual Artists] because of his insistence that nothing but *art* is art and consequently only one art is possible.' (Ibid., p. 195.) For a refutation of this argument, see Bois, 'The Limit of Almost'.

111. Lippard's comprehensive work on Reinhardt, although flawed, has nevertheless contributed more to our sense of his complexity and importance than any other account.

112. Lippard, *Ad Reinhardt*, pp. 191–6.

113. These include: Max Kozloff, 'American Painting during the Cold War', *Artforum*, May 1973, pp. 43–54; Eva Cockcroft, 'Abstract Expressionism, Weapon of the Cold War', *Artforum*, June 1974, pp. 39–41; David and Cecile Shapiro, 'Abstract Expressionism: The Politics of Apolitical Painting', *Prospects*, 3, 1977, pp. 175–214; Serge Guilbaut, 'The New Adventures of the Avant-Garde in America: Greenberg, Pollock, or from Trotskyism to the New Liberalism of the "Vital Center"', *October*, 15, Winter 1980, pp. 61–78; and Fred Orton and Griselda Pollock, '*Avant-Gardes* and Partisans Reviewed', *Art History*, 4 (3), September 1981, pp. 305–27.

114. Lippard, *Ad Reinhardt*, p. 25.

115. Ibid., p. 129.

116. For instance, the recent retrospective of Ad Reinhardt's paintings exhibited at the Museum of Modern Art, New York (30 May–2 September 1991), and the Museum of Contemporary Art, Los Angeles (13 October 1991–5 January 1992). For a discussion of the issues surrounding the retrospective reconstruction of Reinhardt's work, and a critical view of the installation at the Museum of Modern Art, New York, see the author's: 'Review: Ad Reinhardt at the Museum of Modern Art', *Artforum*, November 1991, pp. 130–31. This was not necessarily the case of an earlier retrospective, which at least included a substantial selection of the artist's art comics and satires in the catalogue. See Gudrun Inboden and Thomas Kellein, eds, *Ad Reinhardt*, Staatsgalerie, Stuttgart 13 April–2 June 1985.

117. Reinhardt, 'The Fine Artist and the War Effort', p. 177.

3

Figuring Jasper Johns

Fred Orton

This essay is concerned with one of two painted bronze sculptures which Jasper Johns made in 1960, the one usually referred to as *Painted Bronze (Savarin)*; the other is usually referred to as *Painted Bronze (Ale Cans)*. Savarin, after Jean-Anthelme Brillat-Savarin, lawyer and landowner, mayor and violinist, judge and pornographer, political economist and author of the first great gastronomic classic *La Physiologie du goût* (1825), is here the brand name of a vacuum-packed coffee ready ground for percolators or filters. Straight away you will realize that my topic is a difficult one. What can you say and write about a sculpture of seventeen paintbrushes in a can? What and how does it mean? And what does it amount to?

Painted Bronze (Savarin) ($13\frac{1}{2}'' \times 8''$ diameter) was carefully made in plaster and then cast in bronze. There must be at least nineteen or twenty individual elements here: the can, the turpentine in the can, and the seventeen paintbrush handles, each one screwed into its place beneath the surface of the bronzed liquid. This small sculpture is very heavy. It has been referred to as a 'replica' – but it isn't: the details of the label, for example, have been copied but not exactly. It imitates the look of the original can but it's not a facsimile. It has also been described as a trompe l'oeil work where it would have to function in a kind of game which the viewer plays by being deceived. Johns is not playing this game, surely?[1] *Painted Bronze (Savarin)* does not deceive the eye, and it would not deceive the hand. The label has been copied; it looks like the label. The can's edges have been painted silver in imitation of the aluminium of the original can. The handles of the brushes have been painted to look as if they are made of bare, stained or painted wood, and they have been overpainted with Johns's characteristic palette of primary and secondary colours to show they have been used. A high degree of illusion has been achieved. The possibility is there that one might take it for a Savarin coffee can with seventeen paintbrushes in it, but with very little examination

it becomes clear that *Painted Bronze (Savarin)* is not a can with paintbrushes in it. Look at the label: it is as if the real label was used as a life model;[2] you can see it has been painted, and quite freely; look at the small print – you always should – it is very schematic (sketchy), the marks signifying individual letters do not become them, letters refuse to make whole words, words remain illegible; look at the silver painted rim and the weld on the can, so carefully painted to both convince one and yet to prove the lie of the piece; see the way the silver has been made to run down and across the red label, changing direction slightly as it partly obscures the first 'a' in 'Savarin' and then the 'O' in 'COFFEE'; look at any single brush, see how it is underpainted and overpainted – this is complex painting, playing games with flatness and the illusion of shallow space on a three-dimensional object; the fingerprints on the brushes make the illusion, but the orange fingerprint wrinkling the red oil paint of the can's label and pushing the black band of 'COFFEE' into shallow recession unmakes it.[3] There are no accidents here, just a lot of highly self-conscious hand-of-the-artist facticity. A bronze sculpture, maybe, but one which is not so much painted to look like a Savarin coffee can with brushes in it as one which has had painted on to it – so as to be contiguous with it – a thoroughly modernist painting of a Savarin coffee can with brushes in it. *Painted Bronze* is a good title.

Johns is best known for his paintings, drawings and prints, and maybe that explains why his work as a sculptor is usually overlooked by those persons whose task it has been to tell the history of modern sculpture; that, and the fact that he has produced very little of it – *Painted Bronze (Savarin)* and *Painted Bronze (Ale Cans)* are two of what I count as only twenty-two sculptures that he has made since 1958.[4] If they do get written into the general histories they are placed somewhere at the beginnings of Pop Art, not a mode particularly noted for its sculptural production. Interestingly, discussion of Johns's sculpture is almost completely absented – it has to be mentioned in the monographs, of course – from the vast literature which has been produced to explain, celebrate and value the art of Jasper Johns. Though there have been many retrospective or survey exhibitions of his work and several of his work as a draughtsman and as a printmaker, as far as I know there has never been a retrospective of his work as a sculptor. Maybe it really is a case of what can you say and write about *Painted Bronze* or *Flashlight* (1958) or the *Bronze (Lightbulb)* (1960–61)? Not much, or so it seems.

Rereading the literature on Johns, it becomes apparent that the usual strategy for writing something about his sculpture is to relate it to what one has to write about his paintings, then to discuss technical matters, and then to note how puzzling it is. In this respect, at least, this essay will be conventional. When I began thinking about what it was that I wanted to write I had in mind some of the things which Alan Solomon wrote in his catalogue essay for the Johns retrospective of 1964.[5] I was especially

interested in the way his writing registers the effect that the sculpture has on him: the way he is faced with 'a genuine confusion about the identity of these objects'; 'the ambiguity ... is overwhelming'; 'we encounter a perplexing uncertainty'; 'we are plunged ... into that ... realm of ambiguity.'[6] And Solomon is not the only one to register the effect in terms of a kind of ambiguity and uncertainty – especially amongst those persons who wrote about Johns's work in the later fifties and early sixties: Fairfield Porter and Robert Rosenblum in 1958, Ben Heller in 1959, Leo Steinberg in 1961, Clement Greenberg in 1962 and Michael Fried in 1963 are others who come immediately to mind.[7]

Max Kozloff's monograph on Johns, published in 1969, is particularly interesting in this context because, although it is a book which is most concerned to explain Johns's paintings, it begins with a discussion of a sculpture, *The Critic Sees* (1961) (sculpmetal on plaster with glass – more on this in a moment – $3\frac{1}{4}'' \times 6\frac{1}{4}'' \times 2\frac{1}{8}''$).[8] What he writes about this sculpture provides the entry to, and determines, what he has to write about Johns and Johns's art practice generally. It is a lengthy discussion, too long to quote here, so I will have to précis and paraphrase it.

This is how Kozloff figures, with blindness and insight, *The Critic Sees*. The meaning of any work by Johns has to be regarded as both of and not of him. His practice is based on the supposition that there is no equivalence between a thing and what it represents. A work by Johns must, therefore, be understood not just as having a literal or single meaning but as presenting several possible meanings from amongst which the spectator, instigated or lured into curiosity, has to choose. But the ability to choose is frustrated by the work's initial 'aesthetic appearance', that is, by its obvious and or emphatic artistic value in terms of facture, colour, composition, and so on. In front of Johns's work, then, the spectator's accepted ways of making sense of what is being seen are threatened to such an extent that the spectator might feel that it is he or she who is being examined by the work of art which turns out to offer a rather 'menacing pleasure'. Kozloff then provides as

> an illustration, or almost a paradigm of this situation ... a piece Johns made in 1961.... A gray, soft, metallic looking brick, it presents, on one façade, raised slightly from the surface, a cast of a man's spectacles behind whose lenses, within ambiguous and shadowy caverns, there appear casts of human mouths, one open and the other almost shut. It is made of sculpmetal, a substance of toothpaste consistency (composed of aluminium powder in a plastic or lacquer base), brushable, controlled by a thinner, and sold as a modelling medium for amateurs.

That is the technical information. Next Kozloff writes the meaning of *The Critic Sees*. Again, and I think correctly, he presents us with the idea that this sculpture is focused on the spectator: he or she is the locus of meaning; 'it confronts the spectator in an almost animate guise.' The real action of the

piece is the spectator's learning to read – understand – what it represents about seeing and speaking with reference to the work of art and 'not only . . . works of art . . . but . . . human perception of the visual world'. Kozloff is now near his conclusion. In *The Critic Sees*, he writes, speech and vision are presented as two aspects of the process of understanding. But the relation here, the one to the other, is not clear. Has speech 'usurped' vision? Or has vision 'capped' speech? Whichever it is, the possibility of integrated function remains. Or has speech been displaced on to vision and vision displaced on to speech? Here the possibility of integration disappears in a problematic way (the words 'resistance' and 'disorientation' are used to name the problem). Both interpretations are possible. The spectator is faced with a dilemma. *The Critic Sees* effects uncertainty. But without this uncertainty it would be impossible to experience fully the way the sculpture sidetracks all categories, not just with regard to how it represents speech and vision but also with regard to what it is as an object. Understanding is not immediate; at least, not here it isn't, because *The Critic Sees* is an object that enables the production of knowledge even as it obstructs it. Whatever is to be learned, it will be the result of uncertainty and the way that uncertainty provokes analysis and self-reflection. Kozloff concludes that *The Critic Sees* may even be an *allegory* of this way of apprehending not only works of art but the visual world. This is, for me, the moment of blindness and insight: 'For one moment in his career the artist externalizes, perhaps even allegorizes, the dialogue in which "the prime motive of any work is the wish to give rise to discussion, if only between the mind and itself." '

Although those early writers on Johns's work – Heller, Steinberg, Greenberg, Fried, Solomon, Porter, Rosenblum and Rubin – all write about the uncertainty effected by it – ambiguity or paradox or irony, a fault in style or a self-contradiction or a dissembling or hiding, or combinations of these – only Kozloff hints that it may be best described as allegory.[9] All these early writers on Johns's art are trying to understand his mode of representation. What I find interesting, and potentially very useful, is that Kozloff, at the beginning of his book, glimpses that Johns may be an allegorical artist and that the effect of his work, and its value at that moment, is as *allegory*.[10]

* * *

The double purpose of *making* a reality and making it *mean* something is peculiar to allegory and its directive language. In this it differs from the univocal aim of realistic fiction, which imitates the world-as-is from a view reduced to the commonplace and assumes only what may readily be taken for granted throughout. In fixing and relating fictional identities, allegory gives new dimension to things of everyday acceptance, thereby converting the commonplace into purposeful forms.

*

114

For the meanings of allegory depend, as in poetry, upon the accretion of certain tropes. These tropes make evident a consonance between objective facts and their moral or psychological counterparts, so that the reality – the hypothetical nature of the literal – is ultimately transcended by the total organization of meanings which is the fiction itself. And so one may say that the language of allegory makes relationships significant by extending the original identities of which they are composed with as many clusters of meaning as the traffic of the dominant idea will bear. In this way allegory as an extended trope may include the functions of all the other tropes – metaphor, irony, metonymy, and synecdoche.

EDWIN HONIG, *Dark Conceit: The Making of Allegory*[11]

Allegory is a fundamental process of encoding speech, a radical transhistorical mode or procedure that can appear in more or less any kind of representation, literary and visual.[12] It is a narrative in which actions and agents, and sometimes the setting, are made to make a kind of sense on the literal or primary level of signification and also to signify on another level or at other levels. 'Allegory' is derived from the Greek 'allos' = 'other', and 'agoreuein' = 'speak openly (speak in the assembly or the market)'. 'Agoreuein' connotes public speaking but 'allos' inverts that sense to make allegory 'a mysterious saying, wherein there is couched something that is different from the literal sense'.[13] The political connotation of the verb 'agoreuein' should be noted, in passing, insofar as repression and censorship may produce allegory.

Later we will have to understand allegory in its dialectical relation to symbol, but here, in order to tease out the ways Johns's work might be seen as allegorical, I would want to extend this usual definition of allegory as other-speaking in two ways. First, allegory can be regarded as a twice-told tale: it other-speaks a pre-text, an anterior narrative or visual image.[14] The job which allegory has to do as other-speaking is a complex one, and the relationship between it and its pre-text is more complicated than the usual connection between a conventional representation and its appropriated resources, which are sometimes no more than places where an author found useful ideas, motifs, devices appropriate for making his or her own text. The allegorical mode never aims to hide its lack of invention, especially with regard to its pre-text or pre-texts. Any verbal or visual representation has to be understood as a nexus of several texts or images. But in a more or less conventional representation, even when allusion or reference is meant to be used as a guide to interpretation, the text or image or the nexus of texts or images which make it does not approach the complexity of connection which pertains between an allegory and its pre-text or pre-texts. The pre-text in allegory is not just a good idea taken, borrowed or quoted from some other

place; it's not just an appropriated resource: it is, in a way, the original truth or meaning. Allegory takes over a truth or a meaning and adds to it not to replace it but to 'supplement' it.[15]

Which brings me to my second extended way of explaining allegory as other-speaking. Understanding allegory as a special kind of appropriation of a pre-text, supplementing it while constructing itself as an-other text, enables us to understand allegory as a mode of critical commentary or critical reading of a text.[16] My point here is that in understanding allegory as an organized way of reading and valuing a pre-text, disfiguring and figuring it, we glimpse the ways in which it might be regarded as effecting an endless displacement of meaning, constantly baffling and frustrating the desire for some assurance or security of understanding.

In traditional rhetoric, allegory is defined as a metaphor introduced into a continuous series. For Cicero and Quintilian, it is 'a sequence of sub-metaphors which amount in aggregate to one single, continued, "extended" metaphor'.[17] This is correct insofar as 'part of the function of an allegory is to make you feel that two levels of being correspond to each other in detail . . . the effect of allegory is to keep the two levels of being very distinct in your mind though they interpenetrate each other in so many details.'[18] But, and here my authority is Angus Fletcher's book, published in 1964, *Allegory: The Theory of a Symbolic Mode*,

> This view, which equates allegory directly with metaphor and assumes their effects are essentially the same, holds true as long as the term metaphor is understood loosely. If metaphor is to be the general name for any and all 'transfers' of meaning, it will necessarily include allegory. . . . The difficulty here is that such a rhetorical terminology will obscure the very complications which are the interesting aspect of allegory.[19]

Fletcher recalls the classic distinction between trope and figure.[20] We need to hang on to it. The former is a play on single words, the latter on whole groups of words, or sentences, and even paragraphs. Allegory must fall into the latter category. Then Fletcher picks on and inverts Quintilian's belief that just as he thought that continued metaphor developed into allegory, so he thought that a sustained series of tropes (for example, ironic tropes) developed into allegory also. He writes:

> Perhaps, instead of considering how the parts, the particular tropes of irony and double meaning, have the power to produce a total allegorical figure, we might ask whether the total figure . . . does not give particular symbolic force to the part. The whole may determine the sense of the parts, and the parts be governed by the intention of the whole. This would yield a concept of teleologically ordered speech.[21]

116

And the two kinds of teleologically controlled tropes which come immediately to Fletcher's mind are synecdoche and metonymy. These terms, I'm sure, need a little explanation. (We are not far from Johns at this point, and synecdoche and metonymy are going to get us back to him very soon.) With synecdoche (Greek for 'taking together'), the plural is used to refer to the singular, the whole to the part, genus might stand for the species, something following understood from something preceding, and vice versa. As Fletcher points out, 'A synecdoche could ... easily fit the logical criterion of an element of allegory, since in itself it would always call to the reader's mind some larger organization of symbols to which system it bore an integral relation.'[22] With metonymy (Greek for 'a change of name'), the literal term for one thing is applied to another with which it has become closely – and maybe briefly – and/or contiguously associated. Metonymy is the record of a lacuna, of a move or displacement from container to contained, from thing seen to where it was seen, from goal to auxiliary tool, from cause to effect. Near the end of his discussion, Fletcher has only a momentary and slight doubt about it: 'Taken together synecdoche and metonymy appear to contain the full range of allegorical part–whole relationships, the former allowing us to label *static* relations of classification ... while the latter allow us to label *dynamic* interactions between part and whole.'[23] Then, following Edwin Honig, Fletcher is in no doubt about it: 'we can settle on a generic term to include both synecdoches and metonymies' – *allegory*.[24]

The main trouble we have to contend with when reading allegory is our own psychological and linguistic uncertainty as to what is going on when language is used figuratively in a self-conscious way. Allegory 'does not exhibit devices or hammer away at its intentions ... it beguiles the reader with a continuous interplay between subject and sense',[25] image and meaning. It is the most self-reflexive and critically self-conscious of modes and its aim is to make its reader correspondingly self-conscious. The locus of meaning of any allegory is the reader. And the reader must put an immense amount of energy into the activity of reading an allegory. The real action of allegory is the reader's learning to read the text.[26]

Critics and historians of modern art, those who are empowered to stipulate meaning and feeling, usually write about paintings and sculptures in terms of metaphor without giving much thought to what and how metaphors mean.[27] Most of the time, all that is meant when a work of art is referred to and discussed as metaphor or as a visual metaphor is that in addition to its literal sense or meaning it has another sense or meaning. Metaphors offer the line of least resistance to those explainers who are unconcerned about the subtleties of figuration, rhetoric and stylistics within the language of art. Other, more precise discriminations are possible and we must be mindful of them. Once we are, we can be somewhat less abstract in what we do write about paintings and sculptures. What I was able to show in an article called 'Present, the

Scene of... Selves, the Occasion of... Ruses', which was published in 1987, was that Johns's preferred and dominant trope was very much *not* metaphor but synecdoche and metonymy, and that *Untitled*, 1972 (oil, encaustic and collage on four canvases, each one 6' × 4'), which I took as one of my examples, had to be seen and understood as a surface made up of synecdochic and metonymic elements.[28]

The surfaces of Johns's paintings make very good sense as modernist paintings – paintings made out of the practical and conceptual concern with surface. And the protocols and procedures institutionalized by the professionalization of modern art criticism and history have tended to restrict discussion of paintings like *Untitled*, 1972 to such matters as how the surface is made out of what it is made out of, to how the 'crosshatchings' work, to how the 'flagstones' of the two middle panels make a hidden square, and so on. These surfaces make sense on another level as well. But criticism and history, constrained as they are by their terms of reference, find it almost impossible to go beyond valorizing the surface and to pursue the possibility, often glimpsed, that there might be more to Johns's pictures than meets the eye, that they might have subject matter which gives another dimension to things of everyday acceptance – inside and outside the language of art – and converts them into purposeful forms. This is where it is useful to think about these surface elements as having a literal meaning which Johns turns in an indirect way towards another meaning or other meanings while all the time knowing that that meaning or those meanings will be misunderstood – by some persons – by being taken literally.

Each pattern, object and imprint which makes up the surface of *Untitled*, 1972 is turned by the association of ideas, qualities and values to something else, reflexively to Johns's work, to memories of events and places, to the work of other artists, to other ideas, qualities and values. In 'Present, the Scene of ... Selves, the Occasion of ... Ruses', I was able to show how, for example, the 'crosshatchings' were not, as Johns explained they were, just derived from a paint job on a car which once passed him by on the freeway, but how that brief sighting and his reaction to it – 'I would use it for my next painting' – was metonymically related to some of Picasso's work, especially to the *Femmes d'Alger* (1955), with its striations or hatchings, there a form of autonomous decoration organizing and controlling the surface of a painting with some very vivid imagery, and how in Johns's paintings those hatchings, appropriated from the *Femmes d'Alger*, refer synecdochically to that vivid imagery, the somewhat fragmented-in-the-process-of-representation *femmes*, *demoiselles*, women. I was also able to show how the 'flagstones' which dominate and make the centre surfaces were not, as Johns said they were, just a copy from memory of a design painted on a store-front glimpsed whilst driving through Harlem. That sighting, or the memory of it, was metonymically connected to some of Magritte's paintings, for example *Les six*

éléments (1929) and *Au seuil de la liberté* (1930), and especially *La Femme introuvable* (1928), where the figure of a naked woman is embedded with four large hands in a wall of eccentrically shaped stones not unlike – but not similar to (though similarity is OK on the streets)[29] – the 'flagstones' which get painted on *Untitled*, 1972. As with the 'crosshatchings', these 'flagstones' must be understood or valued not only for what they are but for what they surround in Magritte's painting. Again, what is presented signifies what is absented.

What I'm considering here with *Untitled*, 1972's 'crosshatched' and 'flagstoned' surfaces are not some mechanical actions by contact – a strangely painted car seen whilst driving on the freeway, an oddly painted store-front seen whilst driving through Harlem, and there's a good idea for my next painting – but a more or less fortuitous and exploitable sighting of a strangely painted car and an oddly painted store-front by means of which some of Picasso's work and some of Magritte's work could be appropriated, by Johns, to serve his representational aims, and especially the need to refer to them obliquely and by means of the modernist plausibility of his surface. Those 'crosshatchings' and 'flagstones' were not invented by Johns – that is the point: 'What I had hoped to do was an exact copy of the wall. It was red, black, and gray, but I'm sure that it didn't look like what I did. But I did my best'[30] – they were appropriated and troped to refer to something in some paintings by Picasso and Magritte which could not be represented as such. Picasso's *Femmes d'Alger* and Magritte's *La Femme introuvable* are two of *Untitled*, 1972's pre-texts: anterior but not coincidental with it, they indicate a direction of commentary; they provide a key to its interpretability, but not necessarily to its interpretation.

Given that, I have to acknowledge that I still cannot tell you what *Untitled*, 1972 means. It seems sufficient, however, that I have identified the mode by which it might be taken to represent Johns, that is to say, it seems sufficient to have 'figured' *Untitled*, 1972 as *allegory*.

As yet I have said nothing about the canvas at the right of *Untitled*, 1972 with its encaustic surface, wooden battens and wax casts which may or may not refer to what is troped by the other panels; but I do have something to say about it and what I have to say will return us to *Painted Bronze (Savarin)*. 'Prosopopeia' (Greek for personification), the figure in which an inanimate object or an abstract concept is spoken of – represented – as if it were endowed with life or with human attributes or feelings, is the central device in the sustained allegory of ideas. And here, in this right panel, there is a hint of prosopopeia; it is this which returns us to *Painted Bronze (Savarin)*.

Two objects have been pressed into the wax surface of the right panel, two imprints, two indexical traces, two synecdoches: the sole of an iron and the rim of a can. Both these imprints have a history in Johns's work. The iron imprint goes back to *Passage* of 1962. The can imprint goes back to *Field*

Painting of 1963–64. *Field Painting* has been marked by two cans (no prizes for guessing what they are): the base of a Ballantine beer can and the base of a Savarin coffee can; and the cans are also there, magnetized in place, attached to some of the three-dimensional letters of the colour names RED, YELLOW, BLUE, which divide the surface in two. Published photographs of *Field Painting* show the Ballantine can attracted to either the Y or W of YELLOW and the Savarin can attracted to either the second L of YELLOW or the B of BLUE. Their attraction varies. After these guest appearances in *Field Painting*, they continue to mark the progress of Johns's art. The base of the Savarin can turns up in *Arrive/Depart*, also of 1963–64, *Eddingsville* of 1965, *Passage II* of 1966; it is there in the seventies, most effectively in *Usuyuki* of 1977–78; and it is there in the eighties. The Savarin can also appears, as you will see in a moment, as another kind of sign, in semiotic terms it would have to be referred to as an icon, in the graphic work in the sixties and seventies and the paintings of the eighties.

My concern is, of course, with *Painted Bronze (Savarin)* rather than with *Painted Bronze (Ale Cans)*. It is always interesting to note which of his paintings and sculptures Johns keeps for his own collection. For example, he has kept *Field Painting*. He sold *Painted Bronze (Ale Cans)* but, as I will explain in a moment, that was partly the point. Evidently, he has kept the unopened can which was one of the 'models' for the piece.[31] *Painted Bronze (Savarin)* still belongs to Johns. He did not sell it. This strikes me as possibly significant. My guess – my fantasy – is that *Painted Bronze (Savarin)* means more to him than does *Painted Bronze (Ale Cans)*, and that it has greater use-value, in his art, as a repeatable or exchangeable sign.

As with the 'crosshatchings' and the 'flagstones', so these sculptures have their beginnings in a pre-text. Here is the story that Johns tells about its appropriation:

> I was doing at that time sculptures of small objects – flashlights and light bulbs. Then I heard a story about Willem de Kooning. He was annoyed with my dealer Leo Castelli, for some reason, and said something like, 'That son-of-a-bitch; you could give him two beer cans and he could sell them.' I heard this and thought, 'What a sculpture – two beer cans.' It seemed to me to fit in perfectly with what I was doing, so I did them and Leo sold them.[32]

And thereafter, 'Doing the ale cans made me see other things around me, so I did the Savarin can.'[33] Two Ballantine beer cans – at the time, maybe, Ballantine was a favourite beer[34] – were cast in bronze, painted, finger-printed and 'plinthed'. One has been opened, the smaller one; it's a southern can, from Florida. The other one is unopened; it's a New York can. One is heavy, the other is light. And so on. This obsessive surfaceness interests me less than does the fact that it was a remark of de Kooning's to which Johns

responded. To my mind, this is a sculpture which comments not only on an individual, a certain kind of artist, his ideas about art and his attitude to art dealing, but on the whole ethos of Abstract Expressionism and especially the belief in the expressive quality of the work of art. Johns's dealer, Leo Castelli, did not sell Abstract Expressionism, indeed his gallery was set up to market something else. Johns's attitude to it was ambiguous, but this comment of 1973 – which is almost a description of allegory – has to be noted.

> I have attempted to develop my thinking in such a way that the work I've done is not me – not to confuse my feelings with what I produced. I didn't want my work to be an exposure of my feelings. Abstract-Expressionism was so lively – personal identity and painting were more or less the same, and I tried to operate in the same way. But I found I couldn't do anything that would be identical with my feelings. So I worked in such a way that I could say it's not me.[35]

De Kooning's comment, and Johns's critical commentary on it, *Painted Bronze (Ale Cans)*, was then displaced on to and supplemented by *Painted Bronze (Savarin)*. In the process, *Painted Bronze (Savarin)* loses some of its pre-textual meaning, but it also gains meaning.

Painted Bronze (Savarin) appeared on the plain white cover of the catalogue produced for the Jasper Johns retrospective at the Jewish Museum, New York, 1964 – another example of a sculpture being used to announce or introduce a practice mainly concerned with making paintings, prints and drawings. On the cover it is an iconic sign anchoring 'Jasper Johns' as author-function and, I suppose, relaying or driving the gallery-goer into the catalogue and round the exhibition. It was used again, thirteen years later, as part of a specially designed cover made by Johns for the catalogue of the retrospective at the Whitney Museum of American Art, New York, 1977. It also appeared on the poster. I would argue that on the 1964 cover *Painted Bronze (Savarin)* was used emblematically – not valued for its specious appearance but for its significance, it occupies a position somewhere between a visual sign and a written word – and that on the 1977 cover and poster, developed with the tropes in an extended fashion, it becomes a prosopopeia of the artist and his practice, his persona and corpus. On the Whitney cover and poster it marks the work that Johns had made since 1973, the 'crosshatching' paintings which were still relatively new work, as *of* Johns the author of *Painted Bronze (Savarin)*. The 'crosshatching' paintings – *Corpse and Mirror II* of 1974–75 is represented in the background of the poster – are authenticated by *Painted Bronze (Savarin)* as part of Johns's oeuvre. New work, old work; painting and sculpture; painting, sculpture and graphic art – all brought together. There is also the cover of *Newsweek* magazine, 24 October 1977, that ran a substantial feature article on Johns during the Whitney retrospective, 'Super Artist: Jasper Johns, Today's Master', which

is worth mentioning here.[36] This is just a photo-equivalent of the catalogue cover and poster which makes obvious what they represent obliquely. Johns has to be there on the *Newsweek* cover. The aim is to introduce him, the look of him, to a wider and more general public than the gallery-going community. He also has to be shown as a serious-all-American-kind-of-guy. And for some persons he has to be there, let us face it, because *Painted Bronze (Savarin)* isn't. What is there is a bit of a coffee can with some paintbrushes in it whose meaning for those who know about Johns and his art is turned towards the sculpture but for those who don't know about Johns and his art is just a can with paintbrushes in it signifying all sorts of super-artistry.

But look at those paintbrushes: clean and unclean; bristles up and ready-for-use! Brought next to it, don't they indicate or make clear a certain strangeness about the brushes in *Painted Bronze (Savarin)*? They shouldn't be like that, should they? Well, I suppose they're just having a good soak. And, anyway, they would have been more difficult to cast with the bristles up; and, once cast, they would have been more easily seen as casts of brushes – hair rarely convinces when represented in bronze – and so the uncertainty which the piece effects would have been lessened. That being the case, there must have been good technical reasons for keeping those bristles down in the can. We know that Johns does not keep his brushes like this; but he may have done; and if he did, he must have had a great many moribund or dead brushes. This is how Kozloff described it alongside *Study for Skin I* of 1962:

> As for the content of *Painted Bronze* and *Study for Skin I* . . . they go further in being studies of imprisonment. Into that lovingly rendered bronze replica of his Savarin paint can, Johns wedges his brushes, which, so far from being cleansed by turpentine, stew eternally in metal. It is as if matter has taken the bristles into its own, sealed in the 'soil' of art without any hope of that lifting away which restores freshness to the remembering mind. Even more extreme is the sightless image of the artist pressing cheeks and hands against the blank caging surface of the paper. Like the sculpture, the drawing appears as a frightful dream that will never relinquish its grip. Doubtless it was intended that the impasse envisioned in these two works brings time to a standstill. Without the potentiality for, or allusion to, change, Johns' art takes on a memorial character. It becomes a relic of triumphant memory, closed to all further experience because paralyzed.[37]

Maybe it is not accidental that it's *Corpse and Mirror II* in the background of the poster. *Painted Bronze (Savarin)* has also been seen, again by Kozloff, as a presentiment of Johns's artistic sterility.[38] Maybe we should take such suggestions seriously. Prosopopeia is, after all, the figure of autobiography.[39] *Painted Bronze (Savarin)* might better be understood as figuring doubts about the possibility of a certain kind of painting and a certain kind of sculpture. *Painted Bronze (Savarin)*: the dead-end of modernist painting and sculpture? It is possible to see Johns's practice as representing that,

around 1960 when *Painted Bronze (Savarin)* was made. In order to make this point clearer, I need to abandon prosopopeia and re-engage with allegory, this time in relation to symbol. It's Johns's work as allegory (metonymy) in opposition to the modernist symbol (metaphor) which now needs to be emphasized.

* * *

> Whereas the symbol postulates the possibility of an identity or identification, allegory designates primarily a distance in relation to its own origin, and, renouncing the nostalgia and the desire to coincide, it establishes its language in the void of this temporal difference. In so doing, it prevents the self from an illusory identification with the non-self, which is now fully, though painfully, recognized as a non-self.
>
> On the level of language the asserted superiority of the symbol over allegory, so frequent during the nineteenth century, is one of the forms taken by this tenacious self-mystification. Wide areas of European literature of the nineteenth and twentieth centuries appear as regressive with regards to the truths that came to light in the last quarter of the eighteenth century. For the lucidity of the pre-romantic writers does not persist. It does not take long for a symbolic conception of metaphorical language to establish itself everywhere, despite the ambiguities that persist in aesthetic theory and poetic practice. But this symbolical style will never be allowed to exist in serenity; since it is a veil thrown over a light one no longer wishes to perceive, it will never be able to gain an entirely good poetic conscience.
>
> PAUL DE MAN, 'The Rhetoric of Temporality'[40]

In the copious literature on allegory, reference is usually made to some seminal passages in Goethe's *Maxims and Reflections*, published in 1824[41] – but the result of his speculating on the character of the literary symbol since the 1790s – and Coleridge's *The Statesman's Manual* of 1816.[42] This is Coleridge, following Goethe:

> Now an allegory is but a translation of abstract notions into a picture-language, which is itself nothing but an abstraction from objects of the senses; the principal being more worthless even than its phantom proxy, both alike unsubstantial, and the former shapeless to boot. On the other hand a symbol . . . is characterized by a translucence of the special in the individual, or of the general in the special, or of the universal in the general; above all by the translucence of the eternal through and in the temporal. It always partakes of the reality which it renders intelligible; and while it enunciates the whole, abides itself as a living part in that unity of

which it is the representative. The other are but empty echoes which the fancy arbitrarily associates with apparitions of matter, less beautiful but not less shadowy than the sloping orchard or hill-side pasture seen in the transparent lake below.[43]

Coleridge is describing what he believes to be the uniquely symbolic nature of the Bible as a sacred text, but later commentators took his remarks to define the general nature of a symbol in secular literature and the plastic arts. What Goethe's and Coleridge's writings on the symbol mark is that moment when the symbol is secularized or profaned and the unity of the material and transcendental object, which constitutes the paradox of the theological symbol, is distorted in aesthetics into the indivisibility of form and content, appearance and essence, and allegory is constructed as its 'speculative counterpart'.[44]

Coleridge and Goethe both stress that allegory presents a pair, an image and a concept (a signifier and a signified), whereas a symbol presents only an image. Allegory is the translation of rarefied ideas about things into arbitrary, not necessary, illustrations or decorative images. The symbol is an image alone: synecdochically it's a part of the whole which animates it; and it is characterized by translucence, it is part of, and it acts as a vehicle for, what shines through it. The relation between it and what it makes intelligible is motivated, necessary and immediate. As Christopher Norris has pointed out, in Romantic ideology this moment of transcendence and translucence 'can only come about through the grace of genius manifest chiefly in privileged tropes like metaphor and symbol, tropes that reveal a creative power which is also a kind of second nature, a token of the "one life, within us and abroad" envisioned by poets like Wordsworth and Coleridge'.[45] That will give you some idea of the beginnings of the doctrine of the secularized symbol – as language or sound, stone, colour or whatever – with its clarity, brevity, grace and union of meaning and structure which in the Romantic period becomes established as the highest, most valued form of artistic expression.

Jackson Pollock's *Number 1, 1948* or *Lavender Mist: Number 1, 1950* would suffice as an example of a modern plastic symbol. So would Barnett Newman's *Onement 1* of 1948. So would more or less any painting by Morris Louis or Kenneth Noland or Jules Olitski. And our latter-day Coleridge? Well, that could be Clement Greenberg, almost unarguably the most important and influential critic of modern art, especially between '"American-Type" Painting' of 1955 and 'Modernist Painting' of 1961 or 'After Abstract Expressionism' of 1962.[46] This is Greenberg writing about the kind of painting I have just referred to:

Louis is not interested in veils or stripes as such, but in verticality and colour. Noland is not interested in circles as such, but in concentricity and colour. Olitski is not interested in openings and spots as such, but in interlocking and colour. And

yet the colour, the verticality, the concentricity, and the interlocking are not there for their own sakes. They are there, first and foremost, for the sake of feeling, and as vehicles of feeling. And if these paintings fail as vehicles and expressions of feeling, they fail entirely.[47]

In front of this kind of painting, Greenberg, whose concern with emotional expression is usually overlooked, experiences something which he refers to as 'content'. The content of a work of art is unspecifiable – indefinable, unparaphrasable, undiscussable – and it is this that constitutes art as art. Content is 'quality', and vice versa. Greenberg knows that a work of art has content because of its 'effect'. Content is what Greenberg feels. It is carried by the painting in the way the medium is used by the artist. The implication is that content is the artist's state of mind or knowledge. Clearly there is a difference between experiencing a painting as a vehicle of feeling and experiencing an artist's feelings, but surely these are what are conjoined in the 'content', 'quality' and 'effect' which Greenberg feels?[48] The kind of painting that he values – this kind of painting – effects in him an identification with something which, and someone who, is not him. Indeed, that is why he values it. And how long does it take to effect this identification? This is Greenberg again:

> Esthetic judgements are given and contained in the immediate experience of art. They coincide with it; they are not arrived at afterwards through reflection and thought. Esthetic judgements are involuntary: you can no more choose whether or not to like a work of art than you can to have sugar taste sweet or lemons sour. . . . Because esthetic judgements are immediate, intuitive, undeliberate, and involuntary, they leave room for no conscious application of standards, rules or precepts.[49]

That is Greenberg seeing, and feeling, modernist painting as symbolic. It was more difficult for him to see sculpture like that – it was not as personal and self-contained, self-sufficient and thoroughly abstract as painting had become – until 1958.[50] Even then, he made no claims for it until after he had tutored Anthony Caro in how to make a kind of sculpture that derived its impetus from what he had written about the problems and concerns of modernist painting, and which Caro got right, at the second or third attempt, after *Twenty-four Hours* at *Midday* ($7\frac{3}{4}'' \times 3'1\frac{3}{8}'' \times 12'1\frac{3}{4}''$).[51] Thereafter, Greenberg would value Caro's sculpture for its 'abstract(ness)' and 'syntax' (that is, the autonomy and clarity of its construction), for its 'necessity', and because it was 'compelled by a vision' that was 'unable to make itself known except by changing art'.[52]

Here they are, as far as I am aware, brought together for the first time in the same space, Johns's painted bronze allegory and Caro's painted – Greenberg had problems with this aspect of the sculpture – steel symbol, both made in 1960. And here, Johns is the navigator not Caro.

Now what can you say and write about *Painted Bronze (Savarin)*, seeing it as emblem and allegory, and as a – maybe *the* – personification of Jasper Johns and his practice?

It would be possible to develop some further thoughts on allegory as a mode of other-speaking, as speaking figuratively and making public something which would otherwise remain private, and to consider why Johns might have wanted to, or needed to, do this by making an art which would be valued in modernism for its surfaceness and facticity while at the same time troping and figuring that surface towards a subject matter available only to those who knew what procedures to carry out and techniques to apply. I could then consider Johns's beginnings as an artist in what was a particularly coercive and censorious moment towards the end of the first stage of the Cold War when un-Americanness and homophobia were joined in the same repressive discourse. This was a moment when for some artists and writers it paid to say one thing and mean another. Or, I could track his need to make a concealing and revealing art beyond that moment to more distant and private determinations. However, I'm not going to do this. I want to end not with a discussion of the social production of Johns's allegorical mode in the fifties and sixties but with the opposition between symbol and allegory then, and now.

Allegory, it has been claimed, 'is precisely the dominant mode of expression of a world in which things have been for whatever reason utterly sundered from meanings, from spirit, from genuine human existence', that it is 'the privileged mode of our own life in time, a clumsy deciphering of meaning from moment to moment, the painful attempt to restore a continuity to heterogeneous, disconnected instants'.[53] This could easily be taken to mean that allegory is precisely the dominant or privileged mode of expression – representation – of capitalism.[54] And that would be to claim too much for it. The point is that allegory is not, and never has been, in the modern epoch, precisely the dominant mode. That predominance was and is what was and is claimed by and for the symbol – by and for modernist painting and sculpture – often in confrontation with but precisely as an ideological retreat from the actualities of life determined by capital. Realizing that the modern world is a space wherein things and meanings disengage – that the world is a configuration of things that designates not a single, total, universal meaning but a plurality of distinct and isolated meanings – the allegorist works to restore some semblance of connection between them whilst hanging on to and asserting the distinction between experience and the representation of experience, between signifier and referent. Allegory, set against the symbol as its Other, reminds us of the difference between experience and the representation of it, of the space between signifier and referent. This is why Paul de Man is so interested in those moments when the allegorizing tendency breaks the symbolic effect of a

text.[55] It is there that the text is revealed, or reveals itself, as thoroughly troped and figured and can be understood as corresponding to the authentically temporal destiny that produced it and which it tries to deny. De Man says that the critical conflict between modern allegory and the secular symbol is between 'a conception of a self seen in its authentically temporal predicament' and a self which 'tries to hide from this negative self-knowledge'.[56] Recourse to the symbol in wide areas of Western literature and art in the nineteenth and twentieth centuries is 'one of the forms taken by this tenacious self-mystification' with regard – de Man says – to truths that came to light in the last quarter of the eighteenth century.[57]

The modernist theory of art is a variation on the theory of the symbol. It presupposes that the signifier (the art object) can be equated with its referent (Greenberg's or Caro's feelings). This is a rhetorical strategy of univocity, self-referentiality and self-sufficiency that identifies the medium as the source and vehicle of artistic value, aesthetic pleasure and experience. This view has been increasingly questioned since the end of the sixties but in the fifties and sixties it was the dominant view of the international art community, and it was in the fifties and sixties that Johns's work, more than anyone else's, was effective in giving the lie of it. And this it did not from outside modernism, modernist theory and practice, but from inside it. Terry Atkinson has referred to Johns's art as a 'salutary pox', one generated by modernism and infecting it.[58] Remember, Greenberg valued Johns's paintings and discussed them in his 1962 essay 'After Abstract Expressionism'.[59] This is how he, better than anyone else, explained the uncertainty they produced in critical and historical discourse. Here Johns's 'plastic and descriptive painterliness' is understood as suspended in the 'dialectic' between abstraction and representation.[60]

> The original flatness of the canvas, with a few outlines stencilled on it, is shown as sufficing to represent adequately all that a picture by Johns really does represent. The paint surface itself, with its de-Kooningesque play of lights and darks, is shown, on the other hand, as being completely superfluous to this end. Everything that usually serves representation and illusion is left to serve nothing but itself, that is abstraction; while everything that usually serves the abstract or decorative – flatness, bare outlines, all-over symmetrical design – is put to the service of representation. And the more explicit this contradiction is made, the more effective in every sense the picture tends to be.[61]

Though Johns's painting made 'explicit this contradiction', it seems that, for Greenberg, it did so by being neither abstraction nor representation but both abstraction and representation. This 'device' was not all there was to Johns's art – otherwise, Greenberg notes, he would not get the kind of pleasure from it that he does – but it was what made it effective.[62] The next year Michael – 'Presentness is grace'[63] – Fried, Greenberg's closest follower at that time,

found it almost impossible to write about Johns's paintings – but not quite. This is what he wrote in his review of Johns's 1963 Castelli exhibition:

> My own feelings about the paintings are hugely mixed. On the one hand there is the pleasure they give through their beautiful handling of paint and consummate taste; while on the other there are the, it seems to me, cheapening ironies, together with the decision (as it were, part of the content of every painting) to ignore certain probably insoluble formal questions. This is surely one of the handsomest shows in New York this season. But the paintings are undercut by an awareness of their relation to a particular historical state of affairs; and one's own doubts about the relevance of such an awareness to final judgements of quality chiefly serves to complicate things still further.[64]

Not all mixed feeling or doubt or explicit contradiction is uncertainty, of course. But I take it that the uncertainty – valid uncertainty – which I find in Greenberg's and Fried's writing on Johns is more or less the same as that registered in Solomon's and Kozloff's writing on him. Greenberg and Fried liked Johns's paintings of the fifties and early sixties, but my guess is that they did not like his sculpture. Greenberg certainly didn't. He thought that Johns's sculptures amounted to 'nothing more than . . . cast reproductions of man-made objects that, as far as three-dimensional art is concerned, could never be anything other than merely reproducible'.[65] Solomon and Kozloff did like it, and tried to write about it. In the end, it doesn't matter if you like it or not. Here, beside Caro's *Midday*, the kind of modernist sculpture that Greenberg and Fried did like and valued, Johns's *Painted Bronze (Savarin)* effects its salutary pox by modestly, playfully, allegorically raising doubts about rhapsodizing art's proclaimed autonomy, self-sufficiency and trans- cendence by narrating its own contingency, insufficiency and temporality,[66] which, in the end, is the condition of any work of art, whether we like it or not.

Notes

1. Walter Hopps, 'An Interview with Jasper Johns', *Artforum*, March 1965, p. 36, re the *Painted Bronzes*: 'You have a model and you paint a thing very close to the model. Then you have the possibility of completely fooling the situation, making one exactly like the other, which doesn't particularly interest me. (In that case you lose the fact of what you have actually done.) . . . I like that there is the possibility that one might take one for the other, but I also like that with a little examination, it's very clear that one is not the other.'

2. Max Kozloff, *Jasper Johns*, Harry N. Abrams, Inc., New York 1969, p. 31, recalls seeing Johns at work on *Painted Bronze (Ale Cans)* 'laboriously painting the Ballantine label . . . using an actual label as his "life" model'.

3. Ibid, p. 32, for Kozloff's comments on 'these ostentatious fingerprints' as 'Johns' brand of signature'.

4. Of course, there may be more. Here I am following Roberta Bernstein, *Jasper Johns' Paintings and Sculptures, 1954–1974: 'The Changing Focus of the Eye'*, UMI Research Press, Ann Arbor 1985, pp. 146–7, who lists the sculptures made between 1958 and 1974 as follows – 1958:

Light Bulb I (sculpmetal, $4\frac{1}{2}'' \times 6\frac{3}{4}'' \times 4\frac{1}{2}''$), *Light Bulb II* (sculpmetal, $8'' \times 3'' \times 4''$), *Flashlight* (sculpmetal over flashlight and wood, $5\frac{1}{4}'' \times 9\frac{1}{8}'' \times 3\frac{3}{8}''$), *Flashlight II* (papier mâché and glass, $8'' \times 3\frac{1}{2}'' \times 3''$), *Flashlight III* (plaster and glass, $5\frac{1}{4}'' \times 3\frac{3}{4}'' \times 8\frac{1}{4}''$); 1959: *The Critic Smiles* (sculpmetal, $1\frac{5}{8}'' \times 7'' \times 4'' \times 1\frac{1}{2}''$); 1960: *Light Bulb* (bronze [four casts], $4\frac{1}{4}'' \times 6'' \times 4''$), *Flashlight* (bronze and glass, $4\frac{7}{8}'' \times 8'' \times 4\frac{1}{2}''$), *Painted Bronze (Ale Cans)* (painted bronze, $5\frac{1}{2}'' \times 8'' \times 4\frac{3}{4}''$) *Painted Bronze (Ale Cans) II* (painted bronze, $5\frac{1}{2}'' \times 8'' \times 4\frac{3}{4}''$), *Painted Bronze (Paint Brushes)* (painted bronze, $13\frac{1}{2}'' \times 8''$ diameter), *Flag* (bronze [four casts], $12'' \times 9''$), *Bronze (Light Bulb, Socket, Wire on Grid)* (bronze [four casts] $3\frac{1}{2}'' \times 11\frac{1}{2}'' \times 6\frac{1}{4}''$); 1961: *The Critic Sees* (sculpmetal on plaster with glass, $3\frac{1}{4}'' \times 6\frac{1}{4}'' \times 2\frac{1}{8}''$), *O Through 9* (aluminium [four casts], $26\frac{1}{4}'' \times 20''$); 1964: *The Critic Sees II* (sculpmetal on plaster on glass, $3\frac{1}{4}'' \times 6\frac{1}{4}'' \times 3\frac{1}{8}''$), *High School Days* (sculpmetal on plaster with mirror, $4\frac{3}{16}'' \times 12'' \times 4\frac{1}{2}''$); 1965: *Subway* (sculpmetal on board; $7\frac{3}{8}'' \times 9\frac{7}{8}'' \times 3''$); 1966: *Summer Critic* (cement, wax and glass); 1969: *Hat Form* (sculpmetal and wood hatblock, $10'' \times 8'' \times 10''$); 1970: *English Light Bulb*; 1968–70 (sculpmetal, wire and polyvinyl chloride, base $4\frac{7}{8}'' \times 3\frac{1}{4}''$), *Memory Piece (Frank O'Hara)* (wood, lead, rubber, sand and sculpmetal, $6\frac{3}{4}'' \times 5\frac{1}{4}'' \times 13''$ – closed; $5\frac{1}{2}'' \times 29\frac{1}{2}'' \times 6\frac{5}{8}''$ – open).

5. Alan Solomon, 'Jasper Johns', *Jasper Johns*, The Jewish Museum, New York 1964, pp. 5–19.

6. Ibid., p. 18.

7. Fairfield Porter, 'Jasper Johns', *Art News*, January 1958, 56 (9), p. 20; Robert Rosenblum, 'Jasper Johns', *ARTS*, January 1958, pp. 53–4; Ben Heller, 'Jasper Johns', in B.D. Friedman, ed., *School of New York: Some Younger Artists*, Grove Press, New York 1959, pp. 30–35; William Rubin, 'Younger American Painters', *Art International*, 4 (1), 1960, pp. 25–31; Leo Steinberg, 'Jasper Johns', *Metro*, 4/5, May 1962 (enlarged and revised as *Jasper Johns*, Wittenborn, New York 1963; further enlarged and revised as 'Jasper Johns: The First Seven Years of His Art', in *Other Criteria: Confrontations with Twentieth-Century Art*, Oxford University Press, New York 1972, pp. 17–54): Clement Greenberg, 'After Abstract Expressionism', *Art International*, 6 (8), 1962, pp. 24–32 (revised and reprinted in Henry Geldzahler, ed., *New York Painting and Sculpture: 1940–1970*, E.P. Dutton & Co. in association with the Metropolitan Museum of Art, New York 1969, pp. 360–71); Michael Fried, 'New York Letter', *Art International*, 7 (2), 1963, pp. 60–62.

8. Kozloff, *Jasper Johns* (1969), pp. 9–10.

9. As far as I am aware, the earliest mention of allegory in the literature on Johns is in Steinberg, 'Jasper Johns: The First Seven Years of His Art', p. 17, where he asks of *Liar* (1961) (encaustic, sculpmetal and pencil on paper, $21\frac{1}{4}'' \times 17''$): 'Does it mean anything?'

'It need not. It's a device for printing an indispensable word. Or just Painting with a bit of Dada provocation on top (but we are too sly to be had by a four-letter word). Or it's an allegory concerning the hinges that hold life to art.'

It might be an allegory or it might not. Steinberg's thinking about allegory is confined to this individual picture. It is not extended to inform his reading of Johns's practice as a whole. However, what Steinberg does write, and the way he writes it, is, of course, very much to the point.

10. Richard Francis, *Jasper Johns*, Abbeville Press, New York 1984, also begins by considering the significance of Johns's sculpture. See the 'Introduction' with its brief discussion of *Painted Bronze (Ale Cans)* and its more extended account of *Painted Bronze (Savarin)* and the way Johns used an image of the latter in the *Savarin* lithograph of 1977, the Monotypes of 1978–79, in a lithograph of 1979–81, in the Monotypes of 1982, and the painting *Untitled* of 1983. Francis, following the catalogue essay in *Jasper Johns: 17 Monotypes*, ULEA, West Islip, New York 1982, explains *Painted Bronze (Savarin)* 'as a studio still life and a representational sculpture' whose 'image comes to stand for Johns' public persona and, by implication, for the corpus of his work. What began as a playful manipulation of a joke [*Painted Bronze (Ale Cans)*] has been transformed into a critique of sculptural meaning and then, after a long gestation, into an important element of the artist's thought; at each stage its ambiguities have been compounded.' My discussion of *Painted Bronze (Savarin)* is indebted to Francis's book, and *Jasper Johns: 17 Monotypes*, but its emphases and direction are very different. What interests me, more than it does Francis, is how *Painted Bronze (Savarin)* 'comes to stand for', was 'transformed' and had 'its ambiguities ... compounded'. An epigraph from Ludwig Wittgenstein's *The Blue and Brown Books* (1959) set above Francis's text hints at how we might develop some lines of inquiry:

'But the expression of our thoughts can always lie, for we may say one thing and mean another.' Imagine the many different things which happen when we say one thing and mean another – Make the following experiment: say the sentence 'It is hot in this room', and mean: 'it is cold.' Observe closely what you are doing.

We could easily imagine beings who do their private thinking by means of 'asides' and who manage their lives by saying one thing aloud, following it up by an aside which says the opposite.

This is interesting. Unfortunately, Francis gives little indication of how *Painted Bronze (Savarin)* might be understood 'to say one thing and mean another' or to function as an element in a way of 'private thinking by means of "asides"'. It may be that Wittgenstein, if not Richard Francis, is close to speaking about allegory – which, of course, might mean that he is not at all close.

11. Oxford University Press, New York 1966 (originally published 1959), pp. 113 and 114.

12. On allegory in general, see ibid.; Angus Fletcher, *Allegory: The Theory of a Symbolic Mode*, Cornell University Press, Ithaca 1964; Rosemund Tuve, *Allegorical Imagery: Some Medieval Books and Their Renaissance Posterity*, Princeton University Press, Princeton 1966; Michael Murrin, *The Veil of Allegory: Some Notes Towards a Theory of Allegorical Rhetoric in the English Renaissance*, University of Chicago Press, Chicago 1969; Maureen Quilligan, *The Language of Allegory*, Cornell University Press, Ithaca 1979; Jon Whitman, *Allegory: The Dynamics of an Ancient and Medieval Technique*, Clarendon Press, Oxford 1987.

13. Edward Phillips, *The New World of English Words*, London 1678, quoted in Fletcher, *Allegory*, p. 2. For the etymology of 'allegory', see Whitman, *Allegory*, 'Appendix I. On the History of the Term "Allegory"', pp. 263–8.

14. On allegory as a twice-told tale, see Honig, *Dark Conceit*, pp. 13–14; and for an interesting consideration of the connection between any allegory and its pre-text, see Quilligan, *The Language of Allegory*, chapter 2, 'The Pretext', pp. 97–155.

15. On allegorical imagery as appropriated imagery, see Craig Owens, 'The Allegorical Impulse: Towards a Theory of Postmodernism', *October*, 12, Spring 1980, p. 69: 'Allegorical imagery is appropriated imagery; the allegorist does not invent images but confiscates them. He lays claim to the culturally significant, poses as its interpreter. And in his hands the image becomes something other.' Owens discusses allegorical meaning as 'supplement' in this way: 'He [the allegorist] does not restore an original meaning that may have been lost or obscured; allegory is not hermeneutics. Rather, he adds another meaning to the image. If he adds, however, he does so only to replace; the allegorical meaning supplants an antecedent one; it is a supplement. This is why allegory is condemned, but it is also the source of its theoretical significance.' No such straightforward addition, replacement or supplantation is meant by my use of 'supplement', which I take from Jacques Derrida's *Of Grammatology*, Johns Hopkins University Press, Baltimore 1976, pp. 141–64, where it is neither an optional extra nor a necessary addition but both an optional extra and a necessary addition.

16. See Quilligan, *The Language of Allegory*, pp. 15–16: 'all literature is, in essence, allegorical, if only because all literature has readers, and readers, as is their wont, think about what the work "really" means – which meaning may be no more than their translation of the reading experience into an articulate scheme that makes sense to them, just as every human being processes, orders, and organizes (more or less successfully) the experiences of life. In such a manner Northrop Frye [*Anatomy of Criticism: Four Essays* (1957); reprinted Atheneum, New York 1967, p. 89] has argued that all literary interpretation is "allegorical" if only because, in organizing our reading experience, we are criticizing the work, "allegorizing" it by making our own running commentary as we read.'

17. Fletcher, *Allegory*, p. 70.

18. William Empson, *The Structure of Complex Words*, London 1951, pp. 346–7, quoted by Fletcher, ibid., p. 70.

19. Fletcher, ibid., p. 71.

20. Ibid., p. 84.

21. Ibid., p. 85.

22. Ibid.

23. Ibid., p. 87.

24. Ibid.; and for his debt to Honig, see pp. 12–13.

25. Honig, *Dark Conceit*, p. 5.

26. On 'the reader', see Quilligan, *The Language of Allegory*, p. 24, and, thereafter, for an extended discussion, pp. 224–78.

27. For example, in *Jasper Johns: 17 Monotypes*, *Painted Bronze (Savarin)* is referred to as a 'metaphor equating artist and his art' and as 'a symbol of the creative act'.

28. See Fred Orton, 'Present, the Scene of . . . Selves, the Occasion of . . . Ruses', in James Cuno, ed., *Foirades/Fizzles: Echo and Allusion in the Art of Jasper Johns*, Wight Art Gallery, University of California, Los Angeles 1987, pp. 167–92; reprinted in *Block*, 13, Winter 1987/88, pp. 5–19.

29. See Nelson Goodman, 'Seven Strictures on Similarity', *Problems and Projects*, Hacking Publishing Company Inc., Indianapolis, n.d., pp. 437–46; reprinted in Charles Harrison and Fred Orton, eds, *Modernism, Criticism, Realism: Alternative Contexts for Art*, Harper & Row, London 1984, pp. 85–92.

30. Jasper Johns quoted in Michael Crichton, *Jasper Johns*, Harry N. Abrams, Inc. and the Whitney Museum of American Art, New York 1977, p. 59; see also Orton, 'Present, the Scene of . . . Selves, the Occasion of . . . Ruses', p. 169.

31. Bernstein, *Jasper Johns' Paintings and Sculptures, 1954–1974*, p. 223, n. 9, who also informs us that 'a photograph of it appears in Johns' lithograph and painting, *Decoy*, 1971'.

32. Hopps, 'An Interview with Jasper Johns', p. 36.

33. Crichton, *Jasper Johns*, p. 43.

34. Bernstein, *Jasper Johns' Paintings and Sculptures, 1954–1974*, p. 54, who points out that Johns could also have chosen Ballantine Ale cans 'because of the simplicity of the can's label and its bronze color, which imitates the traditional sculptor's material Johns used'.

35. Johns quoted by Vivian Raynor, 'Jasper Johns: "*I have attempted to develop my thinking in such a way that the work I've done is not me,*" ' *Art News*, 72 (3), March 1973, p. 22.

36. See Mark Stevens and Cathleen McGuigan, 'Super Artist: Jasper Johns, Today's Master', *Newsweek*, 24 October 1977, pp. 66–9. The cover photograph of Johns is labelled 'Jasper Johns Super Artist'.

37. Max Kozloff, *Jasper Johns*, Harry N. Abrams, Inc., New York 1974, p. 21.

38. Kozloff, *Jasper Johns* (1969), p. 31.

39. See Paul de Man, 'Autobiography as De-Facement (1979)', in *The Rhetoric of Romanticism*, Columbia University Press, New York 1984, pp. 75–6.

40. Originally published 1969. Reprinted in *Blindness and Insight: Essays in the Rhetoric of Contemporary Criticism*, second edition, Methuen, London 1983 (1971), pp. 207 and 208.

41. J.W. Goethe, *Maximen und Reflexionen*, trans. René Wellek, *A History of Modern Criticism*, Yale University Press, New Haven, Conn. 1955, quoted in Fletcher, *Allegory*, p. 13:

> There is a great difference, whether the poet seeks the particular for the general or sees the general in the particular. From the first procedure arises allegory, where the particular serves only as an example of the general; the second procedure, however, is really the nature of poetry: it expresses something particular, without thinking of the general or pointing to it.
>
> True symbolism is where the particular represents the more general, not as a dream or a shadow, but as a living momentary revelation of the Inscrutable.

42. Samuel Taylor Coleridge, *The Statesman's Manual*, ed. W.G. Shedd, New York, 1875, pp. 437–8, quoted in Fletcher, *Allegory*, p. 16.

43. Ibid.

44. See Walter Benjamin on 'Symbol and Allegory in Classicism' and 'Symbol and Allegory in Romanticism', the initial expositions of 'Allegory and Trauerspiel' in *The Origins of German Tragic Drama* (1928), trans. John Osborne, Verso, London 1985, pp. 159–67.

45. See Christopher Norris, *Paul de Man: Deconstruction and the Critique of Aesthetic Ideology*, Routledge, London 1988, p. 30. Chapter 2, 'De Man and the Critique of Romantic Ideology', is a thoroughly exemplary critical explication of de Man's writing on Romantic ideology.

46. Clement Greenberg, '"American-Type" Painting', *Partisan Review*, 22 (2), Spring 1955, pp. 179–96 (revised and reprinted in *Art and Culture: Critical Essays*, Beacon Press, Boston 1961, pp. 208–29); 'Modernist Painting', *Arts Yearbook*, 4, 1961, pp. 109–16 (reprinted in *Art and Literature*, 4, Spring 1965, pp. 193–201); 'After Abstract Expressionism', see n. 7 above.

47. Clement Greenberg, 'Three New American Painters', *Canadian Art*, 20, May 1963, pp. 172–5; this quotation is the essay's conclusion. Six paintings are illustrated: Kenneth Noland's *Rest* (1958), $70'' \times 66\frac{1}{4}''$, and *New Problem* (1962), $69\frac{1}{2}'' \times 71\frac{1}{2}''$; Morris Louis's *Gamma*

(1960), 81″ × 53½″ and *No. 33* (1962) 92½″ × 34½″; Jules Olitski's *Purple Passion Company* (1962), 92″ × 56″ and *Green Jazz* (1962), 92″ × 56″.

48. For Greenberg's discussion of 'content', 'quality' and 'effect', see his 'Complaints of an Art Critic', *Artforum*, 6 (2), October 1967, pp. 38–9 (reprinted in Harrison and Orton, eds, *Modernism, Criticism, Realism*, pp. 4–8). On Greenberg's theory of expression, see J.R.R. Christie and Fred Orton, 'Writing on a Text of the Life', *Art History*, II (4), December 1988, pp. 547–9.

49. Greenberg, 'Complaints of an Art Critic', p. 38.

50. In 1948, Greenberg wrote that 'painting's place as the supreme visual art is threatened' and that sculpture, because of its 'self-evident physical reality', was 'in the position to say all that painting can no longer say'. See his 'Art Chronicle: The New Sculpture', *Partisan Review*, 16 (6), 1949, pp. 637–42, especially pp. 638 and 641. By 1958, when Greenberg revised 'The New Sculpture' for inclusion in *Art and Culture* (1961), sculpture had become 'the representative visual art of modernism'. See *Art and Culture*, p. 145: 'It is its physical independence, above all, that contributes to the new sculpture's status as the representative visual art of modernism. A work of sculpture, unlike a building, does not have to carry more than its own weight, nor does it have to be *on* something else, like a picture; it exists for and by itself literally as well as conceptually. And in this self-sufficiency of sculpture, wherein every conceivable as well as perceivable element belongs altogether to the work of art, the positivist aspect of the modernist "aesthetic" finds itself most fully realized. It is for a self-sufficiency like sculpture's, and sculpture's alone, that both painting and architecture now strive.'

51. This story is well known. See, for example, Michael Fried, 'Introduction', *Anthony Caro*, The Arts Council of Great Britain, London 1969, pp. 6–8; or Tim Hilton, 'On Caro's Later Work', *Anthony Caro: Sculpture 1969–1984*, Arts Council of Great Britain, London 1984, pp. 60–61.

52. Clement Greenberg, 'Anthony Caro', *Arts Yearbook 8: Contemporary Sculpture*, 1965, pp. 196–209 (reprinted as the foreword to the exhibition catalogue, Rijksmuseum Kröller-Müller, Otterlo, Netherlands, 1967, and in *Studio International*, 174 (892), September 1967, pp. 116–17).

53. Frederic Jameson, *Marxism and Form*, Princeton University Press, Princeton 1971, pp. 71 and 72.

54. See, for example, the use made of Jameson, ibid., by Terry Eagleton, *Walter Benjamin or Towards a Revolutionary Criticism*, Verso and NLB, London 1981, p. 10, and of Jameson, ibid., and Eagleton, ibid., by Linda Nochlin, 'Courbet's Real Allegory: Reading "The Painter's Studio"', in Sarah Faunce and Linda Nochlin, *Courbet Reconsidered*, The Brooklyn Museum, New York 1988, pp. 22–3.

55. For Paul de Man at his most persuasive, see 'The Rhetoric of Temporality'.

56. Ibid., p. 208.

57. Ibid.

58. Terry Atkinson, 'An Historically Salutary Pox ...', unpublished paper, 1980.

59. Greenberg, 'After Abstract Expressionism', pp. 25–7.

60. Ibid., pp. 25–6.

61. Ibid., pp. 26–7.

62. Ibid., p. 27.

63. This is the finale of Michael Fried's 'Art and Objecthood', *Artforum*, Special Issue, Summer 1967, pp. 12–23 (reprinted in Gregory Battcock, ed., *Minimal Art: A Critical Anthology*, E.P. Dutton & Co., New York 1968, pp. 116–47). It is a neat assertion of the character and value of the symbol (modernist painting and sculpture) over allegory (the theatrical or literal, minimal art or objecthood) by contemporary art history's finest allegorical critic.

64. Fried, 'New York Letter', p. 62.

65. Greenberg, 'After Abstract Expressionism', p. 27.

66. Here I am borrowing from the excellent conclusion of Craig Owens's (much less excellent) 'The Allegorical Impulse: Towards a Theory of Postmodernism. Part Two', *October* 13, Summer 1980, p. 80.

4

Taxinomia and Taxomania:

Some Groundwork towards

an Evaluation of the

Art of Robert Smithson

Jeffrey Steele

An Art of Contravention

This essay envisages an artist's project holistically and its argument is not supported by photographic illustrations or detailed analysis of particular works. It is hoped, rather, that readers will wish to test its generalizations against their existing knowledge of Robert Smithson's work, and perhaps use it in conjunction with some of the many available books and articles bearing upon its themes. There are basically two themes which I have found to converge and illuminate each other in a number of interesting ways. One is a historical narrative of events influencing the practice of an American artist who lived from 1938 to 1973; the other is the abstract philosophical question of *categorical frameworks* or 'taxonomy', a word of complicated origin connoting some kind of law-abiding disposition in both its halves, something like 'the arrangement of the arrangement' or 'how the arrangement is arranged'.

Taxonomies are objective to the extent that their categories are the objects of psychic and economic investment. All classifications of experience into discernible entities are the outcome of engagements in the field of taxonomy, of struggles which may be conceived as occurring at the deepest ontological level where the being-status of objects is determined, but which also irrupt at the most superficial level in demarcation disputes where the names of the emergent categories – their boundaries and definitions – are the signifiers of political victory. Those which concern us belong most obviously within the large category of *social practices*, and then, in descending order of containment, the *signifying practices* (named intellectual and creative professions) and *the arts*, high and low, with their related ancillary practices. The internal

taxonomy of the *visual arts* reflects a complicated history. Within named activities such as *painting* and *sculpture* various artisanal, managerial and also quasi-divine competences vie for supremacy, and this inherited 'art school' taxonomy is flatly contradicted by another one, based, this time, on diverse functionalities (mimesis, utility, propaganda, aesthetics, expression, etc.), each further sub-categorized into *-isms*.

Such catalogues are inherently tedious and there is easy applause to be gained by crying 'away with them'. Robert Smithson, it is often alleged, *transgresses* category boundaries in such ways as to annihilate them and so emancipate us from their baneful effects. This can be illustrated quite easily by means of selective quotation from the important book *The Writings of Robert Smithson*, edited by the artist's widow Nancy Holt and designed by Sol Le Witt.[1] Two other books are also directly relevant here. First, *Robert Smithson: Sculpture*, by Robert Hobbs, with contributions by Lawrence Alloway, John Coplans and Lucy Lippard,[2] and, second, *Art Discourse*, by Jessica Prinz,[3] which not only contains the copiously referenced essay 'Words en Abîme: Smithson's Labyrinth of Signs', but also numerous other interesting references to Smithson scattered throughout its remaining contents. I shall be criticizing Prinz's interpretation of Smithson quite strongly but willingly acknowledge, at the same time, my indebtedness to her scholarship.

Prinz's essay is the clearest example I have found of the recruitment of Smithson in a propaganda battle against taxonomy as such. The word 'taxonomy' is, of course, never used and there is no actual argument because arguments require categories and the essay's central premise is their denial. The premise of the abolition of all categories as the summum bonum must occupy a seamless 'open field' in which it is omnipresent but never given such propositional form as would make it available for refutation. We are reminded that in Gramsci's conception 'deniability' is one of the main characteristics of any ideology. Ideological tenets demand a radical *absence* of taxonomy so as to be free to circulate simultaneously everywhere and nowhere and avoid the self-refuting exposure of *presence*. It is well, therefore, before going any further, to check whether anybody is sincerely trying to serve us with the injunction 'apply no taxonomies!'

At first sight the evidence seems overwhelming. Smithson is not just 'trying to tell us something', as dumb creatures are supposed to, he really *is* telling us, for example, that: 'We are lost between the abyss within us and the boundless horizons outside us.'[4] This is already stronger than Prinz's 'there is no passage through [his] analogic system to any stable meaning, theme, or signification.'[5] The obvious fact that all such remarks *do* have stable meanings reveals the use of the qualifier 'stable' as being itself the seat of instability. Slipped in unobtrusively, it releases Prinz from the most onerous commitments of her unstated hypothesis, for if, in this context, 'stable' simply

means 'politically *estab*lished', or if the further qualifier '*relatively* stable' were admitted, then my problem would disappear. But with it would go the whole purpose of Smithson's project as presented by Prinz. Even accepting 'stable' at its face value, the *weakest* possible paraphrase of her position is that *if* categories of any kind are to be countenanced, then they must always and everywhere be radically *un*stable. Not just mutable. It's a way of formulating the ground hypothesis of anti-foundationalism,[6] the hypothesis that no hypothesis may ground another.

If it is to serve its anti-foundationalist purpose, the absence of stable categories must be permanently hypostasized as its own other. Its tendency to constitute itself as a relatively stable category amongst others must be inhibited and, accordingly,[7] any solution of the problem by way of a classical dialectical *Aufhebung* is ruled out. Towards the end of her essay, Prinz allows us to glimpse a possible object of approval by quoting Smithson's reported response to an interviewer's question: 'It is that cosmic sense of humor that makes it all tolerable. Everything just vanishes';[8] and concludes that 'Smithson, too, "laughs" with nihilistic despair.'[9]

But might it not be possible that the artist was to some extent coerced into representing himself in this way? If he is not to be locked for ever into his own reliquary, this relationship between the recurrent referent of *hilarity* in Smithson's work and an ill-concealed totalitarian nihilism must be questioned. Smithson is obvously interested in the philosophy of the joke and he certainly helps us to reflect on the paradoxical nature of laughter as a kind of gambling with affective integrity, but I do not think he does this either by making us laugh or by laughing himself.

Taxonomies themselves are, incidentally – and despite their bad press – intrinsically funny things. The Venn diagrams are always breaking down. Shift your position slightly and they flip. What was the containing becomes the contained category and vice versa. The phenomena that the categories attempt to accommodate are always threatening to burst out of control and their zero-thickness boundaries can, at any moment, expand into autonomous category status, either increasing the scope of the taxonomy or proliferating sub-categories within it ad infinitum. The 'Borgesian list', as recommended by Foucault, is the best example I know of an attempt to disfunctionalize taxonomy by ridicule.

This book first arose out of a passage in Borges, out of the laughter that shattered, as I read the passage, all the familiar landmarks of my thought – *our* thought, the thought that bears the stamp of our age and our geography – breaking up all the ordered surfaces and all the planes with which we are accustomed to tame the wild profusion of existing things, and continuing long afterwards to disturb and threaten with collapse our age-old distinction between the Same and the Other. This passage quotes a 'certain Chinese encyclopaedia' in which it is written that 'animals are divided into: (a) belonging to the Emperor, (b) embalmed, (c) tame,

(d) sucking pigs, (e) sirens, (f) fabulous, (g) stray dogs, (h) included in the present classification, (i) frenzied, (j) innumerable, (k) drawn with a very fine camelhair brush, (l) *et cetera*, (m) having just broken the water pitcher, (n) that from a long way off look like flies'.[10]

Foucault features prominently in the pantheon of fifty-odd authorities invoked by Prinz to justify her image of Smithson. Here he sets up an opposition between a situation in which the classification of animals into phenotype and genotype seems to lead to their physical incarceration in a zoo, and another which he recommends to us as being heteroclyte and marvellous, hilarious and, by implication at least, in some sense emancipatory. But, like the Freudian libido, laughter has a notorious motility of investment, and I should like, if I can, to turn the tables on Foucault and establish – as a basis for the argument about Smithson that follows – that he radically misrepresents a state of affairs which is both real and ethically objectionable. The joke is in bad taste because the mytheme of the Borgesian list functions as an integral part of the oppression it purports to mock.

Kafka taught us long ago that it is precisely Borges-type taxonomies that are most open to jovial manipulation by state functionaries, who, using their common sense in the spirit of Edmund Burke, exercise favouritism in their choice of candidates for emancipation or incarceration and decide whose transgression it is wise to take as a joke and whose should be treated as a crime. There is not space here to go into such matters as the racialist implications of 'that from a long way off look like flies', nor would I suggest that data banks and index files are not often used repressively, but, in attempting to characterize situations of actual oppression – where the trick is obviously to apply *pairs* of contradictory taxonomies like so many psychological pincers – the suggestion that some taxonomies are culpable and others beneficent is only to add to the oppressive potential of both types.

The enabling factor in a taxonomy can be associated with the precise characteristics of its topology. Its boundaries are the loci of agonistic political dispute, hence the abundance of metaphor – barricade, Möbius strip, tympan, seepage, pellicule, rupture/suture, etc. – characteristic of all attempts to account for the various types of transaction conducted at the category horizon. Provocative asides by Foucault such as the following:

> An attempt is apparently being made to reconstitute what the 'sciences of life', of 'nature' or 'man', were, in the seventeenth and eighteenth centuries, while it is quite simply forgotten that man and life and nature are none of them domains that present themselves to the curiosity of knowledge spontaneously and passively[11]

divert the locus of struggle away from the internal taxonomic boundaries, where the outcomes are historically decisive, to its external appearance or complexion where nothing is really at stake. Despite all this, Foucault must

still be accounted as one of the most competent philosophers to deal with the paradox of a taxonomy which becomes a category within itself. He sketches a serviceable taxonomy of taxonomies where *taxinomia* (his preferred term) forms a main axis which, combined with two other axes called *mathesis* and *genesis*, provides box-like billets for the ordered identities and differences of the *épistémè classique*.[12]

Foucault provides much interesting detail about this system's capacity for accommodating contradiction and confusion (*enchevêtrement*) and convincingly locates the period of its maximum influence as being from Locke (the end of the Renaissance) to the early nineteenth century (the beginning of the age of ideology). I'm sure he would not have objected to my view that he is basically an *agent provocateur*, but my problem is that he propagates a theoretical error whose widespread acceptance has quite serious social consequences. The mytheme of 'the mask of anarchy' gives anarchizing tendencies false credentials as part of the struggle against the capitalist social order rather than seeing them as an integral part of the capitalist programme, and one indispensable for its perpetuation. I hope that this digression has explained my motivation to separate Smithson from his reputation as an anti-structuralist myth-maker and propose a frankly structuralist route towards the appraisal of his work.

Structures of Collective Ideation

I shall approach Smithson by way of a concentric schema, a historical process which begins where Foucault locates the inception of taxinomia and culminates in a series of specific destabilizations in various fields of activity for which I can find no better word than the French *bouleversements*. Both their individual specificity and that of their structural interrelationships are occluded by the tendency to conflate them under the general category heading 'modernism', and I register, in passing, my resentment at having to use this word occasionally. Each of the *bouleversements* of modernism is, in my view, followed by a characteristic re-stabilization or recuperation as the system moves to regain its homeostasis either by accommodating or by expelling its disruptive elements.

The 'identity problem' of subject and object is the most condensed and primitive manifestation of the general problem of taxonomy, the most fundamental of all disputed ontological boundaries. It is surely most accessible to us today in the form presented by Adorno, as a permanent, tragically intractable aporia.[13] Adorno's work of establishing lines of connection amongst three important levels of concern – abstract metaphysics, aesthetic and counter-aesthetic cultural production and more physical manifestations of mass atrocity – has become indispensable to us. The

applicability of any taxonomy depends upon the maintenance of continuous liens between the internal elements of a given category and its external relations to the categorial context of the taxonomy considered as a whole. A full appreciation of Smithson's art would not fail to evaluate it within Adorno's critical framework. Such an evaluation would re-animate both bodies of work in a reflexive way, making their elements available for renegotiation.

There is only space here to hint at how such an evaluation might expose some sectors where Adorno's principled anger blurs his perception, as, for example, in the passage from *Aesthetic Theory* which begins 'One does not have to be a resentful reactionary to be horrified by the fact that the desire for the new represses duration.'[14] The most cursory glance at a practice such as Smithson's would have shown Adorno that his substantive premiss was false and his pessimistic inference unwarranted, but there is a vastly more important unwarranted inference embedded in the rhetoric of Adorno's prose style. The anthropomorphism of *Desire* engaging in an act of repression is typical of Adorno's method of imposing his otherwise unsubstantiated lemma, that our social practice is the reification of an irremediably agonistic ground-ontology. Like that of Foucault, Adorno's mode of address is warlike. It sets up an opponent to be defeated, and this by means of an argument which turns out to pre-suppose, with classical circularity, its own desired outcome.

In contrast to this – and in contrast also to his justified reputation as the most combative type of artist-personality – I shall try to show that Smithson's work, taken as a whole, proposes an essentially peaceable metaphysics, more in keeping with that, for example, of Wilhelm von Humboldt, who argued quite persuasively for the existence of a 'necessary precursive primary correspondence (*Übereinstimmung*) between subject and object'.[15]

Before the *bouleversement* associated with the name of Saussure, and generally in nineteenth-century humanism and the hermeneutic tradition, we find a less rigid compartmentalization and more generous part-to-part and parts-to-whole relationships than those we have grown used to. In particular, a greater effort is made to incorporate pictoriality and matters relating to visual perception (*Bildlichkeit*) into linguistic theory. Ernst Cassirer is justly esteemed as the great mediator and direct inheritor of this tradition who successfully defended its broad, liberalizing ethic in the German- and English-speaking centres of education throughout the first half of this century, but there is a problem here too. Cassirer categorizes the various spheres of human concern – art, language, religion, magic, myth, music, poetry, philosophy, science, etc. – within a generously encompassing *energaeia* concept derived directly from Humboldt. Within this taxonomy, however, each activity is assigned a special duty and creates for itself a sector of sovereignty, constituting a hierarchy of 'worlds' as rigid as the one Foucault warns us against.

Art, in this regime, has the implicitly 'feminine' function of compensating 'man' for the spiritual losses and sacrifices incurred during his establishment of, and later submission to, the scientific symbolic order. Cassirer's promotion of art to an exaggeratedly high spiritual status also has the 'Ortegan' function of segregating 'from the shapeless mass of the many two different castes of men'.[16]

> He who does not understand these intuitive symbols, who cannot feel the life of colours, of shapes, of spatial forms and patterns, harmony and melody, is secluded from the work of art – and by this he is not only deprived of aesthetic pleasure, but he loses the approach to one of the deepest aspects of reality.[17]

This, with its lethal kernel of half-truth, is obviously a doctrine as widely held as it is pernicious, but is it inevitably the unacceptable facet of humanism? Well, before Nietzsche, it was unspoken but clearly lurking somewhere in the offing, perhaps less so in Rousseau, perhaps more so in Locke, but of course there was a major intervening *bouleversement* between the old humanism and the new: the political success of Marxism in placing the *class* referent at the core of all the relevant taxonomies. The absence of 'class consciousness' in the work of Cassirer's antecedents – Humboldt or Cassirer's own mentor, Dilthey, for example – signifies differently from the same absence in that of Cassirer himself or his successors such as George Steiner. In the former cases, it seems possible to accommodate class struggle into the conceptuality of the text in ways that would enrich its scope and meaning. In the latter cases, the effect of such an attempt would be to explode the class-blind categories of 'man' and 'his great art' as constituted within them.

One of Robert Smithson's favourite books, George Kubler's *The Shape of Time*, opens with the words, 'Cassirer's partial definition of art as symbolic language has dominated art studies in our century.'[18] This is true as a statement of fact but this 'dominion' was only secured by Cassirer's perfection of the illusion of an unbroken tradition of *Geisteswissenschaften* and the installation, alongside the symbolic language of art, of other symbolic languages, of science, of religion, of myth, and even of language itself. Within this taxonomy a separable *veritas aesthetica*[19] is concocted which, on the one side, gives rise to a body of theory which is not intended and does not deserve to be taken seriously by scholars in other fields, and, on the other side, destabilizes the category of scientificity, just in those sectors where it is most reliable.

In *The German Ideology* Marx and Engels memorably characterize cultural producers as those 'active, conceptive ideologists, who make the perfecting of the illusion of the [ruling] class about itself their chief source of livelihood'.[20] Whilst this job description is open to dangerously reductive interpretation (and we shall presently see that Marx himself does so reduce it), it does prepare the way for Gramsci's conception of ideology as de-taxonomized

common sense. It indicates a causal lien between capitalist economics and obscurantist metaphysics, and this, in its turn, helps to account for a more general cultural delectation in absurd and paradoxical phenomena; or, better, phenomena which can be made to *appear* absurd or paradoxical, for if any illusion is to be perfected, then another illusion must first be perfected, namely the illusion that there is no illusion, that *it really does all happen by magic*. The interests of the employer class, under whose aegis all cultural activity is conducted, coincide, of course, very imperfectly with the interests of the cultural producers themselves, and so, within the cultural hierarchy, the illusion, its perfection and its subversion become ever more skilfully compounded. Double agency is the norm. Overdetermined assignments in the polis – real artists, entertainers, police officers, priests, etc. – become reified images of their counterparts in the kitsch world of Borges's 'Chinese Emperor' and his entourage. Smithson's remark, 'various agents, both fictional and real, somehow trade places with each other',[21] prefigures the apotheosis of Ronald Reagan, and Smithson himself 'trespassed', in Prinz's words, 'into numerous outside disciplines (psychology, the physical sciences, literature and anthropology, among others) in order to appropriate strategies, forms, and textual materials for his art'.[22] I differ from Prinz in wanting to insist that there is a formal logician at work in Smithson as well as a de Kooning-type 'slipping glimpser'. I shall try to show that the relationship between the two is more determinate than either Smithson or the majority of his commentators would have us believe, and that he never allows one of these tendencies in his work fully to encompass the other.

The few scattered references to Marxism in Smithson's collected writings suggest that he, like most artists of his generation working in the West at that time, 'took it as read'. He seems to have neither felt intimidated by the reverberations of McCarthyism, nor felt any special need to inform himself about the detail of the Marxist argument. But whatever his degree of familiarity with the relevant literature, I think that it will be possible to ascribe to him a fairly definite position within the framework of the old debates amongst Plekhanov, Lenin and Bogdanov concerning materialism, and the earlier struggles of Marx and Engels against anarchizing tendencies in the First International or, earlier still, against the idealisms of 'The Holy Family'. We must go back to Fichte, writing roughly contemporaneously with the French Revolution, to find the central issue presented in its unembroidered state.

> *The thing*, which must be determined independently of our freedom and to which our knowledge must conform, and *the intelligence*, which must know, are in experience inseparably connected.... The dispute between the idealist and the dogmatist is, in reality, about whether the independence of the thing should be sacrificed to the independence of the self or, conversely, the independence of the self to that of the thing.... idealism cannot refute dogmatism.... The dogmatist is

no less incapable of refuting the idealist. . . . a person might fuse together a whole from fragments of these heterogeneous systems . . . but . . . what follows from one of them annihilates the conclusions of the other. . . . In this light, it is interesting to ask what might motivate the person who sees this – and it is easy enough to see – to prefer one of the systems over the other, and how it is that skepticism, as the total surrender of the attempt to solve the problem presented, does not become universal.[23]

One answer to Fichte's question might be that capitalist institutions in general are obliged to wage incessant war against materialism because they could not survive a general success of the materialist account of phenomena, and neither does scepticism alone ensure their security. In order to survive they must continually replenish the plurality of choices of available ideology and see to it that these ideologies are all characterized by a thoroughgoing idealism. The Marxist diagnostic of capitalist depradation is grounded in a materialist ontology which Fichte calls, with some justification, 'dogmatism'. Capitalism's institutions pronounced this diagnosis 'discredited' even before its enunciation, and yet it has never been refuted, but rather translated into various 'occult' forms in which it is not only compatible with but in some ways also indispensable to their survival, esotericized, so to speak, by means of a general antibiotic; the undermining of the approach to the categorial framework, not just of Marxism but of all rational analysis.

The anti-Marxist discourse has thus shifted, throughout the period we have been discussing, towards ever higher degrees of rhetorical abstraction, directed less against any perceived 'communism' or 'Marxist ideology' as such but more against a *method*. This, at least, is the political context within which I understand Smithson's work, and its inscription, nearly twenty years after his death, into the 'postmodern text'. If the unpleasantly sounding category names 'dogmatism', 'materialism', 'formalism' and so forth are understood as having been devised to pre-constitute a methodological *enemy*, then a definite orchestration of conflict across disciplinary boundaries becomes apparent. The three main strands in this campaign are all associated with ideological applications of modernist *bouleversements* in various specialist fields. The main campaign conducted from the base of written cultural criticism is supported by two others, equally indispensable: one from within the institutionalized theorization of visual art and architecture – frequently citing the Bauhaus as a hate-object – the other, in physics and mathematical logic, associated with names such as Gödel, Heisenberg, Popper, Kuhn, Feyerabend and others. I should emphasize that it is not the quality of their scientific work which I am calling into question here, but only that of the associated ideological interpretations of its meaning.

In order to counter some of the deficiencies which he perceived in these interpretations, Imre Lakatos devised a special taxonomy which he called

MSRP (the methodology of scientific research programmes),[24] within which a research programme is envisaged as being developed at three category levels; a 'core' hypothesis or nexus of principles; a 'protective belt' of auxiliary hypotheses; and a 'heuristic' problem-solving machinery. This has the advantage of cutting across the Cassirer-type taxonomy and so de-segregating its components – the various institutionalized artistic and scientific practices – in such a way that each one may be seen to involve elements of scientificity, of myth-making, of affective involvement, sensibility and so forth.

With more space one could mention other proposed taxonomies of this type, perhaps the most elaborate of which is the *Semiotik* developed by Max Bense and his associates at the University of Stuttgart on the basis of categories previously formulated by Charles Sanders Peirce. With its grid systems and cross-referencing mechanisms it was widely discussed and alluded to during Smithson's and Foucault's working life-times, but it has dropped out of the mainstream of discussion since. It aimed to establish a theory which may be seen as substantiating Humboldt's unifying conception of *Übereinstimmung*, both as between subject and object and as amongst the signifying capacities of aesthetic form, discursive and pictorial procedures and those of the mathematically based sciences. Bense appears to have been influenced by the systematized approach to art and design which constitutes the best-known feature of the Bauhaus project. He envisaged the work of his institute as culminating in a generally applicable 'theoretical aesthetic' which was to be not merely *applicable* to instances of semiosis from the exterior – as Greenbergian aesthetic judgements are applied to works of art – but rather an integral and objective characteristic of the 'viewing' taxonomy itself. The works of visual artists of a certain type, most notably those of the former Bauhäusler Max Bill, about whom Bense wrote extensively,[25] exercise an indispensable *Modelfunktion* in this relationship.

These ideas exert an important but often occluded influence upon Smithson's formative milieu, and I begin the next section by describing an instance of this.

Smithson's Formative Milieu

In 1941, the Swiss-American artist Fritz Glarner – a close associate both of Bill and of Mondrian – gave one of his works the title *Relational Painting*. This became the first of a series of over a hundred sequentially numbered paintings with the same title, some in the tondo format, presenting Glarner's sustained formal investigation over a period of some twenty-five years, just at the end of which period Frank Stella begins to refer to his works as 'non-relational paintings'. By 1967, Stella's critical advocate, Michael Fried,

opens his influential article 'Art and Objecthood' by postulating 'the relational character of almost all painting'. The concept of relationality thus entered the mythology obliquely, unattributed, stripped of its own historical relationality and negatively inflected, both as a code-term for rationality and as an ideological token of the Europeanism which artist/journalists such as Donald Judd were actively trying to displace.

'Before Smithson' the irrational imperative was already in place, but one could say that it was in its *proper* place, artists such as Arshile Gorky and Willem de Kooning having established a legitimate American succession in the tradition of *Le Bateau ivre*. The ideological assignment of Smithson's generation is a more complex one, namely to develop the self-refuting moment in rationality itself as a means of bringing the structuralist/ materialist tendency of cultural criticism into disrepute. In carrying it out, they were able to build on a strong tradition in left social criticism – Max Weber, Lukács and Adorno amongst others – which, quite unwarrantedly, associates formal rationality, and specifically geometry, with *instrumental* reason, industrial Taylorism and fascistic aesthetics. There was an opposing tradition in Europe of artists, mostly on the left also, who tried to treat geometry in ways that were both formally and socially responsible, and some of these artists, during the fifties and early sixties, tried to connect their work with current research in such fields as information theory and perception psychology. Some art of this type was presented by *Time* magazine in October 1964 under the heading 'Op Art: Pictures that Attack the Eye' and Irving Sandler recounts how the consequent exhibition, 'The Responsive Eye' (MOMA, 1965), 'was so vociferously denigrated by most art professionals that Op Art was relegated to oblivion in New York'.[26]

Perhaps because it allows itself to be interpreted both as a manifestation of state power and as a form of protest against that power, a completely different type of formalist art has received massive and continuing official approbation since its inception at that time. The simplified and aggrandized geometry and arithmetic of the Minimalist school physically objectifies the general polemic against structural accountability which was interwoven with the ideologies of American popular chauvinism, for the mid-point of the sixties is the culmination of the conjuncture later described by Eva Cockcroft in her article 'Abstract Expressionism, Weapon of the Cold War'.[27]

On the same theme, Patrick Heron begins a series of articles by declaring his personal outrage at Michael Fried's claim, also made in 1965, that 'for twenty years or more almost all the best new painting and sculpture has been done in America.'[28] These articles deal mainly – and plausibly – with Clement Greenberg's agency in the matter of American artists' borrowings from the pictorial techniques of English painterly Romanticism, but, though he does mention Pierre Soulages, Heron is less than candid about the derivations, to be found in the works of both the St Ives and the New York

schools, from Paris-based lyrical abstraction under its various *noms de guerre*, such as *Tachisme*, *L'Art informel*, etc. The hegemonic process absorbed contributions by artists from a wide range of cultural origins, including several American expatriates, but its product was a short-list of *all*-American hero-figures.

This is more than a simple re-location of an art market centre from Paris to New York. The whole philosophy subtending this market was domesticated and reduced to a format within which Robert Hobbs can, without attracting ridicule, advance Smithson's record as a *boy scout* – down to the number of proficiency badges and merit points he obtained – as evidence of his importance as an artist.[29] Thousands of artists and whole international movements were, pace Sandler, consigned to the *oubliettes* as the price of establishing this structure-in-dominance. Those wishing to be taken seriously in their own societies were obliged to submit their performances for appraisal by criteria forged in the USA. A certain amount of sycophancy was required from non-American artists, who often become quite ignorant of significant developments in their own or neighbouring countries, while those close to the administration were tempted to assume a quasi-colonial arrogance towards the affairs of the periphery. Ironically, the taxonomy here is precisely that one called 'democratic centralism' in some theories of socialism.

It seems clear that the project of every artist working at that time must be seen, at least in part, as a response to the ethical dilemma of being caught up in the identity crisis of a particular national bourgeoisie which finds itself possessed of an unprecedented amount of political and economic power. Its eagerness to visit atrocity against all things it perceives as 'Un-American' suggests a classically infantile and irrational psychology-type, an Oedipal craving to secure resources in order to 'buy affection', or, when this doesn't work, to destroy and punish whatever seems to stand in the way of its gratification. At this conjuncture the classical base/superstructure taxonomy appears inverted and, momentarily at least, Freudian interpretations supersede Marxist ones.

Some of the most compelling evidence for a hypothesis of this type might be found in the developing iconography of the American cinema, and any ultimate appraisal of Smithson's work which ignored this body of imagery would be incomplete. But at the level of groundwork – which is our concern – we need to consider the relationship between structuration and signification (in Max Bense's terminology between *Ästhetik* and *Semiotik*) at its most fundamental level of operation. Smithson's work, in this sense, may be described as 'epistemographic', deploying a very specific technique of the concerted functioning of word and image which maps, with equal precision, on to the political exigencies of the conjuncture I have just outlined and to the early theories of ideology mentioned in the previous section. It was

indeed Feuerbach's analysis of the crucial operation of *Bildlichkeit* in the perpetually self-erasing 'perfection of the illusion' that inspired the authors of *The German Ideology*. In her 1984 book, *Marx's Lost Aesthetic*,[30] Margaret Rose traces some of Feuerbach's own sources for this conception.

In its full extension, the category of *Bildlichkeit* would certainly include some aspects of musical presentation and form. Patrick Heron quotes from a 1947 letter from Schoenberg showing that a parallel process of cultural expropriation had occurred in the sphere of institutionalized music. Aside from his music, Schoenberg is also one of the very few theoreticians of this century to treat, in an informed and detailed way, these questions of imagery, affectivity and popular culture which concern us. His essays[31] entitled him to a place amongst those philosophers who involved themselves professionally with the same issues, and who are to be discussed next.

Terminalism

This is Arthur Danto writing in 1984:

> In the first serious philosophical writings on art – perhaps the first writings in which art is so much recognized as such – a kind of warfare between philosophy and art is declared. Inasmuch as philosophy itself is a warring discipline, in which philosophy is divided against philosophy with nearly the degree of antagonism we find expressed between philosophy and art in the fateful initiating pages of platonic aesthetics, it ought to be cause for suspicion that there is near unanimity on the part of philosophers of art that art makes nothing happen.

Danto concludes that:

> When art internalizes its own history, when it becomes self-conscious of its history as it has come to be in our time, so that its consciousness of its history forms part of its nature, it is perhaps unavoidable that it should turn into philosophy at last. And when it does so, well, in an important sense, art comes to an end.[32]

Commenting on this idea, L.B. Cebik notes that:

> The realization of art's goal to become philosophy results inevitably in the demise of traditional philosophy of art.[33]

Danto himself admits, citing Rorty and with apparent surprise, that:

> There has been a recent effort to deconstruct philosophy by treating it as though it were art!

Stanley Cavell's anxiety is nearer the surface. For him, the artist's sole function is to provide aesthetic delectation, and one of Cavell's main functions, as an aesthetic philosopher, is the policing one of exposing what he calls 'fraudulent art' on our behalf:

> There is the realization on the part of anyone who knows what art is that many of the responses directed to works of art are irrelevant to them as art and that the artist's intention is *always* irrelevant – it no more counts towards the success or failure of a work of art that the artist intended something other than is *there*, than it counts, when the referee is counting over a boxer, that the boxer had intended to duck.[34]

In this crude figure, Ortega's supposition about 'two different castes of men' is written very largely indeed and can be seen, in its extension, to underlie hugely influential bodies of opinion including the whole of Adorno's *Aesthetic Theory*. Indeed, one of its plainest articulations is Marx's assertion that 'Milton produced *Paradise Lost* for the same reason that a silkworm produces silk.'[35] Its reverberations threaten the value of the whole Marxist argument, for, on the one hand, the institution of a taxonomic barrier between aesthetic judgement and productive intellectual labour legitimates a chain of actual psycho-economic expropriations, while, on the other, its removal would allow the owners and managers of capital to claim the status of creative artists.

Cavell's 'plain English' removes all these overtones, but his arraignment of the composer Ernst Krenek – on the grounds that Krenek's misunderstanding of the relationship between art and philosophy leads him towards an art of *total organization* – dramatizes our central problem, which I would formulate in the following way. Would the refutation of Smithson's philosophy, which he clearly wants to identify with the main functionality of his art, constitute also (to the extent that it is effective) a refutation of the art? Or are the art and the philosophy, in this relationship, both immune from refutation?

Cavell insists that he has no quarrel with Krenek's *music* but also that 'such philosophizing as Krenek's does not justify it and must not be used to protect it against aesthetic assessment.'[36] Four observations immediately spring to mind when we try to apply this *obiter dictum* to Smithson's case:

1. Within the whole corpus of Smithson's work, not a single decision appears to have been motivated by the type of aesthetic criterion deployed by Cavell, Fried and, most influentially, Greenberg.
2. The 'formalism' from which Smithson flies is already that type of *in*formal formalism constituted within the Greenberg canon. This type of formality is quite distinct from the 'total organization' attributed to composers such

as Krenek and painters such as Glarner, an attribution which is, in any case, mischievous.

3. The way Smithson combines aesthetics and epistemology is quite different from that of the 'total organization' type of artist or composer; however, both methods lend themselves well to explanation using a taxonomic framework such as that developed by the Stuttgart Institute.

4. Smithson owes his permanent place in the history of art to his skill in negotiating what *really was* 'the end of art', in Danto's sense, from the state of a *terminus a quo* to that of a *terminus ab quem*, in a manner that has been serviceable to countless artists ever since.

It is not just that it is hard to find an aesthetic imperative anywhere in Smithson's work, but that his categories have triumphed historically. Story-telling has, for better or worse, ousted aesthetics in virtually all post-Smithsonian art production, and the philosophers' classical conflation of 'aesthetics' and 'philosophy of art' has become devoid of application to the world of practice. Pace Danto, neither those philosophers nor those artists who treat art as a mode of aesthetic investigation have any further place in the entelechy of the dominant narrative.

The trend that really upset the philosophers was neither Parisian Gesturalism nor Viennese Serialism but the one symbolized by 'that confounded urinal'.[37] Wollheim compares it to Mallarmé's 'blank sheet of paper',[38] Dickie speaks of 'the chaste pleasure the eye might take in the curvatures and colours of an object – a urinal',[39] and Gombrich protests: 'I am not condemning Duchamp for making a joke but I am condemning all of us for talking about it after so many years.'[40] We catch them all in the act of philosophizing their own refusal to accept a fact they already sensed to be true but could not bear to concede; that an artist had out-philosophized them on their own terms, leaving them confined within the zoo-like categories of their own inadequate taxonomy.

Mutt's Method

The *petite aquarelle* with its accompanying motto (which none of the philosophers cared to notice) 'the spectator completes the picture' demonstrated that large conceptual transactions can be brought about by minimal means, the inventive juxtaposition of object and context called parataxis. Mutt revived awareness that philosophy has always been an art among arts, and that art has always been a method, among other methods of doing philosophy. Schematically stated: you can't set up a barrier between the assignment of expressing ideas and that of the critical evaluation, both of those ideas and of the means used for their conveyance. Because the

elaboration of data *for* philosophy cannot be disentangled from the evaluation of that data *by* it, the philosophy *of* art cannot, without unacceptable violence, be separated from philosophy *in* art. This is by no means a new idea. Kant's figure of 'the artificer in the field of reason'[41] already brings us close to it.

The art/philosophy relationship in Smithson's work has this 'quadrille-like' structure. On the one side, words take on the character of 'linguistic sense-data';[42] on the other, specifically sculptural procedures generate philosophical meanings. In particular, and using a method which derives directly from the type of parataxis inaugurated by Mutt, the furnished real estate of the presentational space is concretized as an expressive agency to become the site of imaginative excursions into other types of conceptual space. The art gallery takes an ironically *un*privileged place amongst all the other sites of institutionalized space usage, such that the modes of dialogic interpellation that take place within them are given, so to speak, a common denominator which can serve as the basis for an intelligible theorization of the relationships which subsist amongst the physical pictorial spaces of visual art and the imaginative pictorial spaces of the poem and the novel in a way that neither segregates nor hierarchizes them as most of the existing theories do. Perhaps more importantly still, this methodology dissolves the barrier between these various modes of interpellation in art and the actual exercise of authority through ideological positioning in classroom, workplace, courtroom, etc., that is, between what we may call the ludic and the political spheres of interpellation. The techniques for enforcing dialogic inequity are revealed as combinations of the prosodic and the pictorial.

In this sense Mutt's method also undermines itself, for his specific intervention was obviously the historical culmination of a *collective* effort on the part of innumerable artists, famous and obscure. The 'moment' is his in the way that the moment of the liberation of Paris from Nazi occupation was de Gaulle's, but the installation of a *celebrant* of this moment, in the person of Marcel Duchamp, immediately restores to the new 'quality space' many of the characteristics of the basilica-type space it was meant to supersede, with its frontality, fragmented hierarchy of platform and floor, speakers and listeners, etc. The quality space is reduced to an 'identity space' and the furnished real estate of the art gallery becomes once again – as the jingle has it – 'all there is', or, more explicitly, a competitive arena for displays of logistic prowess, in which each artist tries to subsume the work of all the others. Writing of later installations by Duchamp, Brian O'Doherty asks: 'Why did the other artists let him get away with it?'[43]

To interpret in the necessary detail Smithson's rejoinder to 'Art and Objecthood', which he called Fried's 'vindication of Stanley Cavell'[44] and which was published in the following issue of *Artforum*, or the relationship, say, between the *Spiral Jetty* as myth and as material referent, or any other

particular example of his deployment of the Duchampian method, would take us too far afield. But Smithson differs greatly from Duchamp in his primary methodological concern for a certain *dialogic equitability*. His voice is 'Menippean', in Bakhtin's sense, one amongst others of equal status, and he activates the critical and curatorial machinery in precise ways without 'using his elbows', in the sense advocated by Barnett Newman, always making sure that his commentators have something genuinely interesting to write about without, like so many of his contemporaries, lapsing into the inane.

I do not think it would be an exaggeration to claim at this point that a distinctly proletarian strand runs through Smithson's practice, showing itself in his attitude towards the physicality of his materials and in the characteristics of his social engagement. Smithson's materialism is of an entirely different order from that of 'the simple, irreducible, irrefutable object'[45] and I believe that this difference could be demonstrated by using the taxonomy proposed in 1920 by the artist-couple Rodchenko and Stepanova for the evaluation of 'materialist constructive work'.[46] Here *Tektonika* is defined as the natural dynamics of the movement of material substances, *Konstruktsia* as the human activity of organizing and shaping these processes, and *Faktura* as the manipulation of these materials and processes in the service of particular aims. Such a taxonomy might supplement, without undue strain, those of Lakatos and Bense mentioned earlier, but, again, it would take a much longer study to substantiate this.

Smithson is too often praised for being what he is not, for his wit, his wisdom or his prose style. But the style and content of his writing is quite typical of late-sixties art-world discourse and such innovative thinking as it contains is taken from the currently available paperbacks and scrupulously referenced by Smithson. He seems uninterested in verbal prosody beyond the extent of its sculptural/interpellative instrumentality and he is certainly not an art satirist of the order of Duchamp, Reinhardt or Anthony Hill. He enjoyed reading and quoting from authors such as George Kubler and Anton Ehrenzweig in the same way that he enjoyed science fiction and going to the movies; less, I would suggest, for epistemological enlightenment, more as a route towards the realization of certain sensations in himself and his interlocutors. To be sure, these sensations attach themselves immediately to particular complexes of ideas in the manner of the Freudian cathexis or affective charge, but it is a mistake to assume that the original epistemes go through this process unmoderated, as I think Thomas Lawson does when he praises Smithson in the following terms:

> By mixing genres (aesthetics, anthropology and science fiction) and styles (from parody to visionary) Smithson muddied the waters, disrupting the flow of art criticism.[47]

The 'muddy waters' metaphor is obviously doing duty here for a whole ethos of entropic Ehrenzweigian 'de-differentiation' which appealed to Smithson, whose history is bound up with the Romantic reaction to Enlightenment thinking and whose political function has already been discussed. Smithson's metaphysics can be shown to correspond very closely to that of Samuel Beckett in many matters of precise detail as well as in its general characteristic ('the thing to avoid, I don't know why, is the spirit of system'[48]), and I want to suggest that he also shared, perhaps at the second degree but most importantly, Beckett's *pellucidity*. He instantiates into his practice as a sculptor elements associated with many other types of practice, crossing the classical social (that is, *class*) frontiers of the division of labour as well as the more apparent technical ones, producing in the first instance, if you insist, a kind of 'merging' but one within which the elements themselves take on *clearer* outlines. Whilst 'shuffling the pack', so to speak, Smithson never *maltreats* his categories in the way Beuys does when, for example, he claims that the movement of air in his larynx when he speaks 'is sculpture'.

Smithson's Space-Time Conception

This essay has concentrated upon the moment of Smithson's 'entrance', in the sense used by Kubler:

> The analogy of the track yields a useful formulation in the discussion of artists. Each man's lifework is also a work in a series extending beyond him in either or both directions, depending upon his position in the track he occupies. To the usual coordinates fixing the individual's position – his temperament and his training – there is also the moment of his *entrance*, this being the moment in the tradition ... with which his biological opportunity coincides. Of course, one person can and does shift traditions, especially in the modern world, in order to find a better entrance.[49]

Smithson certainly seems to have applied this formulation to the construction of his own career, and I want to conclude by trying to account for the strangely *Victorian* resonance which I pick up from his work via the supposition that he also internalized, along with it, Kubler's 'analogy of the track' as a generalized metaphysic of space and time and, in so doing, exposed his project to the type of ideological exploitation I have criticized (a broadly similar conception is to be found in the writings of Ehrenzweig).

Zeno of Elea's (early modernist) *bouleversement* of our intuitive notion that space and time can each be decomposed into arbitrarily small units, such that motion can be explained as the one-to-one mapping of space to time or vice versa, lay almost dormant in history until its brilliant confirmation in the physics, philosophy and art of the late nineteenth and early twentieth

A N D Y W A R H O L *Joseph Beuys in Memoriam* (1986),
screenprint on paper; photograph courtesy The Andy Warhol
Foundation, Inc., New York

GERHARD RICHTER *Abstract Painting (777–2)* (1992), oil
on canvas; photograph courtesy Anthony d'Offay Gallery,
London

CINDY SHERMAN *Untitled 179* (1987), cibachrome
photograph; photograph courtesy Metro Pictures, New York

LAURIE ANDERSON *United States: Part 1*, performance
Orpheum Theater New York, September 1980; photograph
courtesy ICA, London

VICTOR BURGIN *Family Romance* (1990), silkscreen print
on paper; photograph courtesy John Weber Gallery,
New York

MENACÉ

MENACÉ

MARY KELLY *Menacé* from *Interim*, Part 1: Corpus (1984),
photo laminate, screenprint and acrylic on Plexiglass;
photograph courtesy the artist

centuries. Cézanne's late paintings, in particular, challenge – I would say refute – the idea that our experience of time is like a succession of snapshots with vacuous (or, in Ehrenzweig's sense, 'inarticulate') spaces between them. Bergson called this 'the cinematographic conception of motion' and famously opposed to it his conceptions of '*durée*', '*simultanéité*', '*un mobile dans l'espace*', '*le néant*' and, most appositely, '*les questions qu'on ne peut fixer sans être pris de vertige*'.[50]

All the great *bouleversements* of modernism involve the transgression of taxonomic boundaries and many have had the secondary effect of involving their protagonists in transgressive social behaviour of different kinds. I suggested above that Duchamp's *addition* of the persona of 'the transgressor' to the objective 'act of transgression' produces a 'transgression of the transgression', analogous to a binary switching, such that the effect of the original transgression is undone. Paintings such as *Nude Descending a Staircase* – which conflate the 'Bergsonian' space of say, Robert Delaunay's *Simultaneous Windows* with the cinematographic space of Muybridge's photo-sequences – provide even clearer examples of Duchamp's subversive method, for certainly there is 'simultaneity' here of a sort. One thing, at one time, exists in several places. But, unlike Cézanne or Delaunay, Duchamp *fixes* both the viewpoint and the picture plane in the photographic way to produce that typically 'crystalline' effect which ensured the political victory of the 'bad' Cubism. Robert Hobbs:

> Smithson's interest in crystals received impetus in 1966 when J.G. Ballard's science fiction tale *The Crystal World* was published.... Ballard constructs a glittering realm [which], frozen and crystalline, resembles a Cubist painting, and may well have suggested to Smithson the entropy of a modern art that has become overrefined.[51]

Duchamp's Cubism is comparable to Gresham's 'bad money' on several grounds. It purports to provide, but does not deliver, a working solution to the problem of *continuity*. It reinstates the privileged gaze, the royal perspective on the pro-filmic event, restoring the picture as the site of inequitable interpellative transactions. It is of a piece with the ideological conflation of geometry with instrumental reason mentioned earlier which has enabled later artists such as Peter Halley – who claims to be in a direct line of succession to Smithson – to substitute a lifeless eclecticism, which John Roberts has called a 'carceral image',[52] for the emancipatory possibilities, both dialogic and architectonic, inherent in Cézanne's project. Within this pre-falsified taxonomy, rationality *is* nihilism, Cavell's fear of 'total organization' and Smithson's linkage of crystallinity and the void appear to be justified, for once any situation is completely *auskristallisiert*, in the sense used by Adorno, then, indeed, no further event is possible. But all this has nothing to do with what geometers do in the real world, and even less to do

with the practices of mathematically structured art and music within which the immutability of nomological frameworks is entirely hypothetical.

In the mythology surrounding his fatal aeroplane accident, Smithson's interest in the sensation of vertigo is sometimes associated with the formal structure of the *mise en abîme*, a semi-paradox of regress which, like a continuous fraction in arithmetic, arises whenever any taxonomy includes itself as one of its own parts. Its name derives from its use in medieval heraldry and it also appears in some recent computer graphics associated with the Mandelbrot set. It turns up in images of 'magic mirrors' throughout the canon of imaginative literature and it is easy to see why its trivial 'mystery' appeals to an ideology which wishes to make itself disappear *as* an ideology, together with the availability for interrogation of the structures it is designed to conceal. Smithson, however, does not use vertigo as an ideological *passe partout*, and I cannot see him as a demagogue of the occult. Rather, he interrogates 'vertigo' itself, much as Reinhardt interrogated the sensation of blackness without producing (as is so often alleged) any 'black' paintings, or Mondrian interrogated orthogonality without painting any squares.

In experiments such as *Enantiomorphic Chambers* of 1965 (the same year as 'The Responsive Eye' exhibition), Smithson uses physical mirrors to treat the problem of infinite regress in a practical way, but of course we cannot 'fall' through them into another world. Rather, our *feeling* of vertigo arises when we follow him in his perpetual struggle to extricate himself from the production of first-degree meanings, together with a Beckett-style courtship of his own failure in this struggle. While using the 'crystalline' space-time conception which I have criticized, he does transform it in a revolutionary way. The objects perceived within his point-to-point framework are themselves, in many instances, other conceptions of pictorial space, each of which comports a distinctive mode of interpellative address. We are involved in a vertiginous switching of positions as amongst interpellands and interpellees and, to this extent Smithson undoes Duchamp's undoing of Cézanne.[53]

In the sense I have tried to describe, Smithson may fairly be claimed to have initiated a 'third aesthetic', capable of complementing the previously recognized 'ratiocinative' and 'olfactory' aesthetic modes. It is not his fault that his conception has become a weapon used to 'defeat' the others in the art political arena. But a certain *non*-Beckett-like sense of the tragic and the futile – ineradically and unproblematically present – remains unaccounted for. The vertiginous spaces-in-spaces of the unrealizable *mise en abîme* keep crystallizing themselves out into the forms of the traditionally voyeuristic *peinture mise en boîte*. It's not just the physical cabinets and frames everywhere apparent but also a type of ideological packaging to which his work all too easily lends itself. Beside Smithson's extreme strategic and technical

originality, there is a certain social complaisance, an eagerness to astonish us which places the more subtle and serious aspects of his conceptuality at the mercy, not so much of his theoretical commentators, more, I suggest, of the Emperor's own wine-tasters, so that his wild idea of a *cinematic atopia* tends only to reach us in crudely commodified forms.

Notes

1. Nancy Holt, ed., *The Writings of Robert Smithson: Essays with Illustrations*, New York University Press, New York 1979.

2. Robert Hobbs, *Robert Smithson: Sculpture*, Cornell University Press, Ithaca and London 1981.

3. Jessica Prinz, *Art Discourse: Discourse in Art*, Rutgers University Press, New Brunswick, New Jersey 1991.

4. Holt, ed., *The Writings of Robert Smithson*, p. 105, quoted in Prinz, *Art Discourse*, p. 102.

5. Prinz, *Art Discourse*, p. 121.

6. See Stuart Sim, 'Lyotard and the Politics of Antifoundationalism', *Radical Philosophy*, 44, Autumn 1986, pp. 8–13. Stuart Sim's article is discussed by John Roberts in, John Roberts, *Postmodernism, Politics and Art*, Manchester University Press, Manchester and New York 1990, pp. 12 and 13.

7. Prinz, *Art Discourse*, p. 82.

8. P.A. Norvell, 'Fragments of an Interview with Robert Smithson', in Lucy Lippard, ed., *Six Years: A Bibliographical Chronology on the Conceptual Art Movement*, Studio Vista, London 1973, p. 90.

9. Prinz, *Art Discourse*, p. 122.

10. Michel Foucault, *Les Mots et les choses: Une Archéologie des sciences humaines*, NRF Gallimard, Paris 1966, p. 7. The present quotation is from an unattributed English translation entitled *The Order of Things/An Archaeology of the Human Sciences*, Routledge, London 1991, p. xv (original emphasis).

11. Foucault, *The Order of Things*, p. 72.

12. Ibid., 'Mathesis and Taxinomia', pp. 71–7.

13. Terry Eagleton brings us back to this aporia at the end of almost every chapter of his *Ideology of the Aesthetic* (Basil Blackwell, Oxford 1990), linking it to the axiom of the joint ineffability of ideology and art by means of rhetorical leaps such as the following:

> The unity of social life sustains itself, requiring no further legitimation, anchored as it is in our most primordial instincts. Like the work of art, it is immune from all rational analysis, and so from all rational criticism. (ibid., p. 38)

But, like Adorno, Eagleton seems to fall victim here to the very ideology he is criticizing. His argument falls if his dubious lemma of an ineffable *veritas aesthetica* is replaced by a more plausible one, that artists' decisions are as intelligible as those of any other productive agency.

Prinz (*Art Discourse*, p. 88) quotes Eagleton on Smithson (Terry Eagleton, *Literary Theory*, University of Minnesota Press, Minneapolis 1983, p. 138).

14. Theodor W. Adorno, *Aesthetic Theory*, trans. C. Lenhardt, eds Gretel Adorno and Rolf Tiedemann, Routledge & Kegan Paul, London and New York 1984, p. 41.

15. Wilhelm von Humboldt, *Gesammelte Schriften*, vol. IV, p. 48, discussed in Kurt Mueller-Vollmer, ed., *The Hermeneutics Reader*, Basil Blackwell, Oxford 1986, pp. 16–17: 'the historian is involved in what later generations will call the hermeneutic circle. This means that in any process of understanding, the parts must be understood in relation to the whole, just as the whole can only be understood in relation to its parts.' Mueller-Vollmer adds importantly, 'In actuality this apparent paradox is always overcome by the historian, because he begins his work with an intuition of the invisible coherence which unites the individual event.' Prinz insists, however (*Art Discourse*, p. 190, n. 36), on Smithson's behalf, that 'the famous hermeneutical circle is really a

spiral', quoting Thomas Kent ('The Classification of Genres', *Genre*, Spring 1983, p. 15) in support of this view.

16. José Ortega y Gasset, *The Dehumanization of Art*, Princeton University Press, Princeton 1968, p. 5.

17. Donald Verene, ed., *Symbol, Myth and Culture: Essays and Lectures of Ernst Cassirer, 1935–1945*, Yale University Press, New Haven, Conn., and London 1979, p. 186.

18. George Kubler, *The Shape of Time: Remarks on the History of Things*, Yale University Press, New Haven, Conn., and London 1962, p. vii.

19. 'The attempt to theorize art or the essence of art is like the attempt to theorize the not-theorizable. The "veritas aesthetica" is not the "veritas logica".' (Max Imdahl, ' "Op", "Pop" oder die immer zu Ende gehende Geschichte der Kunst', in H.R. Jauss, ed., *Die nicht mehr schönen Künste: Grenzphänomene des Äesthetischen*, Munich 1968, p. 704.)

20. Karl Marx and Friedrich Engels, *The German Ideology*, ed. C.J. Arthur, Lawrence & Wishart, London 1974, p. 65.

21. Holt, ed., *The Writings of Robert Smithson*, p. 81, quoted in Prince, *Art Discourse*, p. 88.

22. Prinz, *Art Discourse*, p. 80.

23. J.G. Fichte, *The Science of Knowledge*, ed. and trans. Peter Heath and John Lachs, Cambridge University Press, Cambridge 1982, pp. 8–14 (original emphasis).

24. Imre Lakatos, *The Methodology of Scientific Research Programmes*, eds John Worrall and Gregory Currie, Cambridge University Press, Cambridge 1980.

25. Max Bense, 'Max Bill', in *Max Bill, with an Essay by Max Bense*, exhibition catalogue, Hanover Gallery, London 1966. (Trans. G. Staempfli, first published in *Art International*, VII (3), March 1963.)

26. Irving Sandler, 'At-tension to the Wave', in *Michael Kidner*, exhibition catalogue, Center for International Contemporary Arts, New York 1990, p. 10.

27. Eva Cockcroft, 'Abstract Expressionism, Weapon of the Cold War', *Artforum*, June 1974, pp. 39–41.

28. Patrick Heron, three articles headed 'Patrick Heron discloses the American cultural and commercial pressures that have brought about the most extraordinary myth in modern art', *Guardian*, 10–12 October 1974. See also Patrick Heron, 'The Ascendancy of London in the Sixties', *Studio International*, 172 (884), December 1966, pp. 280–81.

29. Hobbs, *Robert Smithson*, p. 231.

30. Margaret Rose, *Marx's Lost Aesthetic: Karl Marx and the Visual Arts*, Cambridge University Press, Cambridge 1984.

31. Arnold Schoenberg, 'New Music, Outmoded Music (1946)', in *Style and Idea: Selected Writings of Arnold Schoenberg*, trans. L. Black, ed. L. Stein, Faber & Faber, London 1975.

32. Arthur Danto, *The Philosophical Disenfranchisement of Art*. I quote here from a conference paper (Institute for Advanced Studies, Caracas, December 1984) circulated before the publication of Danto's book of the same title by Columbia University Press, New York 1986.

33. L.B. Cebik, 'Knowledge or Control as the End of Art', *The British Journal of Aesthetics*, 30 (3), July 1990, p. 252.

34. Stanley Cavell, 'Music Discomposed', in his *Must We Mean What We Say?*, Cambridge University Press, Cambridge 1976, p. 181 (original emphasis).

35. Karl Marx, *Theories of Surplus Value*, trans. E. Burns, Lawrence & Wishart, London 1969, part 1, p. 401.

36. Cavell, 'Music Discomposed', p. 196.

37. Ted Cohen, 'Unfair to Art', conference paper, Institute for Advanced Studies, Caracas, December 1984.

38. Richard Wollheim, 'Minimal Art', in *Arts Magazine*, 39 (4), January 1965, p. 26.

39. Cited in Danto, 'The Philosophical Disenfranchisement of Art' (Conference Paper, see n. 32).

40. Cited in Cohen, 'Unfair to Art'.

41. Immanuel Kant, 'The Architectonic of Pure Reason', in *Immanuel Kant's Critique of Pure Reason*, trans. N. Kemp Smith, Macmillan, London 1929.

42. Smithson's term, see Holt, ed., *The Writings of Robert Smithson*, p. 38.

43. Brian O'Doherty, *Inside the White Cube: The Ideology of the Gallery Space*, Lapis Press, San Francisco 1986, p. 67.

44. Holt, ed., *The Writings of Robert Smithson*, p. 38.

45. Eugene Goossen, *The Art of the Real*, catalogue introduction, Museum of Modern Art, New York 1968 and Tate Gallery, London 1969. This catalogue contains several references to Smithson and a photograph of his painted steel sculpture *Leaning Strata* (1968). It is also worth noting that the original coinage of the Slogan 'The art of the real' – as a response to André Bazin's question 'What is cinema?' – could hardly be further removed from Goossen's application.

46. Aleksandr Rodchenko and Varvara Stepanova, *Programme of the Productivist Group*, Moscow 1920. An English-language translation of this text is printed in Stephen Bann, *The Tradition of Constructivism*, Thames & Hudson, London 1974, pp. 18–20. Its sources are documented more comprehensively in Christine Lodder, *Russian Constructivism*, Yale University Press, New Haven, Conn. 1983, pp. 281–2. It is worth noting that this text articulates the moment of the first and paradigmatic outcropping of the concept of 'the end of art'.

47. Thomas Lawson, 'The Dark Side of the Bright Light', *Artforum*, November 1982, pp. 63–4, quoted in Prinz, *Art Discourse*, p. 185, n. 6.

48. Samuel Beckett, 'The Unnameable', in *Molloy, Malone Dies, The Unnameable*, Calder & Boyars, London 1959, p. 294.

49. Kubler, *The Shape of Time*, p. 21 (original emphasis).

50. Henri Bergson, *L'Évolution créatrice*, Librairie Félix Alcan, Paris 1924, p. 298.

51. Hobbs, *Robert Smithson*, p. 21.

52. See John Roberts, 'Lost in Space', *Art Monthly*, 124, March 1989, pp. 26–8, reprinted in John Roberts, *Selected Errors: Writings on Art and Politics, 1981–90*, Pluto Press, London and Boulder, Col. 1992, pp. 63–71. This is a review of Peter Halley, *Collected Essays, 1981–87*, Bruno Bischofberger Gallery, Zurich 1988. To Halley's credit it should be added that his essay 'Beat, Minimalism, New Wave and Robert Smithson' (pp. 11–21) is a vivid account of an important aspect of Smithson's background which most other commentators ignore.

53. Of course, some types of pictorial space *resist* such treatment, and their resistance itself can be hypostasized, as in George Segal's Meinongian *Portrait of Sidney Janis with Mondrian Painting* (1967).

5

Warhol's Voice, Beuys's Face,

Crow's Writing

Terry Atkinson

I decided to stay at the office and get some work done with Rupert on the diamond dust. If it were real, it would cost $5 a carat and that would be $30,000 to $40,000 for each painting for the diamond dust alone.

The Andy Warhol Diary, Wednesday 1 October, 1980[1]

Writing

When it comes to matters of interpreting Warhol's work, unsurprisingly, no source is more consulted than Warhol himself – the ever-pumping talker, be it the monosyllabic version or something a trifle more complicated. Writing these days about artists (that is, tales of the astounding creatures) is, it seems, writing about their work. By now this amounts to a convention. In, for example, *Andy Warhol: A Retrospective*,[2] the convention seems worked to the point of hero worship. The notion of a physical causal relation between artist and work is complicated enough. However, the notion of a psychological cause and effect relation takes us on to ground where guesswork is the order of the day. Warhol's own talk about his work and working processes is full of slippages which rely on an uncritical reception and avoidance of these complications. Writing about artists and their work is a genre of mostly cavalier writing. Writing on Warhol and his work is amongst the most cavalier of this writing.[3] The modern conversation concerning the two equations, artist→work and work→artist, has some redoubtable and massively more formidable precursors. To reduce these precursors to one brief mention, Kant, for instance, considered an effective work of fine art to be an intentionally produced beautiful thing.[4] Simple as it sounds, the consideration unravels into a series of evasive puzzles.

Here I intend to write about Warhol's own talk and other people's talk

about his work, but I would also argue, although not specifically here, that there are ways that Warhol's work could be written about without worrying over much about Warhol's accounts of either himself or his work. Nevertheless, in writing about Warhol's work, in the light of the persona Warhol built for himself, it is difficult to avoid both Warhol's talk and Warhol-talk. Here, in writing of Warhol's portraits of Beuys, insofar as this involves discussion of how the work was made, of what it is made of, how it was caused, etc., I intend to approach some notion of Warhol's intentions. We ought to know well by now the coy and ofttimes squalid publicity games that Warhol played with what he alleged were his intentions. The approach to Warhol's intentions might be served better here by separating – and I think it can just about be done – the notion of 'what Warhol intended to do' from the notion of what 'Warhol said he intended to do', or, for that matter, what 'Warhol said he didn't intend to do'.

Some years ago, writing specifically on some of Warhol's earlier works, Tom Crow claimed allegedly to be going behind one Warhol to another Warhol: 'it is precisely in thinking about the possible interconnections between the images of catastrophe and the images of consumption that another Warhol can be seen behind the dandyish pose.'[5] Presumably these two Warhols, if they are indeed there, have different intentional structures. Consider what is being asserted here by Crow: that there is a front Warhol, the posing dandy, and behind at least one more Warhol.[6] It is not quite that Crow is saying that the back Warhol (or Warhols) is more real than the frontal dandy; Crow is too alert an art historian to fall for that old chestnut. What he seems to be saying is that this rear Warhol is a more sympathetic respondent to, a more dissenting respondent from, the effects of the social violence upon which late capital is built than is the front Warhol. Over the years since they were published, I've returned several times to ponder Crow's commentaries on aspects of Warhol and his work. I am not convinced by Crow's attempts to extricate one, or a number of, back Warhols from the ethos of the frontal Warhol. I am not convinced that these Warhols are separable to the extent that Crow appears to require in order to sustain his argument.

Crow's reading of Warhol's 'images of catastrophe' raises some interesting general problems about the constitution of the process of reading artworks. The extreme Derridean scenario would be that the text, once released for reception over and above that of its producer, may provision readings which stand outside and beyond, in some telling sense, the intentions of the producer in producing the text. These readings may contradict or violate the intentions of the text's producer. So the receiver's (reader's) intentions may produce a reading which, in one way or another, is alien to the intentions of the text's producer. In this very broad case, my differences with Crow's reading will remain unspecific and the general scenario is outlined here to

suggest that the relation between work produced and the intentions with which it was allegedly produced are perhaps more complicated than conventional assessment of the status of artists' intentions generally allows. The general Derridean scenario might well confer force on both Crow's and my own readings of Warhol simultaneously, offering very little about the substance of the differences of our respective readings.

Crow does seem to argue for a reading of the 'images of catastrophe' showing that the Warhol who produced these had a different intentional structure from the Warhol who produced 'images of consumption'. It is the limits, definition and status of what Crow calls 'possible interconnections' that will flesh out whether in fact Crow is asserting what I believe him to be asserting. In fact, he is never very explicit on the matter, but I would maintain that much of what he writes implicitly assumes these differently intentionally structured Warhols despite the admission of possible interconnections. As I read Crow, 'possible interconnections' is left as a broad kind of cover term strategically placed in the realm of possibility in order that the separation of the Warhols can be executed. His essay seems to argue that (let us call him) Warhol-Catastrophe is an artist who (in some way) is intending to make pictures that are (in some way) about 'the imagination of pain and suffering'.

I had better try to locate rather more detail here. I am assuming, but in the final analysis it is not an assumption without some perilous and heavy logical trudging, that Crow is saying something like: to intend to make works which are about 'the imagination of pain and suffering' is to have some kind of empathy for those victims of pain and suffering. Thus the further argument seems to be that the intentional structure of Warhol-Catastrophe is in some kind of responsive relation with Warhol-Catastrophe's imagination, which is maybe to claim further, or want to claim further, that this imagination is sensitive to the historical/social plight of the victims of this pain and suffering.

We are in swampy logical ground here. Taking into account the problematics attached to reader-response theory,[7] nevertheless the point remains that the Warhol pictures Crow writes about are by now embedded in such a general framework of Warhol persona-building, and we would do well not to underestimate Warhol's wiliness in such building, that the use of 'imagination' here needs a very specific set of reference points. Rather in the way he uses 'possible interconnections', Crow's use of 'imagination' here is very general, tricky – a kind of complex bucket term covering or catching a number of possibilities that can be deduced from what I have called Warhol's wily trail-leaving. Warhol certainly could organize around the public relations of his homespun version of reader-response theory. This never necessarily excluded artful (no apologies for the faint pun) flattering or cozening of any camp he considered, for whatever reasons, worth cosying up to. Radical readers are equally targets of, and seem as susceptible to, this kind

of cozening. Warhol, I maintain, was quite capable of making, and could intend to make, a publicity structure which could absorb a number (often a considerable number) of possibilities of reader-response. Wasn't this for much of the time the name of Warhol's game? And he could do this in a canny way. He could legislate together one set of responses contradicting another set. In this kind of framework, to argue out, to unfold the possibilities of, a phrase such as the 'imagination of pain and suffering' is a task of the first philosophical water. We could, for instance, haul it before Kant's *Critique of Judgement* and see where it might lead when examined by this tribunal. 'Imagination' could be deconstructed with considerable philosophical finesse in this setting. It might, however, take us so far from Warhol's intentional structure, wily as he was, as to overload it, taking it far past the point of even saying something like Warhol's intentions were intuitive rather than highly conscious ones. Even the notion of an 'intuitive intention' gives some picture of the logical strangeness we might encounter here, and itself indicates the strong intuitive grasp we have that there is a critical relation between the notions of intentionality and the notion of consciousness.

Since, if Warhol is to be believed, he followed slippages in his intentional patterns, in the sense that accidents in production, both technical and discursive, were remorselessly incorporated into his public relations production, then such slippages might give some clue as to the intentional composition of the producer named Warhol and/or other sub-Warhols such as the alleged Warhol-Catastrophe. But I think Warhol knew the limits of these slippages. He knew they would not uncover the patterns of social violence which particularly support any capitalism-celebrating artist such as Warhol. Perhaps the biggest point I take to count against Crow's analysis of the 'Disaster' paintings is the extent to which Warhol's oeuvre celebrates not just the pleasures of late capital but late capital itself as a sensational pleasure. It is Warhol's general celebration of this form of society – which in itself was to make him one of its most celebrated members – that leads me to view with some considerable scepticism (of which more below) Crow's singling out of the 'Disaster' paintings as emblems of social critique of late capital. Even in what Crow writes there seems to me to be a sense of, on the one hand, a Warhol who hovers between the frisson of the consumership of disasters and accidents (always a residual suspicion of a ghoulish consumption[8] on the part of Warhol) and, on the other hand, a Warhol who exposes and criticizes a society which consumes people through the instrument of its industrial production and its means and patterns of distribution. The latter Warhol appears to be the Warhol on whose behalf Crow writes his article 'Saturday Disasters: Trace and Reference in Early Warhol' (hereafter SD).[9] The question seems to be whether this Warhol-Catastrophe, sifted by Crow from the other Warhol, or other Warhols, is in fact there, or whether this Warhol-Catastrophe is constructed by Crow because Crow wants him to be

there. If the latter is the case, then we are led on to wonder, and this is not the place for a lengthy consideration, what Crow's motives are for constructing Warhol-Catastrophe; why Crow should want such a Warhol figure. Returning to the remarks immediately preceding, certainly the ghoulish consumption of disasters and accidents is a well-established genre of projection in prominent parts of the media industries in late capitalist societies, and this is an aspect of the characteristic energy and appetites of a late capitalist society such as the United States has been for forty years. And part of these media industries now include significant elements of the complex and expanded diaspora of contemporary art practice.[10]

One further point. Could a kind of generic Warhol be both a producer-consumer of a frisson of 'the imagination of pain and suffering' and then also, as some by-product of this voyeuristic consumership, this particular intentional structure, elicit in certain of his readers the interpretation of this as a non-voyeuristic imagination of pain and suffering? In this last sentence the relation suggested by the word 'also' is the one that an inquiry into these matters would have to try to sort out logically. Assuming there is a way through the mire, then this should offer some clue as to what notion of agency is being raised here. Whilst we clearly are not discussing Warhol's readers here so much as Warhol's intentions, it may be that the role of Warhol's intentions in constructing Warhol readers is one that cannot be ignored. To say that Warhol, even Warhol with his seeming near paranoia that he should not so much legislate for all possible receptions of his work as not legislate against any possible reception of his work, could not administer every reading of his work is to utter a truism. But at least the notion of an 'unconscious intention' does point up the logical problems affixed to the border between 'unconscious', 'intention' and 'accident'.

Warhol's ambivalence and protean slipperiness with regard to matters of meaning in his work was always theatrical; by the later years of his performance it was also studied and senatorial. Crow writes of works from relatively early in Warhol's career. I am going to write below on, amongst other things, two works from late in his career. By the time Warhol made these later works, and I think Crow wrote his SD piece after Warhol made the *Diamond-Dust Joseph Beuys* (1986), it seems to me even harder to separate out early works from the teleological trajectory that the later works exemplified, and it should be noted that Crow shows great circumspection in trying to separate out the 'images of catastrophe'. The later Warhol work, then, seems to offer a strong index into the reading of the earlier work. Warhol is an artist who adored late capital for the kind of power it is – all image – and late capital is a political system which adored Warhol for adoring it.[11] Wasn't this the reason that Warhol was not just famous but a conspicuous celebrity of late capital?

Warhol by the time of his later career was transparently a seamless

political entity, the complete counter-revolutionary artist. Earlier work on behalf of the McGovern campaign, etc. notwithstanding, it seems to me very hard to pull out any section of Warhol's production and clear it from this trajectory, break its links of ideological continuity with the work of Warhol-Consumer. I am suggesting here that the Warhols, such as they are, behind the Frontal-Dandy-Warhol were developed by that Warhol in order to furnish this frontal figure with a notion of ideological intrigue which Warhol had intuited early and then developed quickly since he soon knew it to be an irresistible consumer item to the proliferating cultural legions of late capital. Diamond-Dust-Warhol was one of the later tactical apparitions Warhol invented in order to, by that time, reinforce the impression that Warhol-Himself was Warhol the exemplary late-capital-self-consumer-leader par excellence. Under Warhol's leadership, late capitalist art is the would-be glitzy solvent of the hard utopian glimpses of an art that holds to the pact with Benjamin in his homeless, Pyrenean suicide. Warhol's art lacks any good faith in the social. Late capital found Warhol indisposable, contrary to its and his rhetoric of the disposable, and he took great pains to as far as possible make sure it found him so. Warhol's art is the art that goes shopping for shopping's sake. Diamond-dust, if only it were real pleads Warhol, and don't be fooled by the mock-irony, would be $5 a carat. This is not the irony which is in the slightest bit corrosive of late capital, it is the affirmative irony which celebrates late capital as culture. Art & Language ended a review of some Warhol work at d'Offay's Gallery in London in 1988 with the phrase 'Nothing we have written can hurt him.'[12] They are, I think in danger of encouraging a notion that Warhol-Himself (the persona–work continuum) is unassailable, although perhaps their phrase had a temporal qualification attached to it such as 'Nothing we have written can hurt him at present.' It may take some time but the orders of Warhol and his host of addicts can be resisted and, I think, countermanded. The Art & Language review itself was a good brief step along the way.

Surface

This lacklustre spectacle, however, brought conceptualism face to face with its essential nemesis, 'Popism'. By the mid-1970s, the economic and social ascendancy of Pop had legitimated Warhol's interpretation of ironic mimicry above all others, and led to the eruption of an aesthetic of compulsive and unreflective mimicry of all forms of culture, especially the 'successful' and 'effective' ones, across the whole art market. As the conceptualist struggle for historical memory succumbed, the antithetical cultural forces it wished to defeat burst forth with unprecedented vigor in the

post-pluralism of the late 1970s and the business fetishism of the
last four or five years.

JEFF WALL, *Dan Graham's Kammerspiel*[13]

In the face of Joseph Beuys, Warhol sought out one of the most vaunted
images of art consumer property. Warhol further attempted to render this
image darkly fabulous by proxy: avowing the image as surface through
working (dusting) it with diamond-dust – a kind of literal surfacing of the
portrait. Warhol seemingly intends to surface the surface of the portrait –
and with nothing less than the spectral diamond dust. The metaphorical
pathways unlocked by the suggestion of this dusting process loose the image
of Beuys's face-hat into zones of profligate association. It seems the diamond-
dust portrait became a metaphor of the whole Warhol portrait genre, the
diamond-dust being a proxy for a kind of value-added tax of the surface,
the proxy being worked into the image of Beuys's face, dusted into the eyes
and the nostrils, the mouth, the ears, the skin of the face and head, and, of
course, the famous hat. A dust literally added to Beuys's famous mug-shot.
Into every part of the image, every metaphorical pore and orifice, value was
dusted in.

But the notion of a fabulous dust runs from the gold-dusts of mythic quests
like that seeking El Dorado and the harder historical actualities of the 'gold-
dust' industries of places like the Klondike, Yukon and the diamond mines of
South Africa, to perhaps the most apocryphal of all such particles,
enshrouding and sinuous radioactive dust. Think of the two lone B29s
approaching the Japanese coast in August 1945 on their run in from Tinian.
Or, more recently, the dead sector near Kiev in the Ukraine as the marker for
the clouds that dusted the European continent in the months following April
1986. So the apparently innocent notion of dusting a portrait can be made to
have its discomforts. A dust in these times can be fabulous in its destructive
power. The image of Beuys staring eyelessly out at us can be made to mouth
and ventriloquize Oppenheimer's 'I am ... become destroyer of worlds.'
And all this in the name of value, an ersatz $5 carat.[14] The portrait is perhaps
also partially a parable of power and wealth, a not unknown function for a
portrait to have. So what else of Warhol's unruffled and poised dusting of the
image of Beuys's face? Can it be set in the frame of being quietly but gleefully
pitched against Beuys's self-magnifying politics? A typical piece of Warhol
ironic positioning, using the image against Beuys's publicly established
iconically projected reputation as politician-shaman.

Art kudos is being exchanged here, to say nothing of money changing
hands. I am taking for granted here Beuys's political self-regard. Few artists
could have come up with a title as stupendous as *The Energy Plan for Western
Man*. There is a fine line between ambition and art-market demagoguery
within such a title. By the time Warhol made the diamond-dust portrait of

him, Beuys was resoundingly famous (always something to be reckoned with according to the gradient of the later Warhol's career) and his fame rested upon the relation between his practice and his self-asserted 'creative' and 'principled' politics. Therefore, not only metaphorically in the face, but literally on the image of the face of Beuys, Warhol sprinkles and rubs (I use 'sprinkle' here in the sense of the meaning-anointing function of water in the Christian baptismal service) diamond-dust. A cardinal gesture of anointing Beuys's image on behalf of late capital. Beuys's image literally transformed into an image and surface of late capital, noting here that the image of surface is a paradigmatic one of that conjuncture.[15]

As I have suggested already, I think diamond-dust is used as a proxy, a kind of understudy, for the promise of that fabulous wealth which acts as a main, yet indefinitely postponable, promissory note at the heart of late capital. Held within the range of the material properties of diamond-dust is the augury of wealth showering down – that promise of being showered with wealth. Within the pattern of this kind of text Warhol's portrait of Beuys embeds the image of Beuys (and it is after all Beuys's image that Warhol works upon) in a pantheon of wealthy and fame-ridden art brats, and this is rhetorical regardless of how true such a suggestion might actually be found to be were it to be socially investigated. It is not just the image of Beuys eyelessly looking back at us but the kind of low-level mirror-effect, and a dark mirror at that, which thrusts the mug-shot back upon us: a kind of symmetry-of-viewing field into which we are pulled. It is at points like this that the status of Warhol's intentions is hardest to piece together in detail, maybe hard even to locate at all. That Warhol had intentions is obvious, what is hard to unearth is their precise status, of which Crow's writing in SD is symptomatic.

Warhol attends to Beuys's image as a kind of Warhol infested contrary to the myths of Beuys's politics. The mug-shot, pallidly lustrous, surveys us unmistakably as a Warhol surface. There is a certain coveting of his own power by Warhol, a power over the image: a currency in the image of Beuys with which Warhol is prepared, in characteristic mode, to play out the advertisement of the power of late capital. The material, diamond-dust, functions as a kind of pin-sticking into the image of Beuys's politics. Here the mug-shot becomes, as we look into the curbed mirror-like surface, synonymously an emblem of Beuys's most familiar political caricature, the hat. The double-brimmed hat, whether fortuitous or not, was fastened on to by Warhol as a device emphasizing his shamanistic view of the manipulation of images. This is Warhol jostling for pole-position against one of the few artists whose aura might possibly match his own. Beuys himself, certainly by the time Warhol made his portraits of him, had, at any rate to large sections of the art-going public, come to represent and embody, mistakenly I think, a certain kind of utopian yearning holding still in a way to some of the old mystifying rhetoric of parts of the modernist canon. Beuys's discourse on

creativity, for example, is very high-falutin'. Warhol himself might well share some of the same tenets, but the remarks he would make about such things would be much more tabloid, perhaps even monosyllabic. Beuys was not noted for monosyllabism. In this portrait Beuys's hat belongs irrevocably to Warhol, should there be any doubt about who wears the crown. The whole image belongs to Warhol, lock, stock and diamond-dust.

Does Warhol convert this image of the alleged radical artist into an umbilical cord of diamond-dust (with the especial proviso of Warhol's fantasy that were it real diamond-dust it would be an image at $5 a carat)?[16] The implication that this image of Beuys is a great gold-loaded madonna of late capital is hard to avoid: a secular icon of the religion of late capitalism, a fabulous surface by proxy, stealthily mocking and unmasking Beuys's political vanities, his anti-capitalist (and anti-communist) quasi-liberal artism. And Warhol's fascination and affection for the secular kitsch of late capital finds a sounding in the proxy status of diamond-dust, which is, after all, ersatz, like imitation jewellery. Warhol, perhaps following his appalling hunches, does not miss a trick in working up this image of Beuys. He absolutely reduces Beuys to an image possessed by Warhol's career. The two-brimmed hat parodies Beuys's penchant for caricaturing himself as a massive public relations exercise, the main constructor of which was undoubtedly Beuys himself. All these Warhol moves set us into an interrogative relation with Beuys's status and reputation, particularly Beuys's political pretensions. There is something in Warhol's moves here in the treatment of Beuys's image that pushes Beuys awkwardly against Beuys's philosophical claims about his own practice; a laconic Warhol detection of the hyper-inflation in Beuys's politically therapeutic claims for art and artistry: for example that hyperbole displayed in the title 'The Free International University for Creativity and Interdisciplinary Research', which Beuys founded with Heinrich Böll in Düsseldorf in 1972.

Across this paragon of late capital imagery (and one meaning of paragon is a diamond of 600 carats or more) Warhol ensures his pithy consumer-leader shadow falls. Equivocal though it may be, the suggestion that Warhol knew Beuys, coyote and all, for what he was, an aura-permeated politico and prominent self-marketer, is not hard to see here. Imaging Beuys in this way is itself consummate Warhol marketing. In the way that Beuys made no bones about how he saw his own credentials, Warhol responds in matching Beuys's projection by imbedding the image of Beuys in a line of highly marketable (literally projecting Beuys's image into the Warhol market) Warhol diamond-dust images – shoes, skulls, etc. It is, after all, at its putative fabulous surface that late capital claims its redemptive and absorptive power – leading us away, saving us from, the dark depths, the capitalist-defined abyss, of the political radicals. Surface is late capital's most transformatory moment, allowing it its slick shiftiness, its fickleness and its fast-moving

dramas. Despite Beuys's frequent disclaimers, his propensity for self-projection, for a theatre of the artist Joseph Beuys, meant he could be nothing but a source of profit for Warhol's sharp eye for fame as commodity. A tabloid headline for the juncture of Warhol and Beuys might be 'Andy shops Beuys'. Beuys's seeming political high principle and goodwill is grist for Andy's late capital mill. The latter is perhaps not the same as The Factory but with hindsight it is its logical historical outcome. The mill ran on a flagrant distillation of the rich and the famous – in the end a genre itself for Warhol. Even if it was to be used only as a technical term it would be difficult to sift the use of diamond-dust free of any trace of Warhol's use of self-flattery in the genre of Warhol's portraiture. As is the case with all eminent portraitists, the attachment of their name, in Warhol the name is especially style, to a portrait is the first exchange of flatteries.[17] Unlike the examples of portraits of other fellow artists, say Hockney,[18] there was in the case of Beuys's image perhaps more for Warhol to play for. Whilst on the one hand flattering Beuys in lining up his mug-shot in the gallery of Warhol portraits, Warhol, on the other hand, had some tricky ideological ground to overpaint, to mark, turning, as I have tried to suggest, upon not so much a historical objective analysis of Beuys's reputation per se as upon Beuys's self-acclaimed radical reputation.

Metaphorically and symbolically, there is a meeting in this portrait of the two artists' respective auras. It takes place in the terrain of Warhol's dark glitz, on terrain of Warhol's own choosing. Warhol is on the late capitalist offensive, rolling Beuys up as an auratic ally. Warhol it seems knew a kindred fame-spirit when he saw one. Perhaps the opportunity really was too good to miss. Warhol as maybe the most famous face of the eighties postmodernist imperium uses his reputation at this stage in his career to do nothing but assert his reputation; and there is an element of black comedy involved in the assertion through imaging Beuys, perhaps some self-disgust too. Beuys's mug-shot is hauled into Warhol's throne room where backhanded compliments are served. Both titles, *Diamond-Dust Joseph Beuys* and *Camouflage Joseph Beuys* (1986), assert the portrait as both surface and guise; both assertions, and a Warhol picture is nearly always an assertion, are designed to envelop and enclose Beuys's reputation, literally his image. Maybe a sign, a portent, of Warhol imposing his will, that much acclaimed will-less will – a battle of the two chief medicine men of contemporary art practice organized by Warhol where the odds (surprise, surprise!) are heavily stacked in Warhol's favour. Warhol is literally pushing (the image) of Beuys around.

Ensouling

[The durable institution of the sign – the persistent availability of the sign for an indefinite number of signifying acts in any possible

> signifying substance ... and the sign must be structurally
> independent of the ensouling act of any present consciousness.
>
> HENRY STATEN, *Wittgenstein and Derrida*[19]

It should perhaps be noted at the start that the 'must' in the quote above is a 'must' of necessity belonging to the structural, logical character of the sign itself. It is not a 'must' of the realm of the ethical 'ought'. It may at first glance appear that Warhol, as embodied in the prominent aspects of his public persona, would have found the idea of the sign being 'structurally independent of the ensouling act of any present consciousness' very appealing. And Warhol made many public pronouncements that may have rhetorically conformed to the idea of meaning-construction as a matter of some such swaggering slogan as the 'free play of the signifier'. Quite apart from the undiscriminating overdetermination of such slogans when they are attached, as they frequently are, to the work of Derrida, the evidence for Derrida's subscription to a canon of Kantian rationalism seems to be there for those who take the care to look, and Staten's book tries to point this out. Warhol, and probably not unwittingly, in embracing the rhetoric that marries the model of the 'free play of the signifier' version of deconstruction to the idea of the designer logos of postmodernism, is nothing if not, characteristically, paradoxical; for Warhol was an indefatigable ensouler. In a strong sense there is in Warhol, as in postmodernism generally, an embodiment of the contradiction that meaning is a matter of consensus and power and, dredged from the romantic canon of modernism, the idea that the artist is a naturally auratic performer. This latter is a fixed and traditional role model for the artist. Warhol played it to the hilt and in so doing had to seek to control, to ensoul, the signs which he developed with which to play out the role.

If we could imagine a Warhol who had not built a public persona so resistant to intellectualism, and who therefore did not have an appearance of anti-intellectualism to keep up, then we might imagine a Warhol who talked in terms of an un-ensouled sign, of the free play of the signifier. Even the Warhol we know might have fashioned some easy-to-carry slogan concerning the virtue of the free play of meaning-building. The Warhol I have just tried to imagine, would, for the Warhol we know, be a person with a far too assertive intellectual self-consciousness. Like many parts of the community in the art world, Warhol was suspicious of intellectuality per se and of intellectual artists in particular. The attraction of slogans such as the 'free play of the signifier' to the postmodernist art world is that it matches that strong residue of the Romantic and Nietzschean idea of the artist as an unbounded will, the artist's will as an unrestrained and unimpeachable creative force. For Derrida, the point is that regardless of our intentions, regardless of the myths about meaning-construction that artists or anyone

else might subscribe to, nobody is omnipotent, even postmodernist artists, with respect to the structural functions of the sign. Assertions that meaning can be made randomly, that meaning should be allowed to coagulate as and where it will, is, in the final analysis, an empty truism. No meaning-producer's intentions transcend the rules for the making of meaning. Tracing the match or lack of match between a meaning-producer's intentions and the meaning her or his product embodies is a matter of careful reading.

So in this wide sense of meaning-construction, the signs of Warhol, regardless of his rhetoric claiming they are unensouled, which was itself a determined attempt to ensoul them, will, in the end, come the presence of a careful enough reader, suffer the same fate as the signs of the rest of us. But, as I have suggested earlier, if the matter of the testimony constituted by the record of his own voice is anything to go by, then Warhol is a believer in ensouling the sign;[20] specifically the signs of his own work. He made as if he could ensoul them, perhaps he believed he could with a sufficiently repeated rhetoric claiming he wasn't ensouling them, investing perhaps in the sheer repetition the hope of control. His much acclaimed honesty, even in its alleged lacerating version,[21] was a largely rhetorical device trying to ensure a match between Warhol intentions and Warhol work. Warhol, perhaps, and his work more clearly, were used by the framework of postmodernist theory (if it is theory!) as signs in themselves, a kind of talisman against the incursions of what are seen by postmodernist 'free play of the signifier' adherents (of which there are many, using it as a flag of convenience for sailing under the slogans of opportunism and pleasure) as over-zealous meaning-probers. Isn't Derrida's point that signs (semantic/syntactic rule-bound systems) once realized in the form of writing or, for example, painting, and once released into the relations of distribution and conditions of reception, in whatever potentially readable form,[22] will be subject, with a careful and meticulous enough reading, to the structural constraints of these rule-bound systems, and that such uncovering may reveal that these texts do not say what their producers intended them or think them to say? It is not a matter of signs being asserted as completely malleable entities purely at the mercy of the will of their users. The myth of the unbounded will of the artist is part of this general misunderstanding of notions such as 'creativity'. Derrida is carefully pointing out that the context of use of a sign is accountable and can, with a careful enough reading, often be accounted for in terms which override, outreach, evade and sometimes contradict the stated or implied intentions of their producer. And, it is worth remembering, these intentions, whether stated openly or implied by context, will be necessarily subjected to the rules of the use of the signs of which the intentions are themselves constituted and formed.

How far, for example, a painting will offer within itself signs of the intentions of the producer is critical here, although searching paintings for

signs of the intentions of their producer is conventional for reading artworks. Doesn't Crow claim to be drawing out from the 'Disaster' paintings signs of the intentions of a back Warhol as being different from those of the front Warhol? Or is he perhaps suggesting that the 'Disaster' paintings can be made to by-pass large parts of the then current Warhol soliloquy insofar as this can be read at all as an indication of Warhol's intentions? Does a term such as 'the imagination of pain and suffering' perhaps include, but certainly outreach, the status and scope of Warhol's intentions? My differences with Crow, as I have tried to state already, rest primarily on the case as to whether the signs in the 'Disaster' paintings can be extricated in quite the way Crow appears to me to want them, or certainly needs them, to be in order to make his argument work. In the matter of the testimony of Warhol's voice, it seems that Crow and I are both sceptical. But this does not in itself constitute a sufficient condition; it may, however, be a necessary one, guaranteeing the division between the 'images of catastrophe' and the 'images of consumption' that I think Crow's argument requires.

There is a clear case that whilst Warhol deployed the resources of a telling self-mockery to their full effect in gaining influence upon a channel ensuring a strong control of those meanings of the work which he wanted to enforce, it does not follow from this that as this control comes to break down, as the attempt at ensoulment falters and starts to fall away, the meanings that emerge run counter to the direction of Warhol's fascination with the consumer panoply of late capital. It does not seem to me to follow that such meanings are critical of late capital. In toto, Warhol losing control of the meanings he imposed may in fact allow us to see an even more transparently uncritical bewitchment of Warhol by late capital than the one now conventionally accepted. The notion of the relation between Warhol's intentions and Warhol's beliefs is perhaps of some import here. Therefore, despite Warhol having often talked as if his purposive behaviour was non-purposive (his talk of machine-like production, of accident etc.), that behaviour which constituted his practice was highly controlled, and points to a fascination with late capital far past that posited by the testimony of his voice. And, it seems to me, this bewitchment runs nearly as clearly in his early work as in his later work. Warhol incessantly predicated beliefs and intentions (his diary, if it is itself to be believed, is a record of this predication), and this predication in turn presupposes a person who to a considerable degree believes himself, despite, as I have repeatedly said, his rhetoric to the contrary, in control of his thoughts and actions. It is perhaps worth remembering here that we all predicate beliefs, intentions, etc. in order to ascribe the cognitive and affective attitudes of people, including our own. Warhol in his diary, for example, does a lot of this. Warhol sophistry, then, should not fool anyone, but seemingly it does, and this apparently led by Warhol having fooled himself so often.[23]

So the framework of belief and intention in respect of Warhol might be mapped in something like the following way – I repeat once again: there seems little doubt that Warhol, in a strong public sense, contrived to control the public reception of his work through those same rhetorical moves by which he built up his persona, of which one central contributory factor was a frequent assertion that he was not trying to control, or could not control, the meaning of his work. In the construction of this persona, Warhol was a believer. He believed, for example, that it was worthwhile endeavouring to be famous and glamorous, to have kudos, and these aspirations he posited on a carefully unproblematized set of beliefs founded upon the conventional modernist notions of 'creativity', 'expression', 'self'; those mythic phenomena which have generated such absurd claims about artists and their work, not least by artists themselves. From at the latest very early in his career Warhol was aware that it was in what he defined as his self-interest to help promote, fortify and expand exactly these myths. He knew them to be problematic and developed a sense of irony accordingly, but it was not an irony attempting to corrode them, it was an irony designed to increase their seductively populist attraction. In the above, I enter the qualifier 'very early in his career' because I suspect, although this is harder to sustain since before his 'career' is a time not so fulsomely documented, that a self-obsessed preoccupation with the interests of, and admiration of, the kind of society on behalf of which such myths are promoted may have been a primary motivation for Warhol becoming an artist. It would then follow here that there is the matter of the relation between motivation, intention and belief.

In the present context, we might note the following. The notion of a belief is interlocked with the idea of respecting the notions of truth and evidence. If a person says he or she does not care whether what he or she believes is true or not, then it is very hard to see how such a person could know what it is to believe, since to believe is simply to hold something to be true. In one sense, Warhol is associated with, and associated himself with, the idea that habits of enjoyment and release are the opposite of habits of intellectual scrutiny and inquiry. It is in this way, therefore, that Warhol became the artist most associated with the apparatus of commercial entertainment and consumership. I am prompted again here by Tom Crow in another article, writing that Meyer Schapiro stated 'In the hands of the Avant-Garde, the aesthetic itself is identified with habits of enjoyment and release produced quite concretely within the existing apparatus of commercial entertainment and tourism.'[24] Included in Warhol's rhetoric of controlling the meanings of his work was what was to become one of his most famous rhetorical ploys, that of asserting that important parts of his process of production were a kind of 'machine production' constituted of alleged 'stupid' or 'blind' elements doing non-intentional, non-intelligent things.

So the rhetoric of control was a rhetoric also of enactment, in the sense of

this rhetoric enacting a disguise of the actual enactment of his practice.[25] The suggestion of disguise seems to suggest an intentional act, an intention to disguise. This perhaps needs qualifying. It seems that Warhol's intuitions were often long-reinforced hunches which had been worked with as early as he launched upon his career as an artist, seemingly not reflected upon at any great intellectual length, maybe because such a substantial reflection posed some ethical problems the formulation, let alone the facing, of which Warhol may have found unacceptable. Late capital likes an unimpeded business agenda. There are some tricky ethical pathways here but Warhol was perhaps interested in disguising these issues not just from himself (and we may never fully be able to determine the extent of his self-deception here) but also from the view of the receivers of his work. The careful, softly drummed svengali effect of his relentless persona-building was the rhythmic substance of this disguise. It is not so much that Warhol's rhetoric disguises the work as the opposite of what it appears to be (it may be that Crow is arguing this of the 'Disaster' paintings in SD), but rather that the rhetoric is an attempt to restrain the proper critical reception of Warhol's work as the counter-revolutionary artist par excellence.[26] Warhol revelled in disguising his counter-revolutionary warrant. He was the hard-man of ironic glamour, spangled and fêted throughout the late capitalist world; buried in a depthless jargon he seemingly endlessly reproduced, a mythic projection of both work and persona. He talked about himself a lot. The notion of disguise, of camouflage serving to acknowledge that Warhol fell for his own rhetoric. His rhetorical resources included the bottom line insurance that, if the ideological going got rough, he evaded the strictures of the champions of a sterner problematics of meaning by admitting that such denizens of the 'meaning-deeps' might find meaning where and how they may.[27] He was the opposite of Barnett Newman battling it out over the nuances of his titles.[28] Through his unyielding charm, Warhol probably was able to batten down the hatches on the meaning of his work far more stringently for a while than the open and erudite Newman. When faced by the prospect of deep dives into meaning, Warhol invariably pulled some version of the 'simple artist' out of his bag of rhetorical ruses. Disingenuity was never far away when Warhol was forced into this position.

In the main, however, Warhol's distrust of intellectuals did not that often have cause to become evident, since apart from flattering, in one way or another, those he allowed into his ambience, he seems largely to have avoided them. Given the claims both he and others made and make for his work, however, it is inevitable that it will come under increasing intellectual scrutiny.

His rhetorical games were played not only with the specifics of his own self but also, necessarily, with the general notion of the self.[29] Crow seems to make the observation of Warhol's games with his own self/selves the basis for

distinguishing various Warhols. Warhol's moves, particularly the discursive moves which he used to front out his practice and which he increasingly adroitly manoeuvred in his ever developing role as PR front-man of late capitalist art, were fed out as cues by and through which the meanings of his works were interpreted, and, in Crow's case, battled over. If we look carefully enough at this set of strategic and tactical resources, we can observe Warhol continuously placing a strain on the conventional structure of the idea of the psychologically continuous self. In the end, the beguiling game of placing strain upon this notion of psychological continuity paid the enormous dividend of being an image of psychological continuity, a psychologically continuous 'Andy'. Whilst Crow has argued, and through the avowal of the connections between the 'images of catastrophe' and the 'images of consumption', for a psychologically divided Warhol, I would contend that the appearance of psychological division is a necessity in Warhol's plan of himself as an art power game, the primary symptom of a holistic and politically continuous Warhol – the exemplary artist of late capital for late capital. More precisely, this game of bodily continuity (Warhol's body, like that of Beuys, was famous as a body of an artist) embodying psychological branching is a large philosophical issue and rests at base upon the grand question of what it is to be a human being.

Here, then, are important ideological questions vis-à-vis Warhol's position in the culture of late capital. Warhol's career behaviourism was an especially highly projected account of the myths that inform many artist's careers. But his notion of a Warhol self (made up of moves embracing the idea of selves – a kind of multiple Warhol) rests certainly on the idea of what it is to be a human person since he clearly sussed that for him to be a famous person (an apparent mania of Warhol's) required he have an internally and mutually consistent, indefinitely amplifiable individual biography. In apparently questioning the construction of a determinate individual biography by encouraging through his own rhetoric a public rhetoric about him of branching and overlapping Warhol selves, Warhol asserted a manically self-absorbed autobiography.[30] The notion of a kind of super-self of Warhol sub-selves is the consummate marketable gift to the sycophantic gaze of postmodernism: a series of shifting selves, often characterized by the voice of the super-self as no more than pure but depthless surfaces – a kind of metaphor of a society increasingly politically constituted as a series of *façon de parler*. Warhol was intoxicated by this late capitalist talk-world. There can have been, in an absolute plethora of them, few more celebrated late capitalist talkers, including Jean Baudrillard.

But a robust philosophical counter-argument can be mounted, and it is past the time that it should have been, to the effect that our concept of a person is in fact akin to a natural-kind concept; that is, something with a scientifically discoverable nature which explains its behaviour and its

constitution. There is a kind of intuitive certainty that 'human being', *Homo sapiens* and 'person' are coextensive and that the identities of persons, even selves, are precisely equivalent to the indentities of the animals that we are. Warhol's talk of machine-processes always flirted, and in the most politically coy way, with notions of personality transformations, of brain and organ swaps, of the brains-in-a-vat thesis,[31] of free-floating and contingent multiple selves – I guess he saw these kind of paradoxa as risqué rather than passé. It is in this kind of idealist philandering that Warhol takes up position as postmodernist maestro of late capital. The view of the free-floating essential me (which would itself pass as a typical self-serving Warhol slogan) is, whether its defenders at its base know it or not, an intimate confederate of those managerial political and bureaucratic economic systems that treat individuals as transiently and temporally connected desires, manipulable and malleable as occasion and opportunity offer.[32] This notion of transience and mutability can be seen to match a great deal of Warhol's rhetoric. Crow's argument is that it doesn't match the 'images of catastrophe'. I am not convinced. Certain notions of transience (for example, the apocryphal 'everyone should be famous for fifteen minutes') Warhol may have greeted with his throwaway, laconic distancing, but these Warhol assertions may be transfigured to link with the idea of a transience where people have no solidity and no solidarity. Each person is characterized as a constantly shifting scenario where, given the opportunity, he or she should press home his or her opportunity regardless. Such a concern with transience is also a defining characteristic of the late capitalist obsession with surface, and we perhaps should note the irony that there is nothing presently transient about Warhol's legacy. His fame, certainly temporally, exceeds fifteen minutes, and it seems pretty obvious he intended it so.

Against this view, and incidentally the likes of Lyotard have never made it clear whether or not they hold the particular following grand narrative to be dead, is a sense that a person is a living organism with certain limits and possibilities given to her/him, thereby not only anchoring her/his existence firmly in the physical world and biology, here providing the essential link between the subjective and objective conceptions of her/his existence, but also suggesting a natural background against which ethical choices and political decisions may be measured.

Camouflage

Warhol had the *Camouflage Joseph Beuys* (CJB) made in 1986. This portrait might stand as metonym for the whole genre of late Warhol work. Phrasing it like this is to put the notion of genre under some strain, since the term is clearly not being used in quite the way it is conventionally used when we

speak of the genre of landscape or still life. But such was the self-reflexive and self-reinforcing social function of almost any set of Warhol marks by 1986 that it seems to me a not too forced use of the term to refer to Warhol's late work as a genre in the sense that the late work can be seen as a kind of characteristic species, even a literary species. The metonymic function of CJB has two components: first, and particularly related to the late position of the work in Warhol's output, the particular set of marks CJB can be made to stand for a lot of other sets of Warhol marks, for example many other late works. The metonymic function here works in the way the term 'the Crown' might be made to stand for the term, 'the King'. This kind of function might at first appear to rest on a very general, unspecific kind of scanning across a whole bunch of Warhol works. But if the analysis is worth anything, then it surely must be the opposite of this, resting upon hard-won and arduous searching of these late works. This kind of close reading entails an alertness to what by this stage is Warhol's obsessive problematic of surface. By the time he made CJB, Warhol had long been retranslating his earlier moves into more and more and increasingly ossified sets of recognizable Warhol-like marks. His preoccupation with vernacular and consumer materials had become locked up (and my argument with Crow in SD is that this lock-up had begun much earlier than Crow requires in order to sustain his argument) in a historically reflexive conversion of this material itself into Warhol 'marks' as part of that vernacular of consumership. Warhol wanted and intended to become the vernacular itself, not retranslate its materials into a subversive critique of the consumer society. He may have been confused on the matter, thinking that the avant-garde strategies that, for example, Manet had used deploying vernacular material would serve to furnish him with a position in the pantheon.[33] But using avant-garde strategies within late capital guarantees only appropriation, and whilst it is a necessary condition of fame, at least the kind of art fame Warhol transparently aimed for, it is clearly not a sufficient condition, since many late capitalist artists who celebrate late capital have been dependent on avant-garde strategies and it has not served to make them famous. A number of others who are famous are less famous than Warhol.

Warhol realized early that the pattern for fame was assonance in the guise of moves that were conventionally recognized as dissonant. Warhol is the artist of the historical avant-garde bind, endemic since the sixties, where signs of dissonance were ipso facto assonantly read. Put in more personalized Warholian terms, the move was from outside Warhol (the vernacular materials) to inside Warhol's production: the move from a site, say the state of Warhol's work in 1963, when the heterogenous world of vernacular materials was being openly mobilized in the service of the homogenizing, totalitarian threat of Warhol's self-obsession, to the threat realized, and by 1986, at the time of him making CJB, unequivocally realized. At this stage,

one can look as hard as one wants, but the marks all lay out one thing, the presence of the consumer-leader leading. I would have thought by historical definition this could not be a dissonant figure in art.

Let me weaken my argument against Crow's argument in SD. Crow wants to say, or appears to me to want to say, that the 'Disaster' paintings are a critique of the society of late capital – 'the imagination of pain and suffering' – and they are a critique because of the way vernacular materials are deployed in the images. Crow admits the later works became weaker in this respect (the 'cow wallpaper', for example). Certainly artists can lose their way; it happens to many of them. Their work, if it ever had any, loses cognitive and intellectual power. But some artists do find their way again, and lose it again, and find it again, etc. The pattern or law of uneven development is not unknown in art. Crow hardly needs me to tell him this. But Warhol's development is very, very determined. In one way Crow admits this in saying that there can have been few artists who were more dogged and dedicated in attempting to control the meanings of their work. Even if I weaken my argument to the point where I suppose that Warhol in the 'Disaster' paintings is keeping his options open, let us say the work is critical of the culture of late capital, and in specifically formal organizations of material drawn from the vernacular of that society, we would still have to have a very precise way of describing and accounting for these specifics. Crow's arguments are persuasive at several levels because, first, they focus on the pictures they do. The nature of the focus, however, is precisely where the argument starts to falter. Where the argument moves from the 'Disaster' paintings to, for example, the *Gold Marilyn* (1962), where Marilyn's suicide is marshalled as index not just of pathos but of capitalist waste, then the fault-lines in the reading start to show. The particular pictures, the specific formal organizations, are not so clear of a celebration of the media habits and the habits of perception induced by these media habits as to render them unequivocally as examples of what Crow claims them to be.

The problem at base is this: that though they might just possibly be what Crow claims them to be, it is not clear that they are what he claims. This is enough to counter his argument. But the later evidence is strongly against them, unless we are to admit that Warhol achieved them by accident. Since there are so many of them, what kind of notion of accident would that be? We can read them detail by detail, both in their narrative aspects and their formal organization. In the hanging figure in *White Burning Car III* of 1963, for example: how exactly, really exactly, does this part of the spectacle formally articulate a dissent from late capital as spectacle? I am trying here to follow the configuration of Crow's argument. Is it the sheer quality of the reportage – the figure walking by, the suburban house, the fact of it being a street scene? Might it not, this image, this whole image repeated five times and comprising the formal organization of the picture surface, just as easily

be a celebration of the fact that with modern photographic technology we can do this and with modern media technology we can distribute such an image? Might not such a formally organized narrative be a celebration of this recording facility granted the photographer and this access granted the mass audience through modern media? The ghoulish aspects of shock-horror consumership are not clearly demarcated out of the picture by its formal organization. These are to my mind some of Warhol's most powerful pictures, but they do not seem to me to powerfully express a dissent from late capital, rather they might, at least, just as persuasively represent a powerful confirmation of the spectacle of shock-horror, and specifically our comfortable access to it. It seems to me far from clear that they are a dissenting voice against the powerful interests that decide and formulate that access.

The vernacular material of the consumer society had bequeathed Warhol a taxing set of formal problems. How to retain the potency and energy of the signs of the sub-cultures from which he drew his 'subjects' whilst at the same time refining and representing the Warhol he wanted to be. The equation may well be a contradiction. Warhol's early work had balanced extremely precariously on the construction of a history painting, the persuasiveness of which depended a great deal upon the formal means retaining one form or another of the historical drama of the sites from which they are drawn (accidents, suicides, etc.). But what kind of drama was this? A critical or a celebratory history of these sites, of these vernacular incidents, of the vernacular material of which they were constituted and through which they were represented? Certainly this power, the power of the representation of the effects of the capitalist relations of production and distribution of which they are a record, had to be transmitted and retained; this is certainly a necessary condition of general historically powerful representation, but it is not in itself a sufficient condition of that kind of historical account which Crow claims on behalf of the 'Disaster' paintings – the embodying of an 'imagination of pain and suffering'. Here, once again sliding past the logical trouble with such a description that I have tried to suggest earlier in these remarks, it seems to me that these representations are far from clear of the more local historical effect, their use as vehicles to carry the promotional aspects of Warhol's signature, the representation of Warhol as a kind of exemplary producer/consumer of late capital, not just eating at the core of its body politic, but enjoying reproducing it in doing so.

By 1966, Warhol as signature was to be made itself into the material of Pop. By this date, for example, Warhol wasn't even in the same field as Ed Keinholz in the project of using the vernacular materials to sustain a critical history work of the society of which these vernacular materials were products. At the Pop Art Show at the Royal Academy in London in 1990, it was not accidental that Keinholz was so under-represented. The selection showed no real grasp of the political complexities of the issues of

representation in Pop. Marco Livingstone, the essayist in the catalogue, if it is possible, showed even less. Whilst not saying this in quite such a brutal way, Crow's review of the Pop Art Show[34] does make criticisms which are not too far from the ones I make here. Apart from the brief Minimalist Conceptualist period of high visibility between 1965 and 1970, Warholism has enjoyed renewed waves of hegemony, and always market-driven and market-led, right up to the time I write; and apart from a few exceptions, there seems to be a no better critical grasp of its politics now than there was in 1966.

Finally a return to camouflage, to the putative act of camouflaging. As I wrote in the opening lines of this section, Warhol's *Camouflage Joseph Beuys* was made in 1986. It is part of a string of late works all using the device of a kind of designer camouflage, where nothing much is camouflaged. The portrait image, such as Beuys's or Warhol's face, when it is camouflaged, remains resolutely there, its readability clearly deliberately retained. A *Camouflage Last Supper*, a *Camouflage Statue of Liberty* sits in this series, too, so does a picture entitled just *Camouflage* (all 1986). This latter is not an image plus an image of camouflage, where there is at least some notional idea of an image being camouflaged by the image of camouflage – it is a picture of camouflage, not a picture camouflaged. The idea of a picture camouflaged entails, logically at least, that the picture appear to be something other than it is. Conspicuously, Warhol was not trying to do this.

It is at this point when Warhol starts using the formal device of camouflage that I feel I can ignore any intentional structure he may have had in respect of these pictures. The Derridean model can be used here to show just how historically disingenuous Warhol was by the time of the late work. A completely transparent late capital consumer-leader using a guiseless camouflage. Designer camouflage for the market, and the old hoary favourite from 1980 – the image of Beuys's face – thrown in for good consumer measure. An intentionless, depthless (isn't that the outcome of a camouflage which covers nothing?) strategy. Regardless of any alleged intentions he or his acolytes may have attributed to him in 1986, Warhol's structural position vis-à-vis the history of Pop consumership ensured he be maintained as an icon of late capital. Warhol was his own Frankenstein, self-built within the body of the beast himself. He may yet take us all with him but we shouldn't go quietly. His voice still speaks powerfully; we should contest it.

I want to take my leave of these remarks with an image – an image of Warhol, the one staring out at us from the back cover of *Andy Warhol: A Retrospective*. The hair spiked up and out above the melodramatically hard-edged, patched face. The head patterned around by artifices of the consumer maestro, a self-consumed consumer of a society of consumership. The pattern flat, hard and unrelenting on the surface, literally Warhol-surface. An image of late capital completely uncamouflaged.

Notes

1. Ed. Pat Hackett, Simon & Schuster, Hemel Hempstead 1989.

2. Kynaston McShine, ed., *Andy Warhol: A Retrospective*, Museum of Modern Art, New York 1989. The exception to this is Benjamin H.D. Buchloh's essay 'Andy Warhol's One-Dimensional Art: 1956–66', pp. 39–61. All sources on Warhol used here owe a great deal to Ken Hay, my colleague at the University of Leeds.

3. Notable exceptions to this are the writings of Thomas Crow on Warhol and Pop. The article particularly referred to in this essay is 'Saturday Disasters: Trace and Reference in Early Warhol'. There are two versions of this: the first is in *Art in America*, May 1987; the second is in Serge Guilbaut, ed., *Reconstructing Modernism: Art in New York, Paris and Montreal, 1945–1964*, MIT Press, Cambridge, Mass. 1990.

4. See, for example, Mary A. McCloskey, *Kant's Aesthetic*, Macmillan, London 1987, p. 115.

5. Thomas Crow, 'The Return of Hank Herron', *Endgame Catalogue*, ICA, Boston 1986.

6. Ibid. A view apparently nearer to the one I am expressing here, that Warhol's work is that of a counter-revolutionary artist, can be found in Jeff Wall, *Dan Graham's Kammerspiel*, Art Metropole, Toronto 1991. For example, pp. 18–23, 35, 100–101. See also n. 26 below.

7. See, for example, Paul de Man, 'Reading and History', *The Resistance to Theory*, Manchester University Press, Manchester 1986, pp. 54–72.

8. Crow in 'Saturday Disasters' does not, it seems to me, address this issue of ghoulish consumption. The specifics of consumer patterns in Warhol need another set of remarks. I try to address this particular issue of ghoulish consumption in a bit more detail on p. 175 below.

9. See n. 3 above.

10. See Terry Atkinson, *The Indexing, the World War I Moves and the Ruins of Conceptualism*, Circa Publications, Belfast; Cornerhouse, Manchester; Irish Museum of Modern Art, Dublin; 1992, p. 13. Applying the notion of a diaspora in order to characterize the expansions and complexities of art practice, which, in my view, underwent a rapid and particularly volatile series of conjunctions in the last half of the sixties, is an application intending to predicate that the initial waves rippling out from the unstable constellations of Conceptualism were homeless, and sometimes their practitioners intended them to be so. By 1974, most of Conceptualist practice had found its home; it hadn't made a new home, but had drifted back into the temples of the culture industry. The diasporic function lasted perhaps from 1966 to 1972.

11. Crow starts to address the matter of Warhol's reception by late capital, but only sketchily. My own remarks here are also peremptory. Buchloh's article, mentioned in n. 2 above, also touches upon the matter. It awaits a more substantial and incisive treatment.

12. 'Andy Warhol at Anthony d'Offay', *Artscribe*, November 1986.

13. P. 22. See n. 6 above.

14. There is an irony in respect of the economy of diamonds at present, when we note de Beers frantically buying floods of them apparently cascading uncontrolled from Russia as perestroika unfolds its inevitable economic chains of cause and effect.

15. The metaphorical articulation of the notion of a glass–crystal–mirror–precious stone continuum seems to have two main strands. One is embedded in Expressionism, which hooks back into a long lineage to biblical times, and draws material from Muslim architecture, specifically from medieval times. This strand projects forward from early Expressionism into the designs, for example, of glass skyscrapers by Mies van der Rohe.

> In 1959, in an article called 'The Glass Paradise', in *Architectural Review*, CXXV, Reyner Banham drew attention to the work of Paul Scheerbart, pointing out the connection between the proposals of Scheerbart and Bruno Taut and their eventual fulfilment in Mies' Seagram Building. Today this connection seems even clearer; it can be extended to Philip Johnson's more recent glass-faceted buildings, such as the IDS Center in Minneapolis of 1973 with its crystal court, Pennzoil Place in Houston of 1976, and the 'Crystal Cathedral' of The Garden Grove Community Church of 1980. Johnson's inspiration seems to have come not so much from the Seagram Building, in whose design he collaborated with Mies, but straight from Mies' earlier expressionist glass-skyscraper designs.

This is from an article which is a thorough survey of the continuing function of 'The Crystal Metaphor' by Rosemarie Haag-Bletter: 'The Interpretation of the Glass Dream-Expressionist Architecture and the History of the Crystal Metaphor', *The Journal of the Society of Architectural*

Historians, XI (1), March 1981, pp. 20–43. This article was first pointed out to me in a draft of *Dan Graham's Kammerspiel* which Jeff Wall gave to me in early 1986.

With the use of diamond-dust, Warhol plugs not only into this modernist architectural tradition, but more specifically into an older embedded tradition of the search for a fabulous crystal-like material which will transfigure the vista in which it is placed, or upon which it is made, into a transcendental vision. Consider the following extended quote from Haag-Bletter, p. 28:

> The symbolism of transmutation suggested through glass, crystal water, precious stones, and gold in the later middle ages is not only kept alive through its partial secularization in the minnesinger tradition, but is also retained as a quasi-religious, though now highly objective image in alchemy. . . . The basic desire of all adherents to alchemy consisted in wanting to transmute base matter into a noble material, variously simply called the lapis, the philosopher's stone, or elixir vitae. Gold, but particularly the diamond – because of its fire, transparency and hardness – often appear as the specific carrier of this symbolism. For the alchemist the search for the lapis, a kind of personalized Grail, was a mystical quest for gnosis and transubstantiation. Like the Grail, the philosopher's stone of the alchemists is frequently associated with Christ's transfigured body. . . .
>
> In the later alchemical tradition, by contrast, the quest for the Stone of Wisdom is only a symbol of the self, the crystal imagery loses all its earlier architectural dimensions. That is, when the metaphor of transformation, whether spiritual or secular, implies a general social change, it takes on its architectural form, but when it stands for individual gnosis alone the image is reduced to the shape of a stone. Gnosis and immortality, with the lapis as the image of transmuted self, are discovered within oneself, and consequent introspection and self-searching attitudes become the hallmark of the alchemist. Mysticism that was to appeal to the Romantics later on.

16. This notion of a Warholian conversion coincides, but at an apparently ideologically incompatible conjunction, with Greenberg's notion of an 'umbilical cord of gold'; incompatible in the sense that the 'gold' is there to buy and support Warholian kitsch, even if it is 'kitsch' that has undergone the aristocratic conversion of 'low Pop' into 'high art'. The senior Greenberg may, of course, argue that Warhol's work remains kitsch and is not high art at all. The actual passage from Greenberg's 'Avant-Garde and Kitsch' (*Art and Culture*, Beacon Press, New York, 1961, pp. 3–21):

> No culture can develop without a social basis, without a source of stable income. And in the case of the avant-garde, this was provided by an elite among the ruling class of that society from which it assumed itself to be cut off, but to which it always remained attached by an umbilical cord of gold.

In the far more dispersed, but equally powerful ruling class democracy of Warhol's USA, he knew exactly how to match his use of kitsch to locate and enjoy the gold.

17. An outlandish exception to portraiture as this kind of exchange of flatteries and kudos is the Graham Sutherland portrait of Winston Churchill, which Churchill's wife had destroyed.

18. Warhol's portraits of artists like Hockney and Lichtenstein seem to be a standard Warholian exchange of flatteries. Beuys's theatre of aura seems to have provoked Warhol into another cluster of moves in the genre. ¹

19. Blackwell, Oxford 1985, p. 61.

20. The conventional pathway of using the intentions, or alleged intentions, of the artist as a primary source for interpreting her or his work rests in very large part throughout the interpretive community of the art world upon an unproblematic notion of intention. To recognize the philosophical problematics of the notion of intentional structure is to problematize the notion of practice.

21. 'Lacerating honesty' is attributed to Warhol in Marco Livingstone's essay 'Do it Yourself: Notes on Warhol's Techniques', in McShine, ed., *Andy Warhol: A Retrospective*, pp. 63–78. The idea of Warhol exhibiting 'lacerating honesty' seems a little overheated.

22. Reminding us here of Wittgenstein's assertion that if it's a language, then it's potentially crackable – a basic element in the 'private language argument'.

23. The question of how far Warhol is self-deceptive or disingenuous vis-à-vis some of his most trite aphorisms is not hard to locate and measure, but when applied to the whole recorded corpus of his Warholspeak, the matter is more difficult. It raises the question as to what it is to believe in something. See pp. 168–71 of these remarks.

24. Thomas Crow, 'Modernism and Mass Culture in the Visual Arts', in Francis Frascina, ed., *Pollock and After*, Harper & Row, London 1985, p. 241.

25. The matter of Warhol falling so very late in his work to using the device of what I call, later in these remarks, designer-camouflage, a kind of rhetoric of making transparent the attempt at disguise, is a kind of parable of what Lyotard has called the postmodernist condition. Warhol's response to the riddle, to manufacture items which reinforce his market and condone his late capitalist shopping habits, is no more than we should expect of the maestro, or rather of his self-conception of the maestro – the body and blood of Christ with a direct feed into the shopping malls of the Buonaventura Hotel. Warhol making items for a very, very expensive Lourdes, at this stage having both built Lourdes and had it built around him.

26. The notion of a counter-revolutionary artist remains too much of a slogan; it needs fleshing out a little. I mean 'counter-revolutionary' here in the sense of Warhol being on the side of the winner, that's late capital, its patterns of extreme social violence. Warhol was the exemplary artist of the New World Order. His image, though, in terms of the transfigurative power as symbol of late capital, we should say his body-image, was to sanctify his and our views of the virtues of capitalism. The Warhol body as hymn.

In terms of the problem of using the term 'counter-revolutionary' without appropriate discrimination, then the following quote from John Pilger talking to Noam Chomsky is apposite: Chomsky 'believes revolutions bring violence and sufferings' and he argues that 'one who pays some attention to history will not be surprised if those who cry most loudly that we must smash and destroy are later found among the administrators of some new system of repression' (*Guardian*, Monday, 23 November 1992). The figure of Leon Trotsky is not a ghost that lays comfortably in Chomsky's litany here. Even Chomsky, one American whose stance as dissenter can be made to stand in contrast to Warhol's stance as dissenter (the aesthetic dissenter of contemporary USA), cannot sort out for us in any remotely bearable way the utopian hopes invested in the notion of revolution in the West. They seem to be, at this historical juncture, part of the bad dream of modernism, to echo Tim Clark's term; the rest of the bad dream is late capital. Enter Warhol.

27. Warhol apparently loved (I do not use the word lightly here) to mistake arbitrariness for openness.

28. Barnett Newman was famous, or infamous, for arguing at length about the nuances of meaning and the range of reference of his titles.

29. Warhol's rhetoric contrived a great deal from a notion of making publicly visible his idea of the private self, both the inside and outside (the body of Warhol). Both the notion of 'private self' and that of 'private' have to be publicly defined. How we talk about 'privateness' is governed by how we agree, implicitly or explicitly, to talk publicly about it. Many of Warhol's rhetorical ploys – 'there is only surface, there's no inside', the depthless individual, the disembodied maker, the brain as machine, etc. – rely on the matter of us not inquiring into the philosophical problematics of the notion of the self.

30. See above n. 29.

31. Hilary Putnam, *Reason, Truth and History*, Cambridge University Press, Cambridge 1981.

32. All this material, pp. 169–71, owes a great deal to Anthony O'Hear, *What Philosophy Is*, Penguin, Harmondsworth 1985, especially the last two chapters: 'Human Beings' and 'Ethics and Politics'.

33. The best account of Manet's moves here remains T.J. Clark, 'The Bar at the Folies Bergère', in Beauroy, Bertrand and Gargan, eds, *The Wolf and the Lamb: Popular Culture in France*, Saratoga Cal. 1977.

34. Thomas Crow, 'The Children's Hour', *Artforum*, December 1991.

6

Truth and Beauty:

The Ruined Abstraction of

Gerhard Richter

Paul Wood

Canons of Interpretation

It is a curious fact but a significant one that the reputation of the important artist often has ingrained in it an element of instability. Pollock's work, an extreme case in point, manages to be a test case for both adherents and enemies of modernism's subject/surface dialectic. Gerhard Richter is among the most problematic of major contemporary artists: where 'contemporary' is understood to indicate an art whose concerns are formed after – and hence, in some complex but crucial sense, *out of* – canonical modernism. His art is problematic in one sense because of the challenging tensions and complexities running through his unusually catholic output; problematic in another because of the sheer volume of that output, and Richter's eventual assimilation and easy circulation by the mechanisms of international culture; and problematic also because of what has been interpreted as the very *loss* of a sense of 'problem' in his more recent work, that is, because of the restoration of a quality altogether too *un*problematic for these unfocused times.

All interpretations are layered and intertwined, both with other interpretations and with the semantic laminations of their object. At the same time, each interpretation worthy of the name offers a characteristic slant on an aspect of that object, whose density always exceeds its own. It is indeed one of the chief properties of major art that it can sustain manifold acts of interpretation without becoming exhausted or diminished.

No recent oeuvre has been more relentlessly theorized than Richter's. There is no consensus as such. But a significant convergence has emerged among sophisticated interpretations, which emphasize the photographic aspects of his painting, his linked deployment of mechanical or quasi-mechanical techniques, and his constant switching of representational modes, in order to bring out what may be termed the deconstructive force of

his art. Buchloh, Germer and Osborne, to name only three, have produced a family of readings at once mutually challenging and complementary which establish a distinctive register for the comprehension of Richter's project.[1]

Modern art, in the broadest sense, has often made its most significant moves negatively, the avoidance of established convention having been historically *the* avant-garde gambit. This situation continues to hold for Richter, albeit in significantly altered circumstances, and there is no doubt that much of his work's critical force can be traced to a strategy of refusal, to the manner in which it both meditates upon and deploys – in Osborne's words – a 'double negation'. Yet this view, which seems unquestionably appropriate to much of Richter's output between the early sixties and the late seventies, becomes uneasy in the face of that which has been his main preoccupation for over a decade: his late abstraction. In the world of the text, that is, of the prevailing critical argument, this is the worse for the late abstraction, which tends to be deemed problematic in terms of the critical project ascribed to Richter, or assimilable to it only in terms the artist himself flatly denies. Against this, from a position motivated more by experience of the paintings than by commitment to a philosophical thesis they are held to exemplify, it is possible to argue that the late abstraction may require us to modify the prevailing forms of interpretation; that the late abstraction is no less 'negative', in the sense of 'critical', than is Richter's earlier work; and, as a consequence, to reconsider what we take to be the task of art now.

Towards a Pre-history

Richter is a German artist. He is so, though, not in the manner of a Kiefer, a Baselitz, an Immendorf, nor yet a Beuys. That is to say, that neither the characteristic tropes of twentieth-century Germany avant-gardism – expressive, shamanistic – nor the characteristic dramas of twentieth-century German history are inscribed across the surface of his work. And yet it could not be other than German. His work is *of* that history, enabled by its peculiar conjunctures, and in particular by its vantage on the modern.

A central characteristic of Richter's output, remarked by commentator after commentator, is its diversity. Though quite in what this diversity consists is a little less easy to say: he has, for example, at a time of great diversity in the media of art, remained overwhelmingly *consistent* in his commitment to painting. Were it not for the term's archaic ring, it would be tempting to refer to a 'stylistic' diversity. The word, however, is inadequate, even as it points to something of substance. Inadequate, because it is premised on an organic homogeneity of expressive 'residues', of which – it is as certain as anything can be – Richter's work constitutes a profound and extensive critique. Substantial, because, for all that, the diversity functions

between recognizable parameters. However strongly his work may count as a critique of modernist stylistic categories, a 'Richter' remains a 'Richter' as palpably as does the hallmark work of any mature modernist. The diversity remains characteristic of the output of a single author, albeit one whose authorship is unusually faceted.

This is not to say that Richter is a master of disguise, as if he were to don masks, change identities and elude categorization as he slips through the Berlin Walls of the Cold War avant-garde: Pop artist, Minimalist, Conceptualist, by turns, and painterly painter at last – though, once again, there is something in this. It is the self-policed frontiers that posterity, from its aerial vantage point, will surely notice as the salient feature of the terrain known as modernity. When quiet has settled on the modern movement, it will be its barbed wire that stands out against the snow of affirmative culture. And Richter has done more than most to renounce those prohibitions in practice. He has done so, however, while avoiding the descent into eclecticism. Diversity, that is to say, has not made his art any easier or more open. His is a diversity which has the effect of shifting the site of avant-garde exclusivity from technique to meaning, or, more precisely, from technique considered as a thing in itself to technique as generative of meanings. In this sense, Richter has appropriated a feature which hitherto could breathe only in the margins of modernism (one thinks of Duchamp or Picabia) and installed it, credibly, in the centre of a practice of *painting* 'after' modernism. Richter's work has been technically diverse yet has remained concentrated in critical power.

It is, perhaps, the ends to which he has maintained that concentration that remain uncertain and contested. Be that as it may, there is little doubt that in order so to challenge territorial convention, Richter had to be a figure of this 'After': of a condition widely, albeit often emptily, designated the 'postmodern'. In a fundamental sense, he is indeed not-modernist. But this status is far from merely chronological; and whatever it is that chronology has enabled, it would be mistaken to view it as a liberation from constraining modernism. (These works are far from 'free': that may point to their ultimate realism.) The logic of Richter's being not-modernist is multiple. It is historically and geographically determined; he is, in fact, a figure of several 'afters'.

Richter enters the avant-garde arena at a critical moment: a moment when the dominant paradigm (which, by his own testimony, had attracted him *to* the avant-garde locale) was breaking up. No less critical a matter is where he enters that arena from. He enters it, of course, from the East.

Little is documented at present, too little for any definitive account of Richter's development, of that half of his life which preceded his entry into the Western avant-garde in his thirtieth year: a period of over a decade of early adulthood in which he first studied and then practised as a professional artist in the force field of the doctrine of Socialist Realism.

The early years of Richter's life as an artist, in the newly-formed German Democratic Republic (DDR), were years of the second phase of Zhdanovism. After the war, the demands of the Popular Front in respect of Western liberalism no longer had to be satisfied, and Socialist Realism was reinforced. In Germany, this combined with de-Nazification to underline a rejection of the avant-garde, which, it should be recalled, had been identified by Lukács as complicit in the rise of fascism in the twenties. In the post-war period, the sometime Expressionist poet Johannes Becher, now transformed into sub-Lukácsian commissar – and hence opponent of Brecht – was in charge of cultural affairs in the DDR.

Richter began his professional training in the Academy in Dresden in the early fifties. Before that, he had apparently taken the decision to become an artist at the age of sixteen in 1948. He worked as a photographic assistant and commercial artist; also as a scenery painter for the theatre and as a sign painter in a factory before first unsuccessfully taking the Dresden Academy entrance examination in 1951. He was finally admitted the following year.

As to what may have fuelled the sixteen-year-old's desire to be an artist, nothing is recorded, at least in the English-language commentary. One wonders what was his boyhood position in the enveloping ideological structures of the Third Reich, not least in a city once renowned for its left-wing culture. One wonders also where Richter was when, on the night of 14 February 1945, less than a week after his thirteenth birthday, Dresden was destroyed by RAF Bomber Command. Estimates vary, but as many as 135,000 may have died in the firestorm. If comparison is possible in such matters, 78,000 are said to have perished at Hiroshima. The severity of the situation prompted Churchill himself to suggest a policy review, 'otherwise we shall come into control of an utterly ruined land'. In the country as a whole over half a million German civilians were killed, and at the war's end a quarter of the population of what had five years earlier been the most technologically advanced country in Europe were without water or electricity. Dresden was occupied by the Russians in 1945. Richter later learned Russian at school. Whatever else it is, this is a highly distinctive constellation of conditions for a child beginning to be attracted to a life in art, and one uncommon indeed when set against the characteristic experience of his Western contemporaries.

The general cultural 'thaw' in the Eastern bloc after Stalin's death in 1953 was particularly marked in the DDR. Soviet models of Socialist Realism were no longer directly emulated, and selective passages of pre-Nazi German tradition began to be revived. Under the sway of the Lukácsian critique of Expressionism, first articulated in 1934, the post-war recovery of modern German tradition in the DDR tended to foreground those artists who had somehow maintained a form of committed socialism or anti-fascism, or had been persecuted for doing so, rather than the Expressionist artists who were celebrated in the West as the exemplars of the German modern movement:

that is to say, the left-wing groups of the twenties such as the Red Group and the ARBKD, and their remnants who survived in internal exile during the fascist period. Only committed left-wing masters of the avant-garde were permitted exposure. Richter has mentioned Picasso, Rivera and Guttuso; one may presume Leger too; though what, if anything, there was of the impact of Heartfield, Grosz, Beckmann or Dix (still then himself in Dresden) remains unclear.

In the fifties, Richter worked as a public artist in East Germany under the overall aegis of Socialist Realism. (A mural in the Museum of Hygiene, in Dresden, has been mentioned in the literature, though none of this early work has been illustrated in any Richter publication known to the present writer.) His training had equipped him with a traditionally grounded technical mastery which would have been unusual in the West. This was rooted, also somewhat idiosyncratically from a Western point of view, in the manner of the German Romantics, notably Caspar David Friedrich. Into this matrix he had assimilated what he could of Picasso and other gleanings from a selective acquaintance with the avant-garde. More to the point, he began to be struck by the impact of post-war American art, which he first encountered at Documenta in Kassel in 1959. According to his own testimony, it was the example of this work with its apparently endless and confusing potential, allied to the light which it suddenly threw on the relatively restricted nature of his situation as an artist in the East, that impelled Richter to move to West Germany. He arrived in the Federal Republic in the early summer of 1961, a matter of months before the first Berlin Wall put an end to such excursions in August of that year.

In brief, sketchy though the information is, the condition of Richter's entry upon the space of the Western avant-garde was a significant determinant on his subsequent intervention in it. He was not particularly young, nor was he in any sense uneducated in art when he enrolled at the Düsseldorf Academy in 1961. This relates both to his somewhat archaic technical accomplishment, and to an ingrained conviction of the centrality of painting, to its historic status as a site of critical cultural and moral agency: for example, to its position as a public forum, situated in history, which in the West the development of the avant-garde had done much to etiolate and problematize. In Düsseldorf, Richter encountered the effects of this development in the form of the anti-art legacy of Dada and contemporary developments such as Fluxus. Thus his situation was marked, on the one hand, by the fact that he had entered an avant-garde in crisis, which precipitated the widespread search for radical solutions that afforded the peculiarly open space of the next few years; and, on the other hand, by his own particular condition of having entered that situation not as a neophyte but as a relatively mature artist armed with a philosophy of art which accorded it a profound social significance yet was at odds with its actual significance in the new world to

which he had committed himself. In his subsequent career, Richter could be said to have worked through that historic problematization of painting, without ever having lost a conviction of painting's enduring importance – a course which enabled him, by the eighties, to measure up consciously to what he himself described as the 'enormous, great, rich culture of painting'.[2] The point being, of course, that for the majority of contemporary practitioners and commentators alike that tradition had by then lost its force. In what might be termed orthodox postmodernism, the technical and expressive strictures of modernism were abrogated, but the past re-appeared as little more than the source for an eclectic plundering rooted in a *contemporary*, largely media-informed, consciousness. Richter's enduring commitment to the importance of art and its potential powers to the good gave him a very different sense of the relation it was necessary to have with history.

Painting against the Odds

Richter's first work in his new situation, or, more correctly, that which he chose to accord the status of number 1 in the Index list which he began to compile of his new work – and which remains unbroken to the time of writing – was *Table* of 1962. He later confirmed that *Table* was by no means the first work to be completed in the West. Its primacy was logical: the first work which he saw as signifying his independent oeuvre. As in the comparable case of Jasper Johns, however, who destroyed all the work which preceded his *Flag* of 1954 (barring a few pieces which had already passed into other hands), traces of the old remained ingrained and generative upon the new. Past experience, allied to a sense of the capacities of art, conferred a unique identity on the work Richter was to produce – simultaneously extraordinarily free of a sense of inherited avant-garde protocols and unusually committed to that which the new avant-garde was strategically undermining: the primacy of painting.

It is the former aspect, the relative heterogeneity of his output in the first two decades of his time in the West, that has been used to underwrite the prevailing critical reading of Richter's work: a heterogeneity which is expounded with reference to certain key themes of contemporary theory. These include the concept of the death of the author, derived from Roland Barthes and Michel Foucault, and the notion of difference, associated at least in part with Jacques Lacan and Jacques Derrida. The former is taken to bear upon the distance between Richter's work and a notion of self-expression, of the artist as an expressive author, expressive of psychological urges internal to his centred self, peculiar to that self. The latter connects to the critique of originality: the claim that by manipulating images which exist and mean before his manipulation of them, he is engaged in a process of circulating,

185

altering and deferring meaning, a process in fact of refusing the notion of fixable meaning.

The effect of these readings, by commentators such as Benjamin Buchloh and Stefan Germer, is to align Richter with a Duchampian counter-modernist tradition, wherein modernism itself is seen as pre-eminently defined by concepts of originality and expression. Buchloh argues that Richter is engaged on deconstructing the rhetoric of painting. Germer, for whom Buchloh's conception proves 'insufficient',[3] interprets Richter's abstract paintings as allegories of 'the difference between experience and its representation',[4] invoking Paul de Man as he does so. In both challenging and developing these views, Peter Osborne has offered a reading of Richter's work indebted to Adorno. He perceives it as a 'double negation' of its two constitutive practices of painting and photography. That is, he views the core of Richter's achievement as an avoidance of the consequences of upholding either over the other. Instead of the idealism which would result from attempting to transcend the uncertain state of contemporary painting, Richter's art is taken to 'register' that condition.[5]

What appears to be established and shared by these otherwise distinct readings is a sense of Richter's project as a refusal of two linked stereotypes: the protean modernist artist, and the aesthetically autonomous modernist artwork. The relative security of these views appears, however, to have been challenged by a developing tendency in Richter's work during the eighties which is quite widely perceived to have marked a new emphasis. It is an open question as to whether this emphasis undermines the critical achievement of Richter's art, or to what extent it points to a need to rethink it.

Between 1962 and the mid-seventies, Richter produced a range of works which for convenience have been divided into two generic types: 'photo-paintings' and 'constructed' works. The former, figurative, works operate in a no man's land between Socialist Realism, German Romanticism and American Pop Art and have, perhaps, provided the principal fuel for the discussion of what it is that Richter has effected as to the relationship of art and photography in the contemporary period. Insofar as photography, with its outcrops into the mass media such as newspapers and television, constitutes the dominant form of our societies' visual culture, and insofar as by so doing it usurps many of the traditional functions of art, Richter's photopaintings have proved uncommonly resonant. They have done so, moreover, because of a quality which singles them out from their apparently near neighbours: their effect is not in fact anything like that of either Socialist Realism or Pop Art, both of which, to generalize, tended to be uncritically affirmative of the surface manifestations of their source cultures. Richter's photopaintings, that is, seemed able to support the critical weight they were asked to bear: unlike Socialist Realism and – some – Pop Art, they do not require of us an attitude of assent to what they picture. Arguably they

achieved this through a consistent obliqueness and melancholy produced by their expressive properties as paintings. These seemed to impose a quality of the tragic on the unremarkable debris of what was then, it is important to recall, still an expansive system. As the Western cultures entered depression, what at the time often condemned Richter to being seen as a somewhat backward and provincial variant of metropolitan Pop, instead looked like a prescient insight into the uncertainties, alienations and less than happy anonymities behind the modern surface. In a manner which paralleled some of Warhol's work of the sixties, the buildings, the sexual relations, the way we saw ourselves in the mirrors of the media all came out as slightly grubby and mundane and not at all as harbingers of a brave new world of confident consumer capitalism. The sophistication of the philosophical commentary notwithstanding, it is the evident seriousness of Richter's eye which has made all the critical effort worthwhile. Somewhere in the narrow space between the selection of a news photograph or a picture postcard and the act of painting it as unsparingly as possible, a consciousness entered in: and it is no easier now than it ever was to say how that happens. Lucubrations on the relative status of photography and painting, on the critique of originality implicit in the appropriation of the photograph as readymade, on the always mediated quality of experience in contemporary culture, and so forth, miss something important if they fail to acknowledge that Richter's paintings remain haunting and convincing: even when their ruling concern appears to be a form of the absence, or structural occlusion of the possibility of, conviction in our lived existences.

The 'constructed' works, though they often involved some photographic element, seemed on the whole to be bent on a more reflexive investigation of the problems attendant upon adequate contemporary practice in the arts, particularly painting. Yet at a time when the critique of modernist painting mounted by conceptual art drew *in principle* upon variant modes of representation, there seemed to be something perverse, and even restricting, in Richter's adherence to painting as his vehicle for the interrogation of painting. Once again, he has had the last laugh, and what seemed like a limitation can now be seen as a principled resistance to fashion and the rigorous imposition of a consistency without which the whole project might have escaped into Babel and arbitrariness. It turned out, in fact, to be this stubborn turning and turning again, this gnawing almost at the necessity to keep on painting when painting was impossible, which indicated an exit. This squaring of the circle, which was not at all a purely cognitive matter, offered a route out of nihilism without the bogus spirituality attendant on the greater part of that much-vaunted 'return to painting' which came to mark the transition from the seventies to the eighties.

Of particular importance were a series of grey monochromes, involving differences of tone, texture, size, method of paint application, etc., produced

in the mid-seventies, of which Richter has said that the grey stood as a 'sign'. Representative of conceptual, and perhaps emotional, exhaustion, the grey offered the possibility, so to speak, of action without acting, of content without positive substance, of utterance without affirmation: of painting without painting. It stood for the 'epitome of non-statement', as the 'only possible equivalent for indifference, for the refusal to make a statement, for lack of opinion'.[6] Plunged into this somewhat stereotypical ideological and affective void, however, Richter remained alert enough to make one key insight, the insight which, arguably, provided the springboard for his subsequent development. The 'sign' had a material aspect. 'Grey-ness' could only be *meant* by some particular grey, and grey-in-general as sign always differed from the particular grey-painted surface. Out of this physical excess or remainder, something else was precipitated, as it became evident that the various grey surfaces differed *qualitatively*.

Paradoxically, out of the differences arising in a series of particulars, a new possibility of generalization was won. The importance of this is that it signified the possibility, although at first only the possibility, of a renewal of a form of painting which could carry conviction. This is not to say that the stringent scepticism which underpinned Richter's earlier employment of the photograph and his refusal of painterly painting were mistaken. To the contrary, it is such a belief which disables 'new spirit' painting, failing as it does to address the ruination of the metaphysics of art, effected first by modernism upon the classical/naturalist heritage and then latterly by Conceptual Art upon modernism itself. Rather, the point is that the ruins had to be worked through. The possibility of conviction in art had to be won anew through particularity, and not through philosophical generalization (let alone curatorial wishful thinking). In Richter's language, by the mid-seventies, the prohibitions which had earlier deemed the very ascription of meaning, even the simple act of naming, as 'inhuman', had given way to an engagement with notions of 'commitment' and 'generalization', even of 'truth' and 'freedom'.

Not that this happened overnight. Richter's first move, as it so often seems to have been when he got on to the track of something new, was not to strike out in some completely unrelated direction, but to reverse the terms upon which he was already working. In the present case, this meant deliberately introducing colour and gesture. In 1976 he began to try to paint a series of small-scale coloured abstractions, which resembled 'gestural' or 'expressive' abstract painting without appearing to mobilize the characteristic claims to self-expression or originality which conventionally attach to such work in the modernist canon. It was as if the codes of expressive abstraction were being put between quotation marks, an impression which was reinforced when Richter went on to enlarge the small sketches photographically, and then to re-render them mimetically on a large scale: as he might have done earlier with a found photograph.

One can only speculate about the informing intentional framework of the first abstract sketches. It is possible to rule out any unreconstructed first-order sense of abstract expression, insofar as Richter's previous practice had amounted to a refusal of precisely that. Rather, Richter seems to have set about covering a surface with a series of marks in a way which 'worked', without following any methodical process, or employing symmetry, almost as if he sought to replicate a convincing abstract painting but by starting from the opposite end: by replicating the appearance of the generic type (rather than experiencing some emotion and 'expressing' it according to painterly codes), and then seeing if, so to speak, the conviction worked 'backwards'. As with much of Richter's output, it seems to have been animated by a spirit of 'Why not?', carrying it as far as possible, and seeing where that left one. By the mid-seventies, according to the dominant paradigm, painting abstractly had become as impermissible as earlier, in the heyday of Abstract Expressionism, painting figuratively had been. In both periods, there was a compelling reason for breaking the protocols – and that seems to have been to continue to win for painting as intensive a cultural presence as possible. It is plausible that, in the mid-seventies there was nowhere else for Richter to go than into the degraded and unpromising territory of abstract art, having pushed his version of its two main contestants (namely, Pop Art and Conceptual Art) to the point of the virtual implosion of his signifying practice. As ever the problem was to find a way of, in practice, answering the question 'How'? This he did in the directest possible way: by holding in his mind some sense of what abstract paintings were like, and painting one; and then another; and so on until one worked. 'Worked' here cannot mean anything other than 'succeeded aesthetically'. What aesthetic success might mean after modernism, however, is a difficult matter to determine.

Clearly this question is not confined to Richter's work, though it is raised there with particular urgency. In a broader sense, what is at stake is an account of art since the sixties, and in particular since the tri-partite critical point of the late seventies: the point at which anti-modernist conceptualism as such became exhausted, when a restorationist and in effect pre-modern 'new spirit' emerged in painting, and when an avowedly 'postmodernist' cultural practice dedicated to intervention in the social discourses of class, race, gender, and indeed of culture itself, became consolidated. One of the critical areas here concerns the governing assumptions of contemporary theory, especially as regards modernism itself. These include an identification of modernism with 'traditional aesthetics', and a perception of such aesthetics as, in the last analysis, being aligned not with the critique of modern capitalism (which is seen as having been the task of the historical avant-gardes in the field of culture), but rather with what Marcuse called 'affirmative' culture. That is to say, artistic late modernism in general, and particularly its art-critical annexe, are identified with the ideological

support structures of contemporary capitalism. As such its claim to critical virtue is seen to be forfeit, and to accrue instead, first to modernism's historical opponent, that is, to post-Duchampian Conceptual Art; and then to its supposed descendants in the expanded field of representation.

Conceptual Art and its cognates, indeed the tradition of the readymade before that, had seemed to abrogate the aesthetic. This is not to say that Duchamp was not himself an aesthete par excellence (for his dandyism and fastidiousness were pervasive: it is hard not to feel that his critique of painting was largely motivated by distaste for its artisanal vulgarity). Nor is it to say that decisions of taste did not enter into the installations of Conceptual Art. But the question of the aesthetic judgement as arbiter of success in art seemed to have been suspended by such work. Buchloh has sketched, in somewhat caricatural form, what one may take to be a sceptical rendering of the aesthetic disposition. He pictures a time when 'gesture could still engender the experience of emotional turbulence', when 'chromatic veils conveyed a sense of transparency and spatial infinity', when 'impasto could be read as immediacy and emphatic material presence', when 'linear formation read as direction in space, movement through time, as operative force of the will of the subject', when, finally, 'composition and successful integration of all of those elements into painting constituted the experience of the subject'; this, he says, is a 'memory of the past of painting'.[7] Osborne has concerned himself as to whether Richter's late abstraction is an 'act of painterly re-appropriation', offering a 'merely affirmative celebration of the possibilities of paint', one assumes of the kind described by Buchloh. Such a move would court 'the reinstitution of a traditional notion of the aesthetic object', which Osborne holds to be the main problem which art after Conceptualism has to avoid.[8]

The principal motivating factor behind such expressions of distrust in the aesthetic appears to be its implication of universality coupled with its requirement of disinterest. The concept of the *interestedness* of knowledge which became hegemonic in the wake of structuralist Marxism and the relativist conceptions of scientific knowledge that achieved a paradoxical symbiosis in the seventies, linked to the practical critique of Conceptual Art, led to widespread scepticism about the very possibility of the suspension of investments in decision-making of any kind. This was reinforced by a feeling that the suspension of practical questions demanded by the exercise of aesthetic judgement was used by (institutionalized) modernist criticism to legitimate the systematic occlusion of questions of practical, social align-ments on the part of the institution of art. It was widely felt that this amounted to a legitimation of the status quo and a disqualification of radical cultural practice on the grounds that it was reimporting extraneous matter into the autonomous practice of art; which orthodox theory held to have been the achievement of modernism to expunge. The force of this criticism

was redoubled by the more or less simultaneous emergence of revised conceptions of human subjectivity itself, along the fault-lines of gender and race. The central claim is that the acknowledgement of gendered (etc.) subjectivity acutely problematizes – to the point of remaindering – the aesthetic judgement, insofar as this latter is held to involve a universalization of response under the requirement of 'disinterest': namely, the shedding in aesthetic judgement of contingent interests such as those accruing to one's class, race, gender, etc.

There seem to be two important orders of question which have arisen to problematize this refusal of the aesthetic. The first is that such notions have themselves attained the status of widespread and institutionalized convention. They have become, as it were, the intellectual property of an influential layer with its *own* institutional interests to defend. Oxymoronic though it sounds, a 'radical orthodoxy' has devolved, for complex reasons not unconnected with deep conservatism in the wider social sphere, in the institutionalized productive sites of contemporary culture, 'after modernism'. Like all orthodoxies, this one is susceptible to the bad faith which accrues from the pursuit of its own strategic interests and the marginalization of others: the more so insofar as this ranking is performed under the aegis of unquestionable assumptions of emancipatory virtue. When management comes to conceive of itself as radical, extreme and paradoxical counterstrategies may be required.

The second concerns the consequences of the refusal of imagination implicit in many of the normative claims for differential subjectivity pervading the field. It is, after all, an important question as to whether instrumental interests and partisanship *can* be bracketed. If they cannot, the consequences would seem to be serious insofar as we are thereby condemned to be the creatures of our variant accidents of birth with neither the hope nor the desire for their transcendence. We are literally the prisoners of our skin, our size, our shape and our place, robbed of the possibility of sympathetically imagining the legitimate demands of the Other. This Hobbesian destiny is presumably far from the programme of those concerned to articulate difference. None the less, a prohibition on the exercise of disinterested aesthetic imagination can only have them as its consequence. To deny the possibility of art to sharpen and extend the sense of self in the name of a set of instrumental injunctions to behave in an ethically and politically correct fashion seems a pyrrhic victory for the sponsors of a radical cultural practice.

On one view, then, the dominant one, to entertain a notion of the aesthetic is to reinvest a discredited modernism and all that allegedly goes with it in terms of a mystificatory philosophical idealism and an ultimately reactionary politics. An alternative view might hold that the most assiduously canvassed alternatives, namely a restorationist 'new spirit' painting and an interventionist cultural radicalism, are in fact symbiotic.

Both miss the point of Conceptual Art, and mark a retreat from the ultimate demand left after Conceptual Art's cleaning of modernism's Augean stables: namely, for a renewed aesthetic, a renewed sense of the grounds of art's independence. It is perhaps worth making the point that in the wake of the critique of modernism, the notion of the autonomy of art has been widely misunderstood. It is not a synonym for *l'art pour l'art*. Causally, art is made from responses to everything. There are no limits as to what may or may not be germane to the production of a work of art. In its effects, however, the successful work of art will achieve independence; that is, will not be translatable without remainder into other representational codes. It is the mark of art with ambition to be more than cultural symptom that it addresses the question of what it is to make – or to re-make – an aesthetic totality. As Clement Greenberg himself remarked, of the most pared down Mondrians of the thirties, consisting perhaps of no more than two black bars: 'when it works, there's a world of experience there.' And he then added: 'it's not by accident, either'.[9] 'Post'-modernism notwithstanding, some such sense of purposive effort deployed to the end of achieved totality, which in turn becomes the object of contemplation for itself and which, *as such*, has implications for the conduct of the perceiving subject, still seems close to what the business of making art, as distinct from anything else, is.

Recovery of a Critical Aesthetic

The quintessential experience of late modernity in the West is one of rampant technological development in a murderous embrace with social stagnation: half of our sensation is of being whirled down the rapids, half of being stuck in the mudflats. It is less a sense of particular crisis which seems to matter, in this or that area of social practice, than of the twentieth century's vision of the future being systematically voided. The question of imagination therefore becomes paramount. According to the not unfamiliar avant-garde logic of dialectical inversion, wherein the forcing of a strategy to its limits gives rise to work on a different and apparently opposed order of problem, Richter (and perhaps a handful of other artists) passed through the looking-glass of critical practice and found himself in a world the aesthetic had never abandoned. The point, difficult though it is to establish, is that the repressed aesthetic dimension includes or incorporates that challenge to 'expressive' aesthetics effected by the critical practices of Conceptualism and its cognates. This is a historical logic, inseparable from wider social, political and economic developments since the sixties. The aspiration to cultural fusion, to the sublation of art into life, is one thing in circumstances where social transformation is or appears to be a realistic possibility. It is quite another in circumstances of deep fissure and uncertainty in the transformational

project. Whereas for Alice passage through the glass gave on to a world of fantasy, here it was the fantasy of cultural radicalism which was left behind for the reality of practice in a darkening circumstance.

The relations between an exercise of critical imagination and tactical intervention, between idealism as wishful thinking and utopian modelling, make for a shifting landscape. In this world of mists – our present life perhaps – one thing only is, paradoxically, certain: that the claim to certainty rings hollow. It is precisely the clash of moral rectitudes, their cognitive undecidability inseparable from their experiential poverty, that reinstates engagement with the aesthetic as a critical necessity.

It is entirely apposite for Buchloh to point to the lack of realism which characterizes attempts to reinvest traditional naturalizations of the relation of pictorial signs and emotional referents. The legitimate target of this criticism is, however, not signs per se, but signs taken for wonders. The resumption of authenticity is bathos. But this does not mean that pictorial signification is nullified in perpetuity; nor that the forms of such signification must forever lack aesthetic effect. Richter's late abstraction re-constitutes aesthetic totality *from* the ruin of modernism. It compels conviction because, rather than pretend that the ruination never happened, it is made *of* that debris, that negation. In this circumstance, the charge of a decline into 'affirmation' in the Marcusian sense appears misplaced. For an aesthetic built upon the critique of authenticity, what is affirmed is less the culture of expressive authenticity itself than the requirement of criticism. But equally – and this is where the challenge occurs – what is also affirmed is the insufficiency of mere criticism, of mere cultural intervention. Cutting against the grain of sociologism, Richter indicates the 'mereness' of contingent history. Much is therefore at stake, insofar as the historically contingent is in one sense all we have. 'The world is all that is the case': that is to say, not heaven and earth, but earth alone. Historical materialism, the pre-eminent theory of the earth alone, has repeatedly been enlisted in its vulgar forms to underwrite scepticism of the ineffable. Fear of the aesthetic, however, is ultimately nothing more than a tacit admission of fear of the tests of one's own experience: preference is no respecter of propriety. Evaluation is both a kind of psychological constant, in its continual occurrence, and a rogue element in its unpredictability. Historical materialism thus requires an aesthetic dimension insofar as the latter is integral to the sense of what it is to be an embodied being; and embodied consciousness cannot be adequately represented while shorn of its evaluative aspect.

In the sixties, Michael Fried controversially distinguished between an art which 'compelled conviction' and works which merely solicited attention on the grounds of their 'theatrical' presence.[10] For Fried himself the latter category included much of what has subsequently been deemed the most interesting art of the period. Perhaps the more substantial point, however,

was that Fried, as he later made clear, intended the notion of a 'theatrical' relation between painting and spectator to indicate a condition of dislocation, of estrangement and alienation.[11] Moreover, such a condition is seen to hold, in the world, as a characteristic *modern* condition. Two implications follow, one commonplace, one less so. To the extent that quotidian life embodies a series of unconvincing acts, then convincing representations of the modern condition must represent that dislocation. But Fried also takes it to be central to the nature of art that it works to overcome that dislocation: that it is at some level restorative. For Fried, the painting/spectator relation, which he also calls the object/beholder relation, is a special case of a more fundamental epistemological relation: an object/subject relation, which is the condition of our sense of being in the world. The production of a new form of object, that is to say, is intimately bound up with the production of a new subject. The winning of a new form of aesthetic resolution potentially enables the achievement of a new consciousness, at once synthetic (that is, of the old and the hitherto *un*formed) and critical. In holding out the possibility of imaginative self-transcendence, the intention is not that alienation should be forgotten, but that its disabling aspects may be incorporated into a higher level of experience. Changing the conditions which breed alienation need not be at odds with imagining the possibility of difference.

In his earlier abstract paintings of the mid-seventies, perhaps continuing into the eighties, it seems plausible that Richter was carrying forward the basic strategy of his previous work. Many of these paintings looked as though they might have been assembled from a 'catalogue' of abstract devices: of figure/ground relationships, of lines and planes, of expressive gesture and mechanical reproduction, of thickness and thinness of paint, of flatness and roundness. To this extent, then, there are grounds for Buchloh's claim that Richter is deconstructing the rhetoric of painting without engaging in it.[12] In effect, this is a claim that it was historically not possible for Richter abstractly to express mood or content, and mean it. At most what could be 'meant' was the absence of the possibility of such meaning. But as the project developed, the paintings quite palpably began to lose any sense of being demonstrations and to be able to sustain readings as totalities in their own right. This type of reading was invited not least by the fact that during the eighties the constituting pictorial elements came to be increasingly subsumed by an all-over surface. If the problematic which informs these works is indeed one of drawing the laminations of meaning into a work such that the painting containing those meanings comes to constitute a unity itself capable of generating meaning anew, then such work amounts not to a negative revelation of the impossibility of painting meaningfully, but rather to a representation of the constraints upon contemporary meaning: for example, that it cannot settle, that it is not susceptible to a unified ordering principle.

Such a rigorous pluralism is, however, distinct from liberalism as commonly understood, and lived, in contemporary Western societies. What is arguably in play in Richter's late abstraction is a refusal both of the way things are and of extant remedies.

One of the features which dinstinguishes this work from modernist abstraction, however, is its continued co-existence with a form of figurative painting. In the gravitational field of canonical modernism, such a conjunction would have been unthinkable: abstraction unequivocally marked the supersession of figuration. Only extraordinary historical circumstances, such as the cultural counter-revolution of the early thirties in the Stalinized Soviet Union, could mitigate the force of that opposition: and the work to which it gave rise – Malevich's so-called 'post-Suprematism' – was highly unstable. For Richter, the situation is very different. Doubly distinct from modernism, both in respect of his early enculturation into Socialist Realism and its filtering of German tradition, and in respect of his appearance in the West at the moment the modernist paradigm began to break down, the painterly forms of abstraction took on the character not of, so to speak, irrevocable epistemological breakthrough, but of a potentially available, relatively complete, representational resource, along and on a par with others: such as photography; such as mass media technology; such as traditional figurative painting. What was in one sense a levelling was also, quite clearly, a liberation.

Richter has said of his figurative work in this period, when it mainly comprised of landscapes, with a smaller number of still lifes and portraits, that it had something of the status of a wish, an idealization; whereas the abstract works represented the hard realities of their time. This seems to allude to both the inaccessibility and the ever-presentness of the classical genres to us. We can never inhabit the world which produced the convincing memento mori, the vanitas. But the works themselves, both in themselves and in reproduction, do live on into our world, almost as reminders of what it is that we have lost. Their particular sense of the combination of the material and the spiritual must forever remain outside of us, but *that* such a sense existed can be ours. When he paints a candle or a skull, Richter neither offers a convincing representation of the fear of death nor simply abrogates modernism's evacuation of the genres. By a process resembling subtraction, he represents our culture's silence, its lack of resources for certain types of representation. It is the present that is being painted, but it is a historic present, shadowed by a past it cannot feel, but which yet remains the only measure of our own limitations.

One conjunction of figuration and abstraction seems both particularly close and particularly challenging. In 1987 Richter produced a suite of fifteen paintings titled *18 Oktober 1977* (Richter numbers 667–1 to 674–2), the date of the deaths in prison, either by murder or by suicide, of members of the

Red Army Faction, known also as the Baader–Meinhof group. At this time, or shortly after, he was also engaged in the production of abstract paintings, some of which seem, experientially at least, to emanate from the same matrix of feeling. Much has been written of the Baader–Meinhof paintings, and Richter was subject to censure from both the right and the left. For the former, by failing overtly to condemn the group, he condoned terrorism. For the latter, by failing to condemn the state, he condoned the status quo, and was, moreover, guilty of a voyeuristic use of the tragedy of others to dignify the caution and safety of his own practice. More positively, Benjamin Buchloh has interpreted them as a breaking of the silence which the largely oppressive culture of the Federal Republic draped over the moment of its profoundest crisis.[13] By working from police surveillance and press photographs, Richter challenged the evasions in which both he and his audience were complicit. There is much to be said for this, and some such challenge was undoubtedly part of the effect of the paintings: the opening of debate on a forbidden subject. One canot help feeling, however, that such an account misses a certain quality in the works which is less congenial to a forcefully expressed materialism. When seen, as they are intended to be, ensemble, the Baader–Meinhof paintings performed the puzzling feat of making an obviously deeply-felt address to the tragic '*light*', yet without in the least 'making light' of tragedy. In many cases one would approach art which set out to address such a subject in expectation of the full force of semi-officially felt profundity, as every single stop on what Adorno called the Wurlitzer organ of the spirit built in a tragic crescendo. Richter's paintings had none of this, and were the more genuinely felt for it. They maintained a kind of *thinness* which instantly disabled the proclivity to mourn; in effect which prohibited the sentimentalization of both the individual deaths and the death of a certain distorted utopianism. Quite unlike the memento moris of the skulls and candles, contemporary death was somehow awarded its due. For a death without adjectives, the fifteen blurred light grey paintings played not a funeral march, but a single repeated note on the edge of silence.

Perhaps, however, the matter does not end there. For this mood appears to carry over into some contemporary abstractions, notably the four *Uran* works (Richter numbers 688, 1–4), and the large *Abstract Painting* (number 695). It has been suggested that the three diptychs, *January*, *December* and *November* (numbers 699, 700 and 701) are also related. However conscious one may be of the facticity of pictorial meaning (and surely the enforcement of such awareness has been a feature of the best modern art since at least Cézanne, and arguably of the best art per se), and however constantly one may be reminded of the quasi-mechanical process whereby the signifying surface of these works is produced, a sense of their grandeur and austerity cannot be dislodged. This is a function of their dominant vertical and horizontal articulation, of their colour range, of the ordering of this colour

according to interval and area; of the qualification of this order by accidents, fades, sudden reappearances and interruptions; in short it is a function of the deployment of compositional techniques which, their automatism notwithstanding, Richter controls. The paintings *have* this character, however much their means may be the common property of art history, however much their contexts of display are a function of capitalist property relations. *Abstract Painting* number 695 and its cognates render the contemporary history of *18 Oktober 1977 sub specie aeternae*. Little in our lives is new, little escapes the dominant culture and no one eludes death. This affects not at all the capacity of human beings to live and feel, nor to act purposively to represent those feelings however the pressure to do so truly and originally is increased by the weight of previous utterance. To presume that it does seems like a sociological closure on the imagination which would be impertinent were it not so negligible, as well as implying an unwarranted restriction on the expressive possibilities of our culture. No art can revive the past. That goes without saying, and ours is undoubtedly a dissonant condition. Modernism involved both a moment of negation in its consistent refusal of a culture of affirmation, and – sometimes by that fact alone, sometimes through the addition of a further element – a moment of utopic prefiguration, of modelling. The whole long wave of modernism in every field is now under threat of being diminished to a crust on a great grey beach, curving into the fog without future undulation.

It is surely as much in response to such a prospect as to Buchloh's specific description of a divided and fragmented situation that Richter has intransigently professed himself 'heir to an enormous, great, rich, culture of painting, and of art in general, which we have lost but which nevertheless obligates us'.[14] In a situation in which religion is unavailable and ideology a recipe for war, Richter places the entire weight of redemption on art. It is against this background that we must understand Richter's conception of painting as a moral act. Both modernist aesthetics, at least in its etiolated and stereotypical form of being prised loose from material concern, and a postmodernist refusal of the aesthetic in the name of a pragmatic eclecticism, are inadequate. For Richter, there is still a truth to be told. It is the business of art to tell this truth, and the means of its doing so is the reconstitution of beauty: as he puts it, a 'downgraded' word that none the less offers the only antidote to 'war, crime and sickness'.[15]

This is far from the conventional terrain of contemporary theory, its preoccupation with difference, and its subsumption of art into the factions of contemporary cultural struggle. Richter's work, which on some readings can be made to exemplify the deconstructive force of modern theory and of its abandonment of what it holds to be the metaphysical myths of the past Western tradition, would seem to be made out of an aspiration which is in large part concerned to re-animate that tradition: to render it somehow

available to use, now, as a resource for contemporary practice. There are two sides to this implication. Either that an emphasis on the gulf between experience and representation of the need both to construct meaning and simultaneously to subvert it is not new but an integral part of the history of a critical approach to modern painting. Or that the aspiration to open a contemporary art on to the art of the past under a rubric of comparable ethical effectivity is not necessarily a conservative desire.

This is not the terrain of deconstruction. Or, rather, in the determining conditions given to Richter's oeuvre, given to us, it is *and* it isn't. This is a terrain of difference *and* it is a terrain of continuity. For some time, relativism has tended to eclipse any sense of epistemological constraint. The play of interpretation has supervened over truth in the domain of radical culture. But this in turn has been subjected to the arguments of a re-invigorated philosophical realism. One example of this is the demonstration by Norman Geras that historical materialism does not require of us that we abandon a concept of human nature: the paradigm, one could say, of continuity. The claim, rather, is that historical materialism, both as explanation and as norm, *requires* a concept of human nature: 'it is fundamental to historical materialism in the exact sense of being part of its theoretical foundation.' He goes on:

> if diversity in the character of human beings is in large measure set down by Marx to historical variation in their social relations of production, the very fact that they entertain this sort of relations, the fact that they produce and they have a history, he explains in turn by some of their general and constant, intrinsic, constitutional characteristics; in short by their human nature.[16]

Richter's painting undoubtedly deconstructs certainties and inherited conventions – ideological, political, religious, moral and aesthetic. In order to do so, however, it relies upon a concept of shared human experience, of continuity in history, and commonly held powers of imagination. Imaginative reflection upon the paintings operates under a dual aspect: the paintings as paintings, *and* the paintings as models; the latter being secured solely on the basis of the successful achievement of the former. Success is an open question. Its achievement is to be found in the process of looking at what is shown; though such looking is always embodied, and always discursive. This is not, however, to say that conditions of absorption, contemplation and solitude are not prerequisities of an engagement with art.

After fascism, during and after communism, Richter's work is acutely positioned as both of and about the world that is left. What confers its unique place in that world is that it has never conceded the world as one in which art has no place. To paint thus, in the world of corporations, is both to accept with realism that such a world exists and one is of it, and with equal realism to

exemplify at the level of the imagination that it may be otherwise. The possibility of imagining such difference, and of having grounds rather than mere desires for doing so, is a pre-condition of its realization. It is this which separates art, conceived as a moral act, from ideology. It demands an extension of one's experience. Our capacity imaginatively to face the consequences of experience is the measure of our being in the world.

Notes

1. See: Benjamin Buchloh, 'Gerhard Richter's Facture: Between Synecdoche and the Spectacle', *Art and Design*, 5 (9/10), 1989, pp. 40–45; and 'A Note on Gerhard Richter's *18 Oktober 1977*', *October*, 48, Spring 1989, pp. 92–109. Stefan Germer, 'Unbidden Memories', in *Gerhard Richter. 18 Oktober 1977*, exhibition catalogue, ICA, London 1989, pp. 7–9; and 'Retrospective Ahead', in *Gerhard Richter*, exhibition catalogue, Tate Gallery, London 1991, pp. 22–32. Peter Osborne, 'Modernism, Abstraction and the Return to Painting', in Andrew Benjamin and Peter Osborne, eds, *Thinking Art: Beyond Traditional Aesthetics*, ICA, London 1991, pp. 59–79; and 'Painting Negation: Gerhard Richter's Negatives', *October*, 62, Fall 1992, pp. 102–13.

2. Gerhard Richter, interviewed by Benjamin Buchloh, in Roald Nasgaard, *Gerhard Richter: Paintings*, Thames & Hudson, Chicago, Toronto and London 1988, pp. 15–29, esp. p. 21.

3. Buchloh, 'Gerhard Richter's Facture' and 'A Note on Gerhard Richter's *18 Oktober 1977*'.

4. Germer, 'Unbidden Memories' and 'Retrospective Ahead'.

5. Osborne, 'Modernism, Abstraction and the Return to Painting' and 'Painting Negation'.

6. Gerhard Richter, 'Notes 1966–1990', in *Gerhard Richter*, exhibition catalogue, Tate Gallery, pp. 108–24, esp. p. 112.

7. Buchloh, 'Gerhard Richter's Facture'.

8. Osborne, 'Modernism, Abstraction and the Return to Painting' and 'Painting Negation'.

9. Clement Greenberg, interviewed by T.J. Clark for the Open University course 'A 315: Modern Art and Modernism', 1983: two video tapes, 'Greenberg on Pollock' and 'Greenberg on Art Criticism', Open University publications, Walton Hall.

10. Michael Fried, 'Art and Objecthood', *Artforum*, Summer 1967.

11. Fried, *Absorption and Theatricality: Painting and Beholder in the Age of Diderot*, Chicago University Press, Chicago 1980, see esp. chapter 2.

12. Richter interview with Buchloh.

13. Buchloh, 'A Note on Richter's *18 Oktober 1977*'.

14. Richter, interview with Buchloh.

15. Gerhard Richter, quoted in Coosje van Bruggen, 'Gerhard Richter: Painting as a Moral Act', *Artforum*, May 1985, pp. 82–91.

16. Norman Geras, *Marx and Human Nature: Refutation of a Legend*, Verso, London 1983, pp. 66–7.

7

Victor Burgin's Polysemic

Dreamcoat

Jessica Evans

The vast majority of photographs are ubiquitous, ephemeral and anony-
mous. They are the throwaway, mass-produced images of our culture.
Photography is clearly a medium utterly bound, since its invention, to
instrumental rationality. It is presumably for these reasons that photography
continues to be ignored within the academic disciplines of art history, and
literary and English studies, which still indulge in the discriminating values
of the 'Culture and Civilization' tradition. Recognized and at the same time
condemned for being a primarily visual and accessible medium, it is readily
assigned to being part of affirmative mass culture. Conversely, the
assimilation of photography to the 'status' of art virtually since its inception
constitutes a sublimation of, or at the very least an evaluative attitude to, the
sphere of the popular and its mechanisms of mass production, distribution
and consumption. Whereas painting has an elective 'institutional' affinity
with 'art', the identification of photography as art will always entail a value
judgement placed upon the activity of photography: the striking of an
attitude, the intentional bringing into play of a certain discursive field.

Victor Burgin must be credited with having campaigned on a diversity of
fronts, over the last twenty years, to establish photography as a medium and
a practice worthy of serious critical attention. His work has been a source of
considerable authority and influence in the development of a radical theory
and practice of photography in Britain. If an embattled tone and an
occasional hint of manicheism affects his writings it is hardly surprising,
given that pitted against him have been an assemblage of institutions and
individuals defending a view of the medium narrowly based upon a
contradictory amalgam of the ideologies of Romanticism and conventional
realism. That people in the photography world widely refer to a 'Burginite'
practice attests to the fact that he has established a certain philosophical
approach to photographic gallery practice, distinguished not so much by

'visual style' as by the theoretical self-consciousness of its own position in art historical and institutional discourse.

Burgin's career follows the trajectory of the post-Althusserian arts intelligentsia, spanning the high period of '*Screen* theory' in the seventies, to the embracing of Lacan's anti-humanist reading of Freud and feminist sexual difference theory in the eighties and the development into a broadly postmodern position. He is an artist who has always spoken about the imperative of acting on multiple intellectual fronts – as lecturer and teacher, visual artist, writer-theorist, conference contributor, etc. This represents an attempt to 'shift the ground of the institution as a whole',[1] to contribute towards changing the dominant discourse and beliefs of the art institution and to bring theoretical issues to bear demonstrably on practice itself. To write about Burgin's photographic work without a consideration of these theoretical concerns and their broader context would be a travesty of his achievements. I first present a historical survey of Burgin's work, from the late sixties to the late eighties. I return to specific aspects of his work where relevant later on in the essay. It is not intended as a comprehensive account but I have aimed to highlight artworks which are representative of Burgin's approach.

Selected Photo-works 1969–1992

After an art school training at Sheffield and then the Royal College of Art, Burgin publicly entered the art arena in the late sixties with Conceptualist installations and with a commitment to writing which showed a scepticism toward all 'given' forms, politics and methodologies. Even early on, Burgin's photographic works involved an extreme problematizing of the referential aspirations of art, coupled with an awareness of the contingencies of art and the power of art institutions to confer value. His *Photopath*, exhibited at the ICA's 'When Attitudes Become Form' in 1969, used the physical presence of media (photographs of gallery flooring printed to actual size stapled to the gallery floor) to undermine the idea of direct unmediated access to reality. Presence, as he might have put it later, always takes place in the absence of an origin(al). It was a play on revealing and concealing, an attempt to upset our complacency regarding the 'fit' between reality and an image, a sign and its 'referent'. Significantly for Burgin, Conceptualism represented a 'linguistic turn' in art in its emphasis upon the obsession with the concept of an object as epistemologically prior to the objective thing that can be scientifically investigated.

Photopath was also an anti-capitalist art-market gesture – impossible to move physically without destruction, it only made sense where it was situated, and thus defied the logic of collectability.[2] As such it belongs to the

modernist 'historical avant-garde' tradition of using art to attack art, or expose its 'external' conditions of existence. It was also part of the general Conceptualist project to dismantle the hierarchy of media in which painting was assumed inherently superior to photography. Burgin stated that to use photography was itself an assault upon the decorum of modernism; photography would, as he was later to say, 'exorcize a ghostly "logos" in the ideological machinery of art; the author as punctual origin of the meanings of the work'.[3] From this point onwards, as part of an immanent critique of the dominant modernist ideology of the art institutions, Burgin made work which incorporated some of the tropes of mass culture, elements which can be considered as the Other of modernism; most importantly, the integration of words with images which replicate the 'scripto-visual' and intertextual social uses of photography.[4]

Burgin's early photographic work, up to 1977/78, for example, *Class Consciousness* (1976) and *UK '76* (1976) until *Zoo '78* (1978),[5] can in some senses be understood as didactic and wedded to the project of ideology critique; image and text were often in a relation of contradiction, the text sometimes functioning as an ironic coda to the image.[6] The panel entitled *St Lawrence demands a whole new lifestyle*, from *UK '76*, sets the language of haute couture (and consumption) against the image of an illegal female textile worker (and production, in a factory); it thus aims to reveal the hidden social relations that commodity fetishism disavows. This, of course, relied upon a viewer who agreed or understood the position of distance which irony always demands, for it assumes that the viewer shares the artist's view. It always 'positions the reader as the consumer of my irony'[7] and its political effects were, Burgin felt, too quickly exhausted: 'they could be simply consumed as the speech of any author, there was very little space left for the productivity of the reader.'[8] So, for Burgin, the attempt to 'fuse the horizons' between author and viewer, to replicate the aim of all commercial images to ensure that the encoded 'preferred message' is correctly decoded in order to persuade somebody of something, was rejected. The work which stood Burgin at a theoretical and ideological crossroads was his poster *What Does Possession Mean to You?*, five hundred of which were fly-posted on the walls of Newcastle upon Tyne during 1976. His last foray out of the art institutions, the poster combined a full-colour image of a wealthy-looking glamorous young couple intertwined, with texts ('What does possession mean to you?' and '7% of the population own 84% of our wealth') respectively above and below the image on a black background. It aimed to raise questions about property relationships, sexual relationships that approximate property relationships, and, most significantly, involved a politics of class based on a Marxist theory of ideology as 'false consciousness'. Burgin later not only rejected this theory of ideology but also at the same time, and more implicitly, abandoned the category of ideology and ideology critique altogether.

The poster is interesting as a demonstration of the possibilities of 'reading' a photograph and as an illustration of Barthes's theories of text as relay and anchorage.[9] It shows the subtle variations in the way that image relates to text and texts relate to other texts and developed Barthes's theories by challenging his assumption that a text objectively and inherently functions as anchorage or relay – showing that these interpretations are entirely a consequence of the specific knowledge of the reader/viewer. It was not surprising that, although the posters had a high profile in Newcastle in terms of media and street interest, there was a very low receptivity to their intended meaning.[10] This was Burgin's first and last brush with an audience who lacked the *competence* necessary for making an 'informed' reading of his work, an audience unaccustomed to the self-conscious and ambiguous codes of a gallery practice relocated to the street.

Retrospectively, we can see that Burgin was forced to make an aesthetic and career decision about his future visual strategies, location and audience for his work. As someone who had, since the sixties, worked exclusively with the photographed image, Burgin made a choice at this time to operate within the discursive and institutional domain of art. Adopting as justification the Althusserian position of the irreducibility of different 'Ideological State Apparatuses' to the economic, he took the view that the ISAs are not the 'stake but the site of struggle'. The challenge was therefore to formulate a project specific to the institutions of art, having conceived of the art institutions as primarily serving an ideological function. Burgin clarified this in an interview when he said he was interested in developing the 'specificity of the ideological'. Due to his belief that the ideological struggle can be isolated from the political, he therefore, he says, does not call himself a political artist: 'In such a specific [political] struggle, photographs may be used, but they are not essential.'[11] This absolutist position that 'the ideological' is a separate arena of struggle to the political is a hallmark of post-Althusserianism and can be mapped, as we shall see, on to the other polarized distinction Burgin makes between the 'representation of politics' and the 'politics of representation'.

Althusser re-theorized the undeveloped 'base/superstructure' metaphor of Marx's 1859 'Preface'. His social 'whole' is composed of parts that are defined as external to each other and these eternally preformed levels, the economic, the political and the ideological, take precedence over the totality, each having a 'relative autonomy' from the others.[12] The economy is considered to be determinant 'in the last instance' not because other instances are its epiphenomena but because it determines which instance is dominant. This is of considerable importance, for one of the basic misunderstandings of Althusser hangs over his conception of 'relative autonomy', commonly thought to be a static description of ideology as if in a permanent state. It has now become traditional for Althusserians to juggle

the polar opposites of 'relative autonomy' and economic determinism in the last instance, as if these were quite unproblematic eternal moments of the social formation. 'Relative autonomy' is put to work in order to ensure a kind of compromise between the sin of economic reductionism, on the one hand, and that of idealism, on the other. Ideology is seen as a whole symbolic or cultural order in its own right, a cement which, through acting upon individuals, maintains social cohesion.

However, the problems inherent in the base/superstructure metaphor never really disappeared in Althusser's account; as a model of society it only grasps the surface, the way these levels appear as separate, whereas Marx originally argued that one must first grasp the totality and then the ways in which it appears as fragmented.[13] It is not the social links in Marx's view that need to be explained, but the division or separation in the social world that occurs with the appearance in history of capitalism and 'civil society'. Marx meant that bourgeois society presents itself as a fragmented structure and this mystificatory *appearance* is reproduced in the base/superstructure metaphor. In Althusser's theory ideology became defined as a specific sphere and identified as separate from the structure, rather than as an organic and integral part of all social practices and struggles.[14] Hence Burgin's either/or-ism concerning the choice between the ideological or political as arenas for struggle. He sees the 'ISAs' as primarily an arena of reproduction, as if they were absolutely separated from the sphere of production.

Throughout the seventies and early eighties the theories associated with *Screen* became the formative intellectual project for Burgin, allowing him to develop what has since been labelled as 'Constructed Image' practice, that is, a practice explicitly opposed to naturalism and an unreconstructed realism. Realism became identified in formal terms as a particular signifying practice with inherent ideological effects. This was at the expense of a consideration of its correspondence to 'reality' or to the substantive claims about reality that a text will contain. The political avant-garde, represented by the work of Godard and Brecht, was seen as an advance for *Screen* because it refused to efface the materiality of the signifier; reactionary film, by contrast, places the spectator outside the realm of action. Should the text display its own processes of construction, then it will break the fundamental illusion of the realist text, that of showing 'how reality is'. In his essay 'The Imaginary Signifier' (1975), translated and published in *Screen*, Christian Metz argued for a broadened conception of the cinematic institution, seeing the cinema apparatus as the forum for the production of subjectivity. Metz, Stephen Heath, Colin McCabe and others saw the conventions of realist represen-tation as important because they place the spectator, as Heath said, 'in an identification with the camera as the point of a sure and centrally embracing view'.[15] This cinematic strategy originated in the codes of Renaissance perspective, and through the development of devices such as the depth of

field, long takes and continuity editing, the cinema has perfected a visual illusion in which the viewer is positioned as an all-perceiving subject gazing directly on to an objective reality.[16] Armed with Lacanian psychoanalysis and Althusserian scientism, such a relation was seen to be, of course, imaginary. The 'impression of reality' was the product of a self-effacing signifying practice, McCabe proposing that it was necessary to consider the logic of that contradiction which produces a position for the viewer but denies the production of the 'real' for the spectator. So for *Screen* the key feature of the classic realist text was the illusion of transparency – the production of 'obviousness' – which, argued Althusser, is exactly that mechanism by which individuals are hailed as subjects.[17]

The hold of the *Screen* paradigm began to wane in the mid-eighties. The post-structuralist reading centred on a text, from which inferences were made about effects on a viewer – viewers were assumed to be the same and therefore were in effect seen as some ideal-type. Its mechanistic disregard for the concrete (its assumption that empirical study entails an empiricist method), and for the possibility that different viewers might have very different readings of texts in ways that were more than accidental, meant that it was condemned to the false logic of an inductionist method. It has been argued recently that the denigration of the classic form of illusionism and psychological identification with characters has the effect of writing off mainstream cinema and popular 'realist' culture as retrograde – primarily because of its form. I take up this issue later with regard to Burgin's theorization of his own practice.

In *Zoo '78*, Burgin made for the first time a piece which explicitly addresses the sexual relations implicated in looking, and this heralds a major shift in his work. He became concerned with debates on representation and ideology and these are increasingly understood in the terms of (Lacanian) psychoanalytic theory inflected through a feminist reading.[18] He travelled, then, from one foundational theory, that of class, to another, that of sexual difference in its relations with the 'patriarchial unconscious'. And it is at this point that Burgin began to distinguish between 'the politics of representation' and the 'representation of politics'. He stated:

> A politics of representation has to be concerned with the phantasmic – this cannot be considered as secondary to the political issues of the day, the fetishized real struggles . . . we don't simply inhabit a material reality, we simultaneously inhabit a psychic reality – the former is known only via the latter. Psychic reality, the register of the subjective, of emotion, is organized according to the articulation of sexual difference.[19]

We might note the apodictic tone – there is no dialectics, only a stark choice: you are concerned either with the politics of representation or with the representation of politics, you consider fantasy either as secondary or as

primary; you either know a 'material' reality as a consequence of a 'psychic reality' or dismiss the existence of psychic reality altogether. It is important to situate this theoretical distinction in its early-eighties context – Burgin was providing a much-needed corrective to the representational modes of the unreconstructed 'left'; for example, those documentary and campaign workers who assumed there were already constituted political and 'material interests' at the level of economic relations which the work could activate.[20] However, as I shall go on to argue, art which is exclusively concerned with the politics of representation is at risk of a certain universalist formalism. Conversely, work which appears to be primarily about 'representing' politics does not preclude considerations of the politics of representation. So it seems as if this distinction can be based not upon a claim about inherent aspects of the work, for these may not be so easy to 'read off' the work in question, but, rather, on the avowed intention of the author/artist in relation to a given audience. In fact, this distinction and the practice that ensues is one which artists seem to need more than photographers working in the non-art sphere and it may be linked to the art world's need to specialize, to categorize its 'political/critical artists', as part of the creation of a discursive field. It is self-legitimating, to the extent that it is a way in which certain artists create the mark of distinction, a category of difference from other *instrumental or commercial photographers*.[21]

Zoo '78 deals with a city of the imaginary – the Berlin of sexual decadence and the Berlin of 'the Wall'. The zoo in Berlin is geographically surrounded by peep shows with revolving naked women. Not far away there is 'the wall' with men peeping through slits in concrete boxes. Burgin comments:

> I was interested in the possible links between different forms of surveillance. If we turn to psychoanalysis we find that Freud's discussion of voyeurism links it with sadism – the drive to 'master' is a component of scopophilia [sexually-based pleasure in looking]; this look is a mastering, sexually gratifying look and the main object of this look in our society is the woman.[22]

He says that the oppressive surveillance of the woman in our society is the most visible, socially sanctioned form of the more covert surveillance of society-in-general by the agencies of the state.

For Freud and Lacan, the visual is of key importance in the formation of individual subjectivity: a sight is the founding moment for the child's entry into both the mirror phase and the castration complex. Freud saw the scopic (visual) drive as a component instinct of sexuality, operating in both narcissistic and voyeuristic modes. In the spatial and psychical structure of voyeurism, a controlling and intrusive gaze requires the maintenance of distance; the comfort felt by the viewer is of seeing a spectacle that does not acknowledge it is being seen. As Metz put it, the voyeuristic distance symbolically and spatially evokes the 'fundamental rent of the self'.[23]

Traditionally, the object of the gaze, the 'other', is the woman. Burgin presents voyeurism in *Zoo '78* as an interdependent articulation of power and sexual gratification.

Two panels in the series are set against each other: a photograph of a framed painting of the pre-Wall Brandenburg Gate on a front-room wall; a photograph of the spectacle of a naked white woman on all fours. On a revolving dais, she is seen from the point of view of a pornography booth which is seen reflected behind her in the mirror. We are thus, as (implied male) viewers, positioned by the image and literally given a place within it. A section of text overlaid on to the image explains in a factual way the structural effects of the 'Panopticon' prison upon its prisoners – the building which Foucault used as a metaphor for modernity's condition of pervasive surveillance.[24] One of the aims of the Panopticon, a prison where all the inmates can be watched by invisible warders from a central watchtower, was to inculcate among prisoners the feeling that they were being watched constantly, regardless of whether that was in fact true – the strategy of invisible omnipotence, as Bentham put it. What could Burgin mean by this juxtaposition? Is he pointing to the nostalgia for a once unified city, Berlin, now being rent through a signifier, a gate; the way that the 'rent' between a man and a woman operates through surveillance and the objectification of the one by the other? How can a male theorist use feminist theory without being part of the problem? By showing a naked woman on a pedestal and by juxtaposing it with Foucault's text on the Panopticon, has Burgin problematized the so-called 'phallocentric gaze'?

It turns out that Berlin, an actual place with a historically acute identity, is really a metaphor for Burgin's second-order, more transcendental set of concerns. He says:

> There is a sense in which all desire is desire for the past; for the individual's lost infantile sense of completeness, of plenitude . . . this idea of the lost object, the lack in our being, is inscribed across the entire city of Berlin; the city can easily serve as a general metaphor for the various aspects of what psychoanalytic theory likes to call the 'splitting of the subject' – the division of Berlin and its lost objects, e.g. the gate.[25]

What does this mean? Is Berlin being used to illustrate a more esoteric point about the universality of the experience of lack? Does the post-war carving up of Berlin in the service of Cold War ideologues and the consequent society of surveillance really have a resemblance with the sexual relations between (some) men and (some) women? Is the existence of oppressed women around the Berlin Zoo to be attributed directly to the Wall? In other words, how far can an analogy be pushed?

I am worried about the political implication of this work, about Burgin's apparent claim that the work is not only 'about' psychoanalytic processes but

also 'about' the political geography of post-war Berlin. But Burgin insists that we should not protest, in the name of rationality, that these things cannot, or should not, be associated. In keeping with this attitude, the use of text and image in this and his later work operates less in terms of anchoring meaning and more in terms of 'relay' where meaning, poetic, polyphonous and open-ended, occurs along chains of associations, as in memory or fantasy. He wants the text and image to replicate the unconscious processes which for Freud were to be seen most clearly in the dreamwork, in those processes of condensation and displacement which were later translated by Lacan into the equivalent linguistic figures of speech, of respectively metaphors and metonyms. The dreamwork, particularly displacement, was seen by Freud as the strategic means by which the unconscious foils censorship.

It is logical, therefore, that his future works, *Olympia* (1982), for example, are constituted by photographs taken from a diversity of locations: visiting a museum, looking at a book, going to the cinema: 'one of the things that interests me about photography is its ability to put different things on the same level.'[26] The concept of allegory has been identified as a characteristic post-romantic, postmodernist textual strategy.[27] Allegory suits Burgin's psychoanalytic purpose for its language is that of analogy and of the arbitrary relation between signifier and signified – hence it is incommensurable with scientific analysis (the cognitive, the ego). With allegory, one text is read through another – the allegorist does not attempt to recover an originary meaning that may be lost. Allegory rests upon a reciprocity between visual and verbal, where visual images are offered as scripts to be deciphered and words are transposed into the visual. So, allegory lends itself to the processes of dreamwork, in particular, displacement, where a meaning is represented by conversion into an analogy (or metaphor) that retains its formal properties. Thus, to refer back to the quote from Burgin above, the allegorical impulse allows one to draw from the storehouse of photographic references to build up an intertextual sequence which does not have a rootedness in any external 'societal' logic, in fact it disobeys the logic of photographic taxonomy according to which different kinds of pictures seem to be mutually exclusive in terms of style, use, function, audience, and so on.[28]

Olympia continues the theme of surveillance and the scrutiny made of women through a condensation of Manet's painting *Olympia* (1863), which presents woman as object for sexual contemplation; Hitchcock's *Rear Window*; Hoffman's tale *The Sandman* (1816–17), in which a student falls in love with a girl seen through a window who turns out to be a life-size doll; the case-history of Anna O from Freud and Breuer's studies in hysteria (1895); and Lacan's linguistic sign for sexual difference, the lavatory doors marked 'men' and 'women'. Is Burgin the latest detective to follow in Freud's footsteps searching for the key to the enigma of woman? In the lavatory

photograph,[29] it is the female door of Lacan's pair which is open, revealing the reflection of the photographer in the mirror above the sink. On the one hand, 'she' is being penetrated by a male gaze, but at the same time Burgin/ the photographer is incorporated into the shadowy, claustrophobic feminine space so that what he (and we) see is a reflection of himself. The conundrum of sexed identity, the problem of male desire is foregrounded here. He actively wants to implicate himself in patriarchal voyeurism. Or does he think that by seeking the enigma of woman he will find the solution to the mysteries of his own psyche?

The Bridge, Burgin's work of 1983–84, pursues the theme of obsession with woman as perpetual object of investigation/investigators in a more explicit way. These six photographic panels constructed as a triptych do not constitute a narrative but are a series of tableaux vivants representing the moment in Hitchcock's film *Vertigo* when Madeline is rescued by Scottie from her attempted suicide in the San Francisco Bay. The construction of this piece contains a perspective based on spatial shifts and glances into which the spectator is drawn and, in the process of 'suture', experiences the narrative as if it was its own. It plunders for its psychoanalytic and narrative references two of Hitchcock's films, *Rear Window* and *Vertigo*.[30] Burgin is concerned with the condition of spectatorship; both pieces attempt to demonstrate the way in which an image machine conjoins with the physical apparatus of the spectator to produce meaning through identification, the psychological process through which the subject may model or transform himself, either partially or totally, by assimilating an aspect or an attribute of the other. The fantasized woman is key figure in *The Bridge*. The bridge, says Burgin, represents the penis which joins the parents in sexual intercourse and in the transition of birth and death. Coitus, birth and death are also likened to water – which has long been associated with the body of woman. Burgin's central metaphor 'bridge/water' represents the dichotomous pairs of masculine/feminine and birth/death, which are also figured in the moment in *Vertigo* when Scottie rescues Madeline from the water. Burgin conflates this moment with Millais's 1852 painting of the death of Ophelia, another suicide which is analogous to the investigation and erotic attachment of Scottie for Madeline.

As Jean Fisher argues,[31] what Burgin's work articulates through its own fantasy space of 'looks' to camera and out of frame is the Lacanian theory that the male look does not just desire to see the love object per se, who exists only to fulfil a deeper yearning to suture the rupture opened between the self and the maternal body (the mother–child dyad is disrupted by the imposition of a masculine 'phallic' culture). It desires to return to the self's undifferentiated pre-Oedipal origin, a time before the social order compelled him to repress the feminine in himself. This repressed self nevertheless remains the object of a perpetual nomadic search, to be found only through

displacement in a union with the ideal feminine – his fantasized self. But feminists may feel ambivalent about Burgin's intervention in feminist theory via the male gaze. For he says, 'For the man, woman's sexuality is an *enigma*, a mystery which may arouse an obsessive and insatiable curiosity.'[32] Does Burgin invent her again? In *The Bridge*, is he colonizing the woman's space, *penetrating* it? In the lavatory photograph, he enters the woman's space to pursue the identity of woman, but he is faced, literally, with himself. There is no woman in sight, since woman is reduced to being a figment of a male imagination. But where does this leave the male (Burgin)?

The Bridge makes me want to ask: does this work betray his obsession with woman/the feminine? Or, does Burgin's work critique the general male problem of constructing a femininity which women are meant to emulate but which exists only by virtue of its recognition by men? But perhaps these two questions cannot be posed as if they are discrete categories, as if one designates guilt and the other ideological innocence. Burgin attempts 'critique' not from some archimedian outsider position, but from a position of *being* male. He thus exposes – and metaphors of *exposure* traverse his work – the limits of his own 'critical' position. None the less, if woman is reduced to being his knowledge and nothing in herself, then by that token should not Burgin begin to take men and relations between men as his object? Claire Pajaczkowska once said she was 'tired of men arguing amongst themselves as to who is the most feminist, frustrated by an object feminism becoming the stakes in a displaced rivalry between men because of a refusal by men to examine the structure of the relations between themselves'.[33] The question of female sexuality is itself a bad question from a rotten history. Burgin's work faces this problem but cannot solve it on the terms he sets up; he re-pathologizes the object of knowledge, allowing the masculine constructor of knowledge to escape, scot-free, as it were.

Photography: Postmodernism's Principal Boy?

I now go on to consider Burgin's stated theoretical positions vis-à-vis the art institutions, modernism and photography. I trace his development as a member of what could loosely be termed the postmodern avant-garde and assess the theoretical presuppositions which have formed the practice of someone who as an artist sees himself intervening in representational structures. Since Burgin's preoccupation is with the field of aesthetics and the institutions of art and its discourses of modernism, romanticism and criticism, one would expect him to take a particular stance on photography's relation to modernism. Why does Burgin use photographs in an institution which has historically marginalized technological media? How does his use of photography fit with his criticisms of modernism's hegemony in the art institutions?

Photography in the Modernist Institution

In his essay 'The End of Art Theory',[34] Burgin traces the emergence in Enlightenment philosophy of the configuration of ideas and institutions which substantiate the contemporary condition of art. As Habermas has suggested, following Weber, the project of modernity represents a shift from previous cosmological and unified world-views to a hitherto unprecedented proliferation of autonomously functioning value spheres, the primary ones of which are objective science, universal morality and law, and art. Each of these spheres is rationalized, so that they become self-validating, that is, their existence is legitimated in terms of a set of internally developed criteria. That category of 'art' which we treat as stable, immanent and universal is in fact a product of those Enlightenment divisions between intellect and body, aesthetic sensibility and political interestedness, creativity and productive labour. However, the concept of the autonomy of art and that of a purely aesthetic mode of experience, which are products of a specific history, become transformed in modernist art criticism into the normative proposition that autonomy is a universal and immanent tendency for artistic production.

Burgin is responsible for some of the most trenchant critiques of the ideological tenets of dominant modernist art methodology as it has been, he believes, (mis)applied to photography. These modernist targets may be characterized as follows. First, an art conceived as the 'purely' visual where the visual is isolated from the verbal as if they were independent processes of cognition and different symbolic systems. Second, the notion of the unique and autonomous art object which has its historical roots in connoisseurship in the Renaissance and develops further within a market economy system. In an aesthetic tradition, high modernism's constitution of itself as autonomous (in an aesthetic tradition stretching from Kant to Adorno and Greenberg), through a conscious strategy of excluding an increasingly consuming mass culture, must be understood as dialectically related to the commodity form. Third, Clement Greenberg's prescription for art practice to be self-referential, to be achieved by scrupulous attention to all that is specific to its own traditions and materials. Here, the depicted object is a pretext for the accomplishment of a formal idea.

Photography always sits uncomfortably in the modernist scheme, argues Burgin, hence its usefulness as a radical strategy. For he has nominated photography as principal boy of the postmodern stage, as have other prominent postmodern artists and theorists.[35] The argument goes like this: photographs resist easy incorporation to traditional aesthetic values, since they offer no reassuring presence of human intervention. Unlike paintings, they have resonance beyond the walls of the gallery, and the investment of authority and authenticity in the aura of unique gesture

can be subverted. In *The End of Art Theory*, Burgin admits, in parenthesis, that 'photography is ... quite capable of being assimilated to conservative aesthetics; but the assimilation is never entirely successful, something in photography resists, and a "special effort" must be made to render photography, uneasily, assimilable.'[36] Presumably, that illusive 'something' is the indexical (realist) banality of photographs. But, early in the eighties, he had this to say:

> Photography is on the side of information, and it has a current social coinage, in a way that painting hasn't. Today, few people go to look at paintings, but it is impossible to go through a day without seeing a photograph in some form: advertising, magazines, newspapers, snapshots and so on ... Photography can never become entirely a matter of connoisseurship because a photograph is always a photograph of something which exists or existed; also photographs are encountered in almost every aspect of daily life.[37]

But Burgin acknowledges when pushed that: 'my work isn't much more accessible, but photography is. By this I mean accessible to reading ... the discourse of painting is dominated by a connoisseur's discourse.'[38] This is somewhat contradictory – clearly, traditional art forms such as painting have the potential to be accessible and are endlessly reproduced. A Constable is available for a popular reading in the way that a Rothko (or a Burgin) isn't, and this has to do not just with the widespread availability of Constable reproductions in the high street but also with its subject matter and figurative mode. One can't in the end assume that photography is immune to the institutional pressures of inaccessibility; when photographs are placed in a gallery context they may well be dominated by art discourse, whether of a 'bad' old modernist variety or a 'good' new radical and post-structuralist one.

Nevertheless, Burgin's argument is now an established presupposition of most critics advancing the case for postmodern art.[39] As Douglas Crimp puts it:

> The centrality of photography within the current range of practices makes it crucial to a theoretical distinction between modernism and postmodernism. Not only has photography so thoroughly saturated our visual environment as to make the invention of visual images seem an archaic idea, but it is clear that photography is too multiple, too useful to other discourses, ever to be wholly contained within traditional definitions of art. Photography will always exceed the institutions of art, always participate in non-art practices, always threaten the insularity of art's discourse.[40]

As is well known, this argument originated from Walter Benjamin's 'The Work of Art in the Age of Mechanical Reproduction', an essay which for the first time questioned the effects of photographic technology on the

relationship of artist and work, of work and beholder. Writing in 1936, a few decades after the widespread appearance of photomechanical reproduction,[41] Benjamin said: 'Even the most perfect reproduction of a work of art is lacking in one element: its presence in time and space; its unique existence at the place where it happens to be.' Substituting 'a plurality of copies for a unique existence', reproduction circulates images where no original can go, to the studio or to the living room, the train, the classroom, the book, and so on.[42]

As Adorno observed, endorsed by recent writers such as Peter Bürger,[43] in its attempt to establish a direct link between emancipatory expectation and industrial technique, conceived of as independent of a mediating human consciousness, Benjamin's argument suffered from an inherent technological determinism.[44] This seems to have infected the postmodernists, who see the appropriation of the aesthetic and technical characteristics of mass culture forms as the basis for a radical gallery practice. I hardly need to rehearse what has now become an incantation of characteristic 'strategies': 'reproducibility', intertextuality, appropriation, hybridity, allegory, pastiche, ad infinitum.[45] I want to argue that, first, many postmodernists who use photography only pay lip service to the idea of mechanical reproduction, for the full implications of photography in mass culture have to be denied in order for the postmodern avant-garde to exist as such. Second, it seems to me that two issues have been collapsed into each other, one based on an argument inspired by Benjamin concerning the inherent technical capacities of photography, the other an argument concerning the institutional contexts for art practice, that is, the complexity of relations between artworks, institutions and audience. The ideas of Benjamin have been interpreted in a way which privileges aspects of the production of images, rather than their distribution.

For, paradoxically, many postmodernist artists and theorists display an obsessive interest in the condition of authorship, while at the same time playing down the issue of the distribution of their work. In 'The Author as Producer',[46] Benjamin argued that the question of revolutionizing the means of production has too often been considered apart from that of the 'apparatus', that is, the mode of production and distribution of artistic texts within a given society. It is not sufficient, he said, to consider 'the rigid isolated object (work, novel, book), it must be inserted into the context of living social relations'.[47] Radical work should consider not how it *reflects* the relations of production but what its *position* is within them. The post-modernist avant-garde tend to disavow the full implications of their institutional critique, as Abigail Solomon-Godeau has put it, 'in the belief that such critique is already implied within the terms of their focus on the politics of representation'.[48] Clearly, Burgin has done more than most to provide a strenuous justification of his practice in the terms of theory, and,

more lately, within the terms of postmodernism. However, even Burgin, it seems to me, only speaks selectively of institutional forces and it seems as if his practice, like that of other postmodernists, emerges as relatively free of the determinants of the institution, even though the content of his work is concerned with the highly encoded and conventionalized nature of contemporary culture and subjectivity.

I believe that, however one contests prevailing (modernist) practices within the institutions of art, there are some fundamental ways in which the art gallery as a discursive and non-discursive apparatus is a determinant of Burgin's practice. What I want to argue is that there may be some continuities between postmodernist gallery practice and traditional modernist photography. Works of art of whatever kind, as Pierre Bourdieu has forcefully argued, require for their reception primarily an aesthetic disposition, that is, an internalized willingness to play the game of art, to see the world from a distance, to bracket off a range of objects and practices from the immediate urgency of the struggle for social reproduction. This predisposition is the determinate expression in the 'habitus' of the material conditions of the dominant class, the bourgeoisie. There is, I believe, a significant convergence between Burgin's postmodernism and the much reviled formalist concerns of the modernists. I will now offer a consideration of Burgin's theory and practice as the latest twist in the story of the high cultural refusal of the popular.

The lack of division of labour at the level of production means that the fine arts photographer retains a high degree of control over the technical and aesthetic aspects of photographs.[49] Ironically, this relative freedom is matched by an overwhelming emphasis by today's radical art gallery photographers upon the 'death of the artist/author'. This may be paradigmatic of the privileged position of intellectuals – that is, those with cultural capital – who are secure enough to withstand the dismantling of the 'ideology' of the self-transparent subject, and predisposed to turn this into an aesthetic. The major constraints operating upon fine art photographers are located at the point of distribution, in particular, the gatekeepers of galleries, the discourses of art and criticism, and the fine art market which is a major source of control exerting pressure on the photographer. In terms of the physical and material processes of production of the images, there is a tendency for mechanized technology involved to be suppressed. Hence Burgin is embarrassed to be asked about technical, *manual* matters pertaining to the image and even wishes not to be known as a 'photographer'.[50] He emphasizes the production of his pictures in a craft tradition, as opposed to the merely technical-vocational ethos of the jobbing photographer. It is also of interest here that virtually all of his photoworks have been in black-and-white, thus signalling aesthetic distance from the commercial world of photography.[51] When it comes to questions of audience, Burgin shows a

typically artistic disinterest: 'the audience is always phantasmatic in the sense that we can never know an audience in the form of actual *individuals,* "real people" – audiences are always *projected.*'[52] This is familiar Romantic territory: a certain lack of concern, even disdain, towards the audience ('the public') took hold with the Romantic movement in early-nineteenth-century Europe, and the conception of the artist became someone whose production could not be rationally directed toward any particular audience. Marketing was treated as an unfortunate accommodation to vulgar reality.[53]

Postmodernists state their intent to implode the distinction between 'high' and 'low' culture, to cause havoc with the value conferred upon the unique work by the art gallery distribution system. But this debate is confined to strategies at the level of the image, and therefore condemned to remain within the terrain of 'high culture'. In the end, what legitimates the intentional, self-conscious strategy of intertextuality and appropriation is the gallery. To make images which recycle and refer to popular culture and mass cultural forms is not in itself to break down the opposition between high and low culture, for one is still operating within the arena of high culture and within its terms. One cannot resort solely to textual means to effect change. In another context, Perry Anderson has spoken of 'western Marxist' intellectual development towards a concern with the highest superstructures in the hierarchy of distance from the economic.[54] It is interesting that Burgin's cultural references are to relatively obscure, educated and often literary taste: Freud's case-studies, classical mythology, modernist painters. This is effectively to elevate photography to the taste of those who are entitled to 'high culture'.

It may be possible to see work which is 'about' the politics of representation as all too able to be recuperated by gallery formalism, where work has to be seen as an end in itself. Whether the *content* of the work itself critiques Romantic ideologies of self-presence, authorship and so on, this work relies on the idea that the prerequisite for critical practice is its lack of instrumental rationality. Douglas Crimp, noting that simulating/appropriating had become the routine activities of the postmodernist avant-garde, bemoaned the pervasiveness of this throughout the whole culture and finds the critical potentiality of photographic appropriation curtailed: 'If all aspects of the culture use this new operational mode then the mode itself cannot articulate a specific reflection upon that culture.'[55] The fear of assimilation haunts the postmodernists, and here we can see that in order for the postmodernist's work to be seen as a *critical* practice, and not one which is identical to the very object of its critique, it is necessary for its codes and strategies to be exclusive to a non-integrated art sphere. Should those codes and strategies be re-appropriated by mainstream culture, then the difference between main-stream popular culture and the gallery would implode and 'critical practice' would be rendered impotent.

However much Burgin wishes to plunder from the realm of the popular, the reproducible, his work must pull back from the brink of assimilation. There are shades of Clement Greenberg's horror of popular culture, or 'kitsch', which he saw as an art and a culture of instant assimilation, avoidance of difficulty and abject reconciliation to the everyday. In Burgin's answer to the question he puts himself, 'Why make things so difficult for the viewer?', he says:

> We are a consumer society and it seems to me that art has become a passive spectator sport to an extent unprecedented in history. I have always tried to work against this tendency by producing 'occasions' for interpretations rather than objects for consumption. I believe that the ability to produce rather than consume meanings, and the ability to think *otherwise* – ways of thinking not encouraged by the imperative to commodity production, ways condemned as a waste of time – is fundamental to the goal of a truly, rather than nominally, democratic society. I believe art is one of the few remaining areas of social activity where the attitude of critical engagement may still be encouraged – all the more reason for art to engage with those issues which are critical.[56]

In his appeal to the critical space of high culture (we seem a long way from Althusser's functionalism now!) which affords some protection from the harsh commercial world of consumer culture, social agency is smuggled back in. This is doubly ironic when Burgin's work, for example, *Office at Night* (1986), deals with highly abstracted psychoanalytical issues based, as I will argue, on a determinist conception of subjectivity. Could it be that although social agency is explicitly problematized within Burgin's postmodernist theoretical discourse, it reappears by fiat, untheorized, within the space of the art gallery and criticism? Burgin's emphasis on interpretation is telling here: a hierarchy of discriminating viewers is established in which a consumption model of culture is implicitly rejected for *critical* practice – audiences are not mere *consumers* but intellectuals, *connoisseurs*, who interpret. There has been much emphasis upon the idea that radical practice can construct an 'active' rather than a 'passive' consumer for its images (although it often remains an ideal that needs to be tested). We might question to what extent this denigrates or patronizes not just mass culture, but also its 'consumers'. Moreover, this rhetoric is based upon a rationalist division between the affective and the cognitive, for it prioritizes the intellectual labour of thinking over the pleasure of the text.

The Triumph of the Aesthetic Disposition

> In the case of post-structuralist thought, the rational principle of modernity is equated – although more often implicitly than explicitly – with cognitive-instrumental thought. This then

permits post-structuralist theorists to invoke the characteristic
experiences of aesthetic modernism.
PETER DEWS, 'From Post-Structuralism to Postmodernity'[57]

I have argued that Burgin is a member of an appropriatory artistic
community who none the less barricade themselves against mass culture. I
now wish to explore further the possibility that Burgin may be part of what
Peter Dews has identified as a retreat into modernist aesthetics, and more
specifically, into a fascination with the opacities of form. Modernism is now
well established as the *bête noire* of the postmodernist avant-garde. None the
less, we have to be careful about which modernism this is, for postmodernists
do not seem very keen to extend their embracing of pluralism and difference
to this category which is seen all too often as homogeneous in its strategies
and ideologies. For it is defined narrowly as the Greenbergian attempt to
define and establish aesthetic autonomy, and Burgin in particular has been
responsible for this curious over-emphasis upon one late modernist writer as
the reference point for an alternative critical practice.[58]

Burgin has critiqued the position of 'outsiderism' traditionally taken up by
the avant-garde in its waging of war on conformity.[59] His apocalyptically
entitled *The End of Art Theory* ends with a call for a new 'post-romantic
aesthetic' to replace the dogma of high modernism; now is the time for a
general theory of representation to replace traditional art theory. Indeed the
ideology of avant-gardism clearly displays continuities with Romanticism –
the cult of novelty and originality, anti-traditionalism and *tabula rasa*, the
image of the artist isolated from bourgeois society; what has been called 'the
tradition of the new'. Avant-gardism in art, since the Second World War,
may be seen as the principal ideology which has sustained an important
sector of the art market, in its need to launch new products, new movements
and replace the obsolete; part of what David Harvey has called the 'creative
destruction' of capitalism.[60] Avant-gardism can also be seen as an objective
expression of the artist's actual isolation under capitalism, but at the same
time it has become a necessary ideological support for the market itself.

However, modernism, of which avant-gardism is only one expression, was
a complex and diverse set of responses to the autonomy of the aesthetic. It is
specifically bourgeois art which sets itself up as an autonomous realm. In his
powerful book *Theory of the Avant-Garde*, Peter Bürger argues that as a
consequence of industrialization and the impact of mechanization on certain
traditional skills, and the transition from patronal to market relations, art
becomes defined as unproductive activity; this is part of the general tendency
in bourgeois society for art to lose its social function. As the division of labour
intensifies, the artist turns into a specialist,[61] hence the aesthetic experience as
a specific experience; art becomes the content of art and the tie with society is
severed. The complexity of the concept of autonomy lies in the fact that it is,

as Bürger says, 'a category whose characteristic it is that it describes something real (the detachment of art as a special sphere of human activity from the nexus of the praxis of life) but simultaneously expresses this real phenomenon in concepts that block recognition of the social determinacy of the process'.[62] So, the concept of the autonomy of art is an ideological construct and, as with the character of ideologies, it is at the same time the product of a specific history and the means by which that history is repressed, denied. Bürger identifies the two broad tendencies within modernism as 'the historical avant-garde' and 'aesthetic modernism'. In the aesthetics of high modernism, the disjuncture of the work of art from everyday life becomes the work's essential content. The historical avant-garde counter such function-lessness not by producing an art which would have consequences for society but by sublating art in the praxis of life ('lifeworld'), that is, so that art's purpose can no longer be discovered because it no longer exists as a (separate) identity.

We now know that the attack of the historical avant-garde on art as an institution failed, since the very protest of the historical avant-garde against art as an institution has become accepted as art. As Bourdieu says:

> Nothing more clearly reveals the logic of the functioning of the artistic field than the fate of these apparently radical attempts at subversion.... They are immediately converted to artistic acts, recorded as such and thus consecrated and celebrated by the makers of taste.... Art cannot reveal the truth about art without snatching it away again by turning the revelation into an artistic event.[63]

We can see postmodernism as a collective professional reaction to the institutionalization of the energies and strategies of modernist radicalism.

It could be argued that the procedures invented by the historical avant-garde with anti-artistic intent are now being used for formal-artistic ends by the postmodernists. I have a sense of déjà vu about Burgin's and others' declamatory self-presentation of their theories as a break with the past (modernism) and the signalling of the death of the avant-garde (what could be more avant-gardist than the slogan 'The Avantgarde is Dead!'). What I am suggesting is that Burgin's postmodernist gallery practice demonstrates some continuity with modernist formalism. If modernism stressed self-referentiality, postmodern art stresses intertextuality – both have a desire to abolish questions of content, both are formalist, concerned with the *form* of representation (that is, the signifier). There is another mark of aesthetic distinction in the fact that much appropriation work stakes its claim to the status of critique on the back of its being *about* codes, *about* intertextuality. While advertising, mass culture and so on use intertextuality as another strategy for commodity exchange, postmodernist artists concentrate on the form of intertextuality itself, rather than the wider social purpose and contexts of these forms.

There is thus an aspect of this post-structuralist informed postmodernist aesthetic which has something in common with cultural modernism and stretches right back to Kant's critique of aesthetic judgement. Here, I would like to consider the argument of Pierre Bourdieu's *Distinction*, which can be seen as a political effort to legitimize the aesthetics of the dominated classes against all current formalisms, be they from the (modernist) right or the (postmodernist, deconstructionist) left. Bourdieu begins his critique with Kant, who developed a sensibility which systematically privileged form over content or function, style over substance, means of representation over thing represented. It is this set of preferences which animates a long line of literary and aesthetic avant-gardes, from Baudelaire and the Cubists to the found sounds and 'quotation aesthetics' of today's 'post-avant-garde'. It might also be said to animate the academic and intellectual tendencies of French structuralism, Barthesian and Kristevan post-structuralism and Derridean deconstructionism, for all these focus largely on form, pattern, style, structure. Polysemy and significance are, for example, an unrestricted play of signifiers unconstrained by external reference. They share with Kant's project the notion of aesthetic pleasure as detached, disinterested and rooted in a relationship defined by distance, by the refusal of identification or merger with the object; this which makes the properly aesthetic experience one of intellectual difficulty, addressed to the higher faculties, or to its modern equivalent, 'the intellect'.

Bourdieu's argument has provocative parallels with Peter Bürger's for he argues that from the point at which artists and intellectuals in Europe set out to explore polysemy, art no longer required an outside, a referent or a general public. Art increasingly revolves around a concern with its own histories, codes and materials and it addresses an audience equipped with philosophical and art historical literary references. As Bürger says: 'it asks to be referred not to an external referent, the represented or designated "reality", but to the universe of past and present works of art.'[64] He sees the postmodern theoretical avant-garde as a withdrawal from the immediate, the urgent, by problematizing language as a tool and as a communicative medium – thus emphasizing the difficulties and impossibilities of language as communication, its incoherencies, its lack of consistency, its inability to 'represent' thought clearly or at all (cf. Derrida, Lacan). Surely in the stress on difficulty and on the *work* that the viewer/reader must undertake, there is a residue of the refusal of the high modernist text to allow ease, or pleasure in identification with the text.[65] The language of aesthetics is grounded in refusal of the facile, of the immediately sensual or pleasurable, argues Bourdieu:

> Pure taste...demands respect, the distance that allows it to keep up its distance. It expects the work of art, a finality with no other end than itself, to treat the

spectator in accordance with the Kantian imperative, that is, as an end, not as a means. Thus Kant's principle of pure taste is nothing other than a refusal, a disgust – a disgust for objects which impose enjoyment and a disgust for the crude, vulgar taste which revels in this imposed enjoyment.[66]

Thus, the pure gaze implies a break with the ordinary attitude towards the world, which, given the conditions in which it is performed, is also a social separation. The popular aesthetic is based upon the affirmation of the continuity between art and life, that is, the common – as opposed to distinctive, or distinguished, namely the passions and emotions and feelings which 'ordinary' people invest in their ordinary lives: this implies the subordination of form to function. Intellectuals, Bourdieu claims, could be said to believe in the representation – literature, theatre, painting – more than the things represented, whereas 'the people' chiefly expect representations, and the conventions which govern them, to allow them to believe 'naïvely' in the things represented.[67] But the pure aesthetic is rooted in an ethos of elective distance from the necessities of the natural and social world, which may take the form of moral agnosticism and relativism. And nothing is more distinctive than the capacity to confer aesthetic status on objects that are banal or even common – such as the elevation of photography, as I have already suggested. Bourdieu argues that the dominated classes (defined by their lack of economical and cultural capital) negate the taste established by the bourgeoisie and this arises inevitably from their ethos of 'the culture of necessity'.

Thus, through the economic and social conditions which they presuppose, the different ways of relating to realities and fictions, and of believing in fictions and the realities they simulate with more or less distance and detachment, are very closely linked to the different possible positions in social space and consequently bound up with the systems of dispositions (habitus). It would be beyond the scope of this essay to consider the habitus of a particular group of intellectuals in relation to their affiliation with anti-realist philosophy and their privileging of the internal and representational properties, rather than the communicative and dialogical ethics and actualities, of both language and modernity.[68] However, for Burgin 'autonomy' is irredeemably tarred with the brush of a Greenbergian modernist conception of 'art for art's sake', and at the same time the psychoanalytic theory he uses allows no autonomy to the subject. The categories of experience and autonomy, and, I shall argue, intersubjectivity, are handed over to the opposition, insofar as they are seen as contaminated with the 'metaphysics of presence'.[69] This is not to dispute the absolutely necessary project of attempting to find a way of using psychoanalysis to understand the formation of social identity and the acquisition of political (un)consciousness. None the less, a philosophical theory arguing for progress or emancipation must also be willing to name a social agency for this.

The Refuge in Abstraction

The trajectory of Burgin's work belongs to what Michel Pêcheux has called a 'triple alliance' between Althusserian Marxism, Lacanian psychoanalysis and Saussurian linguistics.[70] Burgin adopts a complex theoretical eclecticism in his theory and practice (no doubt he wants to deny the legitimacy of 'grand totalizing narratives' and the investment in one single theoretical discourse which can offer an explanation for all forms of social relations) but there are some intractable problems when it comes to the political programme that might ensue. His final chapter in *The End of Art Theory* is a quite vertiginous attempt to unify a whole set of thinkers and theories which in fact have different ontological and epistemological claims and political projects; he plays down those very real contradictions which exist between them. For example, an immense number of problems result if one wants to integrate a Marxist materialism and a postmodernist theory informed by post-structuralism. Moreover, Althusser cannot easily be relied upon to knit together the theories of Marx and Freud/Lacan, which are rather differently organized around class and sexual difference. Since psychoanalysis has traditionally cast the contents of the unconscious in terms of sexual difference (although this is now a matter for timely dispute), the reconciliation of these two models has yet to be achieved. There are further tensions involved in finding compatibilities between Lacan and Althusser.[71] Finally, it is disastrous to try to derive feminist theory exclusively from Lacanianism. Any critical theory must demonstrate the possibilities of change or emancipation, that is, it must allow for the dimension of praxis, and Lacan does not provide this.

Psychoanalysis by Numbers

The tendency of cultural theorists in recent years has been to focus specifically on objects of consumption and symbolic mediators such as the mass media, and to make assumptions about the (general) state of political consciousness and subjectivity from these productions. Burgin has very much been part of the appropriation of psychoanalysis for cultural theory in a role primarily as 'reception' theory. But its essential origins in the clinical situation – with relations between people as its analytic material, specifically the analyst and the analysand and the use of the transference – have been forgotten. Many critics ignore the fact that psychoanalysis is engaged with emotional suffering and internal conflict and aims to alleviate these through removing the unintelligible quality of the symptom. Critics are more interested in language and the textualization of the mind, an interest that lends itself to literary-artistic production and analysis. Inevitably this has

meant that study of the means and mechanisms of 'control' – seen as embedded in the texts themselves – have taken priority over a thoroughness of analysis of those people conceptualized variously as 'victims', 'receivers', 'spectators', 'subjects'. Having only a theoretical not a practical understanding of psychoanalysis may go some way to explaining why there is a tendency in Burgin's work to abstraction and a belief in the autonomy of the symbolic. But first, it is necessary to consider the effect upon Burgin's artwork of his double role as artist and (his own) critic.

Burgin himself has argued against what he sees as the traditional role of the critic, which is to put an end to doubt concerning the work's meaning and therefore its worth – to offer the reassuring security of an explanation and an evaluation – in short to put the reader in an easier position of consumer, rather than in the precarious position of producer of meaning. However, much of his exhibited and published work is accompanied by writing which almost obsessively retraces the sources for his pictorial references, which, if not exactly prescriptive, none the less aims to set out some authorial intentions and preferred readings of the work. It is a notably rationalist enterprise; perhaps Burgin, to use Barthes's phrase, suffers from the terror of unknown signs, or the terror of a fantasy viewer who is free to interpret the works as he/she likes, free to meander down the various paths of metonymy and metaphor without Burgin's guidance.

The presentation of his work along with copious texts and commentary as explication of their multitextual references represents a need to control the reading of his works. Perhaps he fears his intentions as an artist would go unrecognized by the viewer if he refrained from this practice of displacing agency on to the supplementary text. He is too immersed in the authority of authorship to give it up, even though he makes overtures in this direction. For, echoing the words of Roland Barthes, he states clearly his wish to distance himself from the condition of authorship: 'Although "I" took the photographs and "I" wrote (most of) the texts, the voices of others intrude, and even my own voice is inconsistent in tone across the work, calling into question the ideology of the individuality and autonomy of an art-work and of its putative "author".'[72] Three years later, he says: 'I have a need to be precise about my experience and I have a need to be understood.'[73] As Amelia Jones has suggested, while his theory argues for the divestiture of phallocentric authorial intent, his artworks direct and manipulate the viewer so as to remove any chance of a reading diverting from Burgin's original intention: 'He wields the abstruse theoretical rhetoric of post-structuralism and repressive visual signs appropriated from the mass media as if to obliterate the possibility of accident, of jouissance, of punctum, of third meaning.'[74] It may be, as I will go on to suggest, that the sense of control he exercises over his work is a defence against the unconcious itself and what it really means to him.

222

Initially, it may appear that Burgin's notion of allegory in the artwork is homologous in function and philosophy to Lyotard's 'language-game', for both assault the idea of a coherent and totalized truth. Lyotard said: 'One can occasionally add together or even combine efforts and effects, mix particular narratives and their enactments, but it is contrary to realism, which is pagan, to totalize them on a long-term basis.'[75] Lyotard was not speaking of psychoanalysis, none the less there is a familiar emphasis upon the homogeneous and prohibitive effects of realism which are seen to destroy heterogeneity. Far from seeing allegory as a means of 'reverie' in the Freudian sense of instincts and regressions, Burgin's use of it is informed by the functionalism that results from too great a dependency upon an amalgam of Althusserian and Lacanian theories. Thus, writing of his work *The Bridge*, he says: 'It is by the way of such metaphorical tableaux – allegories – that the social order is imprinted in the unconscious.'[76] Burgin's uncritical adoption of Lacanianism gets him into the same pitfalls as Lacan. There are important and productive elements in Lacan's theory of the unconscious, and these lie specifically in his intention to construct his theory of the unconscious in opposition to the models of humanistic ego-psychology.[77] None the less, Lacan's equation of the unconscious with the trans-individual dimension of language ('the symbolic order') militates against this. Laura Mulvey commented of *The Bridge* that it is

> a structured, almost programmed, exchange between text, reader and the collective unconscious that has produced both text and reader alike. Collective unconscious is what myth represses and is derived from. It describes the area of pain and desire that myth, with its ritual and safe-guarding function, transforms and reconciles into terms which fit into social reality.[78]

This confused equation of 'the unconscious' as coterminous, or 'fitting', with 'social reality' inevitably means that the possibilities for being able to constitute any alternative to 'social reality' are severely limited. Burgin contributes to this universalizing approach to the unconscious in such unelaborated statements as, 'The collision or collusion of the law and desire is to be found in all parts of the social formation as within the subject itself,'[79] and, 'the social order is imprinted in the unconscious.'[80] The problem lies, then, with this over-reliance on an unreconstructed Lacanian determinism, on a theory which conceives of the individual as the epiphenomena of the social at the most fundamental level.[81]

Lacan's theory is an individualistic one involving a monadic individual in perpetual struggle with an alien other. His concept of the mind is abstract; the development of the mind is equivalent to and dependent upon the acquisition of the Father's Law and inscription within and by the binary logic of language. Lacan argues that inasmuch as we are cultural persons there is only an external reality – the desire of the other, language, the

Father's Law. It is almost impossible to identify historically variable and changeable aspects of relations of domination once these are posited as effects of a universal logic of language. His 'language' is drained of all social content and reduced to a formal structure; language operates as an independent force and its effects on the subject have no dependence on or interaction with the child's relations with actual others. The American psychoanalyst Jane Flax has recently proposed that the narcissistic premiss dominates Lacan's work and in particular his conception of the mirror phase, the most significant developmental moment of the infant's life. It is typical, she argues, that Lacan should imagine this moment to be constituted by a series of encounters between the infant and a reflecting surface, a mirror.[82] This mirror is a reflective object, not the loving gaze of a person who 'anticipates' the infant's wholeness as in the stories of Winnicott. The 'I' comes into being alone, as she puts it.[83] Her main objection to Lacanian theory is that the effects of language are thought of as having no dependence upon or interaction with the child's relations with actual 'others', especially the mother. In Lacan's narcissism she sees the fear of pre-Oedipal dependency on the mother which he casts as being a pre-cultural, non-social and non-interactive stage in the infant's development. Flax argues, consistent with other (feminist) object relations theorists, that it is perhaps less threatening to have no self at all than one pervaded by memories of or longing for suppressed identification with or terror of the powerful mother of infancy.[84] The individual who cannot recognize the other or his own dependency without suffering a threat to his identity requires the formal, impersonal principles of rationalized interaction and is in turn required by them. It is these staged and unemotional qualities that traverse the aesthetic quality of Burgin's own artwork and his theoretical writings on psychoanalysis.

A decline in the capacity to experience was precisely the problem identified by Walter Benjamin as the consequence of the commodification of art coupled to a general estrangement and alienation from an existence marked by authenticity. There was thus an interesting tension in his writings between a negative and positive response to the loss of aura.[85] In his 'On Some Motifs in Baudelaire'[86] he identified the decline of the aura as paradigmatic of a cultural decline in experience and of the intersubjective face-to-face experience. But it is interesting that, conversely, and in the interests of a radical practice, this is precisely what Burgin, following Derrida, has actively sought to do – to erase the marks of presence from photography and writing, and to embrace the loss of authentic self-experience; in fact to erase the category of individual experience altogether. Burgin's use of psychoanalysis, isolated from its concrete and primary origin as a relationship between two people in the space of a clinical setting, and the ensuing transference, also contributes to this loss of emphasis upon human intersubjective experience and the flight towards a masculinist, abstract and

universalizing theory. For example, in his *Office at Night*, the accompanying text states that the piece 'may be read as an expression of the *general* political problem of the organization of Desire within the Law, and in terms of the *particular* problem of the organization of sexuality within capitalism'.[87] This description is at a breathtaking level of abstraction. If women's oppression is to be taken seriously, the specificity of the concrete and the actual needs to be attended to. We cannot speak usefully about Language, Desire, Law, etc. if they are conceptualized in such a monolithic and a priori way.

The task of assessing whether it is possible or viable to make art objects which meaningfully illustrate psychoanalytic insights remains. Yes, there has to be a general theory of the unconscious, but the task remains of accounting for its particular manifestations in different groups and individuals. There can be no universal unconscious even in 'patriarchal culture'. Burgin's Lacanian position, in its transposition of the investigation of the subject from the field of consciousness to the field of speech, in its rewriting of the subject as a site within language defined by the techniques of displacement that constitute language, results in the subject becoming an effect. In the light of Bourdieu's critique of the aesthetic attitude, I have put forward the case that Burgin, like others, is a latter-day formalist, operating a two-pronged defence against both popular culture and the intersubjective and affective dimensions of psychoanalytic theory.[88] The value of psychoanalysis, and therefore of a photographic practice which seeks to engage with it, must derive not only from its extensions into the *theory* of psychoanalysis but also from its understanding of the psyche at a level which can take concrete forms of emotional experience and conflict into account.

Notes

1. Tony Godfrey, 'Sex, Text, Politics: Interview with Victor Burgin', *Block*, 7, 1982, p. 2.
2. Ibid., p. 4.
3. Victor Burgin, *The End of Art Theory*, Macmillan, Basingstoke and London 1988, p. 38.
4. On Burgin's theory of the relationship between word and image, see Victor Burgin, *Thinking Photography*, Macmillan, Basingstoke and London 1981, pp. 142–5. He also says, '. . . a text always intrudes – in a fragmentary form, in the mind, in association. Mental processes exchange images for words and words for images.' (In Godfrey, 'Sex, Text, Politics', p. 8.)
5. See Victor Burgin, *Between*, Basil Blackwell, Oxford, and ICA, London 1986, for reproductions and commentary of his work up to *Office at Night*.
6. Burgin's project *UK '76* provides an example of this use of text-image. The series consists of eleven black-and-white photographs, taken by Burgin, of various urban and suburban scenes. In all cases Burgin superimposed, in the manner of an advertisement, a printed text on part of the image, derived from existing prose found in the publicity media. In the panel entitled 'Today is the tomorrow you were promised yesterday', the message of the text lies in its connotation as erotic-poetic 'mythical' tourist discourse. The image shows a sprawling council housing estate, with a woman pushing a buggy. The text is intended to function strictly as a reference to 'myth', to that which is not true, the promise which is never realized in reality; the image is intended to belie the text, it contradicts it, *shows it* (denotationally) simply to be a myth, through its claim to be the real in a fairly unproblematic way. In projects like these the

photograph functions as evidence of the real; for it to work the audience must concur with a whole set of the artist's presuppositions – namely, that this is a vast, urban, sprawling housing estate, and that vast urban sprawling housing estates are symptomatic of capitalist values, an embodiment of alienation and poverty, and so on. See *Between*.

7. Godfrey, 'Sex, Text, Politics,' p. 81.

8. Ibid., p. 16.

9. For Roland Barthes's theory of text–image relations, see 'Rhetoric of the Image' and 'The Photographic Message', in his *Image, Music, Text*, trans. Stephen Heath, Fontana, London 1977.

10. See Burgin, *Between*, pp. 16–21.

11. Godfrey, 'Sex, Text, Politics', p. 9.

12. See Kevin McDonnell and Kevin Robins, 'Marxist Cultural Theory: The Althusserian Smokescreen', in *One Dimensional Marxism*, Allison & Busby, London 1980.

13. See Lukács on this point in 'Realism in the Balance', in *Aesthetics and Politics*, ed. Ronald Taylor, trans. Rodney Livingstone, New Left Books, London 1977, pp. 36–9. The view of social reality as radically heterogeneous posited by some of the postmodernists was presaged by these elements in Althusser's theory. Once one dispenses with the category of totality both in the sense of grounding a given social order in a central principle of organization and in that of the designation of the configuration of forces opposed to that order, notions of causality and determination give way to a random indeterminacy.

14. Antonio Gramsci, in my view, had a more sophisticated and productive account of the relationship of ideology to structure than Althusser. See A. Gramsci, *Selections from the Prison Notebooks*, trans. and ed. Quintin Hoare and Geoffrey Nowell-Smith, Lawrence & Wishart, London 1971, p. 376.

15. Stephen Heath, 'Narrative Space', *Screen*, 17 (3), 1976, p. 77. Christian Metz, 'The Imaginary Signifier', trans. Ben Brewster, *Screen*, 16 (2), 1975.

16. See Victor Burgin, 'Geometry and Abjection', in J. Donald, ed., *Psychoanalysis and Cultural Theory*, Macmillan, Basingstoke and London 1991.

17. See Louis Althusser, 'Ideology and Ideological State Apparatus', in *Lenin and Philosophy and Other Essays*, New Left Books, London 1971.

18. I do not have the space to enter into the detail of Burgin's use of Freudian theory as seen through a feminist reading of Lacan. For a sympathetic but critical account read Stephen Frosh, *The Politics of Psychoanalysis*, Macmillan, Basingstoke and London 1987, chaps 5–7.

19. Burgin, *Between*, p. 85.

20. Ibid., p. 195.

21. It is pertinent that Burgin prefers the appellation 'artist' to that of 'photographer' whom he sees as 'someone totally involved with the image.' In Godfrey, 'Sex, Text, Politics', p. 9.

22. Burgin, *Between*, p. 78.

23. See Jean Fisher, 'Chasing Dreams: Victor Hitchcock and Alfred Burgin', *Artforum*, May 1984.

24. See Michel Foucault, *Discipline and Punish*, trans. Alan Sheridan, Pelican, Harmondsworth 1977, pp. 195–228.

25. Burgin, *Between*, p. 80.

26. Ibid., p. 135.

27. See Michael Newman, 'Revising Modernism, Representing Postmodernism', in Lisa Appignanesi, ed., *Postmodernism: ICA Documents*, Free Association Books, London 1989, p. 124.

28. See n. 52.

29. The text underneath reads: '"Oh" (A door opens on a memory).'

30. For an excellent account of these two Hitchcock films and how they inform Burgin's *The Bridge*, see Fisher, 'Chasing Dreams: Victor Hitchcock and Alfred Burgin'.

31. Ibid.

32. Burgin, *Between*, p. 174.

33. Claire Pajaczkowska, quoted in Stephen Heath, 'Male Feminism', in Alice Jardine and Paul Smith, eds, *Men in Feminism*, Methuen, London 1987, p. 2.

34. Victor Burgin, 'The End of Art Theory', in *The End of Art Theory*, Macmillan, Basingstoke and London 1988, pp. 140–204.

35. See the work of Douglas Crimp, Abigail Solomon-Godeau, Craig Owen, Hal Foster, for example.

36. Burgin, *The End of Art Theory*, p. 37.

37. Godfrey, 'Sex, Text, Politics', p. 6.

38. Ibid., p. 6. Burgin has more recently continued his reference to a popular definition of photography thus: 'The environment increasingly – at least for us in the so-called developed western world – is an environment of images: from magazines, newspapers, films, videos, paintings in art galleries, snapshots and so on. I'm interested in that complex hybrid environment.' In Victor Burgin, 'Realizing the Reverie', *Ten:8 Photo Paperback: Digital Dialogues*, 2 (2), 1991, p. 9.

39. For example, Rosalind Krauss: 'photography deconstructs the possibility of differentiating between the original and the copy, the first idea and its slavish imitators.' In Rosalind Krauss, 'A Note on Photography and the Simulacral', in Carol Squiers, ed., *The Critical Image: Essays on Contemporary Photography*, Bay Press, Seattle 1990, p. 22.

40. Douglas Crimp, 'The Photographic Activity of Postmodernism', *October*, 15, Winter 1980, p. 27.

41. With the invention of the half-tone screen in the late 1880s, photographs became accessible to off-set printing, allowing the rapid mechanical reproduction of photographs. By 1910 degraded but informative reproductions appeared in almost every illustrated paper.

42. Walter Benjamin, 'The Work of Art in the Age of Mechanical Reproduction', in *Illuminations*, ed. Hannah Arendt, trans. Harry Zohn, Schocken Books, New York 1969, pp. 220–28.

43. Peter Bürger, *Theory of the Avant-Garde*, trans. Michael Shaw, University of Minnesota, Minneapolis 1984, pp. 27–34.

44. Likewise, the condition of modernism's interest in the machine age was the abstraction of techniques and artifacts from the social relations of production that were generating them, as Perry Anderson has argued, in his 'Modernity and Revolution', *New Left Review*, 144, March 1984, p. 99. It is also characteristic of some postmodernisms to define 'late capitalism' as a stage of development of the productive-technical forces (for example, 'Post-Fordism' and the 'New Times' of the late *Marxism Today*).

45. Howard Singerman, for example, takes a characteristic approach. See his 'In the Text', in M.J. Jacob and A. Goldstein, eds, *The Forest of Signs: Art in the Crisis of Representation*, MIT Press, Cambridge, Mass. 1989, p. 163.

46. Walter Benjamin, 'The Author as Producer', in Victor Burgin, ed., *Thinking Photography*, Macmillan, Basingstoke and London 1981.

47. Ibid., p. 17.

48. Abigail Solomon-Godeau, 'Living with Contradictions: Critical Practices in the Age of Supply-Side Aesthetics', in Carol Squiers, ed., *The Critical Image: Essays on Contemporary Photography*, Bay Press, Seattle 1990, p. 76. (Originally published in *Screen*, 28 (3) 1987.)

49. See Barbara Rosenblum, 'Style as Social Process', *American Sociological Review*, 43, 1981. She observes that the key feature of (modernist) fine art photography is a self-conscious representation of space and light and an 'abstract space sensibility'.

50. Burgin seems more at ease discussing technical aspects of digital imaging – see Burgin, 'Realizing the Reverie', pp. 8–9. He compares the 'cross-hatching' of fine, silk-screened lines on the computer screen with the medieval technology of steel engraving and (noting that the screen image is composed in the form of a mosaic) with the mode of representation in the classical period. Note his interest in making a comparison at the level of the 'look' of the image, thus eliding very real historical, technological and epistemological differences between these media and instead finding a basic homogeneity. The piece is littered with references to the technical control he can exercise over the image manipulation process. Given that electronic media mean great changes in terms of image distribution, storage and retrieval it is symptomatic of Burgin's production and creativity-oriented attitude that he should overlook some of the social specificities of the technology.

51. Burgin says: 'Colour photography is also more on the side of illusion than is black and white . . . colour photography will tend to look anecdotal by comparison. I want to stress the image not as illusion but as *text*, to be read.' Godfrey, 'Sex, Text, Politics', p. 8.

52. Burgin, *Between*, p. 86.

53. See Raymond Williams, *Culture and Society, 1780–1950*, Pelican, Harmondsworth 1958, pp. 48–65.

54. Perry Anderson, *Considerations on Western Marxism*, Verso, London 1979.

55. Douglas Crimp, 'Appropriating Appropriation', in *Image Scavengers*, exhibition catalogue, Institute of Contemporary Art, University of Pennsylvania, Philadelphia 1982–83, p. 27.

56. Burgin, *Between*, p. 138.

57. Peter Dews, 'From Post-Structuralism to Postmodernity', in Lisa Appignanesi, ed., *Postmodernism: ICA Documents*, Free Association Books, London 1989, pp. 38–9.

58. See Burgin, *Between*, pp. 1–50.

59. Ibid., pp. 187–97.

60. David Harvey, *The Condition of Postmodernity*, Basil Blackwell, Oxford 1989.

61. Bürger quotes Bernard Hinz regarding the 'special' autonomy of art: 'The reason that his product could acquire importance as something special, "autonomous", seems to lie in the continuation of the handicraft mode of production after the historical division of labour had set in.' Bürger, *Theory of the Avant-Garde*, p. 36.

62. Ibid., p. 36.

63. Pierre Bourdieu, 'The Production of Belief: Contribution to an Economy of Symbolic Goods', in R. Collins et al., eds, *Media, Culture, Society: A Critical Reader*, Sage, London 1986, p. 136.

64. Bürger, *Theory of the Avant-Garde*, p. 3. As Nicholas Garnham and Raymond Williams have pointed out, one of Bourdieu's original contributions has been to suggest that it has been characteristic of the development of cultural practice in the narrowly artistic sense to maximize the complexity of coding (or level of 'difficulty') both textually and intertextually (thus requiring a wider and wider range of cultural reference, art being increasingly about other works of art) and this development has meant that art necessarily requires for its reception high levels of consumption time which is differentially available between the classes. See Nicholas Garnham and Raymond Williams, 'Bourdieu and the Sociology of Culture', in R. Collins et al., eds, *Media, Culture, Society: A Critical Reader*, Sage, London 1986.

65. This wish to abolish the 'pleasure' of the filmic text, considered as irreclaimably ideological, was very much part of the spirit of *Screen*'s avant-gardism, as Laura Mulvey famously put it: 'It is said that analysing pleasure, or beauty, destroys it. That is the intention of this article . . . to make way for a total negation of the ease and plenitude of the narrative fiction film.' (Laura Mulvey, 'Visual Pleasure and Narrative Cinema', *Screen*, 16 (3), 1977.)

66. Pierre Bourdieu, *Distinction*, trans. Richard Nice, Routledge & Kegan Paul, London 1979, p. 488.

67. Ibid., p. 33.

68. The mistake that postmodernists have made in their critique of modernity is the equation of 'reason' with but one of its manifestations – that of instrumental rationality and its calculation of efficient means for achieving given ends. In fact, the very possibility of a critique of domination of the kind to which Burgin and others are committed has its roots in the Enlightenment's interrogation of the controlling impact of tradition and the authority of the merely conventional.

69. See Newman, 'Revising Modernism, Representing Postmodernism'.

70. Michel Pêcheux, *Language, Semantics and Ideology*, trans. Harbans Nagpal, Macmillan, London 1982, p. 211. For a highly critical and amusing account of the dictatorial attitude of this '*nouvelle mélange*', based upon a review of Rosalind Coward and John Ellis's *Language and Materialism*, see Jonathon Ree, 'Marxist Modes', *Radical Philosophy*, 23, 1979.

71. Where Althusser differs from Lacan is in his emphasis upon recognition rather than misrecognition ('*misreconaissance*') as the means by which the subject is constituted to itself and to others. Lacan did not intend the ego to be centred upon the consciousness-perception system nor to be a result of adjustment to external reality. The disparity between Althusser and Lacan is due to the fact that the emphasis upon successful 'recognition' fits Althusser's functionalist theory of social reproduction as it is elaborated in his 'ISAs' essay.

72. In Burgin, *Between*, p. 58.

73. Interview with Geoffrey Batchen, 'For an Impossible Realism', *AfterImage*, 16 (7), February 1989, p. 7.

74. Amelia Jones, 'Romancing the Father', *Artscribe International*, March–April 1991, p. 48.

75. Quoted in Dews, 'From Post-Structuralism to Postmodernity', p. 36.

76. Victor Burgin, 'The Bridge', *Creative Camera*, 232, April 1984, p. 1334.

77. See n. 74.

78. Laura Mulvey, 'Kruger and Burgin', *Creative Camera*, 233, April 1984, p. 1377.

79. Burgin, *The End of Art Theory*, p. 197.

80. Burgin, 'The Bridge', p. 1334.

81. On this problem in Lacan's thought, see Ian Craib, *Psychoanalyis and Social Theory*, Harvester Wheatsheaf, Hemel Hempstead 1989, pp. 116–29.

82. Jane Flax, *Thinking in Fragments*, University of California, Berkeley 1990, pp. 89–96.

83. Ibid., p. 93. On this point, see Caroll Gilligan, 'Mapping the Moral Domain: New Images of the Self in Relationship', in T. Heller, M. Sosna and D. Wellberry, eds, *Reconstructing Individualism: Autonomy, Individuality, and the Self in Western Thought*, Stanford University Press, Stanford 1986.

84. Ibid., pp. 94–5. See also Jessica Benjamin, *The Bonds of Love*, Virago, London 1988.

85. See Susan Buck-Morss, *The Origin of Negative Dialectics*, MIT Press, New York 1977, pp. 160–61.

86. In Walter Benjamin, *Charles Baudelaire: A Lyric Poet in the Era of High Capitalism*, trans. Harry Zohn, Verso, London 1989.

87. Burgin, *Between*, p. 183.

88. I have noticed a possible psychological parallel between the postmodern artist's aesthetic distancing from popular culture, the associated repudiation of realism (for example, the retreat into a fascination with codes and rhetorics), and some remarks made by the Scottish psychoanalyst W.R.D. Fairburn in a 1940 paper 'Schizoid Factors in the Personality'. The schizoid personality typically involves 'the depersonalization of the subject and de-emotionalization of the object relationship'. In these patients Fairburn notes the presence of feelings of artificiality (the 'plate glass feeling'); attitudes of omnipotence, isolation and detachment; the staged qualities of their experiences and the considerable difficulty in giving in the emotional sense. They deal with this by the technique of exhibitionism which involves a defence – it is a technique for giving without giving, by means of a substitute of 'showing' for 'giving'. A strong intellectual defence also operates, often involving an excessive use of words. This is cited in Masud R. Khan, *The Privacy of the Self*, Hogarth Press, London 1986, pp. 13–26. This is not to suggest an account of historical stages of personality types as in Fredric Jameson's theory of schizophrenia, but rather to try to allow for a psychoanalytical dimension to the debate on the attitude and identity of the artist-intellectual.

8

Circuit-breaking Desires:

Critiquing the Work of

Mary Kelly

Catherine Lupton

What *else* is there to say about the work[1] of Mary Kelly? The question might seem ridiculously simple, an unnecessary piece of rhetoric to put at the beginning of an essay which would be assumed to be pointless unless it had something else to say. Yet, broadly charged with the task of writing critically about Mary Kelly's art practice and influence from a historical materialist perspective, I have come to the conclusion that one, if not the major, critical issue regarding her work is a practical difficulty in actually locating a space from which to articulate that 'something else'.

My broad hypothesis is that the discursive apparatus which exists around 'Mary Kelly'[2] is, within its own terms, a remarkably self-sufficient and smooth-running mechanism which is very difficult to question or disrupt, without adopting critical positions which this apparatus has already managed to deflect or contain. The reasons for this phenomenon can be located in the particular formation of Mary Kelly's art practice at the conjunction of certain paradigmatic moments in the history of second-wave white Western feminism[3] and its encounter with varieties of post-structural critical theory. Kelly's best-known works, *Post-Partum Document* (1973–79) and *Interim* (1984–89), deal with the complex formation and lived experience of certain moments of feminine subjectivity, respectively motherhood and middle age, and are thus intimately concerned with one of the major endeavours which have characterized second-wave feminism: the exploration of 'what it is to be a woman'.[4] The fact that they are thus implicated in the analysis and, by extension, (re)formation of feminine or feminist identities only compounds the difficulty of formulating a critique of Kelly's work.

Taking this difficulty as the central problematic of the essay, I have adopted the structure of three interdependent sections which each makes a particular foray into or around the discursive apparatus named above. The

overall movement is from describing the broad historical circumstances within which Kelly's works have been produced, to analysing particular effects of their relationship to those circumstances, to examining the character, operation and some implications of their attendant critical discourse. This movement does not, however, map a 'real' chronology or make any pretence at critical plenitude. The first part sets out to describe the historical circumstances which have shaped Kelly's practice: principally the development of second-wave feminism since the late sixties, and also the general evolution of academic culture in relation to the political profile of the state over the same period. These circumstances are not understood as simply formative of Kelly's work through a movement of straightforward determinism. Rather, her practice is considered to work upon and shape these historical trajectories, by a process which represses many of their implications, as much as it engages with and figures them. The second part examines the operation of the extended discursive apparatus around Kelly's practice, and suggests that its particular mobilization of a feminist politics and certain bodies of post-structuralist theory has both short-circuited existing attempts to critique her work, and effectively foreclosed on the question of interpretation. The final part adopts a psychoanalytic perspective and posits 'Mary Kelly' as an object of desire for those women who spectate and write about her work, suggesting that the process of consuming Kelly's work is a significant factor in their figuration of a feminist identity: this is in spite of the fact that psychoanalytic theory posits identity as an unstable and illusory category.

Described like this, these different avenues of investigation appear markedly discontinuous, as they move from considering historical conditions of production and the relation of works of art to them, on the one hand, to an apparently more abstract examination of the operation and effects of the discursive apparatus around these works, on the other. I have chosen to leave this discontinuity in place, rather than fully arguing through the determinate connections between the different sections of the essay. At the same time, it is taken as read that the critical discourse around Kelly's work *is* somehow symptomatic of the historical circumstances within which it has developed. Put another way, this essay derives its structural formation less from a systematic excavation of the historical conditions which have determined Kelly's practice, than from the assumed priority of finding ways to disrupt that self-sufficiency of the critical discourse around her work which I described at the beginning. In this sense, 'history' is not the disinterested stringing together of a coherent historical narrative from the traces of the past. It is, rather, a critical practice carried out, in the spirit of Walter Benjamin's 'Theses on the Philosophy of History', with full consciousness of the weight and concerns of the present: 'To articulate the past historically does not mean to recognize it "the way it really was"... . It means to seize

hold of a memory as it flashes up at a moment of danger.'[5] My own memory consists of all the written, oral and visual traces I have stored up, of the history, aspirations, achievements and losses of second-wave feminism. My moment of danger is the continual experience of seeing so many of these traces being culturally overwritten and then lost. As I hope the body of this essay will make clear, the work of Mary Kelly is, to my mind, intimately bound up with both the memory *and* the danger.

'Historical Conditions': Articulation and Repression

If the beginnings of second-wave feminism in Britain are dated to 1970, when the first National Women's Liberation Conference was held at Ruskin College, Oxford, then the story of its historical fortunes could run something like this.[6] The expansion of higher education and the public sector during the sixties had enhanced educational and employment opportunities for women, and led to the beginning of demands for equal opportunities. In the same period, the involvement of women in radical political and counter-cultural life galvanized their recognition of sex discrimination, partly because these movements provided the model for the kind of personal liberation politics which feminism deployed; and then ironically because of the extent to which women experienced gender discrimination within them. Women began to organize together in consciousness-raising groups, where personal experiences were articulated and shared, and from this came the realization that women were most strongly oppressed in those areas of life normally treated as personal and private – the family, sexuality and the domestic arena. From this understanding came the slogan 'the personal is political', instating women's experiences across all aspects of their lives as the linchpin of political identity and activity, and asserting that supposedly private and individual aspects of identity are in fact the result of public processes of socialization. On the basis of this understanding, women began to campaign for an end to all discrimination on the basis of gender, with the implicit assumption that all women's experience of sex discrimination was fundamentally the same. In tandem with this process, feminists began to unearth the hidden history of women's participation in culture, and to develop systematic theories to account for the oppression of women. A number of different theoretical accounts emerged, which became the basis of two different and increasingly opposed strands of feminism. Radical feminism posited the oppression of women by men as the fundamental division of society, a division which was manifested in all cultures throughout history. Socialist feminism saw the oppression of women as something historically implicated within the class divisions of capitalist society, and began to extend the analytic categories of

Marxism to theorize sex discrimination as operative in the service of capital. It was principally within the ambit of socialist feminism that psychoanalysis was deployed as a means of theorizing the acquisition of gendered identity through ideological representations.

As the seventies wore on, however, the initial appeal to universal sisterhood began to break apart, as women began to articulate differing and often contradictory experiences of gender oppression, inflected by class, race and sexuality. Differences also emerged as a result of the increasing specialization of feminist activity into different projects, and the division between campaigning and theoretical work. Eventually, the structural existence of a unified women's movement broke down under the weight of these differences – the last National Women's Liberation Conference was held in 1978 – and feminism fragmented to become a specified presence within different and operatively discontinuous areas of life: for example, localized campaigns within the political framework of municipal socialism which marked the early eighties; feminist campaigning on health and reproductive rights issues; and the development of 'feminist approaches' and Women's Studies within the various academic disciplines. Common parlance referred to a multiplicity of feminisms, and the need to develop political perspectives which respected differences among women. This very rhetoric, however, increasingly masked a paradox of uneven development between theoretical and academic feminist discourse, which gained strength, cogency and a significant degree of institutional acceptance during the eighties; and feminist political campaigns, which over the same period faltered and were radically undercut in a conservative and reactive political climate. A situation arose whereby theoretical feminist discourse became the key social site where 'feminism' was defined and mobilized as a political identification and mode of practice. This discourse has effectively taken up the mantle of attempting to distil some commonality from the various feminisms now acknowledged, and synthesize it into a unified political entity.[7] This project is rendered ever urgent by the palpable fact that social discrimination against women is still widespread, but ever more difficult to achieve as gains like abortion rights are undermined while, at the same time, liberal-humanist equal rights feminism is successfully mobilized by the political right to deflect, diminish and contain the more radical demands thrown up by the history of second-wave feminism.

This historical trajectory of feminism is closely implicated within a broader pattern of politico-cultural shifts in Britain, in the two decades after 1968. Bearing in mind the developing profile of theoretical and academic feminism described above, the most pertinent frame of reference is the change in the profile of British intellectual life over that period. Perry Anderson has provided systematic accounts of this shift, from both a 'before' and 'after' perspective.[8] In 1968, he developed a structural account of the

state of British academia, in which intellectual activity was characterized overall as a liberal-empirical support to the state Establishment. The major reason for this was identified as the historical failure of academic disciplines to develop a totalizing account of the British social formation, located specifically in the lack of both a mature sociology and a serious engagement with Marxism. This failure was traced to the absence of a bourgeois revolution within British political history. Twenty-one years later, Anderson produced a lengthy follow-up article which set out to examine how the same structure had changed in the intervening period. The most striking characteristic was seen to be how the radical left had gained theoretical ground within academia. Many of the humanist and social science disciplines had undertaken the development of those totalizing accounts of society which had been lacking, actively engaging in the process with the debates around Marxism and post-structuralism which had been developing on the Continent, particularly in France. Anderson notes particularly the expansion of the critical journal as the paradigmatic forum for articulating these developments.[9] Feminism is acknowledged as having made a significant though uneven impact across the whole range of disciplines discussed. However, this phenomenon of left intellectual blossoming is set within a political and social climate of increasing Conservative reaction. The net effect of the Conservative government's financial cutbacks and ideological attacks on British higher education is characterized not simply as a polar confrontation between the radical left and Thatcherism, but as the effective rupture of the liberal-intellectual support for the political status quo, insofar as Thatcherism undermined the values of traditional liberalism and provoked the opposition of the academic establishment to its educational policies.

Here, the principal question relating to this historical account must be what relationship the art practice of Mary Kelly bears to it. The title of this section suggests a dual aspect to this relation, whereby Kelly's work is seen as not only articulating these historical circumstances, but also as mediating an understanding of them which at some points amounts to a repression of certain of their implications. Before considering the dynamics of this dual movement, it is important to displace any notion that Kelly's work simply 'reflects' a given set of historical circumstances, or even that it 'works' them into culture in a straightforward way. The difficulty with this kind of assumption about artistic activity is that it tends to limit the significance of works of art to their immediate circumstances of production and consumption, and, further, is unable to address two questions which are of signal importance in relation to Kelly's practice. The first is the issue of why her work has achieved such a high profile as a feminist-informed art practice. The second is to address how it might be implicated in a more complex process of figuring, negotiating and effectively managing its historical

conditions of production than the model of simple determinism appears to allow. It should also be reiterated that both the broad movements of 'paradigmatic' articulation and repression which are discussed below are grasped as existing within a constellation[10] of circumstances which is articulated from the perspective of the present.

I have already indicated the partiality of that trajectory of feminist history with which Kelly is most intimately associated. Culturally, socially and generationally specific, this history could be roughly characterized as that of (principally) white women working in Britain, who identified themselves as socialist feminists and took up the mantle of developing theorized accounts of women's oppression, adopting Marxist and then psychoanalytic perspectives. Given the particularity of this history, however, it is interesting to note that the accounts which have been made of it tend to concur on major issues and developments, even though the value of their consequences might be contested. This 'official version' of the development of British socialist feminism is followed through in my own brief account. What is most striking about Mary Kelly's two major works, assessed from the perspective of this historical knowledge, is how they seem to be uncannily paradigmatic of key moments in this trajectory, in terms of both their chosen subject matter and their subsequent effects within wider feminist discourses on historical and cultural issues. The two moments which stand out are, first, the moves made during the mid-seventies to theorize the social acquisition of a gendered identity through the intersection of Marxism and psychoanalysis, and, second, the fragmentation of feminism as a political force, in the face of differences among women. These are the precise moments where Kelly's extended projects appear as interventions, both produced by the circumstances of these two moments and functional as sites through which responses to these moments are then articulated.

Viewed from the perspective of the present, both *Post-Partum Document* and *Interim* stand out as paradigmatic feminist artworks, in the sense that both appear to have emerged from, and successfully articulated, highly significant moments within the history of second-wave feminism, integrating both form and content in a representation of that 'moment' which is both novel and has the capacity to alter the existing representational forces through which people experience the material world. Furthermore, both works represent the articulation of feminism with other developments in post-structuralist theory and established art practice.

Post-Partum Document, which worked to trace the reciprocal social and psychic formation of maternal and infant subjectivity through the process of childrearing, was perhaps the first cultural product of feminism's theoretical intersection of Marxism and psychoanalysis, and subsequent instatement of psycho-social subjectivity as the principal locus of women's oppression. Maternal femininity was conceived as a process, rather than a fixed and

stable identity; a process which occurred at the intersection of a range of discontinuous social discourses on mothering, including popular medicine, statistics, psychoanalysis and autobiography, all inflected by the social division of labour in childcare. The historical circumstances which enabled maternal subjectivity to be thus understood include that highly influential body of theoretical work on the social and psychic formation of identity *through* discursive representations which is associated particularly with the British film periodical *Screen*. Feminism contributed an increasing recognition on the part of many women that gender oppression is most sharply focused upon the so-called 'personal' realms of sexuality, subjectivity and reproduction. Kelly was able to figure and articulate together these developing concerns and knowledge through *Post-Partum Document*, by mobilizing and combining a range of representational strategies including Brechtian cultural praxis, Conceptual Art tactics and developing feminist priorities for art-making.[11] The instatement of feminism, specifically the 'presence' of the maternal subject in the work, is of pivotal importance as it becomes the point through which the various social discourses around maternity are both articulated and found lacking, and at which the gender-blindness of established art practices can be exposed. It is through the process of consuming the work and excavating the traces of this presence that *Post-Partum Document* may be seen to instate the potential to alter established cultural representations of femininity, in this case specifically motherhood.

Interim, the major project which Kelly produced during the eighties, deploys a similar range of theoretical and artistic strategies to examine the formation of female subjectivity at middle age. However, much as this work takes up the assessment of a 'personalized' generational and psychic dilemma for women, at a point in life where their experience of themselves as 'feminine' subjects falters and comes apart, *Interim* is also concerned with a more 'public' project of assessing the impact of second-wave feminism at a point when it, too, is starting to come apart as a unitary movement. Kelly can thus be seen as having an implicit focus on an 'interim' moment for feminism itself, as much as on the now middle-aged women who shaped it.

This apparent success of Kelly's projects, in figuring and articulating the key thematics of second-wave feminism and altering the representational means through which the world is understood, is underwritten by an exceptional 'personal' and 'political' duality which marks their formation. The presence of a 'personal' or autobiographical voice features strongly in both the major works, as one of their most immediate points of identification and access. While this voice is not necessarily Kelly's own, nor is it privileged over the other discursive registers in each work, there is still an impetus of personal investment on the part of the artist in the subject matter of the two works. Her own experience of mothering is used as the raw material of *Post-Partum Document*, and she is entering middle age at the time

when *Interim* is made. Yet the impetus for the two works can also be located within a broader, collective framework of feminist experience. *Post-Partum Document* partly resulted from Kelly's involvement in the collaborative exhibition 'Women and Work',[12] where research into the daily lives of part-time women factory workers revealed that their temporal and emotional investments lay in domestic labour and childcare, rather than paid work outside the home. On the basis of this evidence, the subordination of women at work was related to their assumption of responsibility for childcare and domestic labour, and maternity became a prime object of feminist analysis. *Interim* was developed from an archive which Kelly maintained of conversations with middle-aged women who had been active within the women's movement. It was from these conversations that she identified four principal concerns of the women – the body, money, power and history – which then shaped the four sections of the project: *Corpus, Pecunia, Potestas* and *Historia*.

The high profile which Kelly's practice has attained within the feminist art community can certainly be accounted for in part by this sense that her work has successfully articulated and represented moments within feminism which are seen as 'monumental', to use Benjamin's term. Yet this process of articulation functions at the same time as an effective, and selective, management of the historical circumstances of its formation. This raises the contention that some aspects of the historical developments outlined above are repressed, both by Kelly's practice itself and by the wider discursive apparatus which works to secure its critical profile and artistic identity. The most signal absence from the discourse is an acknowledgement of the negative consequences of the faltering and disruption of the political women's movement since the early eighties. Now this is not to suggest that the effects of political reaction upon feminist achievements are not recognized, nor that the impact of divisions among feminists on the profile of the women's movement is disavowed. Rather, Kelly's work – the case in point being most obviously *Interim* – and its discursive apparatus function together to instate her practice, and incidentally the theoretical, cultural and political problematic which informs its production, as one of the key strategies by which feminist resistance can continue to be mobilized. At the same time, it is constructed as a kind of practice which enables the recognition, rather than the repression, of differences among feminists. This process is borne out in Griselda Pollock's 'Screening the Seventies', an extensive essay which examines the deployment of Brechtian cultural strategies within British left political art during the seventies.[13] Both of Kelly's major works are discussed, and *Interim* is seen as representing the extension and continued validity of these ideas within the changed cultural and political climate of the eighties. Pollock concludes the essay thus:

Postmodernism, post-feminism, all, we are told, is retro, passé, no longer relevant. But the changes for which the women's movement struggles have not come about. There remains violence against women, exploitation, increasing poverty and worldwide inequality. There is power, but there is resistance. These facts of social reality must not be swept away in the gloss and glitter of the spectacle.... While the Brechtian modernism of the 1970s is being transformed tactically as it must by the conditions and debates of the 1980s, its theoretical and practical contributions for a political art practice remain a valid and necessary component of the contemporary women's art movement.[14]

This representation of a continuity of feminist history and struggles is also borne out in *Interim*, perhaps most strikingly in the *Historia* section. This consists of four steel podia, all shaped like an open magazine on a lectern. Each 'double spread' juxtaposes a negative photographic image of a suffragette being arrested and one letter of the word 'VIVA', with a page of text. This page is divided into three columns, each containing in a different typeface three different and discontinuous narrative discourses referring to historical moments of second-wave feminism. Each left-hand column contains a first-person narrative of how four women from differing social backgrounds, aged respectively thirty, twenty, ten and three in 1968, came to identify themselves as feminists. The middle column consists of narrative fragments of historical occasions within the women's movement, when it could be said that women came to recognize each other in a manner whence the dominant ideological circuits of feminine subjectivity might be breached; for example, an acknowledgement of the differences between women occasioned by a delegation of white British feminists meeting with a group of Vietnamese women. The third column is an ongoing ironic and humorous account of older feminists at a party, pondering the current state of the movement. *Historia* works to emphasize the multiplicity and discontinuity of experiences within, and intepretations of, second-wave feminism; and it takes on the question of how the political and cultural presence of the women's movement might have enabled shifts in women's subjectivity. However, it is still worth remarking that all the 'women' in Kelly's account *do* in the final analysis identify as feminists. The other histories which might be told of women who have ceased to make this identification, or who have never found a space from which to forge it, are not brought within the bounds of the text. The extent of their presence 'within' the text, does not go much further than the acknowledgement that certain dimensions of the text exceed interpretation.

Interim thus becomes inscribed as a kind of testament to the historical continuity of feminism, which can also point the way towards transcending current difficulties. However, this positive representation of Kelly's practice fails to acknowledge explicitly its own limitations as a solution to the political

problems of feminism. It also does not fully confront the extent to which her work, or, to be more accurate the discourse which supports it, has come to be perceived by sections of the feminist art community as part of the problem.[15] The criticisms put forward from here have challenged the claims made for Kelly's work, on the grounds that its own confidence as cultural production has been matched not by an attendant burgeoning of the political women's movement, but rather by its demise; and that its notable concern with theories of the production of sexed subjectivities through language and representation is not appropriate to the needs of all women, but has been presented as though it should be.

From one perspective, such criticisms can be taken as straightforwardly symptomatic of the historical fragmentation of feminism described above, and the extent to which Kelly's practice and its attendant discourse repress this problem. In the light of my principal contention in this essay, the exceptional self-sufficiency of the discursive apparatus around Kelly's work, an awareness of these historical circumstances does provide a lever to critique and decentre its apparent seamlessness. At the same time, it is not adequate simply to condemn the Kelly discourse for being blind to history. This assertion does not fully take into account the way in which this apparatus is implicated in the continuing identification and production of feminism as a discursive entity, bearing in mind the suggestion made above that it is precisely theoretical and academic feminism which has come to bear this burden as feminism has become more of a political absence. In short, the abandonment of a rhetoric of political effectivity for Kelly's work would amount to the abandonment of feminism, as it has come to be understood over the last twenty-odd years. In spite of its difficulties, it yet remains vital to uphold this understanding in a reactive political climate which would otherwise quickly and willingly erase it from historical consciousness altogether: 'every image of the past that is not recognized by the present as one of its own concerns threatens to disappear irretrievably.'[16] Even this admission raises a further set of contradictions, for as long as feminism remains effectively the prerogative of those women who have the class, racial, financial and educational privilege and power to theorize and define it, it will remain highly circumscribed in its potential for promoting radical social change. It is also immensely difficult to see how this division of 'feminist labour' among women can be overcome, as it is overdetermined by feminism's inescapable existence within a globalized capitalist social formation.

The issues raised by Kelly's practice in its relationship to, and management of, the historical circumstances of its production are evidently complex, and I do not intend to engage them any further here. I now wish to examine in more detail the formation and operation of the broader discursive

apparatus around her work, considering how its smoothness and self-sufficiency are established, and what implications these latter have for the business of developing critical perspectives on Kelly's practice.

Treading the Circuit

> ['Art'] is never given in the form of individual works but is constructed as a category in relation to a complex configuration of texts ... [the exhibition system marks] a crucial intersection of discourses, practices and sites which define the institutions of art within a definite social formation. Moreover, it is exactly here, within this inter-textual, inter-discursive network, that the work of art is produced as text.
>
> MARY KELLY, 'Re-Viewing Modernist Criticism'[17]

Mary Kelly's essay 'Re-Viewing Modernist Criticism', published in *Screen* in 1981, remains one of the most cogent attempts at articulating and dismantling the implicit assumptions of modernist art criticism about the nature of art practice, and the processes by which it is socially mobilized and consumed. The piece ranges over the incompatibilities and divisions within modernist discourse, and challenges the apparently linear and discrete process of production–distribution–consumption which it constructs. Briefly, modernism posits a self-possessed and unique (male) individual, the artist, who produces works of art through a process of creative struggle during which the 'essence' of his (sic) individuality is directly deposited on the canvas (painting being the paradigmatic modernist art practice). The 'artness' of the works is already established, and it is then the job of the critic, exhibition organizer and historian to simply describe and present this 'artness', read as transparently 'present' on the surface of the canvas. What Kelly instates instead of this model is an understanding that the processes of art-making, the exhibition apparatus and the protocols of critical and historical writing on art form 'interdependent moments in the circuits of production and consumption of culture under capitalism'.[18] Existing discourses on art, produced through the various social institutions of culture, prefigure and determine the processes of art-making, which Kelly conceptualizes as specific interventions within a 'determinant discursive field'.[19] The resulting 'work of art' will have reciprocally determining effects within this discursive field; but its identity and positionality as 'art' within it, as the quotation given above makes clear, are produced by the related practices of exhibiting and critical writing, and not established a priori. The presumed essential creative identity of the artist, and the transparent presence of this identity within the works (s)he produces, are also challenged. Kelly counters the unitary asocial model of identity by posing the question of sexual

difference as a cultural construction. The introduction of the woman artist into the discussion posits the social divisions of identity, in her case between Woman as the culturally normalized object of the look, and Artist as (masculine) subject of the look, producer of representations. Furthermore, if the practices of art-making are recognized as conventional codes of signification, they cannot be the unique property of the individual artist; and if conceptualized as a kind of language, they actually function to inscribe differences which trace the loss of an imaginary self-presence, rather than making this presence manifest.

'Re-Viewing Modernist Criticism' is important in the context of this essay for two reasons. First, it is a paradigmatic instance of the establishment of a meta-discourse *about* the entire social apparatus which produces 'Art' as a recognizable category of practices and objects. Its main function as a written intervention into this apparatus is to tell us that it *is* one, characterized as a determinant discursive field, to name the related practices within it *as* interdependent and mutually determining, and to describe generally some of the structures and effects of this interrelationship. The possibility of producing such a meta-discourse arises from the historical interweaving of a range of structural and post-structural social theories including Althusserian Marxism, Brechtian cultural theory, Lacanian psychoanalysis and Foucauldian concepts of discourse, all inflected by feminism and developed as the support and justification of a particular kind of left cultural politics during the seventies, effected particularly through the pages of *Screen* itself. The resulting theoretico-politico-cultural formation can be usefully and more conveniently referred to as the '*Screen* problematic'; a problematic being defined as 'the underlying theoretical or ideological field which structures the forming of concepts and the making of statements'.[20] Without discussing this formation in detail, what I do want to draw attention to here is the fact that it can name discourses and their operations *explicitly as such*, with the result that cultural interventions made from within this formation are characteristically self-reflexive: they have come to narrate not only their own specific objects, but also the act of their existence as overdetermined moments within discourse. If Kelly's work and its attendant critical writing are acknowledged as paradigmatic interventions in this respect, then this 'dual narration' effect is central to the nature and consequences of their operation as a discursive apparatus.

The other reason why I chose to consider 'Re-Viewing Modernist Criticism' at some length was the fact that Kelly herself wrote it. This is not a happy accident, but one instance of the numerous ways in which Kelly has purposefully transcended the division of labour which conventionally marks 'artists' off from 'critics', 'curators', 'theorists', 'historians' and 'teachers'. This division is not only materially inscribed by the workings of capitalism, but is maintained at the level of discourse to sustain the (modernist) illusion

of autonomy for each of the different practices which constitute the discursive field of art. Mary Kelly has at some point in her career occupied all the other roles listed,[21] as well as having been extensively interviewed, and being an articulate and engaging expositor of her own work. This deliberate and sustained confounding of the 'separate spheres' of art discourse undoubtedly contributes further to Kelly's high profile and influence within the contemporary art world. In this range of activity, only a few other practitioners, for example Victor Burgin and Art & Language, are comparable in the extent to which they have intervened critically within a generalized discourse on modernism which stretches beyond the confines of their own particular practice. The range and complexity of Kelly's operations also denies the popular profile of artists as *idiots savants*, who cannot fully explain their art and therefore require the ancillary support of critics to do this for them, or who resent the work of the critic altogether as a distortion of the 'authentic' meaning of their work.

The cumulative outcome of these two phenomena, the 'dual narration' effect of works of art formulated within the '*Screen* problematic', and the range of Kelly's interventions across the conventional division of labour within the art apparatus, is the remarkable coherence and self-sufficiency of the discursive apparatus around 'Mary Kelly', which I noted in my introduction. Its very self-consciousness *as* discourse, the fact that it can locate structurally and explicitly the ideological interests which underpin *all* interpretive positions (including its own), makes it exceptionally watertight against certain avenues of criticism which it is able to contain and overturn within itself. This same process does, however, have the potential to make Kelly's work immune to criticism altogether, a profoundly paradoxical situation given that the discourse always exhibits the partiality of its own interests and never claims to offer a complete interpretation.[22] The paradox is compounded by the cumulative effect of reading through the critical literature on Kelly's work, where it becomes starkly apparent that there are 'right' and 'wrong' answers to the question: what are *Post-Partum Document* and *Interim* about? – a realization which begs the more general question of the status of interpretation in relation to Kelly's works.

The points I have just covered already suggest a discursive operation of considerable sophistication and complexity, which needs to be examined in greater depth. For the purposes of space, this operation will be roughly hypothesized on two levels. One is the 'literal surface' of the discourse, or alternatively the specific critical moves which are made to secure the validity of Kelly's work. These are relatively easy to work out by reference to particular examples. The other is the 'problematic effect' of the discourse. By this I mean the range of often implicit effects which result from the formation of Kelly's work and its attendant critical discourse within the *Screen* problematic described above. These effects are less easy to locate by example,

so will be described as a hypothetical abstraction. These two levels can be thought as corresponding to the 'dual narration' effect described above.

> Any artwork ambitious to be read as a historical text *cannot* try to revive the *contained and delimited* meaning of traditional history painting. It *cannot*, moreover, be *satisfied* with the *harmless*, modernist play of the signifier in its *endless evasion* of meaningfulness. Rehearsal and quotation from the *overloaded* sign systems of contemporary mass culture, similarly, are *insufficient*. Julia Kristeva writes of aesthetic practices needing to take *ethical responsibility* for the production of *political knowledge*. One conceivable site for such an ethico-political supersession of history painting, modernist art and postmodernist spectacle is the *calculated and playful textualities* of projects like INTERIM. They summon and *redefine all our presences* in the signifying spaces they create by their interventions in the historical, the textual and the subjective. These are initiated as feminist, but *inevitably exceed* that originating moment to affect *all subjects, all identities, all sexes*.[23]

This is the concluding paragraph to Griselda Pollock's catalogue essay for *Interim* at the New Museum of Contemporary Art in 1990. It doesn't cover every specific dimension of the discursive apparatus around Kelly's work, nor does it indicate how its concerns have adapted over time to accommodate historical changes which have affected her practice,[24] but it serves well enough to summarize the main assumptions and rhetorical strategies of the discourse. A range of established art practices (and usually their implicit ideologies) are presented as problems. These problems are normally conceptualized in the form of a limitation, a blockage or blind spot. In the passage above, traditional history painting, classic modernist abstraction and postmodernist works which manipulate cultural systems of signification are variously characterized as: 'contained ... harmless ... [evasive] of meaningfulness ... insufficient'. Their limitations are presented as resulting from a specified lack of awareness. The first two practices fail to recognize their own status as discursively sustained textuality. '[P]ostmodernist spectacle' is assumed to embrace this recognition. All three strategies, however, are ultimately measured and found wanting by the yardstick of political responsibility. *Interim* is then posited as the paradigmatic work which carries this political charge, even though it is named as only one possible option. Because this political charge is consciously linked to the textual strategies deployed within the work, which are characterized as both appealing and radically open-ended – 'calculated and playful' – *Interim* is presented as the work which can transcend not only the limitations of the other art practices which it is described against (while undertaking a critical usage of their representational strategies within itself), but even the partiality of its own historico-political formation: feminism. *Interim* has the capacity to affect, and by implication transform, 'all our presences ... all subjects, all identities, all sexes'.

This dialectical movement from problem with existing practice (thesis), to new work posed as solution (antithesis), to progress (synthesis), is not radically different from the usual channels of critical discourse on art practice. However, the reciprocal historical formation of both Kelly's practice and its attendant critical discourse within the *Screen* problematic has drawn practice and criticism together into an exceptional symbiotic relationship which appears to shore them both up against the effects of their inevitable insertion into a hegemonic liberal pluralist discourse about art. Within this hegemonic discourse, a range of interpretations can be made of a given work of art, so long as an implicit conceptual gap is maintained between work and interpretation, so that the work is always perceived as *exceeding* interpretation, and thus the business of making different interpretations can continue.

What I want to argue is that Mary Kelly's work presents a case where this conceptual gap has effectively been closed. Kelly's practice as an artist explicitly 'narrates' the fact that it is tangibly composed of many different and discontinuous social discourses, which are variously popular, theoretical, academic, pseudo-academic, artistic and (auto)biographical. These discourses converge, and as such are mobilized by Kelly, insofar as they all produce definitions of 'what a woman is', even though these definitions might be multiple and contradictory. These discourses are manifested on the surface of Kelly's works in different representational registers,[25] and are materially figured as fragmentary, discontinuous and contradictory. Three strategies are used to achieve this figuration: the emphasis on discursive 'fragments' and their isolation, the juxtaposition of contradictory discourses, and the insertion of the 'feminine subject position' in the work to narrate the distance between these discursive definitions of femininity, and the experience of living through them as a woman.

Now, we also 'know about' this discursive intertextuality of Kelly's practice because it is described explicitly within the critical discourse on her work.[26] Pace the argument of 'Re-Viewing Modernist Criticism' summarized above, the (modernist) question of which comes first, the work or its critical interpretation, and which produces 'authentic' knowledge of the work, is rendered a non-issue for Kelly's practice. The early criticisms made of *Post-Partum Document* from within the women's movement,[27] that it was too difficult, impossible for theoretically untrained women to understand by itself, are effectively short-circuited by this argument, as is the mainstream critical assertion that Kelly's work is not 'art'.[28] The assumption that knowledge should come from the 'work itself' is exposed as modernist ideology, and then dismantled by the legitimation of contextual knowledge as an integral part of the discursive apparatus which shapes any work of art. The meanings of a specific work do not exist prior to contextual knowledge, so spectators are always/already 'informed'. Even given hypothetical

'uninformed' spectators, they are likely to undergo one of two reactions faced with a work like *Post-Partum Document*. Either they will reject the work completely, in which case they exit the discursive apparatus altogether. Or they will work to overcome the unfamiliarity which the piece engenders by seeking out critical expositions of what the work is about, in which case they immediately become 'informed'. The charge that the work is 'too difficult' is also headed off by the fact that the defamiliarization of spectators from established knowledge, and the demand that they engage as active producers of the work's meanings, are not simply intentional, but integral to its effectivity as a politicized art practice. This intention is legitimated theoretically through the redeployment of Brechtian strategies for the development of a political culture.

Thus far, the 'Kelly discourse' asserts the intertextuality of work and critical writing, and is able to deflect any criticisms which posit their conceptual separation, by critiquing this separation as a modernist misrecognition. However, this argument is not simply a matter of disinterestedly recognizing 'the way things really are'. The act of engaging with Kelly's works as an active producer of meanings, and then working to acquire further knowledge about them through critical texts, is conceptualized as a political activity, undertaken as part of the transformative political project of the women's movement. Both work and critical context have their own specific effects. Consuming the works themselves produces the experience of defamiliarization, or, more specifically, it brings the spectator up hard against the contradictions between social definitions of different 'feminine' subject positions, and the actual experience of loss and lack engendered by living out those positions. This experience then prompts the spectator into political consciousness and the desire for change,[29] and thus towards the acquisition of theoretical and critical knowledge as a basis for effecting this change. 'Reality is to be grasped not in the mirror of vision but in the distance of analysis, the displacement of the ideology that vision reflects and confirms.'[30] This movement serves to bind the elements within the discursive apparatus of Kelly's work even more closely together by explicitly politicizing their interrelationship. The realm of 'the political' or 'the real' is inserted into the discourse as that which has the capacity to halt the movement of liberal pluralist interpretation, and which simultaneously serves to justify the existence of the work as a political intervention.

This strategy can be seen at work in the quotation from the *Interim* catalogue given above. However, to stand up as an argument, it does require that cultural work be understood and accepted as political activity. This understanding is conveniently effected by the *Screen* problematic. Griselda Pollock's essay 'Screening the Seventies', as well as providing a systematic historical account of that redeployment of Brechtian ideas within left cultural practice noted above, also usefully illustrates this operation. The

245

social is defined as a range of textual strategies which work to produce representations. The function of these representations is to mobilize individual subjects into particular ideological identifications, which form the basis of their conscious operation *as* subjects in the social world. Therefore, if the cultural apparatus is identified as the site where these representations are produced and naturalized, then culture becomes defined as a site of political struggle which seeks to expose the ideological nature of representations and to transform them.[31]

The net result of the processes just described is the close seaming together of individual work, critical context and political activity, such that the existence of conceptual divisions between these is rhetorically effaced. The work of art is rendered fully textual, while at the same time retaining its own specific effect of galvanizing defamiliarization. In the case of Mary Kelly, the textuality of her work is reinforced by the fact that she works *across* the divisions of labour within the art apparatus, in practice usually confirming much of the critical exegesis around her work, and also denying the conceptual 'escape' of the artist into a space 'outside' context. The business of producing both works of art and critical discourse from within the *Screen* problematic is defined as political activity. Always implicit within and above this discursive movement, the key gambit in deflecting any criticisms of its assumptions and definitions is the fact that the theoretical resources of the *Screen* problematic enable it to narrate that continuous meta-discourse of its own formation and political identifications, and that of all other critical positions, *within* a discursive structure, which was discussed above. The 'Kelly discourse' always has the capacity to pull the rug out from under any critical position which fails to acknowledge its own discursive existence, and has the strength of admitting the partiality of its own interpretations, while at the same time always rendering these as the most legitimate on political grounds. It also carries with it an understanding that something in a work of art will always *exceed* discursive interpretation. The other metaphor which springs to mind here is Walter Benjamin's automaton chess-player, which could answer every move made by its opponent and could see the table from all angles by means of a system of mirrors.[32]

I want to conclude this section by considering some of the concrete effects of the discursive apparatus I have just described. Looked at from one perspective, these effects positively mark the complexity and confidence of Kelly's practice, and partly account for its success as a politicized artistic strategy. Seen from elsewhere, they have given rise to those critical anxieties and dissatisfaction with this apparatus which were mentioned in the previous section, and also raise fundamental questions about the possibility of an ongoing critical interpretation of Kelly's work.

One such effect is that the explicit intertextuality of Kelly's practice, and the existence of a large body of critical writing about it, makes her work

relatively 'easy' to interpret and write about. The critical discourse serves to describe the political intentionality of the major works and the various discursive resources they mobilize. This 'content' can then be quite comfortably read back into and out of the works themselves. Any 'difficulty' in reading the pieces is already encoded within the critical discourse, in the manner described above, as is the possibility of multiple interpretation *and* the assumption that something in the works *will* exceed interpretation. Add to this the explicit intentionality of the works in mobilizing the spectator as producer of meanings, and the fact that the interpretative act is endorsed as political, and what Kelly's work presents is an eminently attractive de- and re-codable object for analysis.

Now in itself there is nothing wrong with instating a collective and democratic ease of interpretation; indeed the desire to achieve this can be located historically as marking a much-needed break with the obfuscations and increasing contradictions of high modernist discourse. However, this apparent 'user-friendliness' of Kelly's work masks an increasing dissatisfaction with it from within sections of the feminist art community. The smoothness and self-legitimation of the discursive circuit described above have been registered, and interpreted negatively as an attempt to establish a limited hegemony of 'correct' feminist art practice which renders all other artistic strategies, most notably painting, theoretically, artistically and politically inadequate. This critique is clearly represented by Katy Deepwell's 'In Defence of the Indefensible: Feminism, Painting and Postmodernism',[33] which examines the historical developments which have resulted in the privileging of 'scripto-visual' practice, and questions both its implied exclusion of other artistic strategies and its proclaimed political effectivity. Since the appearance of that piece, variations of its criticisms have resurfaced periodically.[34]

I want finally to raise a more general problem of interpretation in relation to Kelly's work: more general in that I have begun to conceptualize this problem as a philosophical one, although I do not intend to do more here than indicate its broad parameters. Briefly, the way in which the discourse around Kelly's practice works to make its 'contextual resources' and its discursive status explicit effectively rules out certain lines of interpretation altogether. For example, it is not seriously possible to argue that *Post-Partum Document* is fundamentally a personal and essential expression of what it is to be a mother, because this would radically contravene the discursive identity of the work: such an interpretation would be 'wrong'. This is not to say that nobody holds such a view, nor is it to mask the paradox already noted, that the Kelly discourse admits the possibility of holding other views. What it does suggest is not only the inability of such an interpretation to affect the parameters of the discourse in any way, but also the question of what other roles there can be for the would-be interpreter of Mary Kelly's practice,

beyond making another exegesis of the major works along critical avenues which are already well-trodden. This question could easily be dismissed as a desire to smuggle liberal pluralism back in under the guise of philosophy. However, this accusation fails to confront the extent to which Kelly's work might already have become assimilated into a pluralist culture. It also fails to consider the possibility that its very discursive self-sufficiency might bind it so inextricably to its own formative historical and social circumstances that its potential for political effectivity in changed circumstances is severely curtailed. I will come back to these issues, but now I want to shift focus and consider Mary Kelly's practice within the psychoanalytic context of 'feminist desire'.

'That Obscure Object of Desire ...'

Now pictures are certainly texts, and they come impregnated with interpretation, as if the truth of the painting is also there in the painting, the truth which is stated by the artist supposed to know. We all know the errors of referring to the meaning of the picture as contained within the authorial intention to mean. But *what interests me is that knowing this argument doesn't stop our fantasies about the artist*, not so much as a person but as a function, the vanishing point at which the picture and its truth would intersect as the source of the picture's correct interpretation. We may call this fantasy of the artist the ego ideal of the spectator, the place from which the spectator's interpretation may be felt to be validated. At this point, when it works, we do indeed think that we are looking at a *masterpiece*.

PARVEEN ADAMS, 'The Art of Analysis'[35]

Parveen Adams is talking generalities here, within the context of a recent essay on Mary Kelly's *Interim*, in which her main line of argument is that *Interim* is not simply a work *about* certain bodies of psychoanalytic theory – this is taken as read – but is actually analogous to the situation of going *through* analysis. This paragraph drew my attention for the way in which it posits a gap, a point of friction and contradiction, between theoretical knowledge (that the meanings of a given work of art are not reducible to authorial intention), and conflicting desire in the face of that knowledge (for the artist-function as ego ideal). This conflict is comparable to the classic psychoanalytic account of the structure of fetishism.[36] Now, if Parveen Adams had inserted 'Mary Kelly' and a woman spectating *Interim* as the leading examples for this hypothesis, then I would be less interested in this gap, and would not have to argue the case for the artist-function 'Mary Kelly' as an object of desire for those women who spectate and support her

work. But instead, Adams asks us to think of Aeneas, the male protagonist of Virgil's *Aeneid*, looking at a wall-painting in a temple at Carthage. Given the various historical, social and psychic asymmetries between men and women as subjects of the look, and between the practice and specific effects of (figurative) painting compared with the range of representational strategies deployed in *Interim*, Aeneas-looking-at-a-painting does represent a very different order of desire from woman-looking-at-*Interim*. Moreover, Adams does go on after the classical interlude to compare the way a female spectator of *Interim* is likely to identify a history like her own in the narrative sequences of *Corpus*, experiencing a similar convergence of recognition, desire and the sense of feeling 'satisfactory and loved'. Adams even goes so far as to draw *Interim* explicitly into the ambit of ego-idealism: 'Perhaps ... what *Interim* does is *to whet your appetite* for a feminine ego ideal, for a point of view from which we can feel satisfactory and loved.'[37] But there is a catch. The desire is not mobilized in the present, but displaced on to an imaginary future and then dismantled altogether. The 'promise won't be made good'[38] because *Interim* does not, according to Adams, construct a space of imagined plenitude, the space of the Other which has what the spectator lacks.

The possibility that *Interim*, or 'Mary Kelly', might operate as an ego-ideal for women is thus disavowed. Adams's argument, however, seems to rest on an assumption which I find problematic: that the processes of identifying an ego-ideal are necessarily a bad thing, because they entail a misrecognition of the relations between subjectivity and its others. I have found Theresa Brennan's thoughts on feminism as an ego-ideal[39] particularly enabling in this context as a way of thinking beyond this assumption. Drawing on Freud's *Group Psychology and the Analysis of the Ego*, Brennan distinguishes between the introjection of parental authority as the super-ego in the post-Oedipal child, and later ego-identifications with 'social prototypes'. She writes:

> A contemporary social identification of the ego-ideal with another could offset the more traditional super-ego.... We can postulate that an ego-ideal identification with feminism, in the form of a person, people or a body of writing, suspends the ego-ideal's existing prohibitions, that it *permits* different thinking. For when the ego identifies its ego-ideal with a social other, it is permeable to the wish, will, or ideas of that other. It does not simply displace the ego-ideal onto someone who mirrors the attributes of the existing ego-ideal (although it certainly can do). On this reading of Freud, by the very fact of displacing the ego-ideal onto another, the subject leaves itself open to new influences.[40]

Now obviously I am drawn to this argument because it positively supports my hypothesis of Kelly as ego-ideal, whereas Parveen Adams's essay by and large doesn't. However, in engaging with Brennan's ideas, I am also struck by how rarely feminists who use psychoanalytic theory ever consider

feminism itself as one of their objects: putting feminism 'on the couch' as it were. The conjunction of feminism and psychoanalysis is more usually understood as the means of escape from the less politically and personally desirable effects of psychic process. Take the last sentence of Jacqueline Rose's essay 'Feminism and the Psychic'. Psychoanalysis is there described as: 'Not a luxury, but rather the key processes through which – as women and as men – we experience, and then question, our fully political fates.'[41] While the essay never disavows the potentially disruptive and contradictory effects of subjective process – in fact it foregrounds them to counter the bourgeois philosophical notion of a unitary and coherent individual identity – these effects somehow manage to be safely contained by, and subtly cast in support of, the rhetoric of political necessity and struggle. This line of interpretation is so implicitly prevalent that Brennan has to qualify her argument by acknowledging that the spectre of a tedious and reductive psycho-social determinism always haunts such suggestions.[42]

The difficulty with the theoretico-political edifice produced from the historical conjunction of psychoanalysis and feminism is that it is (notoriously) resistant to direct criticism. Not only are we returned to the problems already considered; to make matters more complicated, the conjunction of psychoanalysis and feminism is of course a significant component of the discursive apparatus around Mary Kelly. To the best of my knowledge, no feminist working with psychoanalytic theory has ever claimed that it entails a voluntaristic revolution in psychic life, nor that it provides any immunity from psycho-social processes. Indeed, the palimpsest of contradictions between theory and experience is brought sharply into focus in Kelly's own practice. *Post-Partum Document* might be able to deploy the language of Freud and Lacan to name and account for the experience of loss and the process of fetishization which constitute the maternal feminine identity, as the mother relives her own Oedipal moment, but this knowledge never diminishes the anguish of Kelly-as-mother which resonates through her diary fragments and the nagging questions posed at the end of each section of documentation: 'What Have I Done Wrong?'; 'Why Don't I Understand?'

Nevertheless, critical anxiety about feminism's deployment of psychoanalytic theory keeps on surfacing in cultural debates, particularly where the political consequences of psychoanalytic theory are at issue. Many of these anxieties seem to centre on what could be called 'The Eleventh Thesis on Feuerbach Trap',[43] which is to say that feminists have somehow confused the business of naming and describing the psychic processes of subjectivity with that of changing them. One example of these criticisms occurs within the work of Hal Foster, who, discussing the work of Mary Kelly and the other artists who showed in the exhibition 'Difference: On Representation and Sexuality', worries that

a potential contradiction arises in this work between its political desire to transform social institutions and its historical pessimism regarding patriarchy.... This art does indeed demonstrate that the subject is produced socially, but it is not enough to say that its patriarchal structures are thus 'subject to change' when no strategies for change are offered and when these structures are presented as all but transhistorical and urpsychological.[44]

Now it would be quite legitimate to suggest that the roots of many of these disagreements lie in inconsistencies or unresolved aspects of psychoanalytic theory itself. For example, there seems to be a practical difficulty in distinguishing the character and function of the super-ego from that of the ego-ideal. While in the formation of the psyche they appear as two sides of the same coin, the association of the former with judgement and censorship of the ego, and the latter with the ego as feeling 'satisfactory and loved', would seem to mark a politically important distinction for feminism, pace Theresa Brennan's argument.[45] The question of whether psychic *processes themselves* are subject to change, or only their *objects* and *lived consequences*, also appears to be a source of confusion. However, it is not my purpose to begin working out these inconsistencies here. Rather, I want to suggest that it is not ultimately productive to counter anxieties about the fate of women as political subjects, which have arisen as a consequence of the psychoanalytic interpretation of subjectivity as divided and unstable, with a simple reiteration of the fact of this division, along with the assumption that any questioning of psychoanalytic categories automatically reinstates a unitary and essential subjectivity.[46]

Feminists have increasingly recognized that the various post-structuralist moves to disperse subjectivity have different consequences for men and women, and that it is politically important to maintain some notion of female identity, while at the same time recognizing this identity as complex, contradictory and fictive.[47] This is not to suggest that Mary Kelly's practice fails in this recognition: both *Post-Partum Document* and *Interim are* intimately concerned with how the very divisions and fictive nature of femininity could serve to mobilize women politically as feminists. Yet the very fact that Kelly's work continues to be critically targeted as doing the exact opposite suggests that a simple contrary assertion is insufficient. I would argue, instead, that the explicit recognition of 'Mary Kelly' as a locus of desire, an ego-ideal which offers women a different set of possibilities for the formation of a psycho-social subjectivity, is vital in shifting the terms of the existing debate. It is salient to note at this point that Theresa Brennan's 'analysis' of feminism as an ego-ideal was itself developed to try to break the deadlock of debates around feminism and psychoanalysis.[48]

To adopt Kelly's work as an ego-ideal certainly avoids the pitfalls of ego-identifications in the traditional sense and, as Parveen Adams's article

suggests, 'Kelly' does offer more radical, heterogeneous and productive possibilities for becoming a 'feminist subject'. Yet the full acknowledgement that 'Kelly' is cathected by the desires of other women carries with it two important implications. Psychic determinism notwithstanding, one is that it might provide a further explanation for the extent to which criticisms of Kelly's practice are deflected, if a feminist subjectivity is thereby felt to be threatened. The other, perhaps more significant, is that it disrupts any universalizing claims for the relevance of Kelly's practice to all women, even though such claims are less made by her supporters than inferred by dissatisfied critics. I believe that if we can think 'Kelly' back to psychoanalytic particularity, it then becomes easier to recognize that the subjective possibilities mobilized by her work are only really congruent with the experience of very historically, culturally and socially specific women, and that there are 'feminist needs' which they signally do not answer. Further, by attempting to work *within* the protocols of psychoanalytic theory in this section, I hope to have demonstrated the extent to which they can be of use to the process of gaining a critical foothold within the discourse on Kelly's work, while at the same time indicating something of their historical limitations and blind spots.

Conclusion

Looking back on the process of 'circuit-breaking desire' which I have undertaken in this essay, it is clear that the outcome has been perhaps less a historical account of Mary Kelly's art practice than an attempt to clear the ground for a critical space from which to develop such an account, away from the well-worn paths of exegesis which have characterized Kelly's work to date. The major difficulty I have encountered is finding some means to break into the self-sufficiency and self-reflexivity of what I have identified as the discursive apparatus around Kelly; an apparatus which is structured and maintained by the *Screen* problematic, and thus able to deflect much criticism, by mobilizing its own definitions of politics and politically effective cultural activity. In doing this, I do not mean to dismiss Kelly's artistic projects out of hand. I said at the beginning that her work remains intimately bound up with my knowledge of second-wave feminism, and with the possibility of my further enhancing this historical understanding. Instead, my concern is a need to confront the recognition that times have changed, and that the radical and polemical relevance of Mary Kelly's art practice to contemporary feminisms cannot be taken as given, no matter how successful it might be, nor how theoretically and politically watertight it might appear within its own discursive terms. Even if Kelly's work can be accorded a role in the maintenance of a much-needed identity for second-wave feminism in the

face of political reaction, the transformative political potential which is claimed for it is already doubly blunted, first by the disintegration of feminism's political base and the dispersal of its demands into liberalized equal opportunities for some, and second by its inevitable accommodation within a liberal pluralist cultural hegemony, where nappy liners, Lacanian diagrams and the traces of feminine subjectivity no longer necessarily disrupt established political consciousness, and can safely be given a niche on gallery walls. As Brecht himself put it: 'Capitalism has the power to turn into a drug, immediately and continually, the poison that is thrown in its face and then to enjoy it.'[49]

I cannot end by offering up pat solutions to the problems I have raised here. However, it does seem necessary at least that the critical circuits which operate through and around Kelly's practice should be challenged and brought into some kind of productive confrontation with their own historical circumstances and contradictions, as a means of maintaining a dialectical relevance to those contemporary art practices which are informed by feminisms, to borrow a phrase from Kelly herself. Otherwise, they are in danger of being consigned as relics to the vaults of a forgotten feminist past.

Notes

1. For the purposes of this essay, Kelly's work is taken principally to mean *Post-Partum Document* (1973–79) and *Interim* (1984–89). It should be recognized at the outset that my argument assumes a working knowledge of these two projects, in terms of their historical thematics, theoretical resources and artistic strategies. In other words, the reader is expected to know what Kelly's work is 'about'. Her practice has been the subject of a substantial body of critical exegesis, and the interested reader is referred to the following works for further information: Mary Kelly, *The Post-Partum Document*, Routledge & Kegan Paul, London 1983; *Interim*, catalogue produced by the New Museum of Contemporary Art, New York 1990; Laura Mulvey, 'Introduction' to *Interim*, Fruitmarket Gallery and Kettles Yard, Cambridge 1986, pp. 4–7 (also reprinted in Laura Mulvey, *Visual and Other Pleasures*, Macmillan, London 1989); Griselda Pollock, 'Screening the Seventies', in *Vision and Difference: Femininity, Feminism and the Histories of Art*, Routledge, London 1988, pp. 155–99, and the three articles on Kelly's work published in *New Formations*, 2, Summer 1987, pp. 7–36. The first two also carry substantial bibliographies.

2. The term 'discursive apparatus' is intended to embody an understanding that the identity and meanings of works of art are produced *through* discursive operations. This does not mean to say that works of art can be *reduced* to discourse, but that their identity as art, and their public institutional significance, is not given and embodied solely within concrete works. Although the question of how to understand conceptual distinctions between specific works and their discursive contexts is not tackled in this essay, it should at least be noted that the various terms which I use to characterize the discursive apparatus, such as 'Kelly discourse' and 'discourse around Kelly's work', are intended to encompass the works themselves.

3. The term 'second-wave' feminism, is used to characterize the events and developments attending upon the emergence of the women's movement from the late sixties onwards, principally in Western Europe and North America. The particularity of its trajectory in terms of race, nationality, social class and priorities for feminism will be discussed in the body of the essay, but bears emphasis here.

4. See the 'Introduction' to Elizabeth Wilson's *Hidden Agendas*, Tavistock, London 1986,

pp. 3–24, for a discussion of the historical interplay of this exploration with the political project of female emancipation.

5. Walter Benjamin, 'Theses on the Philosophy of History', in *Illuminations*, ed. and introduced by Hannah Arendt, trans. Harry Zohn, Schocken Books, New York 1978, p. 255.

6. Clearly the texts from which I have developed my account are partial in their perspectives on the women's movement. I have drawn particularly on Lynne Segal, *Is the Future Female? Troubled Thoughts on Contemporary Feminism*, Virago, London 1987; Lynne Segal, Hilary Wainwright and Sheila Rowbotham, *Beyond the Fragments: Feminism and the Making of Socialism*, Merlin Press, London 1979; and Elizabeth Wilson, *Hidden Agendas* – all of which are characterized by their broad involvement with and commitment to some form of socialist feminism.

7. This is, for example, the burden of Theresa de Lauretis's introductory essay to the collected papers of the 1985 Milwaukee conference 'Feminist Studies: Reconstituting Knowledge', which she organized. The papers have been published as Theresa de Lauretis, ed., *Feminist Studies/ Critical Studies*, Indiana University Press, Bloomington 1986; see especially de Lauretis, 'Feminist Studies/Critical Studies: Issues, Terms, Contexts', pp. 1–19.

8. See Perry Anderson, 'Components of the National Culture', *New Left Review*, 50, July/ August 1968 (reprinted in Robin Blackburn and Alexander Cockburn, eds, *Student Power* Penguin, Harmondsworth 1969, pp. 214–84) and 'A Culture in Contraflow'; published in two parts in *New Left Review*: (Part I) 180, March/April 1990, pp. 41–78, (Part II) 182, July/August 1990, pp. 85–137, also in Perry Anderson, *English Questions*, Verso, London 1992.

9. 'A Culture in Contraflow' Part I, note on p. 43.

10. '[The historian] grasps the constellation which his own era has formed with a definite earlier one. Thus he establishes a conception of the present as the "time of the now" which is shot through with chips of Messianic time.' Benjamin, 'Theses on the Philosophy of History', p. 263.

11. Brechtian strategies may be taken to include distanciation, fragmentation and juxtaposition of different discourses, the combination of high and low cultural modes, the use of different visual registers such as found objects, photography, type, diagrams, handwritten text, etc. See Pollock, 'Screening the Seventies', for a fuller account. Kelly's debt to Conceptual practice includes the instatement of text as an artistic medium and the use of a serial extended format in both major works. Feminist art practice during the seventies clearly prioritized the viewpoint of the 'female subject', but emphasis was also placed on the use of everyday subject matter and media which were deemed to have a greater significance within women's lives. This may be located in Kelly's work by, for example, the use of her own 'mother's memorabilia' in *Post-Partum Document*.

12. The exhibition 'Women and Work' was produced and exhibited by Mary Kelly, Kay Hunt and Margaret Harrison in 1975, with the object of investigating the impact of the 1970 Equal Pay Act on a group of women workers in a South London Metal Box factory. See Pollock, 'Screening the Seventies', pp. 166–8.

13. Pollock, 'Screening the Seventies'.

14. Ibid., p. 199.

15. See, for example, Katy Deepwell's essay 'In Defence of the Indefensible: Feminism, Painting and Postmodernism', *Feminism Arts News*, 2 (4), NB. 2 (4) or NOT 2 (4), 1987, pp. 9–12, and the debates which took place in *Women Artists' Slide Library Journal* around the publication of Roszika Parker and Griselda Pollock, eds, *Framing Feminism*, Pandora, London 1987. The relevant numbers are *WASL Journal*, 22, 23, 24, 26, 27, 28, 1988–89.

16. Benjamin, 'Theses on the Philosophy of History', p. 255.

17. *Screen*, 22 (3), 1981, p. 58.

18. This is Griselda Pollock summarizing Kelly's article in Pollock, 'Screening the Seventies', p. 161.

19. Kelly, 'Re-Viewing Modernist Criticism', p. 41.

20. This is Kelly's own definition, made in her paper for the 'Art and Politics' conference held in London in 1977. Quoted in Griselda Pollock, 'Feminism and Modernism', in Parker and Pollock, eds, *Framing Feminism*, p. 80.

21. The production of essays such as 'Re-Viewing Modernist Criticism' and 'Desiring Images/ Imaging Desire', *Wedge*, 6, 1984, and Kelly's membership of the editorial board of *Screen*, attest to the range of her activities as critic, historian and theorist. In terms of art education, she has

taught at Goldsmith's College, University of London, and now works on the postgraduate programme of the New Museum of Contemporary Art, New York. Her curatorial work includes organizing and writing the catalogue essay for 'Beyond the Purloined Image', held at the Riverside Studios, London, in 1983.

22. Kelly's own individual discourse on her work is striking in this respect. I have heard her speak about her own work on two occasions, at the WASL conference 'Feminism and Art Criticism', London, June 1992, and at Leeds University in the same month. On both occasions, she has made the remark that hers is only one possible interpretation of what her artistic projects might be about.

23. Griselda Pollock, 'Interventions in History: On the Historical, the Subjective and the Texual' in the catalogue for *Interim*, New Museum of Contemporary Art, p. 50 (my emphasis throughout).

24. For example, Pollock's need to distinguish Kelly's practice from other so-called postmodernist practices is not an issue for earlier writers during the seventies, for example Laura Mulvey's review of *Post-Partum Document* in *Spare Rib*, 1976, reprinted in Kelly, *The Post-Partum Document*, pp. 201–2.

25. These registers include photography, written and typed text, found objects, charts and diagrams, instances of medical or autobiographical discourse, references to the visual discourses of Minimal and Conceptual art, and so on. See n. 11 above for the deployment of these different registers in relation to Brechtian cultural praxis.

26. The recognition that Kelly's work is discursively structured, and the mapping out of the multiplicity and complexity of this structure, has tended to form the backbone of much of the existing critical exegesis of her practice.

27. See the debate in *Spare Rib* occasioned by the exhibition of sections of *Post-Partum Document* at the ICA in 1976. This debate is reprinted in Parker and Pollock, eds, *Framing Feminism*, pp. 203–5.

28. This is the basic thrust of the critical attacks made on *Post-Partum Document* from within the art establishment. Peter Fuller, for example, spares no vitriol in condemning Kelly's practice in an essay significantly titled in this respect 'Where Was the Art of the Seventies?', in *Beyond the Crisis in Art*, Writers & Readers, London p. 28. See also Griselda Pollock, 'Feminism, Femininity and the Hayward Annual Exhibition 1978', for an analysis of the critical responses to this show, which included sections of the *Document*. A common line of attack was that Kelly's work did not belong in an art gallery, but rather in the foyer of Mothercare or a maternity ward. The essay is reprinted in *Framing Feminism*, pp. 165–81, see esp. p. 174.

29. That a certain kind of cultural experience will produce a desire for political change in the spectator may be summarized as the rationale of Brecht's cultural strategies. See Stephen Heath, 'Lessons from Brecht', *Screen*, 15 (2), Summer 1974.

30. Heath, quoted in Pollock, 'Screening the Seventies', p. 165.

31. Ibid., p. 162.

32. Benjamin, 'Theses on the Philosophy of History', p. 253.

33. Deepwell, 'In Defence of the Indefensible'.

34. Take, for example, Mira Schor's review of the New Museum's debate on *Interim*, published in *Artforum*, Summer 1990, pp. 17–18, where she argues that Kelly's practice has come to embody less political validity for feminism, than an exclusive intellectual elitism.

35. Parveen Adams, 'The Art of Analysis: Mary Kelly's *Interim* and the Discourse of the Analyst', *October*, 58, Fall 1991, p. 90 (my emphasis throughout).

36. See, for example, the pattern of Kelly's account of female fetishism in 'Desiring Images/ Imaging Desire', pp. 5–9.

37. Adams, 'The Art of Analysis', p. 92 (my emphasis).

38. Ibid., p. 93.

39. Theresa Brennan, 'Introduction' to Brennan, ed., *Between Feminism and Psychoanalysis*, Routledge, London 1989, pp. 9–14.

40. Ibid., p. 10.

41. Jacqueline Rose, 'Feminism and the Psychic', in *Sexuality in the Field of Vision*, Verso, London 1986.

42. Brennan, 'Introduction', p. 10.

43. 'The philosophers have only *interpreted* the world, in various ways; the point is to *change* it.'

(Karl Marx and Freidrich Engels, *The German Ideology*, ed. C.J. Arthur, Lawrence & Wishart, London 1970, p. 123.)

44. Hal Foster, *Recodings*, Bay Press, Seattle 1985, pp. 9–10, quoted in Pollock, 'Screening the Seventies', p. 156.

45. The difficulty of distinguishing the ego-ideal from the super-ego is figured in the definitions of the two terms provided by Jean Laplanche and J.B. Pontalis in *The Language of Psychoanalysis*, Hogarth Press, London 1973, pp. 435–8 and 144.

46. This assumption seems to be suggested by the editorial for the 'Sexuality' issue of *m/f*, 5–6, 1981, p. 3, which counters challenges made from within feminism to its particular attempts at developing the use of psychoanalytic theory in the analysis of socio-sexual identity.

47. This development is exemplified by Nancy K. Miller's influential essay 'Changing the Subject: Authorship, Writing and the Reader', in de Lauretis, ed., *Feminist Studies/Critical Studies*, pp. 102–17.

48. Brennan, 'Introduction', pp. 1 and 9.

49. Quoted in Heath, 'Lessons from Brecht', p. 113.

9

Cindy Sherman: Theory

and Practice

Gen Doy

In this essay I look at Cindy Sherman's work and the theoretical and critical comments written on it during the eighties. Sherman's career began in the mid- to late seventies, but it was really in the following decade that her reputation, and her sales, became established and grew quite dramatically. An exhibition catalogue of her works in 1990 stated that she had produced 238 publicly registered pieces by that date. The same catalogue reveals a large increase during the eighties in exhibitions, reviews and critical articles about her work. In 1990, public museums and collections in the USA, Europe and Australasia contained examples of her oeuvre. Only one public collection in a semi-colonial country, however, had an example of her work at that time, and that was in Mexico City.[1] In addition, her work has been purchased by private collectors on a large scale. The best-known examples in Britain are the Saatchis, famous for running advertising campaigns for the British Conservative Party almost as much as for their collection of contemporary art. The Saatchis' collection combines the appearance of being a resource open to the public with total control by the owners – for example, works are sold when the Saatchis want to sell and are bought in the same way. There is a paradox at the heart of Sherman's success in that her work is owned and exhibited by collectors who appear to espouse the very ideology of consumerism, glossy media imagery and capitalist life-styles which it challenges.

However, there are many audiences for Sherman's work, not all of whom read the same meaning in her images. Her popularity with students is apparent. I cannot offer a statistical or scientific documentation of this, but the number of pages ripped out of glossy art magazines in our college library indicates that the student population prefers Sherman's work to that of Barbara Kruger and Mary Kelly. (Of course, I am assuming here that art history and fine art lecturers do not rip pages out of library material!)

Sherman has on many occasions pointed out that she is not particularly interested in critical theory, either in terms of the understanding of her works once they are made, or in terms of the making of them by the artist herself. In this sense, she is an interesting foil to Kruger and Kelly, whose practice is informed by an awareness of a body of post-structuralist theory on discourse, language and the construction of the viewing 'subject'. It is interesting to note that in the recently published volume of theoretical writings on art edited by Paul Wood and Charles Harrison, *Art in Theory, 1900–1990*,[2] Cindy Sherman is referred to once in 1,127 pages, whereas texts by both Kelly and Kruger are included in the anthology. We should perhaps ask ourselves what, if any, implications this has for ideas about the relationship of practice and theory. Are Kelly and Kruger 'better' or 'more interesting' artists because a knowledge of structuralist and post-structuralist theory informs their work? Can we read Sherman's work as 'kitsch', as defined by Greenberg in his writings on 'Avant-Garde and Kitsch',[3] because it is figurative, too close to commercial culture and mass-media imagery and not 'difficult' enough really to qualify as avant-garde? Or has Sherman's determination not to exploit the potential for mass reproduction inherent in the photographic medium, as it developed in industrialized capitalism, re-affirmed her 'artistic' if not avant-garde status? Does theoretical awareness and understanding necessarily produce 'good' art? If not, then this is a serious problem for the vast bulk of postmodern artists from Victor Burgin to Mary Kelly. Perhaps Jo Spence was one of the few practitioners of photographic work to combine an accessible integration of theory and practice without diluting important theoretical problems or patronizing her audience.

There is therefore a particularly interesting investigation to be made of Sherman as a postmodernist who really isn't interested in theory – if we are actually to believe her own comments in interviews. For example, she says in a recent interview, concerning her 'untitled film stills', 'I never thought of it as some sort of, oh, idea about the male gaze, you know', and 'No, I have never been a fan of criticism or theories, so that actually none of that affected me and still doesn't', and 'Many of my pieces are much more innocent than they are interpreted.'[4]

Now, of course, it is quite often the case that artists are not the most articulate in explaining the meanings of their works or the reasons for their production, but I think the issues raised here are important questions of ideology and consciousness; the complex and contradictory ways in which works of art can be both affirmations and subversions of a particular view of the world *at the same time*. This is what makes Sherman's photographs interesting, because in her work we see a dialectical process working itself out through her approach to photographic images, from the black-and-white untitled film stills to the grotesque disintegration of the world portrayed by glossy colour photography in the later eighties works.

This process did not really come about because of Sherman's theoretical understanding of subjectivity, the male gaze or the crisis of capitalism – she has said that she is not a feminist and to my knowledge has never been described as a socialist – but because of the historical and cultural situation her works are produced and exist in. Without this historical reality, they would not look the way they are – indeed they would not exist. Yet the contradictions and tensions present in Sherman's works are not simply 'reflexions' of her experience of living in a capitalist society in the USA but also the result of both conscious and unconscious aspects of her existence in a particular historical and economic conjuncture. In spite of the critical writings which happily seize on Sherman's works as pure masquerade, role playing, and visual discourse unrelated to the 'real' Cindy Sherman (and, of course, there is a sense in which this is true of her work), there nevertheless *does* exist a person who made these images.

What is more worthwhile to consider is *why* Sherman uses the visual strategies that she does and why so many of the theoretical articles written on Sherman's work are so eager to argue that the text is so much more important than any material reality it might refer to. In fact, for much of postmodern theory, material reality is unknowable and fragmented; as individual subjects we are theoretically denied the possibility of knowing material reality since we are ourselves constructed by various texts, and discourses, through which subject positions are created for us. Hence material reality is not just unknowable but unchangeable by conscious intervention. In this idealism, there is no room for an analysis of the processes by which individuals or social groups can achieve any conscious awareness of their situation and change it. A materialist view would obviously re-assert that ideas and concepts are created by people, not the other way around. I think there is a real problem here for the sort of theoretical position that has been argued by Griselda Pollock and Laura Mulvey, among others. If we all enter into gendered subject positions already prepared for us at an unconscious level, for example, how do we explain the fact that individuals (and groups) ever consciously analyse and reject these positions? Where is there any notion of dialectics or contradiction in these theoretical models, apart from occasionally using the odd Marxist term? How are we supposed to understand how Sherman is able to reject media images of female stereotypes, fashion models and beauty when, on the one hand, she is continually being 'construed as a particular gendered subject' by media texts and discourses and, on the other, she has never consciously, she claims, used any theoretically developed position to criticize the dominant images of women in commercial mass imagery?

I would argue that most of the writings on Sherman's work have not really managed to tackle many of these issues concerning the production of her work since many of them are written from a fundamentally anti-materialist stance, and, what is more, appear to have very little idea of

dialectical materialism. For, after all, it is dialectical materialism and not just historical materialism that is the basis of Marxist theory and practice. This mistake has led many radical critics to scorn and reject Marxism as a method of cultural analysis because they see it as hopelessly crude and deterministic.

The Critical Context

It is important at this stage to consider the situation in Britain with regard to radical cultural criticism and history, to look at some of the key writers on cultural history during the eighties and their present positions, and to reflect on what sort of world economic, political and cultural situation they, and we, find ourselves in.

For the moment, I'd like to look at the theoretical positions of Griselda Pollock, whose writings on women artists and 'images of women' (a term she now theoretically rejects) were highly influential throughout the eighties; John Tagg, whose work on photography was similarly important; and Tim Clark, who has been seen by supporters and critics alike as an important practitioner of a Marxist approach to cultural history. (This is sometimes confusingly referred to as 'the social history of art', even by Clark himself. 'Social history of art' is not the same as Marxist art history and there are many examples of conservative 'social historians of art' such as Michael Baxandall.)

Pollock's writings have had a huge influence on the way women's art and representations of women have been studied, and obviously women's art history owes a great deal to her researches. However, a result of this work and the theoretical positions it argues (along with the work of other feminist art historians such as Tamar Garb) has been that feminism has come to be viewed as *the* theoretical position from which to analyse women's art and representations of women.

On many occasions during the eighties Pollock criticized Marxism as being flawed, patriarchal, gender-blind and inferior to feminism as a means of analysing any questions concerning women. I'll take just one example, from her book *Vision and Difference* published in 1988.[5] In chapter 2, 'Vision, Voice and Power: Feminist Art Histories and Marxism', a revision of a paper first published in *Block*, in 1982, Pollock criticizes Marxist art history (she also calls it the social history of art). She criticizes T.J. Clark, and more especially Nicos Hadjinicolaou's *Art History and Class Struggle*,[6] for economic determinism and reductionism. As far as Hadjinicolaou is concerned, Pollock is quite right. His method is very crude and rigid, with no real grasp of the complexities and contradictions of the relationship of visual culture to its economic base. But the same can hardly be said of Clark. In fact Clark tries in his writing to embody the complex and ambiguous ways in which

images relate to economics and class (or [un]consciously try not to). Clark's writing is sometimes complex, indeed obscure, but I personally read this as a serious and conscious attempt not to oversimplify a very complicated process of analysis. Yet Pollock heavily criticizes Clark as well, and refers to 'crude Marxist formulation of all cultural practices being dependent upon and reducible to economic practices (the famous base–superstructure idea)' and 'the paternal authority of Marxism under whose rubric sexual divisions are virtually natural and inevitable and fall beneath its theoretical view'.[7]

Both of these statements are quite untrue, but quite commonly accepted. For example, Craig Owens also accepts feminism's critique of Marxism as 'patriarchal', the discourse of Marxism as 'oppressive', and writes:

> One of the things that feminism has exposed is Marxism's scandalous blindness to sexual inequality. Both Marx and Engels viewed patriarchy as part of a precapitalist mode of production, claiming that the transition from a feudal to a capitalist mode of production was a transition from male domination to domination by capital. Thus, in the *Communist Manifesto* they write, 'The bourgeoisie, wherever it has got the upper hand, has put an end to all feudal, patriarchal ... relations.' The revisionist attempt (such as Jameson proposes in *The Political Unconscious*) to explain the persistence of patriarchy as a survival of a previous mode of production is an inadequate response to the challenge posed by feminism to Marxism. Marxism's difficulty with feminism is not part of an ideological bias inherited from outside; rather, it is a structural effect of its privileging of production as the definitively human activity.[8]

Marx and Engels are referring in this passage from the *Communist Manifesto* to the destruction of feudal social and economic relations and their replacement with capitalist ones – that is, the wage labour system and the market, where individuals are 'free' to sell their labour to the capitalist. They are not arguing that women are no longer oppressed under capitalism! Owens's interpretation of this passage is nonsense when we consider the numerous books, pamphlets and actual practical work undertaken by Marxists in defence of women's rights and against women's oppression. Why would Engels have written his book on the *Origin of the Family, Private Property and the State* in the 1880s if he and Marx had believed women's oppression had disappeared under capitalism? Owens's position is unsupportable; unfortunately, however, it is one that is commonly encountered.

In an essay published in 1990, Pollock returns to the question of the superiority of feminism over Marxism as a theoretical method of cultural analysis. Her method remains idealist. She looks back on an earlier article she wrote on 'images of women' and now argues that the term is a misconception. There is no reality to which 'images of women' refer. Rather, all representations of women are constructions and fabrications, so none can be more or less comparable to the 'reality' of women or their social and cultural existence than any other.

Pollock then goes on to revise slightly her scathing comments on Marxism and actually quotes an original text by Marx, which is a distinct step forward from many of her other writings on Marxism. She discovers that, after all, Marx and Engels never had a theory which stated that the superstructure (culture, politics etc.) was simplistically determined by the economic base, and that the process is actually very complex. In fact, culture is 'relatively autonomous' from its economic base. This, of course, is hardly an original discovery, as many cultural historians interested in Marxism will readily perceive. Pollock seems surprised, however, and notes: '*Ironically*, one of the key texts for understanding the role of representation can be found at the heart of historical materialism.'[9] There is no attempt to correct misleading criticisms of Marxist theory that appeared in her earlier work, however, and no notion of dialectical materialism as distinct from historical materialism. Pollock goes on to say that feminism nevertheless has far morepotential for 'radical reworking of ideas about representation' than Marxism. Her theoretical position, as far as I understand it, is that there are two economic systems in existence: an economy of capitalism (described and analysed by Marx) and what she calls 'a sexual economy', described and analysed by feminist theory. These exist parallel to one another, with, however, more weight being given to the 'sexual economy' and the superiority of feminism as a method for understanding these factors in women's oppression. Yet Pollock's attempt to argue that her feminism is superior to Marxism in terms of analysis of 'images of women' is unconvincing. She concludes that 'Every image of the feminine coded body is at the same time an image of woman and not an image of woman.'[10] I see no reason why a dialectical materialist would argue anything different. Fundamentally, Pollock sticks to her analysis of gender difference as the basic division of historical development and the main reason why cultural products take on the form that they do. She writes, there are no 'images of women' in the dominant culture – only 'masculine significations figured by deployment of body signs'.

Finally, we have to ask what practical conclusions Pollock draws from her theoretical arguments. Again these are unclear. Are they in any way directed at the 'economic base' as described by Marxism? How do they address the state which guarantees the continued existence of inequalities of race and gender while proclaiming they no longer exist? All this is equally unclear. What seems to have happened in Pollock's more recent writings is an appropriation of certain Marxist terms through a particular type of academic feminism. She concludes her article on 'images of women' with the sentence: 'Advertising photography is a major scene of representation of sexual difference in this conjunction of two economies of desire, where commodity and psychic fetishism entrance us through their mutual investments in and constant trading of our subjectivities.'[11]

Pollock's increased awareness of what Marx and Engels actually said about the complex dialectical relationship of base and superstructure did not manifest itself at the conference of the Association of Art Historians at the University of Leeds in 1992. Tim Clark and Griselda Pollock were two of the three main plenary speakers, and the theoretical concerns of the conference were very much presented as a debate between these two individuals as representatives of opposing theoretical viewpoints. To underline this, Pollock chose to present a feminist epistolary journey to conscious awareness of the meaning of Manet's *A Bar at the Folies Bergère* (1882). It was perceived by the conference participants that Pollock had chosen this work precisely as a 'critique' of Tim Clark's 'patriarchal' discussion of this in his book *The Painting of Modern Life*.[12] Unfortunately Clark made no reply or defence of Marxist theory as an adequate means of analysing women's art or the representation of women. His own plenary lecture revealed a scholar who, while still proclaiming himself a Marxist, neither demonstrated this, nor seemed very clear theoretically what the practice of a Marxist was. He seemed rather disoriented, politically and in his art historical practice. Clark said that gender oppression was 'the most basic form of oppression' in history, and also that Marxism would virtually have to go back to the drawing board and rethink almost everything. It must be said that most people at the conference were hardly brimming with optimism as the first day, on which Clark gave his talk, dawned with the news that a Conservative government had been re-elected. However, this was not the main reason for Clark's uncertainties, I think. Although he thought that the former Soviet Union had been state capitalist for many years, he nevertheless seemed unclear what, as a Marxist, he would say about the process of its economic disintegration. He further confused his audience by the concluding slide to his talk which showed Simone de Beauvoir and Jean-Paul Sartre with Fidel Castro. Clark's rejection of any notion of a Marxist party further complicates his position. I would argue that his position at present is one which is in difficulties for a whole number of reasons, including an unwillingness to take on the arguments of feminism. The fact that Clark seems unwilling or unable to do this does not prove that Marxist analysis is incapable of understanding women's art.

Finally in this section, I would like to briefly look at some recent writings by John Tagg. Again, here is a cultural theoretician who made useful and stimulating contributions to cultural analysis and debate in the eighties. Yet again, however, Tagg seems to be going through something of a personal re-assessment of his theoretical premises and actual practice. In the Introduction to his recently-published *Grounds of Dispute*,[13] Tagg indicates his trajectory towards increasingly idealist theory. A number of the essays in his volume refer to his involvement with the British miners' strike in 1984–85 which went down to defeat after a long, bitter but exhilarating confrontation

with the British government. It is not surprising that many radical writers on cultural history, such as Tagg, appear demoralized and drifting further away from materialism (dialectical or otherwise).

I would like briefly to focus on Tagg's paper 'Articulating Cultural Politics: Marxism, Feminism and the Canon of Art', which he gave as a contribution to a symposium organized by Linda Nochlin, entitled 'Marxism and Feminism: Convergence in Art', held in November 1988. Tagg, like Pollock, rejects deterministic notions of class inscribed at the level of the economic base, and states that even in early Marx,

> much hangs on the play there is in the usage of the word 'determination' and the precise application of the terms 'base' and 'superstructure', inextricably complicated today by the growth of cultural and communications industries which, *like the material practices of language*, find no comfortable place on either side of the theoretical divide. If we turn, however, to works like the *Grundrisse*, *The Eighteenth Brumaire of Louis Bonaparte* or, indeed, the central chapters of *Capital* on the development of the factory system and the transition from absolute to relative surplus value, we find very different models in which to think the constitution of class.

Class, therefore, says Tagg, is conceptualized by Marx in these texts as a complex articulation of processes which constitute class subjects. He continues:

> Drawing on such theoretical resources, we are, then, simply able to sidestep tedious and unproductive theoretical disputes about the most fundamental determinant: class, gender, race or ethnicity, where these terms are conceived as essential, originary forms imposed on cultural and political 'expressions', and where claims for the logical priority of one must conflict with claims for another.[14]

There are several important issues at stake here. First, the concept that 'material practices of language' are not part of the superstructure is taken from Tagg's particular interest in a type of 'Marxist' scholarship associated with Althusser and Foucault, and most obviously Lacan. Marxists would find it hard to accept that language is part of the material base of society and indeed that the growth of cultural and communications industries in present-day society was *qualitatively* different from the development of printing or the invention of the telephone, and therefore necessitated a revision of Marxist theory of history as a history of class struggle. Of course Marx sees political ideas and a whole array of social practices as having a very complex and highly mediated relationship to economics and 'The Eighteenth Brumaire of Louis Bonaparte' sets out to demonstrate this. Interestingly, this text is the one also referred to by Pollock in her 1990 article, in order to acknowledge, at last, that Marxism does not equal economic determinism. However, Marx does not really draw the conclusions that Tagg claims. In 'The Eighteenth Brumaire of Louis Bonaparte', Marx writes:

> Upon the different forms of property, upon the social conditions of existence, rises an entire superstructure of distinct and peculiarly formed sentiments, illusions, modes of thought and views of life. The entire class creates and forms them out of its material foundations and out of the corresponding social relations. The single individual, who derives them through tradition and upbringing, may imagine that they form the real motives and the starting point of his activity ... and as in private life one differentiates between what a man thinks and says of himself and what he really is and does, so in historical struggles one must distinguish still more the phrases and fancies of parties from their real organism and their real interests, their conception of themselves, from their reality.

So, says Marx, there is a knowable reality, and the basis of that reality which ultimately explains the complexity of motivation, concepts, illusions, unconscious motives, etc. is 'different forms of property' and 'social conditions of existence'. In Engels's preface to the third German edition, written in 1885, he writes:

> It was precisely Marx who had first discovered the great law of motion of history, the law according to which all historical struggles, whether they proceed in the political, religious, philosophical or some other ideological domain, are in fact only the more or less clear expression of struggles of social classes, and that the existence of and thereby the collisions, too, between these classes are in turn conditioned by the degree of development of their economic positions, by the mode of their production and of their exchange determined by it.[15]

Now, of course, this does not mean that the work of Cindy Sherman, for example, can be understood as a manifestation of class struggle or anything so simplistic. What it does mean is that discussions about her critical reputation, the meaning of her work, the spectator it may or may not address, the representation of the female body, the possible psychoanalytic significance it has, need to be understood, ultimately, in terms of the situation of Sherman herself as a producer of artworks which are graped in terms both of the values of the international art world, and of the critical apparatus of the radical intelligentsia in a decaying and crisis-ridden imperialist-dominated world.

As stated above, there is little evidence that I can find to argue for a cultural significance of Sherman's work outside of imperialist countries at present. None of the critiques and explanations of Sherman's works has sought to address these issues. Most have concentrated on the fragmentation of the subject, either as the body portrayed or as the viewer, without really trying to conceptualize the material context in which Sherman's work is produced. Of course, that was not the aim of these writers, for example, Laura Mulvey, but this problem does not go away because Tagg decides he can interpret Marx to mean we can 'simply ... sidestep tedious and unproductive theoretical disputes'. I feel that, quite understandably, many

radical critics have moved further and further towards idealism as material reality appears more barbaric.

This, therefore, is the theoretical context in which Sherman's work has been discussed by radical cultural analysts. What, then, of the material conditions of the eighties in which her international reputation was established?

The Historical and Cultural Context

In an interview in 1983 Sherman stated: 'I like the idea of big editions and cheap art, and the closest I get to that is every year when I do a large edition of a hundred and twenty-five that are sold at the gallery for like fifty dollars.'[16] This is probably referring to the untitled film stills, which now cost $10,000.[17] In a period of world recession, Sherman's prices have rocketed, and here are obvious reasons why she does not produce large editions of her work. In a useful chapter of *The State of the Art*, published in 1987, dealing with the international art market, Sandy Nairne quotes Robert Hughes, who states:

> Twenty or thirty years ago, dealers in New York used to struggle against dealers in Paris or London, each affirming the national superiority of their artists. Those transatlantic squabbles are now extinct. What you have instead, on the multinational model, is associations of galleries selling the one product in New York, London, Dusseldorf, Paris, Milan. The tensions of national schools are dissolved.[18]

It is true, of course, that markets and marketing are now international concerns, but there remains an unresolved (and unresolvable) tension between the internationalization of profit and national economic political and cultural interests. The utopian project of the creation of a European superstate with its own market is a current manifestation of these irreconcilable aims, and also of the fundamental economic interest which will override long-term political strategies, as in the recent example of German banks overriding the political aims of the German government regarding the European Exchange Rate Mechanism.

In the continuing world recession, trade wars are threatened by the USA to maintain its own national economic interests. The USA, still the most powerful political and military force in the world, as demonstrated by its 'smart bombs' during the Gulf War, is, however, economically weak. The American dream is now a nightmare for many US citizens. The political triumphs of the USA and other imperialisms in the winning of the Cold War, hailed as a triumph for democracy, have resulted in chaos and barbarism in the former Yugoslavia, and the continuing disintegration of the economy of

the former Soviet Union. In this period of so-called post-feminism, thousands of women continue to die from back-street abortions and suffer other miserable forms of oppression, including mass prostitution, in imperialized countries (and indeed in imperialist ones). In addition, the eighties saw the emergence of AIDS on a massive scale. In 1981 the first cases of AIDS were reported in the USA and by 1983 the virus had been identified. The World Health Organization estimates that as many as six million people may be infected with AIDS in Africa alone. Yet while the World Health Organization tries to develop basic precautions to prevent the spread of the virus, its own funders, primarily the USA, are clawing money out of the countries where it is killing most people in demands for payment of international debts.[19]

The physical disintegration of the body is not simply identifiable as a trajectory in Sherman's work in the eighties but has become a physical reality for millions of people. Sexuality and contact with body fluids is an increasing source of potential death. It is thus possible to read the transformation of the body in Sherman's work of the eighties in this wider context. Paradoxically, this disintegration and dismemberment is presented in large glossy images printed in saturated colour reminiscent at one and the same time of advertising imagery and 'high' art objects.

Her use of the grotesque body may be paralleled by that of Rabelais in the early modern period, with his use of forms of 'popular' culture in 'high' culture. Bakhtin, in his book *Rabelais and His World*, argues that the grotesque body, as constructed by Rabelais in the early sixteenth century, is literally an embodiment of a qualitatively new conception of the relation of the physicality of the body to an understanding of the world. It moved away from a medieval hierarchic picture of the world to a humanistic focus on the body as the relative centre of the cosmos. Rabelais presented the grotesque body in all its materiality. For him, the comic and grotesque body 'reflected the struggle against cosmic terror and created the image of the gay, material bodily cosmos, ever-growing and self-renewing'.[20]

However, Sherman's photographs of the later eighties show grotesque bodies in a far from optimistic light. The relationship of these bodies is to a very different world than that understood by Rabelais. Here the disintegration, dismemberment and putrefaction is an embodiment not of optimistic self-renewal, but of a gradual collapse of bodily coherence which was still apparent in the black-and-white untitled film stills of the later seventies and early eighties. As if to retreat from the further development of this trajectory, Sherman in 1989 made her body into 'art' in a rather different and far less threatening sense, with the production of images showing herself in the guise of 'old master'-type paintings, albeit with grotesque trappings of false noses, breasts and so on.

Sherman's critical reputation has not diminished with the increasing

emphasis on the horrific and grotesque in her self-presentation. While radical critical writings on her work provide almost a 'who's who' of cultural studies in the eighties, there were other, less radical attempts to analyse her work running in parallel to post-structuralist theoretical writings. Sherman herself has ambivalent comments to make about what is practically her 'star' status in the art world: 'Hype, money, celebrity. I like flirting with that idea of myself, but I know because my identity is so tied up with my work that I'd also like to be a little more anonymous.'[21] Madonna, in a recent interview on British television about her book *Sex*, explained to watching millions that the person in the book was another, it was someone acting out roles and masquerades as in Cindy Sherman's photographs. All this has been interpreted as a radical challenge to notions of fixed 'femininity' constructed by the male gaze in patriarchal society, but it really is dubious to what extent Madonna subverts objectification of the female body in images designed for profit-making, even if the recipient of the profit is the author/producer. In a recent article, Laura Mulvey compares Cindy Sherman's and Madonna's strategies for 'debunking of stable identity', and mentions Madonna's aware-ness of the disintegrative 'side of the topography of feminine masquerade in her well-documented admiration for Frida Kahlo'.[22] Kahlo, however, was not just concerned with female self-image in her activities, she was also a political activist, and a tendency to ignore this has not helped develop an analysis of Kahlo's work which would attempt to relate her political views and activities to her presentation of herself as a Mexican, a woman and an artist.

Sherman's strategies of self-presentation are interesting because they consciously set out to engage with mass media images of women which attract and distance at the same time. In the course of the eighties, the weight of this contradiction tipped further in the direction of distancing and criticism. The untitled film stills show Sherman involved with her B-movie pseudo-sources, yet aware of the mechanisms at play in the positioning of the woman as both subject and object of the image. Sherman goes on to interrogate the format and photographic 'genre' of the centrefold, and the fashion and beauty advertising image. She consciously aims to destroy dominant notions of beauty and desirability: 'I'm trying to make fun of fashion. I'm disgusted with how people get themselves to look beautiful, I'm much more fascinated with the other side.'[23]

In 1984, Sherman was commissioned to produce fashion photographs for French *Vogue*. This commission was rather a bold attempt to tackle the whole 'look' of fashion photography on its own home ground and with access to its own audience. Not surprisingly, the odds were heavily weighted against Sherman and she felt she had to compromise. Her aim had been to debunk the ideological premises on which glossy fashion photos were constructed:

They expected me to do with their clothes what I had done with this other company ... make kind of cute, funny pictures. From the beginning there was something that didn't work with me, like there was friction. I picked out some clothes that I wanted to use. I was sent completely different clothes that I found boring to use. I really started to make fun of, not really of the clothes, but much more of fashion. I was starting to use scar tissue on my face to become really ugly. This stuff you put on your teeth to make them look rotten. I really liked the idea that this was going to be for French *Vogue*, amongst all these gorgeous women in the magazine I would be these really sick-looking people.[24]

Although Sherman felt rather disappointed with what happened, this series of photographs and her ideas about the commission demonstrate quite clearly the deeply contradictory position of Sherman and her work's engagement with the imagery and modes of address of mass media photographs. What is also noteworthy is Sherman's conscious desire to criticize and oppose these images using their own techniques and means of diffusion. Nevertheless, it is clear that this was not realistically a strategy likely to succeed, and Sherman's works are more easily accommodated by the notion of 'art' to be exhibited in 'art' galleries, and marketed by 'art' dealers. What is also of great interest, and raises a problem for many of the theoretical analyses of representations of women, is that Sherman has obviously become not just fascinated and engaged by media images, but consciously critical.

The Unconscious in Context

Now the problem posed for the kind of post-structuralist theories which argue that subject positions are already constructed for us, that discourse and language construct the subject and that there is no 'reality' to which images and texts actually refer, is this – how do they explain the process by which Sherman moves to a conscious decision to destroy particular types of imagery of women? If women enter into gendered subjectivity at an unconscious level, how are they consciously supposed ever to be able to criticize the ideology and social practices that oppress them? It seems to me that none of the linguistic and psychoanalytic theories currently in vogue in writings about representation and women even tries to explain this. Unless we take a materialist view of Sherman's development and argue that it is likely to be her own experiences in a 'real' material world which prompted her to question and eventually try to destroy dominant notions of fashion and beauty, I really don't see how Sherman as an individual was ever likely to escape from the subject positions she was already 'written into', as this idealist argument would have it.

I feel that this is a major problem with analyses such as Laura Mulvey's. Her articles 'Visual Pleasure and Narrative Cinema' and 'Afterthoughts on Visual Pleasure and Narrative Cinema'[25] written in the mid- and late seventies set out to examine the reasons why women watching Hollywood films took pleasure in what Mulvey argued was their own objectification by the technical and cinematic means of the film medium and its consumption by the cinema-goer. Sherman seems to have taken great pleasure in these same Hollywood productions. Mulvey argued that the female spectator viewed the film taking on the gaze of the male, embodying social and psychological power over the fetishized representation of the woman in the film. Leaving aside the problems of applying an analysis of film straightforwardly to still imagery, there are still some serious problems with Mulvey's thesis. Again, if all this happens on an unconscious level, how do we explain the emergence of female (and male) artists and film-makers who consciously try to criticize, and develop alternatives to, dominant visual culture? The idea of voyeurism and scopophilia being applied to the cinema and the still image also needs to be carefully considered. There is a difference between the pleasure people get from looking at photographs and so on, and the conditions Freud tries to analyse where his patients cannot achieve sexual fulfilment other than through fetishistic voyeurism. There is a qualitative difference here between watching an image and having an orgasm watching an image. If the spectator gazes at many images, her/his pleasure will quantitatively increase, but it won't necessarily qualitatively transform her/him into a 'male voyeur'. Furthermore, every visual image, especially every photographic image, has to be looked at, so are we supposed to accept that the visual image at all times and under all conditions, and irrespective of the identity of the spectator, will objectify and fetishize what it represents? This is a pretty pessimistic view to say the least. Moreover, is Mulvey arguing this is the case under capitalism or under all societies where women are oppressed? Is it the case that the mechanism and processes of the unconscious and conscious in relation to social existence have transhistorical validity?

The situation is made no clearer in Mulvey's 1991 article on Sherman's work. She argues that Sherman attempts to defetishize the female body but comments 'it is hard to trace the collapse of the female body as successful fetish without re-presenting the anxieties and dreads that give rise to the fetish in the first place, and Sherman might be open to the accusation that she reproduces the narrative without a sufficiently critical context.'[26] This sounds like an impossible task, especially if the photographic image by its very nature is supposed to objectify and fetishize in any case. Also, there is still no theoretical conceptualization offered by Mulvey of how the female subject achieves any consciousness and critical awareness. Now it is not the case that psychoanalytic theory is, in itself, idealist, but I would argue this has been a definite characteristic of the use of psychoanalytic theory by such

writers as Mulvey, Pollock and Craig Owens, among others. Freud himself saw the mechanism of the conscious and unconscious as related to the preservation of the social status quo, as one of the functions of repression was to deal with sexual desires which would destabilize social norms and practices if they were consciously acted upon.

Obviously, the processes by which socially disruptive desires and needs are repressed and the ways in which we become 'conscious' of the unconscious, and indeed of the fact that our experience has been lived through ideology, are of great interest to dialectical materialists. We need to learn more about the ways in which socially oppressive subject positions are internalized, and how they can be overcome. But this means rescuing psychoanalysis from idealism. Trotsky, writing in his *Notebooks on Dialectics* (1933–35), says that certainly

> psychoanalysts are frequently inclined toward dualism, idealism, and mystification.... But by itself the method of psychoanalysis, taking as its point of departure 'the autonomy' of psychological phenomena, in no way contradicts materialism. Quite the contrary, it is precisely dialectical materialism that prompts us to the idea that the psyche could not even be formed unless it played an autonomous, that is, within certain limits, an independent role in the life of the individual and the species.[27]

Sherman's monstrous and grotesque images of decay and ugliness attempt to articulate the kind of imagery through which the unconscious represents repressed fear and terror. As such her images are a critique of a world-view which sees the female body as coherent, beautified, idealized and glamorized. Her own processes of applying make-up and wigs developed from the late seventies where various body and facial disguises were applied to enable her simultaneously to participate in and interrogate movie images. From 1983 onwards, her use of make-up, wigs, plastic and rubber breasts, noses and buttocks, scar tissue, etc. has constituted a destructive parody of the glamorization of the body. The socialized fears with which women are brought up and taught to internalize – fear of being 'unattractive' and 'undesirable', even 'ugly' – are here thrust by Sherman right at the spectator on a large scale. I feel that these images are just as much for a female as a male spectator, irrespective of what psychoanalytic theorists say about the 'theoretical' spectator that they posit.

The Art World Context

However, we still have to ask why Sherman's works have been so successful in the international art world. Is this not an apparent contradiction if her works are so destructive of canons of beauty and desirability? In attempting to

answer this question, I shall look mainly at two articles on postmodern photography by Douglas Crimp and Abigail Solomon-Godeau. Crimp's article, written in 1980, obviously could only refer to Sherman's early untitled film stills. He locates her work within postmodern photography, which in turn he sees as part of two trends developing out of the seventies – the resurgence of expressionist painting and the triumph of photography as art. Both of these developments return a sense of 'aura' to the work of art. Crimp is, of course, referring here to Walter Benjamin's argument in his famous essay 'The Work of Art in the Age of Mechanical Reproduction' (1936). For Benjamin, the work of art had a unique existence in time and place, an authentic presence in social ritual. The development of photography and film, he says, has the potential to destroy the notion of the aura of the individual authentic artwork. This potential is destructive and constructive. 'Its social significance, particularly in its most positive form, is inconceivable without its destructive, cathartic aspect, that is, the liquidation of the traditional value of the cultural heritage.'[28]

Crimp goes on to argue that the young postmodern practitioners of photography-as-art restore the aura to the artwork, but only to displace it and show 'that it too is now only an aspect of the copy, not the original'.[29] Cindy Sherman, he claims, destroys the fiction of the self, thereby adding to the destruction of the auratic presence of the photograph as art. I find this argument a little problematic, since social, cultural and economic factors, as well as what the individual work does, or does not, intend to do, influence whether the photograph is accepted as a work of art. Sherman certainly doesn't exploit the potential for mass reproduction of the photographic medium as it was developed in industrial capitalism. Her photographs need to be seen in relation to traditions of the artist's print, as well as photography and painting, or even 'records' of events staged by the performance artist. Benjamin's vision of the potential of mass-reproduced imagery as socially and culturally progressive rather ignored economic considerations. On the one hand, capitalism sells films, cameras, photographic development and reproduction services to a mass of purchasers. But where scarcity means increased value, then the photograph's potential for mass reproduction is not exploited. Social, cultural and, primarily, economic factors determine whether the photographic negative is used to produce an 'art image' or a mass reproduction image. Sherman's images are very much part of the 'art' tradition, not just because there aren't massive 'editions' of them (her term), but also because of their existence in, primarily, a context of galleries, criticism, collections, and the notion of a professionally trained artist working in a studio. (Her earlier photographs were often taken on location.) As mentioned above, Sherman's attempts to 'show' her work in mass circulation magazines did not result in it reaching a 'mass' audience, but, rather, encouraged her to move back to the gallery and museum world.

Benjamin's essay also raises the interesting notion that if the essential defining component of photography as a medium is reproducibility, then modernist photography would be photography that interrogates and analyses this aspect of itself. However, this development has largely been a characteristic of postmodernism. When most people think of modernist photography, they think of works like those of Man Ray or Edward Steichen. However, there are different types of modernism in photography, including propaganda images like those of Heartfield, or ideological and cultural deconstructions like those of Hannah Höch. This causes problems in seeing photographic postmodernism as a qualitatively different phenomenon from photographic modernism. There was never the huge emphasis on formal self-criticism and non-figuration in photographic modernism as there was in the dominant painterly notion of modernity. Mass reproduction and formal modernism do not always coincide in modernist photography. In a sensibly written and very useful article, Janet Wolff, like others, suggests that 'the radical relativism and scepticism of much post-modern thought is misplaced, unjustified, and incompatible with feminist (and indeed any radical) politics. The project of post-modernism as cultural politics is more usefully seen as a renewal and continuation of the project of Modernism.'[30]

For Abigail Solomon-Godeau, however, Sherman's work has simply been recuperated by the art institutions which help preserve modernism in art, and its critical edge has been blunted. In her article 'Living with Contradictions', Solomon-Godeau examines the process of recuperation whereby works by, for example, Sherman, Levine and Kruger, have 'directly challenged the pieties and proprieties with which art photography had carved a space for itself precisely *as* a modernist art form'.[31] Solomon-Godeau places considerable emphasis on the ability of institutions and academic and cultural practices of the art world to define and incorporate particular photographic works into a corpus of imagery valued for authorial presence, originality, authenticity, etc. This, of course, means that it is very difficult to subvert these values from within the institutions that work to preserve them, but, as the title of Solomon-Godeau's article suggests, radical artists live with these contradictions, and indeed the contradictions are present within the institutions and practices of the art world. Otherwise how could we explain the purchase and critical success of Sherman's huge coloured images of worms, vomit, rotten junk food, dismembered bodily forms, etc.? Solomon-Godeau argues, however, that postmodern photography's critical potential vis-à-vis mass media images of fashion and advertising has collapsed. Writing in 1987, she comments that, in contemporary photography,

> Postmodernism as style, on the other hand, eliminates any possibility of analysis insofar as it complacently affirms the interchangeability, if not the coidentity, of art production and advertising, accepting this as a given instead of a problem. . . .

273

Now firmly secured within the precincts of style, postmodernist photography's marriage to commerce seems better likened to a love match than a wedding of convenience. Deconstruction has metamorphosed into appreciation of transformation, whereas the exposure of certain codes has mellowed into self-referential devices.[32]

All the same, she illustrates Sherman's *Untitled Film Still* (1979), where Sherman lies on a sheet wearing a shirt and pants, looking sensually dreamy, lipsticked mouth slightly open, a trashy-looking sensational novel by her side. I think if Solomon-Godeau had chosen a later example of Sherman's work she might have had a less clear-cut case.

Solomon-Godeau then goes on to discuss the work of Heartfield and concludes that really this is insufficient as a model for contemporary critical photographic practice. Solomon-Godeau seems not to consider Heartfield's work as modernist, and I think she has a tendency to see a critical political stance as something basically incompatible with modernist formal critical awareness. This is rather problematic. While she says Heartfield's great importance is that he meshes political criticisms and politics of representation, she does not see this as in any way linked to modernism; her concept of modernism is that of 'official art photography' and 'art practices predicated on signature styles'.

Solomon-Godeau's essay is a usefully thought-provoking piece which attempts to explain the market success of postmodern American photographers. Although photography fetches lower prices than painting 'despite the prevalence of strictly limiting editions and employing heroic scale', in 1980, the work of, for example, Sherry Levine hardly sold at all and was understood only by a small number of artists and critics.

> When this situation changed substantially, it was not *primarily* because of the influence of critics or the efforts of dealers. Rather, it was a result of three factors: the self-created impasse of art photography that foreclosed the ability to produce anything new for a market that had been constituted in the previous decade; a vastly expanded market with new types of purchasers; and the assimilation of postmodernist strategies back into the mass culture that had in part engendered them.[33]

Unfortunately, Solomon-Godeau does not go into any detail about the 'vastly expanded market with new types of purchasers', which would have been useful. Would the Saatchis belong to this 'new type of purchaser'? I find it hard to believe there are vast numbers of Saatchis out in the market buying postmodernist photographs. More work on this would be useful, but the literature on Sherman says very little about her patrons and prices, and virtually nothing about the historical and economic situation in which her work exists.

Before concluding, I should mention some other types of criticism of

Sherman's work. Some reviews are simply dismissive of her work, some try to inscribe it into a 'fine art' tradition, and some see her as a continuing part of a heroic creative myth of the tormented individual finding sublimated equilibrium through the creation of 'Art', in this instance to escape being female.

In the catalogue of the Saatchi collection, Sherman's work is linked to the history of painting, rather than to that of photography, and her lighting effects compared to Mannerist and Baroque art ('as with Baroque art, there is a great theatricality in Sherman's work'). Her attention to surface detail apparently stands in the tradition of Velázquez and Matisse![34] This is analysed as an example of the 'human presence returning to art'. Even more bizarre is an article by Donald Kuspit, who reads Sherman's work as a (successful) attempt to go beyond the contradictory experience of woman-hood, to artistic fulfilment. Her art can bring

repulsive, ugly scenes under aesthetic control, make them aesthetically appetizing – this surely signals Sherman's profound ambivalence about her experience of her womanhood, something she abhors yet enjoys, and brings under control by putting it to artistic use. It is this artistic use – her wish to excel with a certain aesthetic purity as well as to represent inventively – that reveals her wish to heal a more fundamental wound of selfhood than that which is inflicted on her by being a woman.[35]

Conclusion

In some respects, Sherman's successful career in the eighties was helped by her reluctance to engage in any critical or theoretical debates, claiming that theories about women, the fragmentation of the subject, etc. were interesting, but did not consciously inform her work. They were a kind of 'side effect', in her words. This obviously made it possible to have the most diverse views on the critical potential and cultural radicalism of Sherman's work. Also, in some ways, by focusing always on notions of the 'feminine self', radical critics largely ignored the specific historical and economic situation in which Sherman's work was produced and changed. We need to ask why it did change, not just how it relates to psychoanalytical theory, for example. Since feminism sees virtually all societies in history as patriarchal, then the formation of the subject is posited as broadly similar over vast periods of time, stretching from Ancient Greece to the crisis-ridden imperialism of the present day. This is not very helpful in trying to understand exactly what contradictions exist within an individual's, or a social group's, conscious and unconscious articulations of how they understand the world, and the images they choose to construct of it, and produce to exist within culture. Sherman's decision not to use texts with her photographs, with the explicit intention of

making them more ambiguous, also has the possible result of increasing the diversity of meanings that can be attributed to them by the different audiences for her work. However, use of a text is not an automatic guarantee of escaping from galleries, museums and the modernist notion of the apolitical avant-garde, even if that is the conscious intention of the artist. Ultimately, the directions of the contradictions and tensions in Sherman's work, both conscious and unconscious, will be determined by factors over which she, as an individual, does not have a great deal of control.

Notes

1. Catalogue of the exhibition 'Cindy Sherman', Padiglione d'Arte Contemporanea di Milano, 4 October–4 November 1990 by M. Meneguzzo, Mazzotta, Milan 1990. See bibliography and list of public collections with works by Sherman.

2. Blackwell, Oxford 1992.

3. See Greenberg, 'Avant-Garde and Kitsch', first published in *Partisan Review*, vi (5), Fall 1939, pp. 34–49; reprinted in Francis Frascina, ed., *Pollock and After: The Critical Debate*, Harper & Row, London 1985.

4. David Brittain, interview with Cindy Sherman, *Creative Camera*, February/March 1991, pp. 34–8.

5. *Vision and Difference: Femininity, Feminism and the Histories of Art*, Routledge, London 1988.

6. Pluto, London 1973.

7. Pollock, *Vision and Difference*, pp. 4 and 5.

8. Craig Owens, 'The Discourse of Others: Feminists and Postmodernism', in Hal Foster, ed., *Postmodern Culture*, Pluto Press, London 1985, p. 79 n. 17.

9. Griselda Pollock, 'Missing Women: Rethinking Early Thoughts on Images of Women', in Carol Squiers, ed., *The Critical Image: Essays on Contemporary Photography*, Lawrence & Wishart, London 1990, p. 206 (my emphasis).

10. Ibid., p. 219.

11. Ibid.

12. T.J. Clark, *The Painting of Modern Life: Paris in the Art of Manet and His Followers*, Thames & Hudson, London 1985.

13. John Tagg, *Grounds of Dispute: Art History, Cultural Politics and the Discursive Field*, Macmillan, Basingstoke and London 1992.

14. Ibid., pp. 58–9 (my emphasis).

15. For these quotes see Karl Marx and Friedrich Engels, *Selected Works in One Volume*, Lawrence & Wishart, London 1973, pp. 95, 117–18.

16. Interview with Paul Taylor, *Flash Art*, October/November 1983, p. 78.

17. Information kindly provided by the print and photography department at the Victoria & Albert Museum.

18. Sandy Nairne, *State of the Art: Ideas and Images in the 1980s*, Chatto & Windus, London 1987, p. 65. The quote from Hughes dates from late 1984.

19. See Clare Heath, 'AIDS, Capitalism and Oppression', *Permanent Revolution*, 9, Summer/Autumn 1991, pp. 149ff.

20. Mikhail Bakhtin, *Rabelais and His World*, trans. Hélène Iswolsky, MIT Press, Cambridge, Mass. 1968, p. 340. I am indebted to John Roberts for the suggestion that Sherman's depiction of the body might be studied in relation to Bakhtin's analysis.

21. Interview with Paul Taylor, p. 79 (see n. 16 above).

22. Laura Mulvey, 'A Phantasmagoria of the Female Body: The Work of Cindy Sherman', *New Left Review*, 188, July/August 1991, p. 149.

23. Quoted in Peter Schjeldahl and Lisa Phillips, *Cindy Sherman*, Whitney Museum of American Art, New York 1987, p. 15.

24. Quoted in Nairne, *State of the Art*, p. 36.

25. 'Visual Pleasure and Narrative Cinema', *Screen*, 16 (3), Autumn 1975, pp. 6–18; 'Afterthoughts on "Visual Pleasure and Narrative Cinema" Inspired by King Vidor's *Duel in the Sun* (1946)', *Framework* 1981. Both articles reproduced in Laura Mulvey, *Visual and Other Pleasures*, Macmillan, Basingstoke 1989.

26. Idem, 'A Phantasmagoria of the Female Body', p. 146.

27. Leon Trotsky, *Notebooks on Dialectics: Writings on Lenin, Dialectics and Evolutionism*, trans. and with an introduction by P. Pomper, Columbia University Press, New York 1986, pp. 106–7.

28. Walter Benjamin, quoted in Francis Frascina and Charles Harrison eds, *Modern Art and Modernism*, Open University Press, Milton Keynes 1982, p. 219.

29. Douglas Crimp 'The Photographic Activity of Postmodernism', *October*, 5, Winter 1980, part 15, pp. 98, 99.

30. Janet Wolff, 'Postmodern Theory and Feminist Art Practice', in Roy Boyne and Ali Rattansi, eds, *Postmodernism and Society*, Macmillan, Basingstoke and London 1991, p. 205.

31. Abigail Solomon-Godeau, 'Living with Contradictions: Critical Practice in the Age of Supply-Side Aesthetics', in *Photography in the Dock: Essays on Photographic History, Institutions and Practices* (Media and Society, vol. 4), University of Minnesota Press, Minneapolis 1991, p. 127. (Originally published in *Screen*, 28 (3), 1987.)

32. Ibid., p. 143.

33. Ibid., pp. 136–8.

34. *Art of Our Time: The Saatchi Collection*, vol. 4, Lund Humphries, London 1984, p. 20.

35. Donald Kuspit, 'Inside Cindy', *Artscribe International*, September/October 1987, p. 43.

10

Laurie Anderson: Myth,

Management and Platitude

Sean Cubitt

The relationship between the avant-garde and popular culture goes back some years now – at least to the days of Courbet, and probably to Goya, if his chapbooks can be considered avant-garde in the sense we have come to recognize in the twentieth century. The problematic of artist and audience so effectively singled out by Peter Bürger[1] has seen a long and often unpleasant history of artists looting the supermarkets of pop for images for art. In Laurie Anderson's 'O Superman' – 'the first – so far only – work of performance art to become a Number One hit',[2] the process is reversed. The institutions and, ultimately, the audiences of mass culture have begun to loot the museums and galleries of the avant-garde for images for popular consumption. But if this were all, Anderson would not have generated the fascination that she has, a woman marking a track through performance, poetry and music. What is it, then, to be visible and audible, to make yourself heard? And what are the processes by which the complex interplay of art and industry seems to make her, in some malicious sense, author of the archetypal yuppie album? How come it is still interesting that an artist move across the boundaries of the popular and the high cultural? In a period in which, we are told, nothing has depth, is there any point to art anyway? This essay traces four phases of Anderson's work: the phenomenological production of a performance persona; the textualization of performance; the industrialization of the avant-garde; and the reclamation of Anderson for a progressive politics. Perhaps these reflections may cast some light on the questions that arise around her.

The Phenomenological Production of a
Performance Persona

Your eyes. It's a day's work to look into them.
'Il Tango' (1982)

I am in my body the way most people drive their cars.
'Words in Reverse' (1980)

What is it to be visible in a technological age? The problem of visibility for us, now, must begin in the mind/body duality characteristic of rationalism. As if my mind did not extend, through my nervous system, to the edges of my body. As if, touching the world, I were not also touched by it. For touching is to be touched by the world, and more: it is to enter into a world where things touch each other, a tactile world, the world of the tactile. It is impossible to touch without being touched, to see without being seen, without entering the world of the visible. Yet the *specific* modes of technology in advanced capitalist societies are such that these necessities – the necessity of entering the worlds of the tactile, the visible, the audible – are no longer clear to us.

Cultural technologies, in an age in which culture has become technologized, restate and rework historical and social relations of perception. Technologies do not cause, but are homologous with, the constant reorganization of instinctual pleasures of perception in the interests of, usually, some form of social organization. Thus our senses are privileged hierarchically in the contemporary world, with sight at the top, hearing second, touch third, and taste and scent drawing up the rear. Moreover, the empiricist notion of vision has become dominant: an ideology of vision as the reception of rays of light from an external and objectified world. For the empiricist, as for the dominant culture of the West, the eye is there to receive but not to give, to discover, not to illuminate. Our technologies, from the industrialized theatre, through cinema and television to video and, to some extent, computers (crucially in computer gaming), are one-way channels. They succeed, within the terms of the dominant, if we become 'all eyes', if we forget where we are, if we lose any sense of the rest of our bodies. If, that is, we become invisible, like the invisible observer of empirical experiments. Certainly, the reading of books has been of the same kind, and for longer, but for fewer people, and for those with the ability to write the medium as well as read it. And certainly there are other cultural forms – dancing, amateur sports, fashion – that make visible, but only within the parameters of an organization of vision whose roots lie in a dichotomy between seeing and being seen. Still there seems a historical drift towards an understanding of perception itself as reception, whatever the complexity of our subsequent dealings with what we have perceived.

Merleau-Ponty's remarkable chapter on 'the intertwining',[3] subject of an important reading by Lacan,[4] challenges the empiricist version with a phenomenological one: on the analogy of touch, sight presumes our existence in the visible world. To see is to be the object of the gaze for an Other, whether that Other be understood as another human, or as the gaze of a world which shares its visibility with us. But the rich fields opened by this analysis must first be crossed by a further, materialist observation: that not everyone enters the field of the visible equally. Not only sight-impairment and blindness queer the pitch. The field of vision is orchestrated in regimes of inequality: some look and some are looked at. The tourist, for example, looks but is shocked to be pursued by stares. Men and women look differently at one another. The patient, the specimen, the athlete, someone with a disability, an elderly person, a star, are looked at differently. Their presence to visibility, their power to look, is uneven. The universe of vision is lumpy. Merleau-Ponty is too utopian.

Since the invention of perspective and of maps technologies of vision have only entrenched these inequalities, despite the best efforts of visual artists to crack open their systematic regimens. User-friendly computer graphics packages have only added axonometric perspectives derived from architecture to the simple roster of available systems, presenting virtual worlds to us, not us to them. And we're grateful. Being sucked into the TV world is a nightmare shared by many recent productions (*TRON*, *Poltergeist*, *Stay Tuned* . . .), a nightmare in which what is at stake is identity. But identity is marked, in this zone, by unequal power in the field of vision. We cling to those identities – being beautiful, being black, being male, being transvestite – that name our places in vision. Those who disown them we call artists, or exhibitionists. A performance artist will, of necessity, be both.

Much has been written on the question of the 'lack in being', and specifically about how that lack might gravitate specifically about the identity of women. Were we to trace the history of this story of lack, we might start with Heidegger, for whom the mystical totality of the relationship between man and the world bears the name of Being, but for whom Being has, in history, become distant, perhaps impossible to discern. The Lacanian 'lack' derives, circuitously, from this persuasive pessimism, announcing the permanence of this state in which we are never to be happy, driven by desire which simultaneously draws us towards and debars us from the Real. For some feminist analysts, this thought must be driven further, for in their lack of a castration complex, women lack lack. Lacking lack, they lack the means to enter into the Symbolic as men do, lack the stake in all societal, scientific, cultural forms that men have. They lack identity – save as the object of a male gaze. But as Rodowick argues, this presumes a simple map of sexualities and genders: male/female; homo/heterosexual.[5] This map is too simple. If

nothing else, Freud demonstrates the incompleteness of such definite categories of psychic life. The problem is, for a performance artist who is also 'woman', to create a mode of becoming visible/audible which is more than an identity. Little girls should be seen. And not heard.

Making a noise is the prerogative of the powerful: police and emergency service sirens, aeroplanes, roadworks. Some noise is political – a demonstration. Some noise is social – football crowd or an audience. Some noise is anti-social – a portable hi-fi system, a car stereo. But a woman's voice should be ever soft and gentle. It marks both the weakness of women's relationship to language and the Symbolic, and their subordination, subjected to the fuller subjectivity of men. Making a noise, as Anderson does, and making a noise with her voice, not just, in the words of the old rock 'n' roll song, in the kitchen rattling the pots and pans, challenges both subordination and weak subjectivity. But it cannot do so without profound ambivalence about what is to be achieved.

Near the beginning of *United States I–IV*, a diagrammatic line-drawing of a man and a woman is projected on to a screen behind and above the performers. They are naked, and recognizably white. His hand is raised, palm forward. Anderson's voice, transformed by vocoder into that of a man, says 'In our country, we send the pictures of our sign language into outer space. They are speaking our sign language in these pictures. Do you think they will think his hand is permanently attached this way? Or do you think they will read our signs? In our country, goodbye looks just like hello. . . .'[6] There has already been some debate over this image, chosen to be beamed out to the stars in hopes of meeting some intelligent extra-terrestrial species. Why whites? And why is it he who does the greeting? We might ask, why is the human race depicted in terms of sexual difference? For Anderson, the question is a statement of absurdity. Hello and goodbye, coming and going, look just like one another; arrival and departure at any place are the same. Like identity: you have never quite arrived at, never quite left, the identity you were looking for.

Anderson's tactics are irony and ambiguity. Her stage persona is dry, trading in banalities as if they carried the secret of life. But the ambiguity is: they do. Ambiguity covers her stage presentation of herself, with that tomboy haircut, loose suits and shades, and extends into the robotic language of gesture and movement that characterize *United States*. Likewise her voice is manipulated electronically to sound as squeaky as Minnie Mouse, or as gravelly as John Wayne. In each instance, visible and audible, there is a second ambiguity – one between human and machine, hinging on the possibility of reconstructing whatever has already been constructed. For identity means already having been constructed in some shape, as some sound, having been constructed in a particular relation to your visibility and

audibility. There can be no return to some imagined primal innocence before construction. There can only be reconstruction on the basis of what history has made available. A cyborg reconstruction.[7]

The Textualization of Performance

> I never sang the songs . . . HEY AH HEY . . . of my fathers . . . HEY HEY
> AH HEY . . . I am singing for this movie . . . HEY AH . . . I am doing
> this for money . . . HEY HEY AH HEY
> 'Words in Reverse' (1980)

On the one hand, technology appears to us as determining. McLuhan reads it that the screen relation builds us into some specific way of thinking, informs our every thought and, to add something here, our every phantasm. For Heidegger, technology is *Ge-Stellt*, the frame in which our relation to the world is bound within a historical process in which everything appears to us as objects, and ourselves appear to ourselves as subjects; a relation that shapes both its terms. Baudrillard combines the two: shaped by technology, we constitute the world as objects, and our shaped subjectivity is drained of power until it, too, takes on the form of objectivity, though with the additional sense of 'objective' derived from optics, where the objective of a lens is the place at which a virtual image is formed. For Baudrillard, objectivity is already so profoundly mediated as to render the subject/object relation itself virtual, a virtual relation in which, none the less, we are imprisoned. A more materialist analysis might argue that such processes of objectification are the necessary prelude to our commodification; that we, too, as subjects, feel ourselves becoming first objects and then commodities, first our physical labour power, and then our mental. We greet ourselves as objects, for example, in body culture: treat your body well and it will repay you. Invest in your mind. 'I don't know about your brain – but mine is really bossy' ('Babydoll', 1989). This is the price of individuality.

Anderson's purchase on this objective subjectivity is that it is neither a prison nor a disaster, but the raw material with which irony is built, and in irony the possibility for building a new subjectivity. 'There is a crack, a crack in everything. That's how the light gets in', as Leonard Cohen sings ('Anthem', 1992). Anderson's frequent use of anecdote as a method of narration is a constant revelation of contradiction in the heart of how we are today. The little girl who talks to her cuddly rabbit in digital slang; the advice to carry a bomb on a plane because the chances of there being two bombs is minuscule; paranormal voices on tapes made in empty rooms – these are at once urban myths that serve to give meaning and depth to meaningless and shallow experience, and the notation of a larger music running through hundreds of disparate lives, uniting their states. Like an

answering machine that does anything but, that listens but never talks back, many of the anecdotes come to their ends not with a narrative wrap-up but with silence: a deaf couple's attempted conversation that ends with 'What?' That silence underpins her speech as much as a different kind of silence underpins the music of John Cage.

But a different kind of silence confronts the would-be commentator. Performance art is, by its nature, fleeting. It is impervious to documentation, putting on the colours of memory as soon as you try to write about it. Caught on the cusp of action, it builds on time as a process of change. Anderson's performances run so much on memory and history, on the sense that her anecdotal characters live in an amorphous past that might be minutes or days or years old – the past of stories that begin 'It was up in Canada', 'I saw a photograph', 'It was a large room ...' – a past that might perhaps be the formal past tense of fiction. That past she makes present (re-presents) in multi-media performances, but even listening to tapes of UK performances of *United States* from 1982, it is difficult to re-create in the mind's eye the work that went on that evening in the Dominion Theatre on Tottenham Court Road. The video for 'O Superman' helps, and the stills on the inner and outer sleeves of the *Big Science* LP; but each takes on the same weightlessness of the quasi-fictive past as you struggle to re-create it from what documents, photographs, articles and reviews come under your hand.

Anderson's work plays on this precise ambivalence of memory, through the line of work that comes to us as artifacts, commodities, records, tapes and CDs and their associated packaging. This merchandise is a record. But it is not simply secondary or supplementary to the performances which might then be origins of the recordings. For the performances themselves are records – not only in their use of memory, not only in their deployment of pre-recorded sounds and voices, but in the way that they construct themselves as Events: moments whose purpose is to inhabit the memory of their audience. Performance doesn't entail the presence of the performer to the audience in any unproblematic manner. The performance image, the personae adopted, the necessary distance that makes it possible to perform or to be an audience, as in any pop concert, work on the same dialectic of presence and absence that fuels the glamour of the cinema screen. The more you approach a film screen, the more the image dissolves, becomes incoherent. The more you approach a performer, the more you inhibit the very performance you are there to see. No matter how much a performer gives, no matter how intensively you attend to her, the gap remains between.

Not that this gap is either innocent or evil. It is real, in the sense that it is the *dialectic* of distance, of being both close to and distant from, that allows art to occur in the first instance. There is no primordial unity, even in the most profound of performance experiences, where the performer might feel both the community and the loneliness of performance. In our period of history,

and in our Western societies, there is no performance that is not always already a commodity. We might mark this in the amplification and electronic modulation of Anderson's spoken and singing voice: what we heard, that night in London, was not her voice, but a voice already distanced from its author by acoustic engineering. (The same, I think, can be argued for the artifice of speech and song adopted by actors and opera singers, whose technical control of breathing and articulation must alter their 'natural' inflections. Perhaps it is possible to say much the same of our adoption, in everyday life, of appropriate – socially appropriate – tones of voice for speaking in most situations.) Even the voice is always already mediated, by air and the mechanisms of the ear if nothing else, before we hear it: the voice itself, sign par excellence of the presence of the speaker, is always past.

Merleau-Ponty has an anecdote that illuminates this process. A woman in Manchester asks him, ' "*Shall I wrap them together?*" ', which I understand only after a few seconds – and then *all at once.*' Merleau-Ponty describes this as a Gestaltung, which translates as 'a retrograde movement of the true',[8] arguing that it is no longer possible, having somehow pieced together the true interpretation of the statement in retrospect, to understand its constituent parts other than in the sense of this overall reading of them. A performance is very like this, especially one involving story-telling. We listen as intently to the words of each sentence, the accumulation of sentences, as we would watch a tightrope walker, or listen to a singer strain for the high notes. The slow, meticulous pronunciation of words keeps us waiting: a relation with the future that makes sense only when reassembled with what is already past. We live with the belief that only some arts are time-based, and that it is possible to see a photograph, for example, in only the same amount of time as it took the shutter to blink open. Music cannot help but be, like narrative, clearly temporal: we wait for its completion. Perhaps it is because our first impression of a painting or a photograph is that it is already complete that we imagine that it takes no time to see it. But even the rapid flickering of film and video images takes a measurable amount of time, a twenty-fourth or a twenty-fifth of a second. Each word and each sentence, takes time, with Anderson's characteristic embedding and right-branching sentence structures making us still more aware of the distances between where we are now and the completion of each phrase, each sentence, each narrative gesture, each anecdote.

Equally characteristic is Anderson's strategy of building anecdote upon anecdote, so that we are never sure of the ultimate destination which we might expect to reach. Each tale is so inconsequential, and their relation so non-sequential, that time begins to stretch out. 'This is the time. And this is the record of the time' ('From the Air', 1982; also *United States* Part II). Music and speech are not just in time, and taking time: they are also representations

of time, the kind of time-consuming activity that dominant media set out not to be. The TV schedule and the cinema film try to erase time even while they occupy it: a successful cultural product steals time, by filling it while making you unconscious of its passing. Consciousness of time passing is, for such a culture, boredom: unnecessary, wasteful, even evil ('The Devil makes work for idle hands'). Anderson makes much of time passing, and makes of it an entertainment – a remarkable achievement. Her performances are temporal objects, and unlike the records we have no clear sense of when they will end, when they will be complete. This should open us up to the idea that no art object is atemporal or complete, in the sense that the relationship we enter into with it cannot be finalized, merely abandoned. Looking back for a gestalt in *United States*, I find accumulation, networks and patterns of interconnection, but also a profound disunity, a severance of image from image, gesture from gesture, story from story that can only be called a unified whole by a rhetorical gambit.

Even that is disrupted by a passage in which all the previous ten minutes or so of the show are repeated at high speed, the voices of the performers recorded and accelerated to a high-pitched gabble in which only the bare bones of the meanings are available. This fast section concludes with the accelerated voices repeating 'This is the time. And this is the record of the time.' The game with temporality – repetition, recording, speeding-up – indicates how time is its own record keeper, but not a trustworthy one. For us, time has become something else again from the temporality recorded by Lukács in the early twenties: 'time sheds its qualitative, variable, flowing nature; it freezes into an exactly delimited, quantifiable continuum filled with quantifiable "things" (the reified, mechanically objectified "performance" of the worker, wholly separated from his total human personality)'.[9] Now that the accumulation of fixed capital also includes the accumulation of human knowledge (as well as culture); now that knowledge, turned into information, becomes subject to human interest (in the sense of vested interests); now that information itself has been abstracted from the mind and is exchanged as commodity, not only is the nature of knowledge changed but the construction of suitable technologies has altered the temporal relations between the mind and knowledge. They are no longer synchronous. The very speed of transmission debars us from participation in this instrumentalized knowledge, until we acquire devices to slow down the flow, devices designed from the ground up with corporate capital in view.

The metaphor of management has taken over from the metaphor of engineering. Lukács's metaphor is the factory, with its mechanical tempos. Our metaphor is the office, with its doctrines of efficiency and its manipulation of power rather than labour. We manage information, rather than engineer it. But these are metaphors: the fundamental business of

extracting surplus value continues, only its medium has been displaced from production to exchange. Something akin to Lukács's reification still holds good for us (though we cannot share his faith in a 'total human personality').

Often Anderson's tales and images have a certain internal gestalt, a sense gained as they end that they have ended and that we have reached a limit point, a horizon beyond which it would be fruitless to go. Mostly, they do not prompt a 'What happens next?' Their isolation from one another mimics the isolation of characters in them, little tales in which the relationships between people become frozen or impossible. Their words take on, with their temporality, a solidity like that of concrete poetry, like that of bits of information. Words that no longer serve, but take on an autonomous life of their own, circulating in a system that has no human reference points. Even the human exchange of pleasantries has become a mediated sphere of rituals that no longer signify, of messages without meaning. This is a kind of reification Lukács would have recognized, even as he would also recognize the changes wrought in the microhistory of subjectivity in the industrial West. His greatest philosophical error was not the positing of a human 'essence', but the belief that his epoch witnessed an ultimate moment in the development of capitalism. The word 'ultimate' should be placed under a ban until history is actually over – or actually begun.

For Anderson, the crux of this breakage in communication is that the media of interpersonal communication have taken on a life of their own generally: not just language, but all its mediations have solidified into protocols whose sheer presence overwhelms their communicative purpose. Answering machines, in-flight announcements, tannoy calls, phones, radio, TV evangelists, all have their clichés, their intonations, their exhortations and commands, their etiquette, their platitudes, their distortions that have become part of the repertoire of what we have to speak with. Even the language of love has become as predictable as the language of astrology columns, 'a conflictless succession of events' as Adorno says of popular narrative drama.[10] Anderson's constantly remodulated vocals not only enact the decay of individuality that accomplishes its ossification; they also continue the estrangement of the voice from the body in which we can recognize the theft of knowledge under the guise of information. Our speech is not our own. The triumph of the signifier over the signified arrives not as the strength of formal technique, but as the distances between speaker and spoken, spoken and hearer, the tyranny of mediation.

Formal discoveries still fuel the work. In 'Beautiful Red Dress' (1989), a typically ironic song about consumerism is interrupted when, the backing track sinking to rhythm section alone, and vocals to speech, Anderson gives a quirky rendition of statistics on the difference between average pay for men and women. This montage works to punctuate and to redirect the song, to resituate its ironies as specifically feminist, a direction which her work

seemed to have taken increasingly during the eighties. But perhaps it is in the sale of her records that she most radically restates the commodification of everyday life in formal terms.

The Industrialization of the Avant-garde

He says: I have wasted my life on our stupid legend.
'The Dream Before' (1989)

To own ourselves. To own our own faces.
'The Human Face' (1991)

We hear, in a 1989 South Bank Show special, from Jimi Hendrix's light show operator, of a 1969 concert given by Hendrix in Newark, New Jersey, the day after the assassination of Martin Luther King, a concert entirely devoted to a free-form jam that left the audience and road-crew in tears. On TV, the technician lamented the lack of any recording. One reaction is to feel that such moments are better held in memory. Another regrets not having something to place alongside Hendrix's Woodstock version of 'The Star-spangled Banner'. A third, however, suggests that the commodity form is suitable only for certain artistic purposes, and that the liveness of this event could only be damaged by documents of it being circulated in the same way as any disc. Hendrix brought to pop performance the raw Romanticism of soul, perhaps the last desperate attempt to resituate the body in popular culture as a source, not as an appendage. That something of his work must disappear with his death is part of the work itself. Anderson's work, on the other hand, seems to start from the premiss that the visibility of the body is always in question, always mediated, just as is the voice. Mediation is at the core of her art, but mediation that is itself always caught in the webs of capital. The familiar question must then arise of the relation between the avant-garde and the transnationals.

An image from *United States* dresses the inside sleeve of *Big Science*, the image of a two-pin socket, massively enlarged and turned upside down so that the shadows across it give it the feeling of some archaeological find, some crude and awesome deity. The pun itself is clear enough: electricity has the power of godhead in the age that learns to mourn the death of God. And we think: how fragile and insecure the two-pin socket looks there on the wall, and how enormous it is here (and how much bigger still projected on slide in performance). For a moment, perhaps, the nature of the image as photograph might cross our minds, the way photography allows moments of the world to take on new aspects. We recognize an imagination at work on the raw materials of the everyday world, feel the power of contradiction between the thing and its representation which is one of the well-springs of

art in our time. We know we are in the presence of art, which is the name we give to a certain experience of uncertainty. We understand the simplicity of formal means as elegance, the distance from familiar perceptions as aesthetic, the troubling of assumptions as avant-garde.

The photo is credited to Laurie Anderson, although the copyright in the recording belongs to Warner Bros, and in the songs to Warner Bros Music. The copyright information on the sleeve is unusually spare. But there are few readers of this piece who will not recognize the name of Warners, now one of the world's largest entertainment corporations. This is a record sleeve: we know we are in the presence of capital. The image acts like a logo, a 'corporate' identity that is as much part of what we can understand about Anderson as the conception of her as artist. Not that we are unfamiliar with the notion of the artist as entrepreneur: the towering figure of Picasso towers, as Berger first noted, because of his enormous wealth.[11] Much closer to Anderson, Warhol made of his work a pinpoint targeting of the commodity status of painting, even naming his studio The Factory. We might want to define art in a different way: as that form of luxury commodity, produced in an archaic artisanal mode, that circulates in galleries and is characteristically employed as a form of investment.

This gives us a historical question concerning the derivation of art as an autonomous mode of activity. As art emerged into its separate existence, and as other cultural domains took off along another route, was it art that was doomed to sacrifice itself on the altar of its own elitism? Or was it rather that art presumed an autonomy which in fact it has never possessed, an autonomy from the everyday which it was never in a position to effect? Art has always been complicit with culture, even when – perhaps most of all when – it has attempted to distance itself from it. It is that distance from ordinary culture that has marked it: popular culture has been – as folkloric or mass culture – the Other that guarantees the distinction of art, as the peasant and worker guaranteed the distinction of nobility. Without the popular, artistic culture is unthinkable. And in our day this means: it is impossible to think art unless we also think mass culture and the commodity form. In this definition of art, we can only understand art practice within the artistic enterprise, with its galleries and markets, festivals and auctions, magazines and adverts, and we need only then to understand the unusual appeal of the unit-production of individual works as serving particular kinds of economic and social need. These needs are, almost exclusively from this point of view, the need for portable and unique items for investment (how much drug and arms money is laundered through the art markets?), and the need for cultural capital, in Bourdieu's felicitous term: the status that possession of a unique art object brings to its possessor. In this perspective, art is then a mere variant on fan culture, the collectors of seven-inch picture discs and Elvis Presley's old jackets.

Intervention in mass production has been a fruitful strategy for cultural producers formed in the schools of autonomous art but painfully aware of its limitations. From Dürer's devotional woodcuts to the situationist construction of the Sex Pistols, mass circulation has produced much of the most fruitful and inspiring work of the last five centuries. On the other hand, it must also be constantly reiterated that the machinery of capital is capable of assimilating the most extreme and outrageous of art practices and turning them into commodities: as witness, in the end, the re-marketing of the Sex Pistols in the nineties as both symbolic heroes of anti-art and anti-everything, and as CDs. Performance art makes its own intervention in the commodification of art by producing only works that can have no objecthood and therefore no permanence, and which therefore cannot become vehicles for investment. But they, too, can provide artifacts: Beuys's blackboards sell quite well, and the cultural capital acquired from attending one of his performances is astronomical. Even the act of refusal, of negation of commodity status, can be recycled in other moments of capitalism, most of all in the form of an ideological statement that if such things can go on, we must be free. To some extent, the most outrageous performers are the ones who most accurately fulfil this role for capital, since the more their actions outrage, the more freedom there must be. The avant-garde does not suffer from too great a distance from the rest of the world, but from too great a proximity to it.

Anderson's recordings do not document her work: they stand free of the performances, and offer themselves as commodities, cheap commodities stripped of uniqueness. The music is a skeletal account of pop forms, drawing certainly on the avant-garde discovery of percussion in the twenties, but reverting to its sources in jazz and folk music as much as it bears the memories of the development of formal music from Serialism to Minimalism, and applying electric and electronic instruments to the fundamental tones of handclaps and breath. For the most part, it is not a music that berates us with formal innovation. It shares with pop a fundamental repetitiveness and a fundamental brevity, as well as the familiarity of the song as its central form. Pop and the avant-garde had been in conjuncture in New York at least since the Velvet Underground, and in the seventies the links spawned several New York art scene bands: Talking Heads, Blondie, the New York Dolls, Suicide, among others. One simple reading is that the music industry offered a means of earning a living after art school. The art–pop connection traced by Frith and Horne leads, they suggest, to a realization that

> the interplay of artifice and authenticity is central to *everyone's* lives in consumer capital. In looking at the shifting ways in which the love-hate relationship of the artist and society has been worked out in pop, we simply find the dialectic in graphic outline. The art pop story, in short, is not just a chronicle of defeats, but reveals how the terms of resistance and recuperation keep changing.[12]

It is not to belittle the work of Frith and Horne to query the terms of the critique in which they are engaged. The dialectic of resistance and recuperation which is so intrinsic to the continued growth of capitalism is also the mark of its failure to secure a lasting paradise, even for that minority of the world's population who are invited to the feast. Resistance to the totalizing efforts of the administered society is always to be celebrated. But we need also a level of analysis which sees in this dialectic an ongoing catastrophe, in which the processes of objectification and alienation whittle away at the cores of experience, colonizing with each sweep across from subversion to assimilation another area of life, another element of our selves. At the same time, this analysis should be complemented with or opposed to another, which sees in the gradual abolition of identity and selfhood the emergence of another humanity, less strangled by the boundaries of individuality. In a perverse sense, having created individuals, capitalism cannot sustain them, but by the power of its own logic must capitalize upon more and more human faculties. But in doing so, it cannot but socialize these faculties. If my voice and words are no longer my own, then I must learn to accept that such are the terms upon which it will be possible to speak. Language is no one's property – at least not the natural languages, at least not yet.

Property rights, especially copyright, are in a state of crisis not unrelated to this dialectic. On the one hand, the software manufacturers seek to prevent copying. On the other, hardware manufacturers seek to profit from the sale of copying devices – cassette decks, photocopiers, computers. Now that dialectic between the interests of hard- and software is conducted within the largest multinationals like Sony. At the same time, it is experienced on a daily level by hackers, DJs, researchers, civil servants, visual artists and designers, video freaks and home tapers. The languages on which we wish to draw are no longer simply verbal: they are visual and auditory too, a language made up of lines from the movies, pin ups, TV theme tunes and news images. But copyright law has scarcely caught up with print technologies, certainly in the UK, and is incapable of arguing a moral case for 'intellectual property' when the copyright holders are almost universally not the authors but publishing houses, record companies and photographic agencies. It is not a case of arguing for the 'freedom' of visual and auditory languages from archaic constraints, nor of insisting upon the rights of cultural practitioners to earn a living from their work. We have to recognize that the silkscreened image of a Campbell's soup can belongs both to the estate of Andy Warhol *and* to Campbell's Inc., that these are the terms under which the making of cultural artifacts is possible. Moreover, the image of the soup can has become part of many people's cultural reference, almost willy nilly. Were I to make a similar screen, as Sherrie Levine re-creates classic photographs, would it not be a perfectly viable, if hardly original, appropriation of the image, leaving me, too, with a claim on it?

'If all aspects of the culture use this new operational mode', writes Douglas Crimp on an exhibition containing works by Levine and other 'image appropriators', 'then the mode itself cannot articulate a specific reflection upon that culture.'[13] Crimp is correct to the extent that sheer formal innovation can only work within the culture which it addresses: Levine's critique of art photography can only be understood within the culture of art photography, just as Warhol's soup cans need a culture containing both soup and art to make sense. Such work simply outlines the grounds on which any kind of cultural activity can occur today. The failure of postmodern art practices to do more than sketch the grounds of their own possibility (or, more radically, impossibility) leaves them within the dialectic of resistance and recuperation which Frith and Horne highlight. Such is, to a large extent, the problem with Anderson's recorded work, which contests the triviality of the pop song through an ironic replay of the banal rhetoric on which it is based, but all within the commodity form of the record industry.

She is, of course, not alone. The terms under which Heartfield and Eisenstein could intervene politically in the mass media of the twenties and thirties no longer obtain, and they cannot be used as simple talismans for politicized crossover work between art and popular culture. We need an even more sophisticated understanding of contemporary media than Benjamin had of film, radio and photography, since the media we deal with are more complex. And we can no longer act as if Europe and the USA constituted the whole of the world which we inhabit. The ease with which Anderson's recordings are assimilable within the music business, not only as records, but as a targetable genre of New York adult-oriented art pop, alongside Talking Heads and Lou Reed, should make us yet more aware of the relative strength and scale of the art world and the transnational culture industries. The latter will invariably win, and indeed thrive on having their research and development work undertaken by artisans in the art world, rather than paying for it themselves. Such is the message of the recordings. Words, relationships, anecdotes and the connections between them seem like barriers to communication because of their objectification. Such, too, is the status of the record itself: time, and the record of the time, are one. The commodity status of the album enables as it defuses critique. Communication is scarcely possible, and almost undesirable.

The Reclamation for a Progressive Politics

He says: You know, I can see two tiny pictures of myself and there's one in each of your eyes.

'Sharkey's Night' (1984)

Another kind of humanity is coming about: through the intensifying isolation of the individual beyond the point at which it is bearable, by

extending the fragmentation of body and mind and even of the internal dynamics of the psyche, and by the colonization of psyche and soma by the structures and images of transnational capital. But the result of this in terms of cultural life is a dialectical process of intra- and extrapsychic development. On the one hand, the subject surrenders its external identity in favour of a profoundly inward-directed, even narcissistic, culture, and, on the other, its language and fantasy life are extensively socialized by the processes of colonization. The conflicts of society at large are re-enacted in the processes of subjectivity.

At the same time, however, these processes hold good only at the expense of internal divisions in the industrial West and the increasing immiseration of the rest of the world. Protecting the gains of Reaganomics and Thatcherism, and the savage deregulation of finance capital, have produced what threatens to become permanent impoverishment of the disenfranchised poor in the developed world. Intensified accumulation of fixed capital has helped create crises in employment, welfare, housing, health and education that might have threatened political stability, were it not for widespread political apathy among the disenfranchised and oppressed as well as among postmodernizing intellectuals. Longer-standing divisions of class, 'race', gender and disability overlay these newer developments in regional and global inequality. It is the business of a critical culture not just to undertake an analysis but also to understand how the new modes of subjectivity unearthed by Anderson and artists like her are implicated in a global complex of economic and cultural catastrophe. If ecology has provided the most potent new politics of the post-war period, then we should use it to understand culture, too, ecologically. The regional development of a post-culture cannot be understood apart from the fundamental global system within which it flourishes. The failure of postmodernism to provide such a global understanding in the age of global corporations and global communications is indefensible. The understanding we might have of culture may no longer be founded on political economy, but it can no longer afford to ignore it. Anderson's work and the thought it gives rise to can give us a vital purchase on basic elements of this inquiry.

In 'O Superman', Anderson scored her most spectacular coup, riding into the British singles charts with a self-evidently avant-garde song (deriving from the sprawling performance piece *United States*). The single and the accompanying video form a fascinating conjuncture with the Britain of the early Thatcher years, which among other policies was committed to a virulently pro-American line, especially in military affairs. At the same time, Britain was (and is) itself a major military adventurer, with a long-running war on its own doorstep and the Malvinas war only months away, while maintaining an important weapons industry. 'O Superman' speaks directly to both American imperialism and the world-wide trade in arms in which it

figures so powerfully. Britain's position as both subservient partner in the Atlantic partnership and a major arms exporter perhaps left us generally disposed towards an amused recognition of Anderson's concerns.

The video, directed by Anderson, re-creates some of the effects of the stage show, especially light effects in which she is illuminated, her shadow cast, the shadow takes on a life of its own, and she becomes, momentarily, a light source thanks to some form of lamp in her mouth. These devices not only play upon the technologies of representation – cinema projection, TV monitor as light source – and upon theories of aesthetics and ontology – Plato's cave, Goethe's discovery that the eye is a source as well as a recipient of light – but they also indicate the problem of (re)presenting the self, of becoming visible. To some extent at least, that process includes the process of becoming an object for an Other, and not just in the phenomenological sense of Merleau-Ponty's theories of perception. It must also include the process whereby the artist herself, as performer and as videoed, becomes a commodity. This presentation is alienable, exchangeable, equivalent to other commodities. Though produced without the industrial scale of many pop video's resources, and to some extent artisanal and gallery-oriented, it takes its place in the general circulation of commodities in the mass marketplace of global communications. The devices of self-reflexivity hamper and disturb the simple consumption of the tape (and the song) but do not finally halt this process of reification and commodification. What they do do is to bring that process into the foreground of the product, so that one level of the tape's meaning is the process by which it becomes a marketable entity. Its games with light and with perceptual expectations (as when a pool of light becomes in turn a revolving disc and a globe) mark not the impossibility of this process but its inevitability: even these illusory pleasures can be turned into the life-blood of capital.

The song, too, plays with reflexivity, most of all in the ploy of the ansaphone message, the half-conversation which is always over, always past. Again, the speaking voice is marked as already history, even though its message ('You better get ready') is future-directed, a future that might perhaps now be in the listener's present. For, indeed, she converses with the voice on the ansaphone, but both of their voices are recorded in the song, already objects completed and circulated as commodities. Their dialogue, like so many others in Anderson's work, is marked by non sequiturs and the sense that communication is not really going ahead: a dialogue of the deaf. At the same time, the 'message', couched in a poetic language, is plain: the military might of the USA threatens us all. The poetry of the language – by which I mean the way in which the words are made to carry more connotations than in normal speech – also opens up a set of cross-gendering allegories for the power of the military: two men (Superman, Judge), a heterosexual couple (Mom and Dad), and finally Mom. No single or simple

identity holds under the demands of either allegorical composition or the analysis of human relations in a time and a country intimately stitched into the fabric of warmongering and profiteering.

Mom, of course, is a political figure, as in Mom and apple pie. But Mom is no longer comforting in any unambiguous sense. Her arms are automatic, electronic, petrochemical, military. And long. The embrace of the military-industrial complex is as insistent as maternal phone-calls, that surprisingly frequent image in Hollywood films of career women and their loneliness. And Mom is also home, but as Anderson's second caller says, 'Is anybody home?' For if home is entirely imbricated within the arms trade, what value does it have? Who can be there and still be themselves, not the objects of its masters? But perhaps the most appalling section of the song indicates Mom's true position within a world marked increasingly by the abandonment of ethics: without love, without justice, when even force has failed, there is Mom. As Anderson's sentence moves along its narrative chain, the end of each phrase ('justice', 'force', 'Mom') comes with a perceptible weight, even when Mom appears at the end with the force of a punchline to a gag. The final refrain, inviting Mom to cuddle her errant child, is in this context an enormous expression of weakness, of an exhausted acceptance of Mom's ever-present hold. The metaphor is extraordinarily evocative, and even without a sense of the allegorical edge to it, it is surely strong enough to account for some at least of the song's success.

'O Superman', then, is a song whose narrative, while expressing something of the fear and loathing that the US arms industry inspires, speaks also of the way in which some kind of accommodation, however grudging, however marked by the sense of defeat, is inevitable. Irony and the brilliance of both the melodies and the electronic production may distance but cannot erase that accommodation, and in some sense reproduce the doubt, so widely shared in the post-war period, that progress only takes us towards a future in which universal defeat is inevitable. This chill surrealism certainly struck a chord with British audiences, though it would require an ethnographic project of a scale that can't be accommodated within this essay to discuss why and how people took such a liking to her work, and this piece in particular. Intuitively, I'd guess that it has something to do with the association of futuristic sounds with melancholy music, so that a disturbance is set up between the New Frontier glamour of the technological progress and the widespread fears expressed, among many others, by my students, who, asked what they expected the world to be like in fifty years' time, thought that it would either be nuked or polluted into destruction. The assimilation of this contradiction into an easily appropriable form, even at eight minutes, twenty-two seconds, contributed to the song's success. At the same time, its status as yuppie culture marks both its power as cultural capital – the avant-garde you can actually enjoy – and the ease with which it was assimilated into mainstream cultural formations.

The fatalism of the song as narrative, and the contradictions marking its music, combine into a third level of action, for while it foregrounds and accepts its status as commodity, it does so only on the grounds that there is no other way in which it might exist. That is the wellspring of its sadness. Anderson makes no calls, here, for revolution, not even for subversion or resistance. She merely mourns the state of the world in which she has to work. The image of the child cradled in her mother's arms, even if those arms are the arms of a vast and destructive industry, delimits the weakness of the individual, created as such, but debarred from the processes of love or justice that would otherwise provide the means to form links and networks with others. The solo voice, especially, establishes the loneliness of individuality. The repeated keyboard figure carries the weight of all repetitions, the endless cycle of exchange in which all individual strivings and yearnings are caught. In the end, there is only Mom, the paltry comfort of accepting the boundless love and forgiveness of the system that assimilates us, artists and mass cultural audiences alike.

The postmodern world is the property of a small, even a diminishing, proportion of the world's population. Anderson's work operates only in a particular space, marking out an ironic and in some important sense disinterested account of contradiction in the heartlands of finance capital. We do not and cannot require of her that she be a global artist, as perhaps once it was possible to imagine Picasso to be. Global platitudes can't help: Picasso's dove is of no more use to us than 'Do They Know It's Christmas' – though no less. The scale of the task before us is enormous, and the way forward consequently no longer individualistic. The change that has come over the world involves both an altered subjectivity and an altered society. The intensification of inwardness comes about in the West at the same time that capital has succeeded in organizing production and exchange on a global scale. In these days, the Great Artist is probably no longer possible, and certainly not necessary. It is in the accumulation of cultural acts, involving thousands, even millions, that we can find some germ of hope, some remnant of the concept of the future, to make this living worthwhile.

Notes

1. Peter Bürger, *The Theory of the Avant-Garde*, trans. Michael Shaw, Manchester University Press, Manchester 1984.

2. Jeremy Welsh and Stephen Bode, 'Putting the Artist into Focus', programme essay for *To Camera*, Film and Video Umbrella, London 1992.

3. Maurice Merleau-Ponty, *The Visible and the Invisible*, trans. Alphonso Lingis, Northwestern University Studies in Phenomenology and Existential Philosophy, Evanston, Ill. 1964, pp. 130–55.

4. Jacques Lacan, *Le Séminaire, livre XI: Les quatres concepts fondamentaux de la psychanalyse*, Seuil, Paris 1973, pp. 65–74.

5. D.N. Rodowick, *The Difficulty of Difference: Psychoanalysis, Sexual Difference and Film Theory*, Routledge, London 1991.

6. Laurie Anderson, 'Words in Reverse' (1980), in Brian Wallis, ed., *Blasted Allegories: An Anthology of Writings by Contemporary Artists*, New Museum of Contemporary Art, New York/ MIT Press, Cambridge, Mass. 1987.

7. See Donna J. Haraway, 'A Cyborg Manifesto: Science, Technology and Socialist-Feminism in the Late Twentieth Century', in *Simians, Cyborgs and Women: The Reinvention of Nature*, Free Association Books, London 1991.

8. Merleau-Ponty, *The Visible and the Invisible*, p.189.

9. Georg Lukács, 'Reification and the Consciousness of the Proletariat', in *History and Class Consciousness: Studies in Marxist Dialectic*, trans. Rodney Livingstone, MIT Press, Cambridge, Mass. 1971, p.90.

10. Theodor W. Adorno, 'The Schema of Mass Culture', trans. Nicholas Walker in J.M. Bernstein, ed., *The Culture Industry: Selected Essays on Mass Culture*, Routledge, London 1991.

11. John Berger, *The Success and Failure of Picasso*, Penguin, Harmondsworth 1965.

12. Simon Frith and Howard Horne, *Art into Pop*, Routledge, London 1990.

13. Douglas Crimp 'Appropriating Appropriation', in *Image Scavengers*, exhibition catalogue, Institute of Contemporary Art, University of Pennsylvania, Philadelphia 1982–83; cited in Abigail Solomon-Godeau, 'Living with Contradictions: Critical Practice in the Age of Supply-Side Aesthetics', *Screen* 28 (3), 1987, p. 8.

Index

TITLES OF RELATED INTEREST

RAIDING THE ICEBOX
Reflections on Twentieth-Century Culture
PETER WOLLEN

Raiding the Icebox presents an alternative version of the history of twentieth-century art and culture, focusing on the rise and fall of modernism. Beginning with an analysis of the role of Diaghilev, Wollen also examines Matisse and Pollock and reviews the hopes and fears of artists and critics fascinated by Henry Ford's assembly line as much as by the Hollywood dream factor. The emergence of a subversive new sensibility is chronicled in the underground films of Warhol, and the new cultural forms that some non-Western artists are using are explored: raiding the ice-box of the West.

Peter Wollen draws on an idiosyncratic range of sources to reflect brilliantly on aspects of contemporary culture, from film robots to tourist souvenirs.
Marina Warner, *The Independent on Sunday*

256 pages, 1993
Paperback ISBN 086091 578 6
Hardback ISBN 086091 366 X

WHAT SHE WANTS
Women Artists Look At Men
EDITED BY NAOMI SALAMAN

Images of men selected from the work of over 60 European and American women artists are contextualized by critical essays from Claire Pajaczkowska, Naomi Salaman, Cherry Smyth, Linda Williams and Lola Young.

The photographs we see in this book are raunchy, beautiful, funny, awesome and tender. They ask me to look anew at bodies and organs which I have rarely seen pictured for me. So what do I see? I see pornography and eroticism, I see intimacy and distance, I see penises and phalluses. What do I want? Most of all, I want the chance to keep looking.
From Linda Williams's Introduction to *What She Wants*

168 pages, 100 colour and b/w photos, 1994
Paperback ISBN 086091 656 1
Hardback ISBN 086091 491 7

For further information about books available from Verso please write to:
USA: Verso, 29 West 35th Street, New York, NY 10001-2291
UK & Rest of World: Verso, 6 Meard Street, London W1V 3HR